# Murals of the Americas

EDITED BY VICTORIA I. LYALL

**DENVER** ART MUSEUM

# CONTENTS

Denver Art Museum's holdings of ancient and Latin American art constitutes one of the most significant collections in the United States. The ancient material spans nearly four millennia and represents the great artistic achievements of the region. The collection, which began with a few pieces of northern and western Mexican material, grew exponentially in 1968 with the formation of the New World Department. The vision and foresight of then director Otto Bach and curator Robert Stroessner ensured the development of a comprehensive and expansive collection. The generosity of longtime museum supporters Frederick and Jan Mayer has made the collection truly extraordinary. Beginning in 1968, the Mayers supported the growth of the department and the purchase of exquisite material.

In 2001, a pivotal gift from the Mayers made it possible to establish the Frederick and Jan Mayer Center for Pre-Columbian and Spanish Colonial Art at the Denver Art Museum. The Center's purpose is to increase awareness and promote scholarship in these fields by sponsoring academic activities including symposia, fellowships, study trips, research projects, conservation, and publications. This volume, which presents papers from the seventeenth symposium, held in 2017 and the first organized by curator Victoria I. Lyall, both continues that tradition and heralds a new way of thinking—and talking—about these collections. As the chapters in this volume demonstrate, art from the ancient Americas continues to be a touchstone for contemporary Latinx artists. For the first time, the symposium included the voices of living artists whose practice resonates with those of ancient artists and their traditions.

As we enter the Denver Art Museum's next phase, the reinstallation of the permanent collection galleries, it is time to reevaluate the antiquated terms used to describe our collections and reaffirm our commitment to promoting art of the Americas. Jorge Rivas Pérez, formerly curator of Spanish Colonial art, will now be known as our Curator of Latin American Art. This collection encompasses work created after the arrival of Spanish to the Americas in the 1500s to the present. Victoria I. Lyall, formerly curator of pre-Columbian art, will now be known as the Curator for Art of the Ancient Americas. The term "pre-Columbian" applied to objects produced prior to the arrival of Christopher Columbus; therefore, it defined ancient cultures by the arrival of Europeans. While the ancient Americas collection primarily focuses on objects produced during the four thousand years of civilization prior to the Spanish arrival, its expanded scope includes works by contemporary artists whose practice or technique resonates with those of ancient artists. Reflecting the title changes and the new emphasis of both collections, the museum will no longer use the term "New World," and the Mayer Center will be known as the Mayer Center for Ancient and Latin American Art.

The 2017 symposium reflected Victoria's new vision for the department. The topic, "Murals of the Americas," included work from the American Southwest, Mesoamerica, and contemporary murals. Scholars from across the region, as well as artists, considered the role of large-scale art inscribed on walls in sparking dialogue, furthering learning, or inspiring viewers. The chapters in this volume, like the collection, span from the earliest civilization in Mesoamerica to the present, and include the perspectives of artists Judith Baca and Ed Kabotie as well as those of well-regarded academics. Each chapter discusses how murals function as a powerful tool for the expression of political, social, or religious ideas across diverse time periods and cultures. In its breadth and ambition, it is the perfect volume to inaugurate our renewed commitment to the art of ancient and Latin America.

Christoph Heinrich
*Frederick and Jan Mayer Director*
Denver Art Museum

# Introduction

As the Denver Art Museum re-envisions the Mayer Center symposia and explores connections between artists across the Americas, I thought it necessary to underscore the legacy today of ancient practice and technology. For the first time we have included the voice of living artists who make clear that space, place, and process are as important today as for ancient artists.

Our topic, murals, was broad enough to accommodate this wide-ranging approach. The word "mural" derives from the Latin *murus*, or wall, and has come to signify an image inscribed on an interior or exterior surface. These images rely on an audience to integrate them into a coherent whole. A mural's meaning can shift depending on the viewer, just as a story's meaning can change depending on the reader. In other words, murals should not be seen as static but rather as the result of a complex interaction between artist and viewer and their physical, social, or cultural environment.

This book brings together case studies from across the Americas that interrogate the possibilities represented by the visual record. As many of the essays make clear, as scholars of the past we must go beyond the fixed image to consider both the environmental and performative context of a work.

We begin with an interview with Chicana muralist Judith Baca, who began her career as an artist, educator, and social activist during the social upheaval of the late 1960s. In her words, mural painting is a political act, a vehicle to give voice to marginalized people as both the subjects and makers of images. Throughout her forty-year career, Baca has proved that public art transforms lives.

Decorating the sides of crags overlooking the valley floor or the interior of an expansive cave network, the murals of Oxtotitlán are embedded in the landscape of Guerrero, Mexico. Since they came to light, scholars have looked to the paintings as a social and cultural record of the origins of Mesoamerican society. Recent work by the Urban Origins Project—imaging, data, and regional surveying—gives a broader chronological and environmental context for these works. For the first time, thanks to new dating techniques, we are able to understand the temporal framework for the paintings' production, which spans millennia. They form part of a topographic shrine, a pilgrimage site that continues to attract devotion today. The continuity of use denotes what Yi-Fu Tuan

*Opposite, right:* Detail of Fig. 22, Martínez

identified as topophilia, the emotional bond that exists between people and places. Hurst et al. suggest that in order to understand the paintings' power, we must consider their environmental context and connection to communities through time.

Similarly, Franco Rossi's study of the Xultun murals encourages us to consider these as both interactive works activated by the transmission and absorption of knowledge as well as a record of ranking systems in Late Classic Maya society. The room housing the paintings includes a mural depicting eleven individuals identified as belonging to the order of *taaj*, or obsidians, and the ruler of the site, but it also includes hundreds of annotations painted or incised on the walls' surface. Much like a schoolroom chalkboard haunted by the ghosts of unresolved equations, so too the walls of Xultun record the messy process of active learning. Identified as calendrical or astronomical calculations, these microtexts underscore the interactive nature of the space. The presence of the ruler, however, makes clear the didactic role the state played in the education of its youth to ensure the continuance of a moral order. Hurst and Rossi illustrate how murals could both inspire and instruct.

Claudia Brittenham's study of the development and spread of the rainbow serpent motif considers murals as repositories of cultural memory and, like Rossi, as vehicles for the transmission of knowledge. The site of Chichen Itza in northern Yucatán lay at the crossroads of the Maya tradition and the greater Mesoamerican world. Its artists, indebted but not beholden to the artistic canons of the Classic Maya, drew from the powerful symbol systems employed to the west. By tracing the origins of the spiky, rainbow-hued serpent seen throughout the site from Teotihuacan to Chichen Itza, and subsequently following its

re-emergence in both Mixtec and Aztec visual culture, Brittenham ably expresses the interconnectedness of Mesoamerica and suggests the importance of collective memory in preserving and promoting ephemeral aspects of culture such as religious belief and practice.

Like Brittenham's, Kelley Hays-Gilpin's chapter on Hopi mural tradition considers murals as an integral part of shared memory and heritage. Among modern Hopi artists, murals capture the relationship between ancient peoples and their living descendants. As she makes clear, the path between past and present is not unbroken; nevertheless, her study illuminates the role archaeology and oral tradition play in preserving the central tenets of land and history in the murals of the modern Hopi. Hays-Gilpin traces the development of Hopi murals throughout the Southwest and how archaeologists disseminated their findings to both the local Hopi communities and the wider world. By connecting the history of discovery to three generations of Hopi artists, the Kabotie family, she reveals the complex interplay of past and present. In order to reflect the complexity of this artistic legacy, we invited Ed Kabotie, whose father is Michael Kabotie and grandfather is Fred Kabotie, to offer a reflection on his practice and his relationship with his father and grandfather's work.

Severin Fowles and Lindsay Montgomery underscore the importance of mining the knowledge of contemporary Native communities to recover ancestral narratives inscribed on the rock faces of the American West. Because of the pictorial rather than alphabetic nature of these stories, they are frequently omitted from current scholarship, thus ignoring the voices of Native people. In their essay, Fowles and Montgomery propose the existence of a counter-archive, a source of Native stories that offer a counterpoint to eighteenth- and

nineteenth-century text-based accounts of the American West: the petroglyphs found throughout the region. Fowles and Montgomery demonstrate the connection between Biographic Tradition rock art and Plains Indian Sign Language, arguing that the enacting of the story—the gestural act of making such images—was as important as the resulting picture. These works stand as historical records, authored by Native voices, during a period in which their world underwent rapid cultural transformation. Notably, Spanish colonists appear as minor players in the compositions; instead, horses and battles among rival communities occupy the main storyline. Like their counterparts in Mesoamerica, these works do not function as static images, but active participants in a dialogue across time and place as later visitors have added their own marks.

In her essay on Denver's Chicano murals, Lucha Aztzin Martínez, like Fowles and Montgomery, presents these works as a counter-archive to the dominant discourse of Colorado history. The murals stand as a testament to the complex heritage of Colorado's Chicano community, whose roots trace back to the Southwest. Martínez de Luna, the daughter of Emmanuel Martínez, a Denver artist and leader of the national Chicano movement, offers a personal perspective on the iconography employed by artists throughout the state. The murals she discusses reflect the community's ties to Hispanic and indigenous populations of the Southwest and the displacement they endured as the region industrialized. Nevertheless, the continuation of the tradition by a younger generation of artists celebrates the Denver Chicano community's vibrancy in a changing city.

The essays in this volume bring to life the stories and memories of communities past and present and remind us that not only do walls have ears, they have voices as well.

Victoria I. Lyall
*Frederick and Jan Mayer Curator of the Art of the Ancient Americas*
Denver Art Museum

◎ ◎ ◎

JESSE LAIRD ORTEGA

# Interview with artist Judith Baca

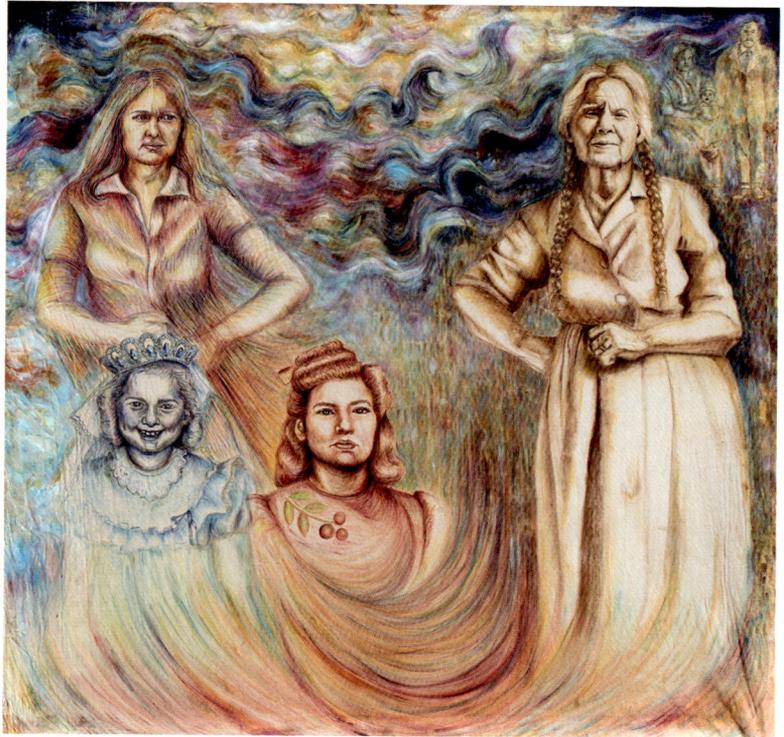

A self-proclaimed "political landscape painter" who throughout her almost fifty-year career has repeatedly reinvented her practice, Judith Baca is a woman of multifaceted talents whose unrelenting passion makes her a force in both the Chicana/o mural movement and the broader Los Angeles arts scene. Baca's art and social practice focus on community and cultural issues, and she pursues her vision for a better, more peaceful world by making and supporting public art. She infuses her own art and stories with those of underrepresented people. Baca roots her practice in the idea that land is a "site of public memory." Through both research and the recording of first-person accounts of people living near the site she is painting, she taps into local memory to tell the stories of what came before.[1]

Born in 1946, Judy Baca spent her formative years in the Watts neighborhood of Los Angeles in an all-female household with her mother and grandmother (fig. 1). She holds bachelor's and master's degrees, plus an honorary doctorate of fine arts, from California State University, Northridge, and is now a professor in UCLA's Department of Chicana/o Studies.

However, she says, "most of my teaching and learning has not been in a classroom nor has it been called education, but instead art and community transformation."[2] Her career as an artist and social activist began in the late 1960s, at the height of the Vietnam War, when she protested the war at the expense of her teaching job and mobilized gang members to paint murals in public parks. For Baca, public art is political and completely intertwined with her vision of herself as a social activist, educator, and mentor. She believes that we, as members of a larger community, have an obligation to question what we know and express ideas that might be viewed as contentious. She expresses these views through public murals. For Baca and the young people she works with, creating public art is a transformative experience. Her ability to inspire people and engage the community in her artistic practice—from research, to design, to execution—is unparalleled. She gives each participant a stake in the project and therefore

Fig. 1. Judy Baca, *Tres Generaciones*, 1973. Oil paint on canvas; 6 × 6 ft. © 1973 Judith F. Baca, image courtesy of SPARC Archive (sparcinla.org).

in shaping their community. Participants leave transformed, with a new sense of being a part of something greater. Each time they walk past the mural they helped create, they see the part they played in making it happen.

In 1976, Baca cofounded the nonprofit Social and Public Art Resource Center (SPARC), with painter Christina Schlesinger and filmmaker Donna Deitch, as an alternative art center that helps fund public art projects focused on social activism. SPARC was created to solve what Baca saw as a major issue in public art funded by the government: censorship. She first experienced this issue when she started the city of Los Angeles's Citywide Mural Program in the early 1970s and decided, with others, to take action. She created SPARC with the support of other artists, friends, and attorneys with the goal of having a nonprofit that would fund mural projects that were protected by freedom of speech throughout Los Angeles. According to Baca, the early supporters of SPARC saw the organization as a way to "carry out mural programs in such a way as to animate public discourse and free expression of the diverse communities of the city without direct official intervention."[3] SPARC's first project is also one of Baca's most important and ambitious, the half-mile-long *Great Wall of Los Angeles* mural (1976–83), her vision of a marginalized history of Los Angeles painted along a flood channel in the San Fernando Valley. SPARC now houses her personal archive as well as the largest mural archive in the world with photographs, written documentation, and interviews. In 1996, she founded the UCLA@SPARC Digital/Mural Lab, one of the first of its kind to advance the practice of mural painting in the digital age and explore more permanent ways to execute mural painting.[4]

The following interview with Judy Baca took place at the Denver Art Museum in November 2017 when she was the keynote speaker for the Mayer Center "Murals of the Americas" symposium. She and I spoke about her work as a muralist, social activist and community arts advocate, scholar, digital media artist, performance artist, and photographer, but perhaps most importantly, as a teacher and mentor.

JESSE LAIRD ORTEGA: *When did you first know you would be an artist? Was it before you went to art school?*
JUDY BACA: I always wanted to make art. I never thought of myself as an artist, and I probably would not have said I was an artist even when I had done my first public works, because what I was doing didn't look like art. I was working with kids, I was working in social justice, so I thought of myself as an organizer, a teacher.

JLO: *Who stands out in your early life as a mentor or teacher?*
JB: The first women I met who were just not producing babies, who were educated and powerful women, were the sisters of St. Joseph of Carondelet. Sister Louise Bernstein, whose father was Jewish and mother was Mexican, was one of my mentors. She's still my dear friend after all these years.

Another incredibly important person to me was Jane Rule, the Canadian author and feminist who wrote *Desert of the Heart*. I met her in the seventies because one of the cofounders of SPARC, Donna Deitch, was a filmmaker, and she wanted to make Jane's book into a film, and that's how I got acquainted with her and how I fell in love with the Northwest. Over the years, she was an incredible, magnificent mentor.

I would also name Gilbert Roland, the movie star, who I became acquainted with because journalist Bill Moyers had done a piece

on my work and [Gilbert] loved it. He sent his wife to meet me and brought me to his house in Beverly Hills. From that point on, I spent every Sunday with him.

JLO: *So these were important people in your life, but they weren't necessarily artists or teachers.*
JB: Well, the person who taught me to draw was Hans Burkhardt. He was wonderful. He did those amazing pieces about the war and Vietnam (fig. 2). That was very influential for me.

JLO: *I read that when you'd just graduated from art school and were at your graduation party showing your grandmother your work, she said, "What's this for?"*
JB: [Laughs]

JLO: *Is that why mural painting came into play—because it was art that was* for *something? Is that why teaching became a part of your career?*
JB: You have to remember that at the time I graduated [1969], there was huge civil rights [and antiwar] activism going on. People were marching against the war and advocating for Chicano studies departments.[5] Then there was the feminist movement, and I began to kind of straddle the two movements—feminism and Chicano advocacy—much to the chagrin of many Chicanos who thought I shouldn't be mixing it up.

I was trying to find a way that my work would be useful to the revolution of feminist thought and Chicano civil rights. I knew the injustices; I'd lived them firsthand. I'd seen it;

Fig. 2. Hans Burkhardt (American, 1904–94), *My Lai*, 1968. Oil and assemblage with skulls on canvas, 77 × 155 in. © Hans Burkhardt Estate Collection / Curatorial Assistance.

I knew from my mother who was an activist, who worked in social services—my sister does too, still. I came to muralism because boys and young men were writing all over walls, and I was teaching for the parks and recreation department in various parks, and every park was totally damaged with head-to-toe roll calls of gang members. At that point, it wasn't images at all; it was just roll calls.

JLO: *Of just their names?*
JB: Territories. You know, Soy Flaco, the Cyclones—whatever their clique was. I could see them using the walls as a newspaper, in a sense, telling who they hung with, and it was a comfortable way for them to communicate. When I was teaching high school and then got fired,[6] I concluded that putting kids of different races into collaboration was a great way to teach, so I had them doing giant projections on the sides of buildings.[7] I would have them draw a model and then each take one part of the model and blow it up ten times and then sew the whole [canvas] together into a giant piece that we would unroll from the second-story window. So I began working with scale as a method of teaching.

JLO: *And with students from many different backgrounds.*
JB: It was primarily Latino, but it was in the San Fernando Valley, and it was a mixed group, so I was trying to work across those differences.

JLO: *That has really continued in your career.*
JB: Absolutely.

JLO: *I wondered if you could talk more about the* Emancipation Project *and its inspiration. The project grew out of an early workshop that you did with "emancipated" seventeen-year-olds from foster homes in Los Angeles. Though your current*

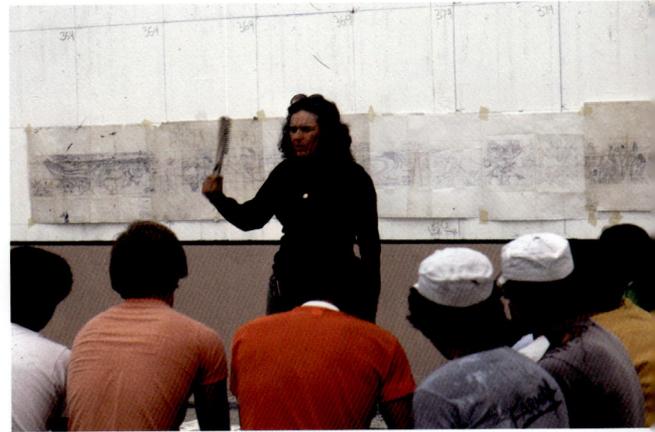

Fig. 3. Judy Baca in youth teaching session, 1982. Judith F. Baca, *Great Wall of Los Angeles* © 1976, image courtesy of SPARC Archive (sparcinla.org).

*iteration carries on the name "Emancipation Project," you and SPARC now work with sixth graders who attend your namesake school, the Judith F. Baca Arts Academy,[8] pairing them with UCLA students from your Beyond the Mexican Mural class to create portraits using the ULCA@ SPARC's Digital Mural Lab.*
JB: I love that project. I got a call from a foster care home, and the organization that ran it was, I think, called CASA of Los Angeles. At the age of eighteen in foster care, kids are "emancipated," which means basically they are kicked out. It's not emancipation; it's neglect and irresponsibility. Anyway, they asked me if I would consider doing a workshop with some of these kids, and I said OK, I'd be interested in that—that would be a real challenge. And so they brought together a group of kids about to be emancipated, all about seventeen years old and artistically inclined. For the workshop, I decided that they could create portraits of themselves. But kids, they destroy the face; if you ask a child to do a portrait, they really don't record their own faces—they can't *see* themselves. Even if you have them look in the mirror and you tell them to turn the paper upside down. You have to trick them into recording

Fig. 4. Judy Baca with students at Judith F. Baca Arts Academy, Watts, Los Angeles, CA, 2016. © Judith F. Baca, image courtesy of SPARC Archive (sparcinla.org).

what they see, right? So I thought, why not use a digital process in which we photograph them acting out who they are, and what they're good at, and then print these out at a giant size, like five feet high. It's really scary to see your head that big! And the kids are saying, "Wow, do I look like that?" or "He looks like my brother." They can't see themselves. They immediately think it's someone else.

JLO: *That's so interesting.*

JB: Very interesting. But next, I said, modify the figure with your dream of who you want to become. So we were emancipating their dreams. The workshop is about emancipating ideas about yourself and also keeping them from destroying the image—so they paint into the piece, keeping the shape, adding stuff, and by the end what you've got is a portrait that really looks like them and becomes a view of the future. Then we put them together and they become these giant murals.

JLC: *And do you have kids come back and visit as they get older?*

JB: It's just like that thing where you go up to the doorway and mark the top of your head,

and three years later you stand next to it and you're a foot taller and you can see your growth. That's because somebody loved you enough to record it, right? They're interested in the fact that you're growing, right? So that little action of recording where they are—for the sixth graders, permanently placing them in the school: they came through here, they left a mark, they move on, they come back and they see, "Oh, I wanted to be a veterinarian," you know?

JLO: *Have kids come back who are pursuing the dream they put in the painting?*

JB: Yes. We see them continuing in the arts, going to school. But some of them come up with the most horrible things, like "I want to be a border patrol agent," because they think that is power.

JLO: *I guess you have to let them work through that.*

JB: Well, we added a workshop called "Power." Power to, power for, power over, power against, power with—we talk about power in a much more nuanced way.

JLO: *I want to talk a little about one of your best-known works, the* Great Wall of Los Angeles.

*You painted this mural with a team of over four hundred young people from diverse social and economic backgrounds over the course of five summers from 1976 to 1983. The mural spans the 2,754 feet of the Tujunga Wash, a flood control channel in the San Fernando Valley. It records the historical moments that defined Los Angeles, decade by decade, from the prehistoric period to the 1950s, and in particular it highlights the stories of the marginalized and forgotten people of California, including stories from American Indian, Latinx, Jewish, LBGTQ, and African American people. Your team spent the year before each summer researching each new section of the wall before it was designed and executed. In order to decide which scenes or stories would be included in each decade, like the "Red Scare and McCarthyism" and the "Origins of the Gay Rights Movement" in the 1950s, your team would conduct academic research on the topic. Then for the more recent decades, when there were still people living who had witnessed or participated in the historic moments, they would interview them to bring in firsthand accounts and incorporate the lived experience. Once the team chooses the topics that defined a decade, they look at them through a series of prisms—age, immigration status, gender, and economic privilege—to see if they missed something.*

*During your talk yesterday, you discussed your process for deciding what scenes really define a decade, which involved personal conversations and firsthand interviews. Now I see you are doing some crowdsourcing on your website. Are you still using the same process and prisms? Is the intention to bring the history on the wall beyond the 1950s and into the present? How does social media affect storytelling for you?*

JB: I think we are on a track that's true and that we should not change that. There are aspects of the narrative that should not change, and the methodology and the quality of the imagery will stay within the grand style of Mexican muralism. I'm not going to do pretty faces in spray paint, nor will I allow the men I've trained to do that as long as I'm alive. But I will be turning

Fig. 5. Judy Baca, *Great Wall of Los Angeles*, Detail from the 1950s section. © 1976 Judith F. Baca, image courtesy of SPARC Archive (sparcinla.org).

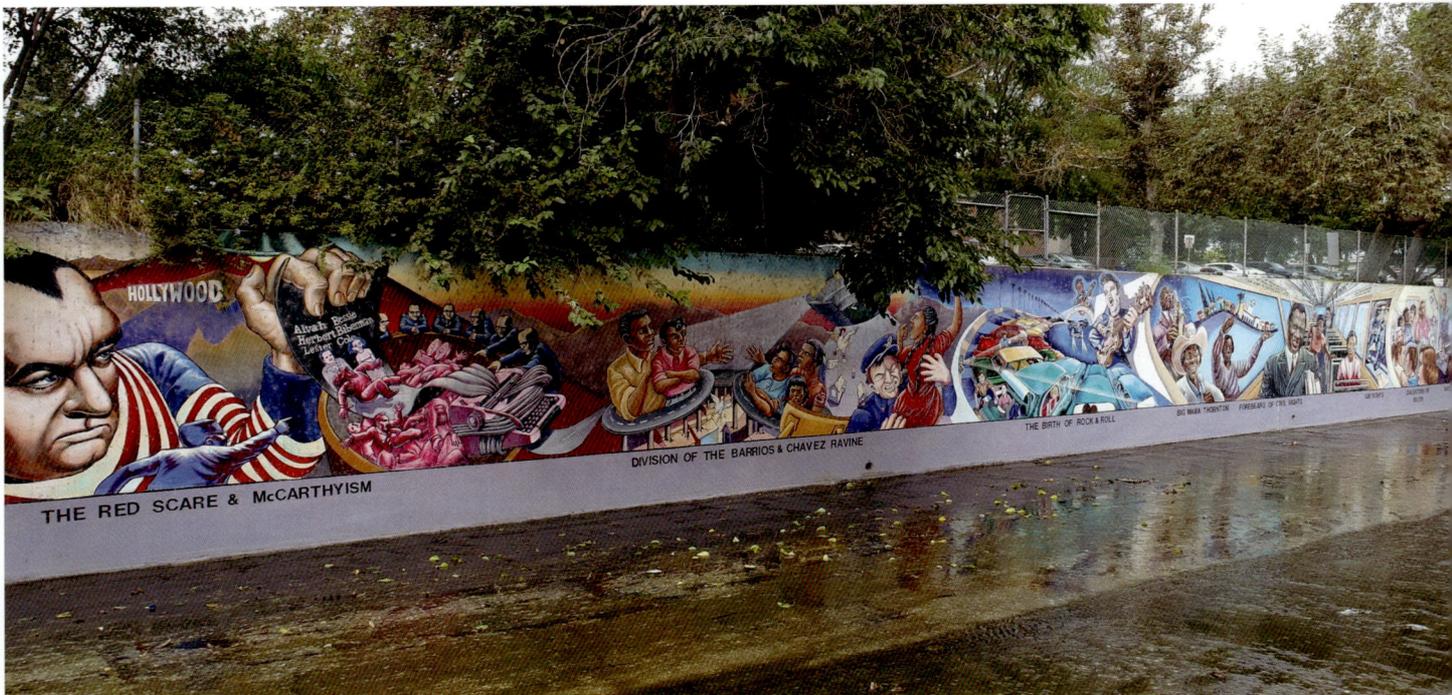

over the training and the work in the community to others and training a whole new group to do that, and we'll be able to work year-round. I hope as this process goes on that it's sustainable without me, that beyond my lifetime there will be continuing narrative works on an endless wall that interpret the moment we're living in, whether people like it or not. You'll get to see the changing ideas of young people, but I hope that they will continue to have the wisdom to seek elders and listen to them tell their stories.

JLO: *What's your opinion of the current state of public art and mural making?*
JB: We are going increasingly to shorter-term solutions, cheaper solutions, faster solutions, and in a sense, it is not as permanent or as lasting or as deep a commitment to the making of public works. And that worries me—that trajectory worries me. I think we need civic money, public money, and good leadership to re-elevate the art form. So that's one thing I'm thinking about. I'm also thinking about when I started out and how I was an anathema and what I did was not accepted. I'm thinking of a director of a municipal art gallery in the 1970s saying in a speech that she gave before I was to speak that "there's no such thing as political art; it does not exist, and it isn't real, and it's not serious art," and that's how I was introduced. I got up and said, "It's all political."

JLO: *It's always been political.*
JB: It's always been political. So, I think now there are no apologies for the fact that we fall on one side or another, or we fall on neutral ground and we're simply trying to get ourselves over.

One has to decide: if you're going to choose the place and the work that is so difficult, especially if you're a woman—if you choose the life of a political artist, then you have to recognize that it has to be worth it. It has to be something that you can commit to that is important, and

I think it's perhaps one of the most important endeavors you could be engaged in, because I've watched how it can be transformative, and I've watched how the creative process is one that elevates you, changes you profoundly. When I started that mural, I wasn't the person that I am now. I learned alongside those kids. The smartest things I've heard have come from children, you know, and from those who are really not recognized as intellectuals. I find the sort of "intellectual masturbation" in the university to be absolutely boring. I, like an adolescent, say, "I've had about enough of that." I think that technology brings us a promise, but it also brings us great pitfalls. As it can activate human connection, it's important, and as it deactivates human connection, it's a problem. So I caution those brilliant young ones to find ways to not become roadkill on the information highway. They need to be able to manipulate and transform the very medium that they're using, and it'll be the artists who will do it—it's not going to be the corporations that are figuring out how make bigger and better billboards. It's going to be us.

JLO: *Let's talk about the mural you did for the Denver International Airport. You began work on this in 1998. It is not a traditional mural painted directly on the wall; it is actually a digital mural. You painted the landscape and background, scanned and digitized the painting, and then in the UCLA@SPARC Digital/Mural Lab, you incorporated historic photographs onto the painted landscape before printing the entire mural on biodegradable billboard vinyl that was attached to an aluminum substrate and installed on the wall. Can you tell us more?*
JB: I wanted something that nobody could censor or destroy, so I've got [a digital file] in my back pocket. Destroy it, I'll make it again. No one can make it disappear. It was the first

piece in which I combined the hand-painted mural with digitized historical photographs. I actually painted that piece at Harvard during a residency there. I found amazing photographic images, and then when I did [further] research in Denver, I found a photo of my grandfather in the railroad library. I opened the first box, and my mother said, "That's my dad." I said, "That can't be possible; it's not going to be that easy." But she said, "There he is; that's my dad."

JLO: *You mentioned in your talk yesterday that the UCLA@SPARC Digital/Mural Lab recently turned twenty-three years old, and you are now able to print at a very high resolution and are pushing the medium further than before. What did you want to achieve by creating digital murals and then transferring them onto a permanent surface like a wall?*
JB: I gathered all this material, and I knew that I was trying to bring out the history through the landscape. It gave me the opportunity to use the photographs for source material and turn them into transparent, apparition-like images and then to embed them in a previously painted and composed setting. I did elaborate drawings of the collision of landscapes beginning in Chihuahua, Mexico, and ending in Colorado in the Garden of the Gods. I actually made the journey myself.

JLO: *You did?*
JB: Yes, I did a road trip along the railroad, and I could see where my ancestors had been, and it was unbelievably enlightening. I understood on a whole new level what they went through. I mean, they got to Juárez, and they had family there, and they thought of staying, but there was a full-scale revolution going on, the Mexican Revolution [1910–17]. So they kept on going to my great-grandfather [Seferino Baca] in La Junta, Colorado.

JLO: *So, you knew this story about your family, but you did more research for this mural project? I know this was the first time you used your own history as inspiration for one of your pieces, right?*
JB: Well, I knew the legend, the family story, that my grandfather was robbed on the train while going north for supplies because Pancho Villa robbed the ranch, and my grandmother got robbed at the same time at the hacienda, and what do I find when I do the research? I found out there were train robbers.

JLO: *It was true.*
JB: The story [became] solidified through the research, and I began to understand that my grandfather married my grandmother when she was fifteen and took her off the hacienda where she'd been—she was probably a serf—before the revolution. . . . They have eight children, two of whom die in La Junta—shoebox twins they call them. We couldn't even find their graves, but we brought the babies' spirit back to the Baca familia gravesite. My great-grandfather Seferino Baca is buried here and so is my grandfather Teodoro.

JLO: *So your roots are really connected to Colorado, though you are also so connected to Los Angeles.*
JB: I was born in Los Angeles.

JLO: *True, but your roots are sort of buried in Colorado and Mexico.*
JB: Yes.

JLO: *Did that make you excited to do the mural here?*
JB: I chose it . . . because of the loss of my grandfather's grave.

JLO: *Can you explain a bit more about this and about the role your mother played in you deciding to focus on your family's story in this mural?*

JB: [My mother] had come back for a reunion, and she found all the Mexican parts of the graveyard [where my grandfather was buried] destroyed. We looked for my grandfather's grave, and then we found the headstone turned over and the whole area going foul, and I thought, I'm going to do this piece, and while I do it, I'm going to uncover this story.

JLO: *I have just one more question. You've said that in order to do a mural in L.A., one has to apply to the chief of police. Because funding is so difficult to find and often comes from a government source, do you think that creates censorship of public arts? Is that a trend you see in government-funded mural painting? Or do you think that artists are still free to paint what they want?*

JB: No, I see that everything has been dumbed down, that increasingly no narrative works are being done—no works that are deeply interrogating place or time.

JLO: *The work is more decorative.*

JB: They're decorative, they're spray paint, they're "throw-ups"[9] because there's no money. Without public money and good political leadership, there will not be a public art movement. Without political leadership that believes in it, there will not be any public art—I think we're in a crisis now because we're in a crisis as a country. That's why works like the *Great Wall of Los Angeles* have to go on. There's a precedent that's been set, and I don't think they can stop me.

P.S. My advice to young muralists is, get a job, and then you can do what you want. You don't have to starve. Find a way to support yourself, and then do what you believe in. I sold my skills, not my art.

◎ ◎ ◎

**Notes**

This interview has been condensed and edited from conversations with Judy Baca on November 2, 2017, and follow-up emails.

1    Judy Baca, interview by Jesse Laird Ortega, November 2, 2017.

2    Judy Baca keynote lecture at "Murals of the Americas" 17th Annual Mayer Center Symposium at the Denver Art Museum, November 2, 2017.

3    "Brief History," Social and Public Art Resource Center (SPARC). Accessed July 8, 2019. https://sparcinla.org/brief-history/.

4    UCLA@SPARC Digital/Mural Lab, Social and Public Art Resource Center (SPARC). Accessed July 8, 2019. https://sparcinla.org/digital-mural-lab/.

5    To read more about the early Chicana/o civil rights movement, see George Mariscal, ed., *Aztlán and Viet Nam: Chicano and Chicana Experiences of the War* (Berkeley: University of California Press, 1999). For more on the foundations of Chicana/o studies departments, see Rodolfo F. Acuña, *The Making of Chicana/o Studies: In the Trenches of Academe* (New Brunswick, NJ: Rutgers University Press, 2011).

6    In 1970, Baca was teaching at the Catholic school she had graduated from, Bishop Alemany High School. Baca and several other teachers were fired from the school for participating in protests and marches against the Vietnam War.

7    Anna Indych-López has identified Hollenbeck Park, Wabash Recreation Center, and Costello Recreation Center as some of Baca's earliest projects with youths and gang members. See Anna Indych-López, *Judith F. Baca, A Ver: Revisioning Art History* (Los Angeles: UCLA Chicano Studies Research Center Press, vol. 11, 2018), 10.

8    In 2012, the Los Angeles Unified School District named a school after Baca. The Judith F. Baca Arts Academy is located in the heart of the Watts neighborhood. It serves a student population that is about 90 percent Latino/Hispanic and about 10 percent African American.

9    A "throw-up" is a more elaborate version of a graffiti artist's tag, or signature.

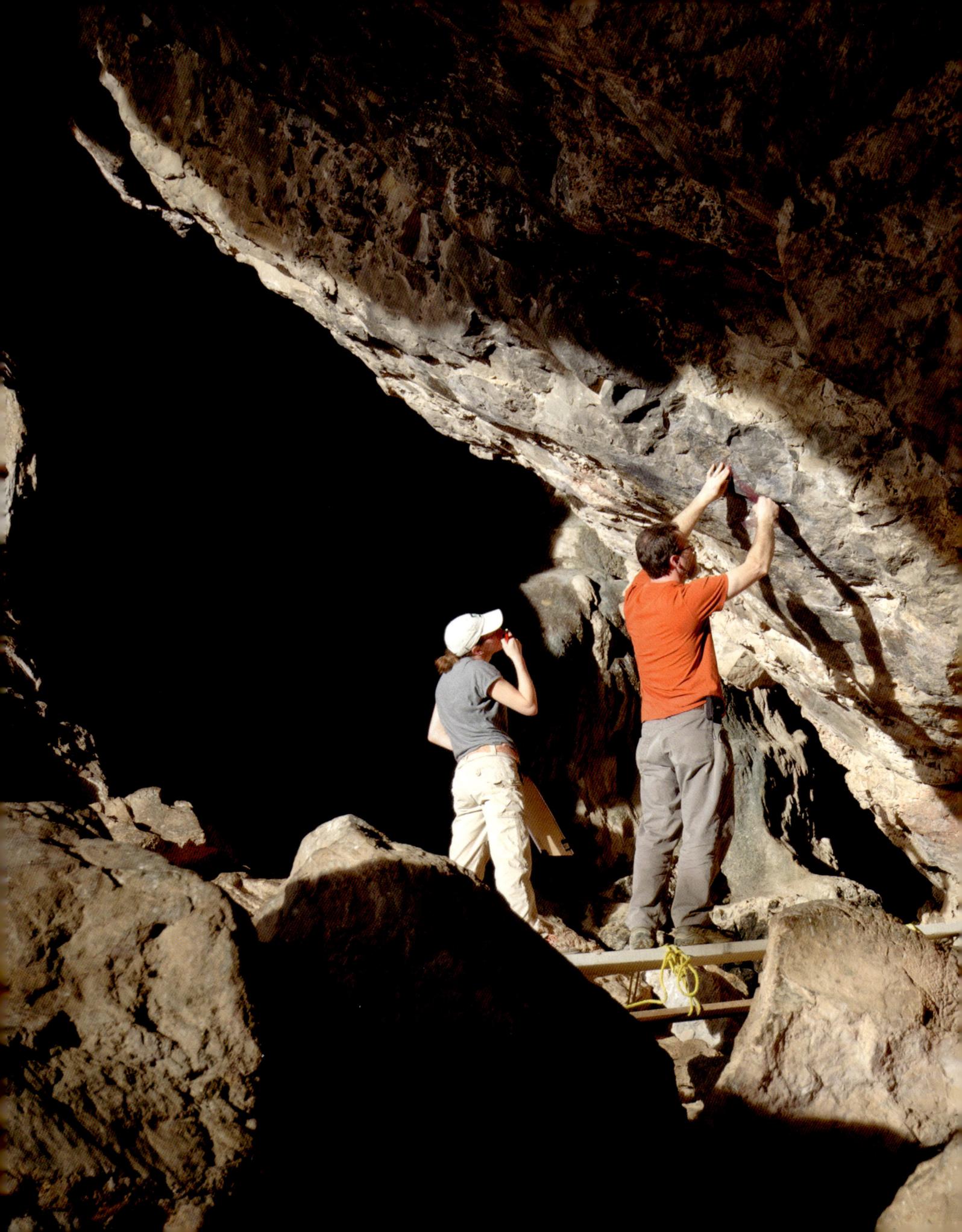

HEATHER HURST, LEONARD ASHBY, MARY POHL, AND CHRISTOPHER L. VON NAGY

# The Artistic Practice of Cave Painting at Oxtotitlán, Guerrero, Mexico

The region of Guerrero, Mexico—its people, worldview, technology, and practice—are fundamental to understanding Formative period culture and beliefs, specifically the "Olmec-style" artistic canon in contexts outside of the Gulf of Mexico lowlands. The valleys are rich with archaeological material, as first noted by Miguel Covarrubias in the 1940s, yet Guerrero has been described as "the neglected stepchild of Mesoamerican archaeology" (Diehl 2004, 166)—highly looted and until recently very peripheral in terms of investigative research. However, work by investigators such as David Grove, Gerardo Gutiérrez, Mary Pohl, Mary Pye, Paul Schmidt Schoenberg, and Christopher von Nagy, building on work by Guadalupe Martínez Donjuán, Christine Niederberger, and Louise Paradis, among others, is changing this trend by characterizing residential life, refining chronology, and reevaluating the interregional connections of Guerrero. The polychrome paintings located in caves and grottos of Oxtotitlán, Juxtlahuaca, and Cauadzidziqui (also spelled Cahuaziziqui), along with the relief carvings of Teopantecuanitlan and Chalcatzingo,

distinguish a regional style for Guerrero that suggests greater affiliation between these sites and diversity from their contemporaries of the gulf coast, the Pacific coast, the Basin of Mexico, and Chiapas (see Guernsey et al. 2010; Gutiérrez and Pye 2007; Pye and Gutiérrez 2017; Niederberger and Reyna Robles 2002; Schmidt Schoenberg 2008). The richness of pursuing a contextualized, local history has been demonstrated by archaeologists working across Mesoamerica on Middle and Late Formative interaction (e.g., Inomata et al. 2013; Joyce and Henderson 2010; Rosenswig 2012). A refined view of the Oxtotitlán paintings' localized context can provide evidence regarding social dynamics of the era, as well as contribute to conceptualizations of landscape.

The report of cave paintings in modern Guerrero, Mexico, by Carlo Gay and Gillett Griffin in the 1960s, followed by David Grove's documentation of the Oxtotitlán paintings in the 1970s, first brought attention to early examples of Mesoamerican figural painting. At the time, Mesoamerican mural painting was associated with Early Classic (CE 200–600) and Classic (CE 600–950) period Maya temples at Bonampak and Chichen Itza, the elite residences of Teotihuacan, and the tombs

*Opposite:* Detail of fig. 5.

15

of Monte Albán (see Kubler 1962, 1975). The Guerrero paintings stood apart from these other examples as clearly related to the widespread "Olmec" art style, which shares the name with the archaeological culture of the gulf lowlands identified by Matthew Stirling (1943) and his colleagues in the 1940s and 1950s. The context of Oxtotitlán's rock art, with many pictographs and handprints in close proximity to more elaborate paintings, suggested great antiquity and contributed to the acceptance of a unilinear sequence of Olmec, Izapan, and Mayan stylistic succession (Coe 1965; Gay 1967; Grove 1969, 1970; Willey 1962). This long-standing view has been revised through refined archaeological chronologies and new discoveries that demonstrate coeval and diverse cultural activities in the Middle Formative period across Mesoamerica. The Formative period was a complex mosaic of regional centers, vibrant trade, and an ebb and flow of alliances and aggressions (e.g., Clark and Pye 2000b; Coe and Koontz 2002; Niederberger 2000; Rosenswig and

López-Torrijos 2018). Scholars generally agree that multiple uses of the term "Olmec" need to be employed (see Grove 1989, 1997; Clark and Pye 2000b; Pool 2009), and "Olmec-style" objects may include entirely local practices (Joyce and Henderson 2010). To this point, the paintings at Oxtotitlán (and other rock art of Guerrero) are better understood through a contextualized and local lens.

A few prominent paintings from the Guerrero caves are generally the best-known aspect of these sites, with much less awareness of associated archaeological features, spatial context, or adjacent artworks. Although Grove's initial publication documented Oxtotitlán's numerous artworks and described the nearby archaeological site, the painting of the figure seated on a throne (Panel C-1, referred to by Grove as "mural"[1]) and the man-jaguar scene (Panel 1-03) are the most cited compositions out of perhaps one hundred pictographs that are present. These two artworks are often published using an illustration created by Grove in 1968 or by Felipe Dávalos in 1970, rather than

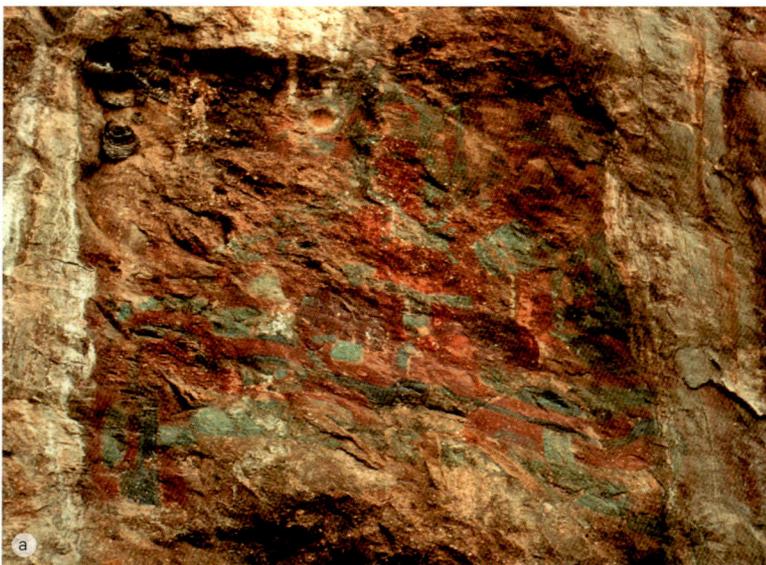

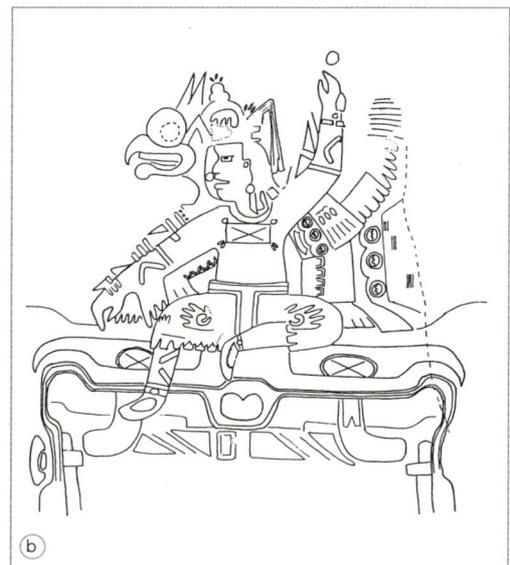

Fig. 1. *a)* View of Oxtotitlán Panel C-1. Photo by David C. Grove, 1968; *b)* illustration of Oxtotitlán Panel C-1, figure seated on throne, by David C. Grove, 1970, INAH.

a photograph, for reproductive clarity (Grove 1969, 1970) (figs. 1a and 1b). As a result, forty years after initial documentation, the rock art of Oxtotitlán is still largely unfamiliar. The best-known panels are often reproduced to illustrate a chronological benchmark ("a very early example of . . .") or glossed over for their content (such as "ruler seated on throne"). Treatment as such isolates these paintings as unique at best and anomalous at worst; the challenge is to better represent the role of Formative period rock art in broad cultural context.

Grove (1970) describes the three types of rock art present at Oxtotitlán as polychrome, black, and simple red, which are each located in three somewhat separate areas of the shallow cave. The rock art can be considered at the level of individual pictographs and as interrelated compositions that make use of adjacency, both of which are inseparable from the geology of the grotto itself. Although numerous iconographic comparisons can be made to images found on carved monuments, engraved reliefs, and incised jade, Oxtotitlán artists chose the medium of paint. Importantly, the cave painting traditions of Guerrero are foundational to a long tradition of mural painting in Mesoamerica. The paintings of Oxtotitlán (as well as Juxtlahuaca and Cauadzidziqui) expand beyond the bichromatic nature of petroglyphs and related pictographs in order to develop complex narrative scenes that combine forms and figures in vibrant polychrome. In their symbolic vocabulary, calligraphy, and paint technology, the caves of Guerrero establish the genre of Mesoamerican narrative painting (a tradition that includes murals and is closely related to codices) and represent the work of experienced artists who were proficient in complex iconographic systems and talented in representation.

While forthcoming publications by the Urban Origins Project at Quiotepec-Oxtotitlán, Guerrero (UOP) research team led by Mary Pohl and Christopher von Nagy will present detailed iconographic analysis of redocumented images, the goal of this chapter is to consider the practice of image making at Oxtotitlán cave. Archaeological, ethno-historical, and ethnographic studies present rich information surrounding the importance of caves as a sacred natural landscape in Mesoamerican cultures, with clear connections to symbolism of power, sustenance, and fertility (Taube 1986; Prufer and Brady 2005). One corpus of data includes representations of caves and depictions of associated elements, deities, and activities, and a second dataset consists of archaeological features and deposits located in caves themselves. Andrea Stone's (1995, 241) pioneering research demonstrated that cave paintings and drawings are special among the second type of archaeological data because they provide a greater understanding of artists'/communities' interaction with a topographic shrine.[2] Cave art rarely depicts a cave; rather, cave art populates, engenders, and interacts with the entity of the cave itself. Among the visual data of cave art, I argue that a contextual consideration regarding *how* a painting was made can provide a more nuanced understanding of image creation as part of ritual practice within the sacred landscape. The use of the Oxtotitlán cave spans millennia; however, the activities there, including image making, have a temporal element that exists within a historical context.

## The Oxtotitlán Urban Origins Project

Oxtotitlán includes a cave site sitting above a river valley and a nearby hilltop habitation site (figs. 2 and 3). Archaeological work in the

1970s by Louise Paradis and David Grove, who first documented the paintings at Oxtotitlán, established a regional occupation sequence spanning the Early (1900–1000 BCE) and Middle Formative (1000–400 BCE) periods. Later work at Teopantecuanitlan, among other projects that also included topographic shrines, have characterized residential and ritual life in the region and brought Guerrero into focus in relation to its neighbors (Niederberger and Reyna Robles 2002; Gutiérrez and Pye 2007, 2010; Pye and Gutiérrez 2017). Paul Schmidt Schoenberg (2008) completed an archaeological survey in the Chilapa-Zitlala area between 2003 and 2005. He documented 125 sites within the Río Atempa valley where Oxtotitlán is located. Until recently, little attention had been paid to the archaeological site of Cerro Quiotepec (also spelled Quiatepec), an 89 m high knob immediately west of the cave face of Oxtotitlán and separated by a narrow expanse of fertile floodplain. There, Grove (1970), then Schmidt Schoenberg (2008), documented a series of terraces, plazas, and low mounds including a rectangular complex facing east, toward the cave, at the top of the hill. Ceramic material indicates the majority of construction is Middle Formative, but archaeological materials continue through the Late Postclassic period (AD 950–1200). From 2003 to 2008, Sandra Cruz, conservator for Mexico's Instituto Nacional de Antropología e Historia, carried out a major cleaning of the Oxtotitlán paintings; her removal of modern graffiti and some calcification deposits resulted in newly identified compositions, nearly tripling the number of pictographs documented by Grove (Cruz 2009; Lambert 2012). Following Cruz's work on the paintings and Schmidt Schoenberg's survey, Mary Pohl and Christopher von Nagy formed the UOP in an effort to better document the cave paintings and evaluate their

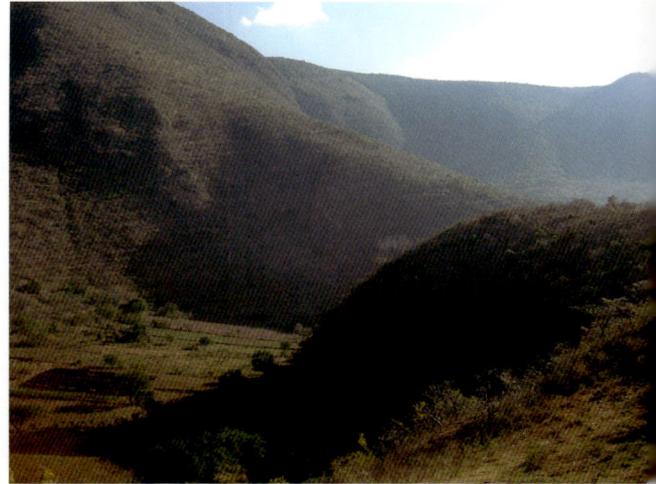

Fig. 2. View east toward Oxtotitlán cave from Cerro Quiotepec, Guerrero, Mexico. Photograph by Leonard Ashby, 2012.

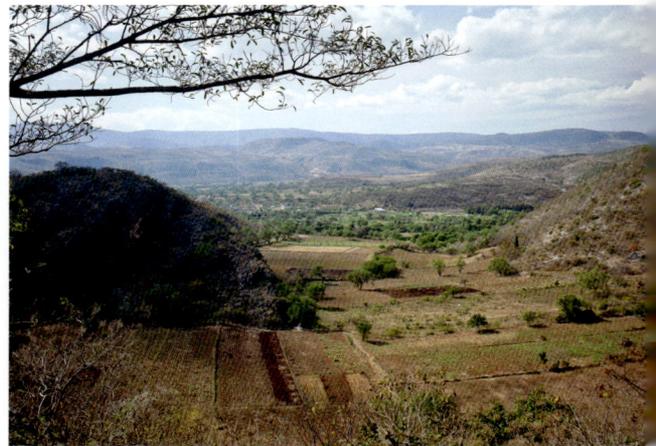

Fig. 3. View west from Oxtotitlán cave, Guerrero, Mexico, into valley. Cerro Quiotepec is the rocky outcrop on the left. Photograph by Joseph Gamble, 2012.

archaeological context with respect to settlement areas. In 2012, Pohl and von Nagy led a team of photographers, chemists, illustrators, and archaeologists to record and sample the rock art at Oxtotitlán. In subsequent seasons, archaeologists excavated both within the cave and at several units across the residential site and terraces of Cerro Quiotepec.

As part of the UOP, I worked with my husband, Leonard Ashby, to make measured drawings of the well-known Oxtotitlán

paintings documented decades earlier by Grove and later by Dávalos, as well as get a sense of undocumented works. We worked closely with photographer Joseph Gamble, using traditional photography and multispectral imaging. Our objective is to re-vision what we know of the Oxtotitlán artworks through new archaeological illustration with increased clarity and accuracy, bringing forty years of subsequent scholarship and knowledge of Mesoamerican archaeology to each drawing. A forthcoming monograph by Pohl and von Nagy will publish the results of this collaborative project and the accompanying new images it produced. However, the process of illustrating the rock art highlighted the value of detailed documentation as an analytical approach. Documentation drawing introduces mechanical and temporal elements—*how* an image is made—into the study of an image. Prioritizing the practice of art making (i.e., identification of preliminary sketch, sequence of brushstrokes, completion of color fields) alongside stylistic and iconographic analysis of images provides evidence regarding the artists who created these works (Hurst and O'Grady 2015). For Oxtotitlán, the microscale of individual brushstrokes will be considered in light of two initial project publications—the first, on paint chemistry (McPeak et al. 2013), and a second, on dating pictograph pigments (Russ et al. 2017)—to reflect on what Matthew J. Liebmann (2017) calls "landscapes of signification," which take into account the cumulative nature of human activity at Oxtotitlán that spans millennia.

## Landscapes and a Temporal Approach

Geographer Yi-Fu Tuan's neologism "topophilia" remains a useful concept with which to describe the unique relationship between humans and places. Tuan (1974) characterizes this relationship as a spectrum of attractions and bonds, ranging from love to obligation, as well as servitude. Our capacity for memory, symbolism, ideology, and cognition of the future provokes new significance (and more intense bonds) in regard to these places. For Tuan (2014), there is a mutuality that comes from topophilia: from peoples' love of place (and pouring their energy, affection, work, reliance into a place), "that place in turn imparts its qualities to people." Within an agrarian community, such as our Middle Formative inhabitants of present-day Guerrero, where rain (not too much and not too little) will yield good crops, the connection to landscape would have been starkly different from the humid, wet Veracruz coast or the Oaxacan highland ridges of their neighbors (see fig. 3). The landscape of Oxtotitlán resonates "topophilia" forged from rugged rocky hilltops contrasting with rich valleys and their interstices of caves and springs. Tuan's contribution to the study of landscape includes prioritizing an emic approach to the very production of place. Liebmann details recent theoretical strands and schools of thought surrounding landscape archaeology to put forward "landscapes of signification" as an approach that "hinges upon the connections between symbolic and indexical modes of meaning in the archaeological record" (2017, 646). In his research at Jemez Pueblo, Liebmann paired oral traditions, ethnography, and iconography, with sampling surveys conducted with tight chronological control of lithic debitage and chemical signatures in order to identify patterns of obsidian acquisition surrounding the Valles Caldera. The result is a "living landscape" that is dynamic in its conception and experience, wherein the landscape of Valles Caldera can have continuity as a framework for the Jemez people, yet its meaning changes, and symbolism associated

with the sacred landscape is not an essentialized vision of the past (Liebmann 2017, 657–58). By prioritizing temporality, archaeologists can better reconstruct the variety of meanings that exist in the archaeological record of layered, symbolically rich landscapes such as the Oxtotitlán cave.

In the Mesoamerican worldview, landscape is animate. Natural features (caves, springs, sinkholes, rocky outcrops, and mountains) are places where interaction with the living entities associated with life, sustenance, fertility, and power occur through ritual negotiations (offerings, caches, feasting, music, and performance). Experts in the study of symbolism and Mesoamerican religions describe various active agents of caves, forests, and mountains in Aztec, Maya, Olmec, and Zapotec worldviews and detail Mesoamerican myths of emergence, rebirth, ancestry, and fertility, as well as danger associated with these entities (see Carrasco 1990; Finamore and Houston 2010; Florescano 2009, 2017; Taube 1986, 1992, 1996, 2004, among others). Yet it is important to consider that while deities and myths may be shared by a broad cultural group, each community negotiates with these entities in a distinct topographic reality. Natural features of the local landscape become shrines through human ritual practices; their ongoing use embodies and produces the cultural identity and social networks of their particular communities (Stone 1992, 1995; Prufer and Brady 2005; Brown 2004; Brown and Emery 2008). Linda A. Brown and Kitty F. Emery (2008, 301) identify shrines as places in the landscape used for ritual negotiations with nonhuman agents associated with animate topographic features, and these function as thresholds between realms where interactions between community and landscape agents occur. Paths between shrines might simultaneously define geographical boundaries, migration histories, economic resources, alliance networks, and cosmological beliefs; paths may also be pilgrimage routes that are part of ritual negotiation or transformation practices.

Working with contemporary K'iche' Maya ritual practitioners, Brown (2004) asks why particular locations of a mountain are chosen as suitable for specific ritual practice and examines the materiality associated with different types of ceremonies. This ethnoarchaeological approach demonstrates "how [these] offerings are deposited, and the spatial locations of offerings in relation to a sacred topographical feature are intimately linked to the emic purpose of the rite" (Brown 2004, 34). A similar material studies approach to local ritual practice can be engaged at Oxtotitlán in the study of cave painting. Considering how the paintings are created and the spatial locations of the paintings in relation to offerings and sacred topographical features enriches scholarship much more than looking at the images alone.

## Guerrero's Network of Landscape Shrines

Guerrero's geology of dramatic rocky outcrops with numerous caves and rockshelters has a unique natural beauty with outstanding physical qualities for rock art. Caves penetrating the earth, openings exhaling cool air, springs that emerge out of rock, and sinkholes that retain water even in the driest part of the year constitute a highly animate topography rich with symbolism (fig. 4). In his original work at the caves and archaeological sites of Guerrero, Grove (1969, 1970) notes the focus on rain rituals and specialized shrines. In his work at Oxtotitlán, Grove pairs paintings' iconographic connections to rain deities with informants' descriptions "that in times past the cave contained lagoons of water that would overflow the mouth of the cave and cascade into the

fields below" and notes the hilltop site locally called Cerro Quiotepec "in Nahuatl signifies 'the hill of rain'" (1970, 31). Gerardo Gutiérrez and Mary E. Pye describe the region as "a network of sanctuaries or shrines dedicated to the gods of rain and wind" (2010, 46); this network of shrines combines hilltops, caves, and springs, where early rulers cultivated their power through weather control, specifically the mediation of wind and rain. The importance given to an ability to mediate natural phenomena might be ubiquitous in agrarian communities; however, regional needs for common phenomena differ:

*In the Olmec region, water caused problems in several ways. The inhabitants [in southern Veracruz] fought against the swamps, and the long rainy seasons frequently inundated hamlets and devastated planted fields. . . . Paradoxically, this is similar to what happened in the highlands with unexpected droughts that obliged people to implore their gods for aid and perform propitiatory rites. (Ortíz and Rodríguez 2000, 91)*

Central to understanding the ancient paintings at Oxtotitlán are interactions between humans and nonhuman agents associated with the animate landscape. A great deal of literature documents the Middle Formative symbolic complex that is dominated by an avian-serpent and a rain deity (primarily in jaguar form) and ritual practices that bridge the supernatural and human realms, often led by human actors who are shamans, ballplayers, or have the ability to transform (see Reilly 1989, 1995; Furst 1995; Gutiérrez and Pye 2010). While rulers had special abilities to mediate natural phenomena through their capability of human-animal transformation (the concept of a *nahual*), participation in transformative ceremonies was also a community practice. Interpretations

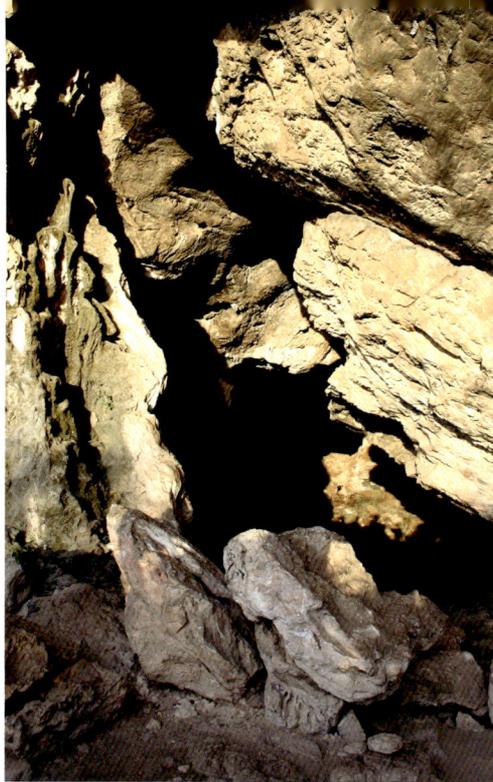

Fig. 4. View into north grotto area, Oxtotitlán cave, Guerrero, Mexico. Photograph by Leonard Ashby, 2012.

of the Formative symbolic complex have been informed by ongoing ritual practices in Guerrero and other indigenous communities across Mesoamerica.

In Guerrero, rain-petitioning rituals at mountaintop shrines still take place today, and these rituals involve transformation—men and boys wearing jaguar masks and costumes engage in ritual fighting *(pelea de tigre)* and barren branches burst into bloom with offerings of flowers (Saunders 1984; Díaz Vázquez 2003, 8; Zorich 2008; Taube 2017; Gutiérrez and Pye 2010, 46). Less attention has been given to other aspects of these rituals, including community peregrinations to landscape shrines located at caves, springs, and river sites; these are often led by religious leaders and/or holders of local office in late April or during the month of May, the driest months of the year with only 1 mm of average rainfall in Guerrero. Widespread participation in these pilgrimages includes making offerings (food, blood from chickens and turkeys, maguey, flowers, incense, pottery, candles) at existing or constructed altars, into sinkholes, or at the base of large trees; and

community activities of feasting, dancing, singing, and either erecting a cross or dressing an existing cross, in addition to the aforementioned jaguar emulation (Villela Flores 1997; Claassen 2011).

Other landscape rituals documented in Guerrero include the peregrination to boundary shrines in Petlacala, which incorporate altars also used in this community's rain petitioning ceremonies; during these rituals, community *lienzos*, local histories painted on large cotton cloths, are displayed at the altar sites where offerings are made (Jiménez Padilla and Villela Flores 2003). The contemporary community rituals of Guerrero negotiate with nonhuman agents associated with rain and fertility at topographic shrines that involve multiple types of offerings and activities by religious leaders, holders of local office, and community members. The Petlacala celebration, as well as ethnohistorical research by Gutiérrez (2015)

on colonial heraldry and Amos Megged (2017) on eighteenth-century land tenure, demonstrate how community leaders also hold specialized knowledge of social histories engendered in landscape shrines. This research makes clear that special topographic places were used to claim land tenure and negotiate alliances. As characterized succinctly by Keith M. Prufer and James E. Brady, "Caves functioned as arenas for religious rituals, with all the social and political baggage that ritual implies" (2005, 2).

Spanning these contexts—from ancient iconography to contemporary practice—are the cave paintings of Oxtotitlán. Although first painted in the Early Formative period, they have never been out of use. In fact, layers upon layers of painting, some high up on the rock face, and deep deposits of material culture record the active nature of this important landscape shrine. In a northern alcove near the access to the cave, a shrine with a cross embedded in an elevated

Fig. 5. View of Panel 1 area with Heather Hurst and Leonard Ashby taking measurements of the human figure of Panel 1-03, Oxtotitlán cave, Guerrero, Mexico. Photograph by Joseph Gamble, 2012.

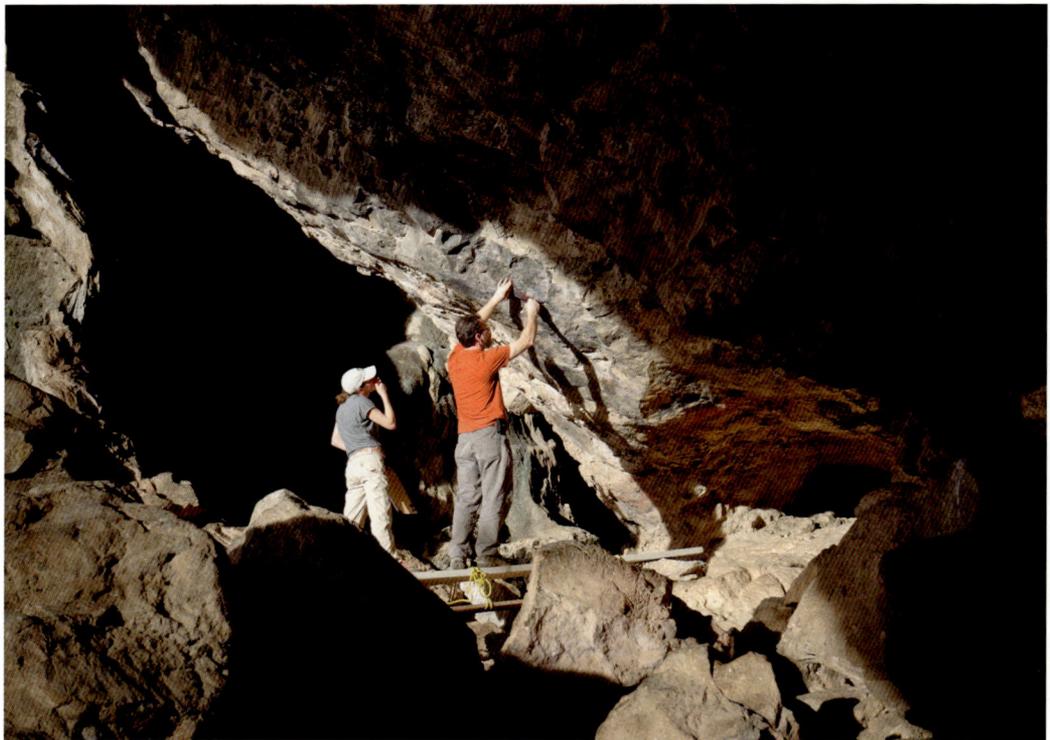

recessed area of the rock receives candles and flowers as regular offerings, and ritual processions incorporate the cave along their route during the spring rain petitioning.

The Oxtotitlán rock art exists in a landscape rich with duality—a place that is both a recessed cave and elevated mountain, both a craggy shadowed rock surface and a relatively smooth sunlit façade. The cave is remote, natural, and wild, and yet the site is framed by plazas, terraces, and houses of Cerro Quiotepec and the cultivated fields of the river valley; it is both a place of memory, ancestors, and past things, as well as the focus of present-day conditions and the locus for intervention on behalf of the future. This challenging contextualization is critical for understanding the role of the images. The western-facing hilltop cave moves dramatically between darkness and light during the day, small openings and crags of rock create pinholes of light and cast shape-shifting shadows that play across surfaces and recesses, and sound is either swallowed or a whisper amplified depending on one's position (see figs. 2–5).

## Overview of Oxtotitlán

It is difficult to quantify how many pictographs are present at the Oxtotitlán cave. Numerous paintings, over one hundred documented to date, are found at various heights and depths across the face and into the openings of the cave (see Cruz 2009). The cave can be roughly divided into three areas: north grotto, south grotto, and the cliff face. In the grotto areas, paintings begin at the entrance and penetrate into each cavern approximately 10–15 m (fig. 6). The caverns terminate at approximately 25 m, although deeper tunnels or chambers may be present beyond the rock falls at the back of the north and south grottos. The face is a sheer vertical cliff wall rising 45 m above the opening of the

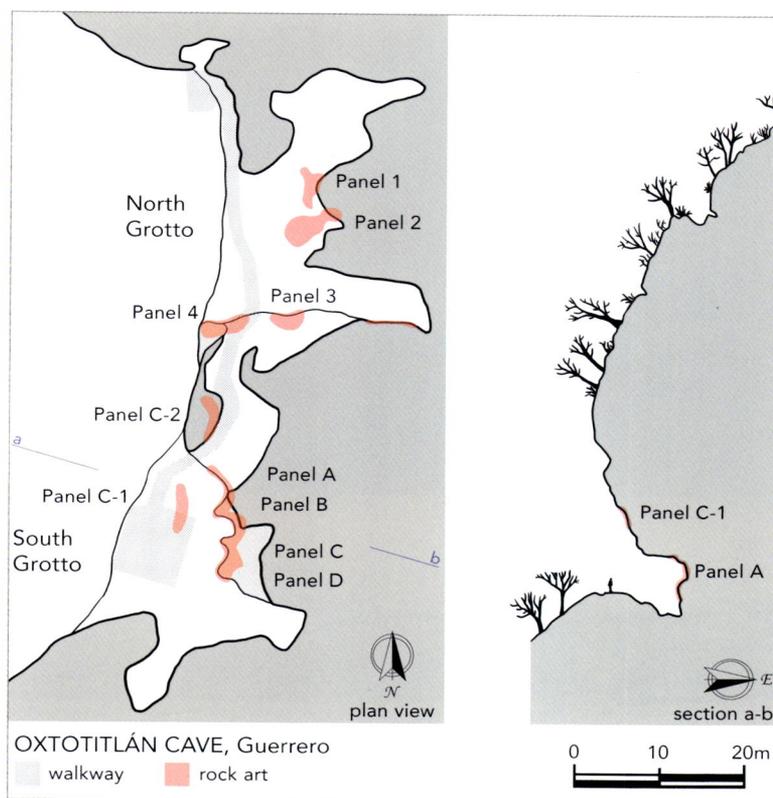

OXTOTITLÁN CAVE, Guerrero
walkway    rock art

south grotto and a passageway that leads to the north grotto. The cliff wall is visible from a great distance, including the valley below, and is roughly the same elevation as the terraces of Cerro Quiotepec (see figs. 2 and 3). Below the primary cliff wall where Panel C-1 looks outward, the lower wall is the site of Panel C-2, a poorly preserved polychrome painting. This same exterior rock face then wraps into the north grotto, with an area that is outside of the sheltered recesses located between the north and south grottos. This area, denoted as Panel 4, is visible upon approach but is not visible from as great a distance as the cliff wall.

As noted earlier, the three areas of the cave have distinct stylistic divisions: the north grotto is the site of black paintings, the south grotto is generally restricted to red paintings, and polychrome paintings are located on the upper and lower cliff face. The scale of painting

Fig. 6. Map of Oxtotitlán cave, Guerrero, Mexico. Image by Heather Hurst, after Grove 1970 and Cruz 2009.

Fig. 7. Handprint stencil, south grotto, Oxtotitlán cave, Guerrero, Mexico. Photograph by Leonard Ashby, 2012.

varies tremendously, ranging from the size of a handprint (or similarly sized symbol) to larger than life-size figures in the polychrome paintings (figs. 7 and 8). Many of the red pictographs and black pictographs are high on the cave walls and ceilings, ranging from 1 to 6 m above arm's reach when standing on the boulder-strewn floor. The polychrome painting, Panel C-1, is located an impressive 10 m above the cave floor (see fig. 17). At Oxtotitlán, most paintings would have required the use of ladders or scaffolds, a point I will return to in the discussion.

Today, visibility of the paintings is variable due to the natural thin deposits, or oxalates, that have slowly covered the artworks over time (see Cruz 2009). In effect, this encapsulation might also help preserve the paintings. The changing light throughout the day greatly aids or diminishes pictograph visibility. At times, the oxalate coating (which is present beneath the paintings as well) is fogged by reflecting light and the painted surface is nearly invisible. As the orientation of the sun changes, painted lines become clear and shadows add dimension to the crags of the rock formations (see figs. 4 and 5). The surfaces recently cleaned by Cruz afforded the best opportunity to document these ancient paintings, as well as the use of multispectral imaging (MSI) by the UOP. MSI

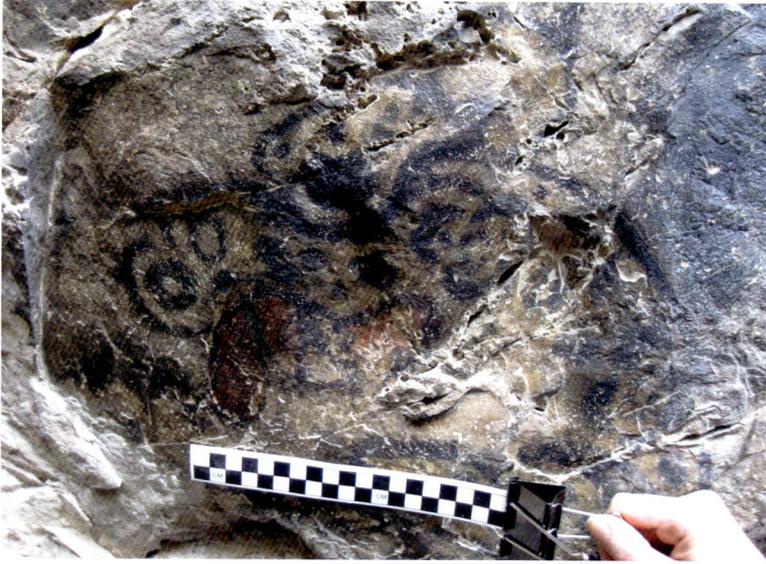

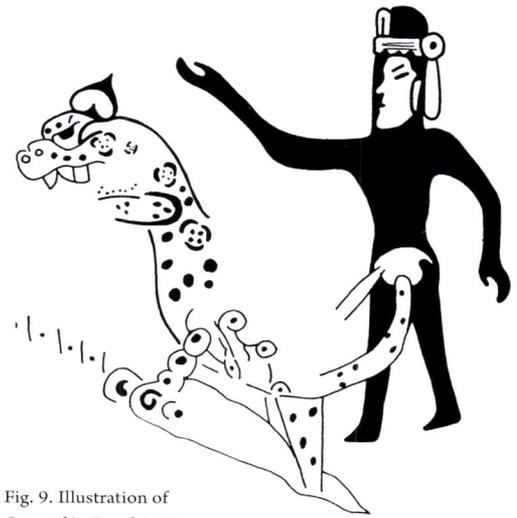

Fig. 8. Detail of jaguar head of Panel 1-03 in natural light showing the natural rock surface, Oxtotitlán cave, Guerrero, Mexico. Photograph by Leonard Ashby, 2012.

Fig. 9. Illustration of Oxtotitlán Panel 1-03, man and jaguar, by David C. Grove, 1970. Courtesy of David C. Grove.

captures data within specific wavelengths, enabling the differentiation between the reflected light of pigment and that of the rock surface. Photographs by Gamble and subsequent image processing by von Nagy enhanced our ability as illustrators to reveal the original paintings with accuracy. Among the numerous paintings, examination of three details associated with artworks from the north grotto including Panel 1-03 (man and jaguar), Panel 4-01 (profile head with mask), and Panel 4-05 (feathered disc) are discussed here as a sample of practice and temporality in cave painting at Oxtotitlán.

## Panel 1–03: Man–Jaguar

Oxtotitlán Panel 1-03 is centrally placed on a large descending crag of rock (see figs. 5 and 8). A jaguar stands to the left of a standing male figure wearing a headdress; both face north (fig. 9). The nature of the association between these two figures has been debated based on their position (the jaguar in a standing, anthropomorphic position) and elements of contact at the midsection. Overall, there is a lack of clarity regarding the relationship between figures. Gutiérrez and Pye express the

general consensus, describing it as "a painting of a human whose body is shown with black paint and who wears a headdress; a jaguar stands in front of him, and his tail reaches back and is attached to him at the genital area of the individual . . . perhaps an example of a jaguar nahual" (2010, 47). The connection to contemporary jaguar-emulation rituals in association with spring rain petitioning is strong; however, our forthcoming publication will present refined details from both figures and expand on this interpretation with greater specificity in regard to Formative symbolism.

For this discussion, we will focus on the face of the human figure, which we have reillustrated with greater detail and increased accuracy in representing the original artwork. In the head area, several new elements emerged under close field examination and scrutiny of

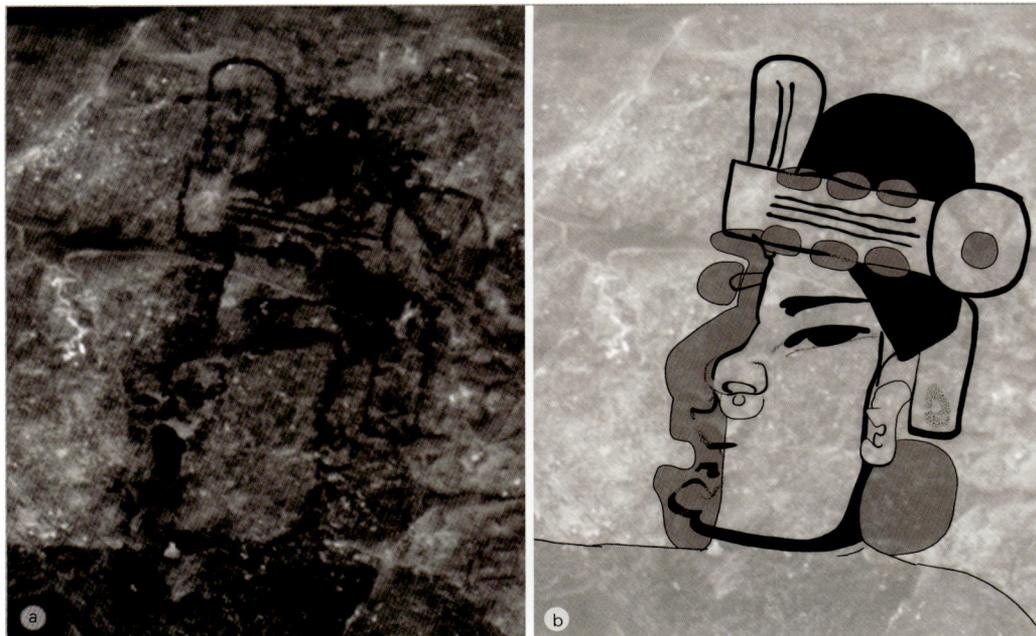

Fig. 10. Detail of human face of Oxtotitlán Panel 1-03: (*a*) image by Joseph Gamble, 2012; multispectral computational enhancement by Christopher von Nagy, 2013; and rectified to measured field drawing by Heather Hurst, 2013; (*b*) illustration of human face of Panel 1-03 by Heather Hurst and Leonard Ashby, 2013.

MSI data, including a headdress with feather, jade beads, a mirror, and a jade mask (fig. 10). Grove and Dávalos documented the Panel 1-03 figure clearly wearing a headdress, but with close inspection, it is actually possible to see the layering of the brushstrokes that developed its composition. First, the human figure, face, and head were painted. Next, a banded headdress with diadems, specifically a feather in the front (denoted by its tapering shape, rounded lobe, and the central shaft), two rows of three stones, and a circular disc at the back of the head with fabric from the tied band hanging down behind were added. Due to the larger scale of the disc, I believe it to be a mirror. The figure has a naturalistic human ear with large earspool just behind.

While Grove documented the narrow-slit eye and eyebrow, precise rendering of the brushstrokes gives greater individuality to the human. Refining facial features identifies that he wears a simple nose bead and has another bead at his forehead; he has somewhat flared lips with a downturned mouth, and his lower teeth are visible (see fig. 10b). The refinement

of these details, particularly the headdress assemblage, suggests this figure is a ruler and/ or ritual specialist. Notably, the dark area in front of the face (seen as a darker gray field in the drawing) is an actual mask. Painted after the human face was rendered, the mask is chunky and thick; it has an open mouth, which overlays the figure's mouth, and there is a large bead at the forehead. The similar gray hue used for the headdress beads, the earspool, and the mask suggest these may be like materials, probably jade. Masks are a well-known Olmec art form, yet the profile of the mask is not particularly discernable as animal, deity, or human. However, its presence indicates the man is assuming another role—he is transforming. The layering of brushstrokes follows a sequence that can be considered the "dressing" of a figure, from creating the face to donning the diadem and finally the mask.

## Panel 4–01: Profile Head with Mask

Oxtotitlán Panel 4-01 is a profile head painted at the mouth of the north grotto, generally at

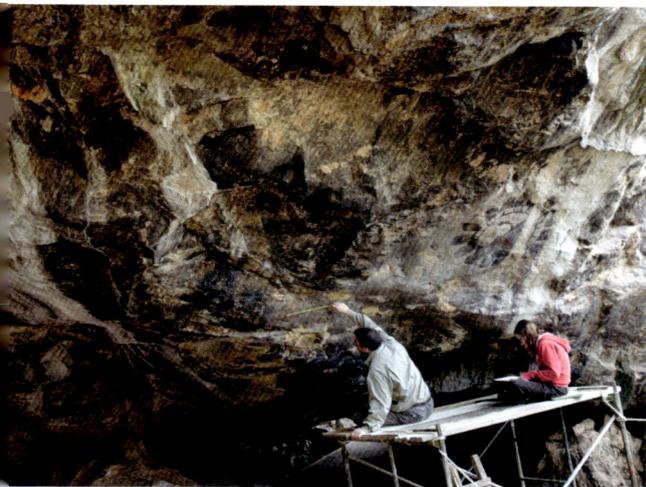

Fig. 11. View of Panel 4 area with Leonard Ashby (left) taking measurements of the profile head of Panel 4-01, and Heather Hurst (right) working below the shield-bearer of Panel 4-05, Oxtotitlán cave, Guerrero, Mexico. Photograph by Joseph Gamble, 2012.

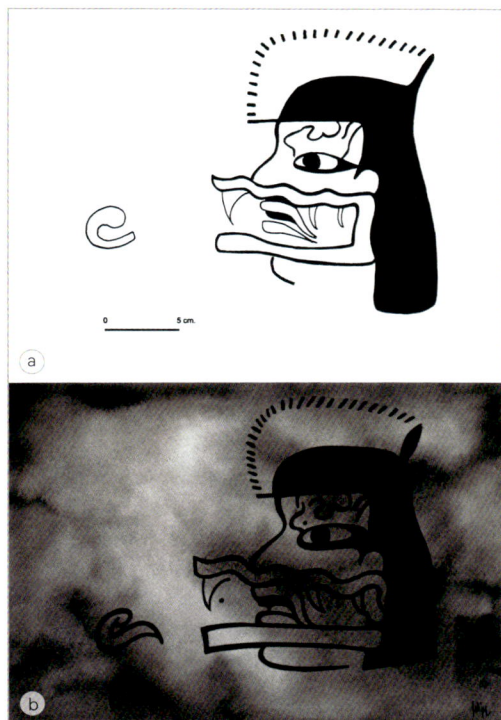

Fig. 12. Oxtotitlán Panel 4-01, profile head: (a) illustration by David C. Grove, 1970. Courtesy of David C. Grove; (b) illustration by Felipe Dávalos, 1970. Courtesy of David C. Grove.

an area where the exterior face wraps inward to the east and slopes back, creating an overhang (fig. 11). The head faces into the cave, or to the left when one is facing the artwork. The Panel 4-01 head is approximately 20 cm wide × 25 cm high, which is nearly identical in scale to the head of the human figure in Panel 1-03. This profile face exists without a body but wears a mask and headdress assemblage (fig. 12). Again, with close examination, the layering of the brushstrokes is visible, and like Panel 1-03, the human face was painted first and then the mouth mask and headdress were painted on top (fig. 13). The face has an almond-shaped eye and an open, downturned mouth with the upper lip defined and upper front teeth visible. The jaw is square, and there are two strokes forming the chin that give the figure a fleshy volume. The downturned mouth is rendered with expert calligraphy, its lines swelling around the lower lip and tapering into the corner of the mouth; the upper gums are visible with a single front tooth in gray, which then is obscured and transformed by the fang of the mask. In the head area, the figure was first painted with a double line above the forehead, suggesting a cranial profile and a hairline, which then terminates in a rear hair knot; however, all of this human detail is then obscured by the opaque black headdress (see fig. 13a–d).

The Panel 4-01 mask includes adornment added around the eye and a projecting mouthpiece. The eye is modified by thickening the line below the eye and adding an eyebrow with lobed curl at the front and a bifurcated element at the back that has been referred to as a "scroll eyebrow" motif associated with snakes. Indeed, this mask shares many elements with Oxtotitlán Panel 1-01, which depicts a feathered serpent with rattlesnake characteristics, specifically the wavy upper lip with multiple curved fangs, a rectangular toothless lower lip, and the feathery

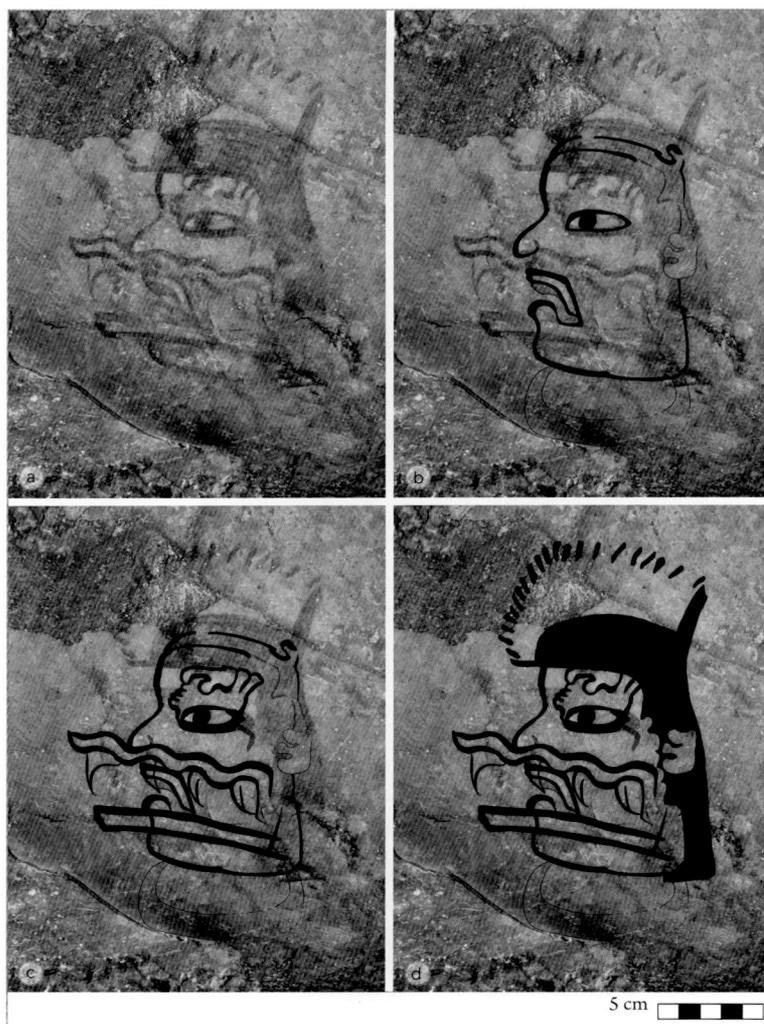

Fig. 13. Sequence of artistic practice of Oxtotitlán Panel 4-01, profile head: *(a)* image by Joseph Gamble, 2012; multispectral computational enhancement by Christopher von Nagy, 2013; and rectified to measured field drawing by Heather Hurst, 2013. Illustration by Heather Hurst and Leonard Ashby, 2013, showing the sequence of brushstrokes of Panel 4-01: *(b)* first rendering human face, *(c)* then adding eye and mouth mask elements, and finally, *(d)* complete rock art of human face wearing mask and headdress.

5 cm

eyebrow. However, the Panel 4-01 figure wears other elements that include a headdress with long flap covering the back of the neck; this flap has a scalloped edge in front of the figure's ear (left unpainted). This type of cap-like headdress, long in the back and with a wavy element at the ear, is seen in Formative period sculpture, such as the Azuzul figures (Cyphers Guillén 1994) or hollow ceramics such as the Atlihuayan figure (Coe et al. 1995, 294). The front part of the Oxtotitlán headdress is defined by hatch marks arching above the cranium, which suggests a soft or puffy element; these markings are used in Preclassic Maya

iconography to show fuzzy materials, such as the fur of a pelt, the crural feathers at the top of a raptorial bird's leg, or the surface of a flower blossom. Below the chin, a simple necklace in gray, likely indicating a jade pectoral, was visible during reillustration. In sum, the visage of the human figure has been transformed by a snake mask and a headdress of a style often worn by a ritual specialist, suggesting both his social role and nahual identity. Finally, Grove (1970, 21) notes the presence of a speech scroll approximately 5 cm in front of the mouth (see fig. 12a). Today, we have other Late Formative examples of such scrolls, notably at San Bartolo,

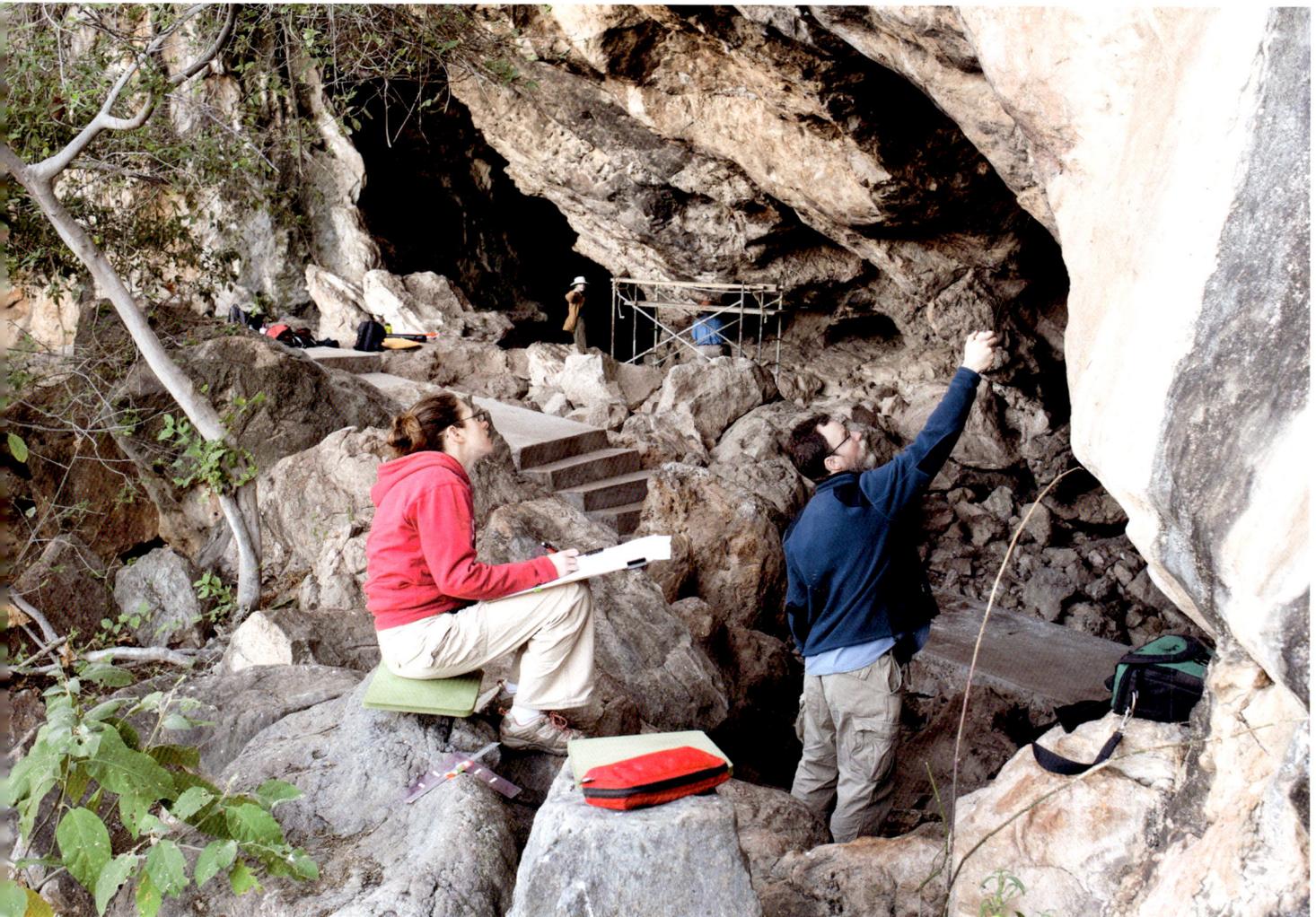

an early Maya site in Guatemala, in front of both naturalistic birds and an early Maya version of Ehecatl, the wind god, who dances and sings to petition the arrival of the principal bird deity from stormy rain clouds above (Taube et al. 2010, 48–49). The pictographs of Panel 1-03 (see fig. 9) and Panel 4-01 (see fig. 12) are similar in their stylistic qualities, and both images represent human–supernatural transformations that employ objects of material culture—masks, headdresses, capes—to change one's identity. In these paintings, one figure dances (Panel 1-03) and the other figure sings or is engaged in oration (Panel 4-01), capturing an active moment of performance within the cave itself.

## Panel 4-05: Feathered Disc

Oxtotitlán Panel 4-05 is a feathered disc (see figs. 15 and 16) with a newly identified profile head located to the upper right that suggests this figure is a shield-bearer (Russ et al. 2017, 171–73). Panel 4-05 is located approximately 3 m south of Panel 4-01; however, this pictograph is very distinct in its size, style, and motif. In contrast to the numerous artworks (such as Panel 4-01) that must be viewed from within the cave itself, several polychrome artworks

Fig. 14. Exterior area of cave, Oxtotitlán, Guerrero, Mexico, with Panel 4 area in foreground and Panel 1 area near scaffold in distance. Photograph by Joseph Gamble, 2012.

were painted at a very large scale on the exterior rock faces as *public* artworks. Panel C-1 is the best preserved and best known of the public rock art, but Panels C-2, 4-05, and 4-06 are also similar in scale. Moving clockwise from C-1, down and toward the north grotto, these exterior paintings make use of the largest panels of visible rock. Panel C-2 is a poorly preserved area with jaguar pelt and feathers within a recessed arch that is below and north of Panel C-1. Panels 4-05 and 4-06 (originally labeled Paintings 8 and 9 by Grove) are located at the mouth of the north grotto in an area of high mineralization and have poor preservation (fig. 14).

The most visible element of Panel 4-05 is a large circle with a border segmented into rectangles and fifteen (possibly sixteen) black feathers with red shafts radiating from the disc (fig. 15). The interior of the disc is divided by a diameter line from approximately the one o'clock to seven o'clock orientation. The upper half of this circle has a black curl and two small rectangular elements, whereas the lower half includes a gray inverted-V shape. We interpret this form as a shield with feathers. On-site inspection, paired with live-viewing MSI data, resulted in documentation of a previously unidentified profile of a human head just above and to the west of the shield (fig. 16; Russ et al. 2017, 171–73). The figure looks eastward, into the cave, with forehead, nose, mouth, and chin rendered in a single line that is somewhat poorly preserved. The eye is formed by a straight upper line and circular lower line with a dark pupil—quite distinct from the faces previously discussed. A thick curved line, possibly the side of an earspool or helmet, crosses the figure's cheek. Small circular elements form a line across the forehead, suggesting the border of a beaded or feathered headdress; however, only fragmentary iconographic elements are preserved, leaving no clear identification as to its form. Finally, a dark area in the upper-right corner of the shield is inconsistent with the other well-preserved feathers and might be the arm of the human figure. The sequence of brushstrokes documented in the previously discussed examples to "dress" a human figure is not visible in Panel 4-05. Although preservation is poor, the facial profile terminates at the border of the headdress, and the chin stops at the curve of the probable earspool.

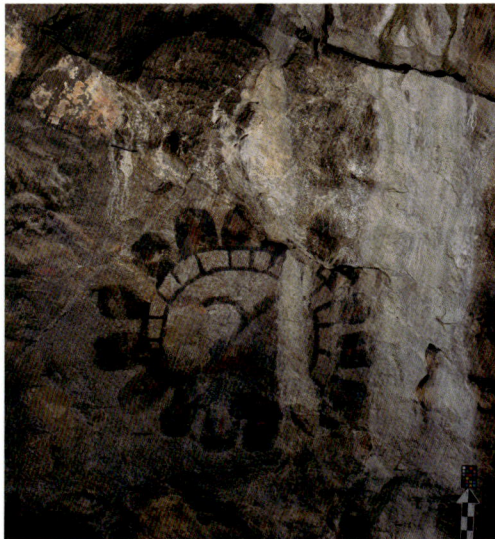

Fig. 15. Natural light photograph of Panel 4-05, shield-bearer, Oxtotitlán, Guerrero, Mexico. Photograph by Joseph Gamble, 2012, and rectified to measured field drawing by Heather Hurst, 2013.

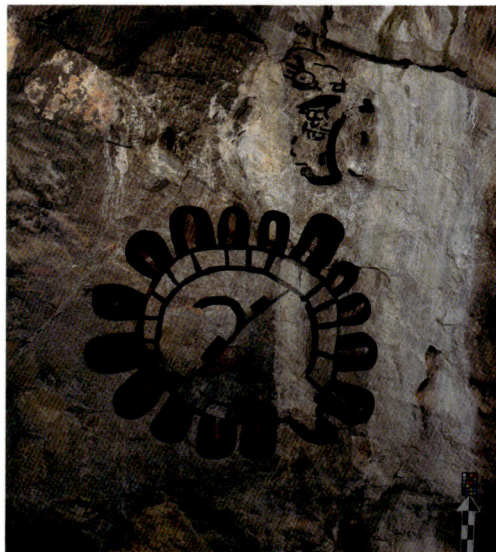

Fig. 16. Photograph by Joseph Gamble (rectified) of Panel 4-05, shield-bearer, Oxtotitlán, Guerrero, Mexico, with illustration overlay by Heather Hurst and Leonard Ashby, 2014.

The shield-bearer figure is related to another standing, full-size figure (Panel 4-06) located to its right, or west, which also faces into the cave. Panel 4-06 includes one element previously identified by Grove (1970, 23), but this image actually extends in all directions to include a massive headdress, striding legs, and associated elements that include celts, arrows, leg wraps, and a large feather backrack or cape. Given their proximity to one another, similar scale, and shared orientation facing into the cave, Panels 4-05 and 4-06 may be read as a unified composition—striding figures processing toward the cave mouth. Grove suggested a possible relationship between the shield and scroll-like elements, which is increasingly likely given the extended area of the composition that became visible to the UOP through revisitation and MSI data. Viewed together, Panels 4-05 and 4-06 depict two individuals striding toward the cave entrance with elements associated with warrior identities (shield, arrows, leg wraps), although the multiplicity/flexibility of this symbolism is well documented (e.g., Taube 2017). This scene evokes that of San Bartolo's north wall murals, where heavily wrapped, helmeted men carry offerings to the cave of Flower Mountain (Saturno et al. 2005, 37–41).[3] The Oxtotitlán shield figure is uncommon among Formative period imagery (Russ et al. 2017, 180); indeed, Grove (1970, 23) saw connections ranging from Postclassic sun disks to the Formative monuments of Tres Zapotes, leaving Panel 4-05 ungrounded in time and cultural affiliation. I will return to the date of this panel in the discussion below but highlight its connection to the previously discussed paintings wherein a human figure is represented with material objects in an active pose within the cave, suggesting an engaged practice or experience that has been recorded through image making.

## Chronology of Painting

In 1969, Grove assigned a stylistic date of "possibly about 800 to 700 B.C." (1969, 422) to the Oxtotitlán paintings, refining this to "between 900 and 700 B.C." (1970, 32) following archaeological fieldwork. Grove notes that the variation of painting types, ranging from "simple geometric and linear designs" to "more elaborate," makes dating and attribution difficult. Like Chalcatzingo and Juxtlahuaca, the complex figural artworks of Oxtotitlán exist alongside abstract, symbolic pictographs (labeled "primary symbols" by Gay 1973). Such multiplicity of forms and styles is very difficult to date, and an evolutionary framework is often imposed on cave and rock art wherein bichrome isolated symbols and handprints are seen as "earlier" or "archaic" in contrast to figural art or grouped combinations of symbols. Grove (1969, 422) resisted this impulse and suggests that the three areas of the cave and their divergent styles are in fact contemporary, with one notable variation. The presence of a Tlaloc face in the south grotto is cited as likely evidence for either a later painting date or a range of painting dates at Oxtotitlán (see Grove 1969, 422; 1970, 33; Schmidt Schoenberg 2008, 287–88). Attempts to describe and interpret the entirety of paintings at Oxtotitlán invariably result in focusing on the "Olmec" nature of a few well-known paintings (see Stone 1995, 47–49; Diehl 2004, 170–72), producing a reduced temporal scope for the cave artworks and little discussion of the active use of this landscape shrine over time.

The recent application of rock art dating methods to the Oxtotitlán paintings by the UOP resulted in the first direct dating of ancient pigments at the site. The analytical team led by Jon Russ, Karen Steelman, and Marvin Rowe sampled both the thin natural rock coating and the paint layer encapsulated beneath

this coating for three paintings at Oxtotitlán, enabling a stratigraphic $^{14}C$ analysis of carbon black pigment and the subsequent oxalate deposit to constrain the age of the ancient painting (Russ et al. 2017). The three paintings sampled included Panels 4-05, C-1, and C-2 (Painting 8, Mural 1, and Mural 2, respectively, in Grove's numbering). As described above, Panel 4-05 is a large painting at the mouth of the north cavern depicting a shield-bearer. Panel C-1 (fig. 1) is the famous polychrome painting of a seated figure, one arm raised, located high above on the cliff face. Panel C-2 is a polychrome painting on the lower portion of the cliff face and is a poorly preserved, fragmentary image of a jaguar pelt and feathers. The three panels selected for sampling are similar in that they are large-scale, figural images with a "public" placement, in contrast to the small, intimate pictographs and paintings located within the caverns. The results document a range of painting activity that occurred during the Early Formative period (prior to 1520–1410 cal BCE) for Panel C-2 and sometime between the Late Formative and Early Classic period (500 cal BCE–cal CE 600) for Panel 4-05 (Russ et al. 2017, 178). Unfortunately, Panel C-1 was inconclusive, as the oxalate coating presented a range of dates and the black pigment was notably made of processed bitumen, which cannot be dated (Russ et al. 2017, 178; McPeak et al. 2013). The results of this study demonstrate that the earliest sampled artmaking at the shrine occurred in the Middle Formative period and confirms that painting took place at Oxtotitlán across a span of many centuries.

Direct dating the pigments provides a framework with which to reevaluate stylistic observations. Stylistically, the human figures in Panels 1-03 (fig. 9) and 4-01 (fig. 12) are fully consistent with Middle or Late Formative practices; this is also true of Panel C-1. Numerous

publications have demonstrated iconographic elements that these artworks share with other Formative period stone monuments, ceramics, and sculpture (Clark and Pye 2000a; Guernsey et al. 2010; Taube 1996). We must look outside the immediate region for contemporary comparisons for painted artworks. The calligraphic line quality, particularly in the rendering of the eye, mouth, ears, and feathers of Panels 1-03, 4-01, and C-1, are most closely related to the sequence of murals from San Bartolo, which AMS radiocarbon date from 300 to 100 cal BCE (Saturno et al. 2006). Furthermore, a color palette of greens and a range of purples, as well as the more common red, yellow, orange, black, and white hues, are shared between Oxtotitlán and San Bartolo but with very few other known Formative period examples, suggesting a technological horizon of sorts. That said, the advanced technological practice of paint preparation at San Bartolo, even in its earliest murals, indicates that the lowland Maya tradition of polychrome painting has earlier roots (Hurst 2009). I believe a similar early Late Formative date for Oxtotitlán Panels 1-03, 4-01, and C-1 is a conservative estimation for their minimum age in absence of directly dated pigments or oxalates from these pictographs, and that a Middle Formative date (1000–400 BCE) is a reasonable and likely date for Panels 1-03, 4-01, and C-1. However, the successful dating of Panel C-2 establishes a much earlier minimum age for polychrome figurative painting at Oxtotitlán of 1520–1410 cal BCE (Russ et al 2017, 178), potentially leaving room for the date of the three panels to be pushed back earlier.

While details of this chronology will continue to be refined, our current data supports a scenario in which several figural paintings, including Panels 1-03, 4-01, and C-1—three images of human transformation—were

created at Oxtotitlán in the first millennium BCE, while much earlier paintings, including the jaguar pelt composition of Panel C-2, were visible from the second millennium BCE. By the fifth century BCE, to paint an image at Oxtotitlán would be an interaction with layers of very old, previous artworks. As time passed, the cave continued to be actively used in ritual practice, and new major public artworks—the shield-bearing figures of Panels 4-05 and 4-06—were added to the mouth of the north grotto most likely during the Early Classic period. Even prior to the radiocarbon dates, the shield of Panel 4-05 stood out for the lack of comparative Formative iconography, and the newly identified profile face associated with the shield diverged stylistically from the other human faces present among the Oxtotitlán pictographs. Radiocarbon dates confirm that Panel 4-05 was painted centuries later, likely in the third or fourth century CE, which is also the likely stylistic assignation for the Tlaloc, the rain deity, among other small paintings, demonstrating another layer of interaction with this topographic shrine.

## Discussion: Temporality and Artistic Practice

Using multiple lines of evidence, then, one begins to build a sense of the cumulative nature of the cave paintings and perhaps the changing imperative to make artworks at Oxtotitlán. The large-scale, polychrome exterior artworks indicate that public visibility was an objective employed at various times: during the Early Formative, an alcove on the lower cliff face depicts a jaguar pelt as part of a lost composition; in the Middle Formative, paintings of transformation by mask-wearing individuals were featured; and in the Early Classic, a painting of larger than life-size figures with military attributes was added to a prominent entrance area.

These public artworks that occurred across long intervals of time punctuated an ongoing rhythm of small paintings made with more frequent periodicity, as well as material culture evidence indicating recurring cave use. This pattern of repeated practice at the Oxtotitlán cave in two temporal frequencies spanning over three millennia begins to construct the cumulative social history of the topographic shrine.

The small pictographs exhibit a large variation of image types including handprint stencils, glyph-like symbols, animals, anthropomorphic figures, and geometrics, as well as isolated dots of paint and single lines (see Grove 1970; Cruz 2009). These are clearly the result of many hands and accumulated over time. A multiplicity of styles and perhaps scribal skill is often true of cave art, as noted by Stone (1995), and is indicative of the ritual practice that occurred in caves and rockshelters (see fig. 7). In order to create most of these small paintings at Oxtotitlán, ritual practitioners would have to construct a scaffold or tall ladder after arriving at the cave with pigments procured elsewhere (or possibly rappelling down from above, although the terrain and rock overhangs are less favorable to such an approach). The numerous paintings are evidence that this practice was repeated as many as one hundred times at the cave.

Activities resulting in public artworks occurred less frequently and involved larger, collaborative efforts. Physically, paintings such as Panels 1-03, 4-05/06, and C-1 would have required more extensive scaffolds and were likely created by a team of participants (see figs. 11 and 17). Similar to any architectural mural, the Oxtotitlán large-scale paintings were not direct executions (e.g., approach the wall and paint start to finish), because a painter could never really see the whole image as it developed on the rock surface. The large public works would

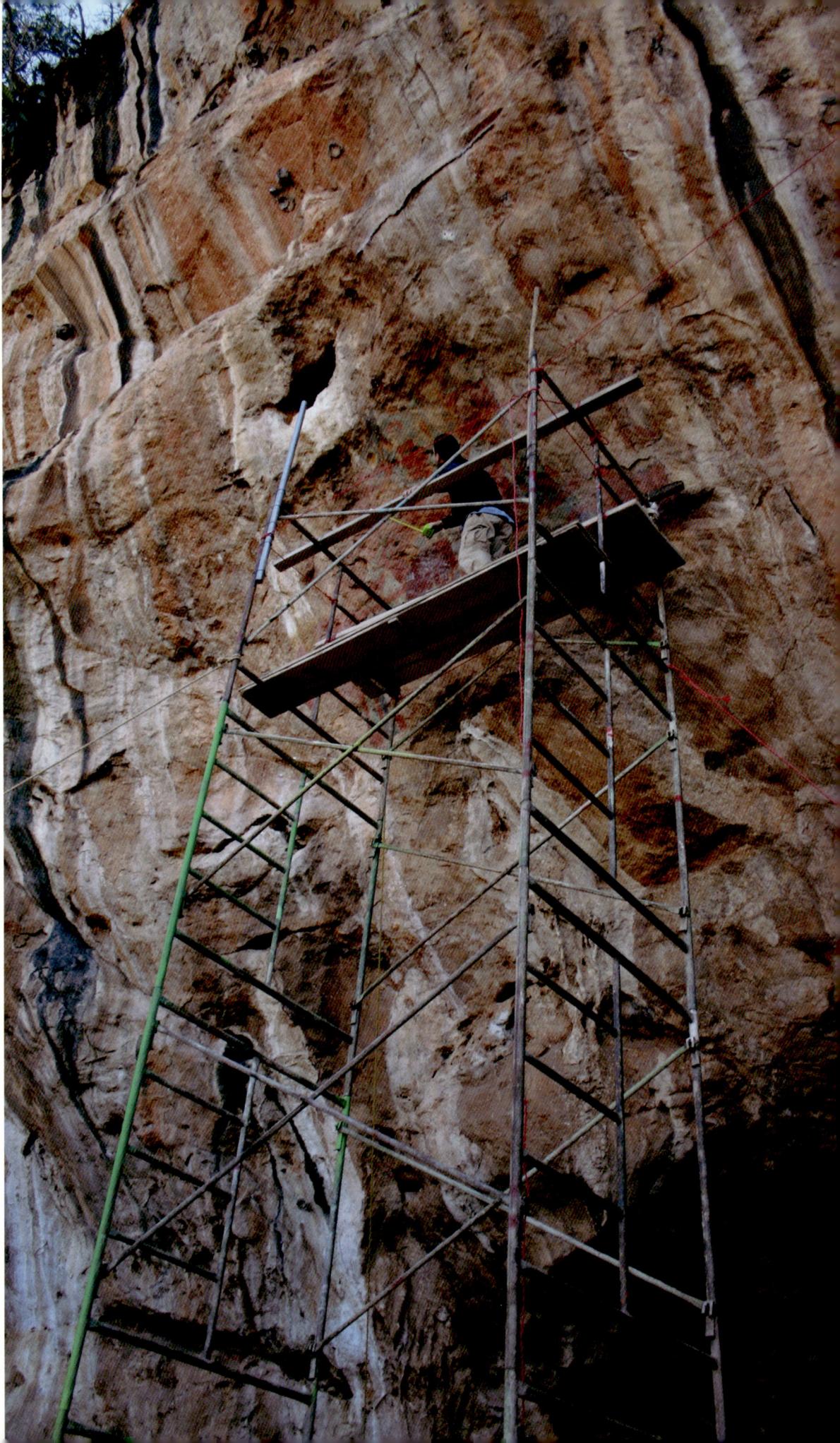

Fig. 17. Panel C-1,
Oxtotitlán cave, Guerrero,
Mexico. Photograph by
Heather Hurst, 2012.

have required preliminary sketches and verification of proportions as images were created in situ due to both the scale and the irregularities of the rock wall. In regard to content, these public-facing paintings are best described as narrative artworks that combine figures and symbolism to tell a story or communicate a complex concept. Finally, select public works employ a range of polychrome pigments that would require different economies, technological knowledge, and practice than are represented among the small works.

Close examination of how the paintings were made provides additional nuance to the paintings' chronology and some insight regarding changing practices connected to the social history of Oxtotitlán. Among the Formative period figural artworks, microscale examination reveals that the human form was first represented in its entirety, such as the hair and head included beneath the headdress of Panel 4-01 or the rendering of the ear of Panel 1-03. Then, through additional brushstrokes, human figures were "dressed" and transformed, both in physical appearance and in their essence, to another identity (see Hoopes 2018). Upon completion, the supernatural identity remains within the cave, residing in the topographic shrine. In this way, the unique human faces represented in the first brushstrokes of Panels 1-03, 4-01, and C-1 may indeed be portraits of historic individuals, but it is their nahual identity that populates the rock and cave while the corporal being may exist elsewhere.

Centuries later, the shield-bearing figures of Panel 4-05/06 were added to the cave. These figures wear clothing and carry objects, but they have not been "dressed" in a way that indicates transformation. Instead, the individuals appear as life-size humans who stand at the mouth of the cave and look inward, toward the supernatural entities populating the descending crags and uneven recesses; they interact with the ancestral figures that inhabit the cave and engage with identities present in the existing paintings. In this way, Oxtotitlán provides a tangible example of how foundational principles of Mesoamerican belief systems are retained but also adapted to have new signification. In this case, third- to fourth-century roles associated with power and governance are newly expressed through militarism and employed at an ancestral sacred topographic shrine to underwrite this power. The visit to the shrine and the negotiation with nonhuman agents (entities that are from a cultural and historically distant place) are recorded in Panels 4-05/06. The recording of such an action calls to mind events depicted on cartographic history paintings, such as Cuauhtinchan Map 2, that relate stories of peregrination to topographic shrines (Boone 2000), but at Oxtotitlán the event is recorded in situ.

Understanding the Oxtotitlán cave as a topographic shrine hinges on a nuanced and holistic approach to the paintings' chronology. Ponciano Ortíz and María del Rodríguez (2000) model a contextualized, material studies approach to ritual practice at the Formative period topographic shrine of El Manatí within an animate landscape. Chronological assessment of offerings made at the El Manatí spring document a change in offering patterns (both in type of objects and the manner in which they are offered, such as randomly cast axes that change to formal patterns and shaped bundles of axes) that the authors tie to "change in the conceptualization of sacred events" (Ortíz and Rodríguez 2000, 79). In addition to change over time, archaeologists also documented a difference in scale regarding who is making offerings. El Manatí spring was used both by individuals in petitioning events and as a site of large-scale, likely collective, ritual events with

massive offerings (Ortíz and Rodríguez 2000, 75–83).

At Oxtotitlán, both individual and collective events are documented in the rock art, and the temporal inscription of image making encapsulated between oxalate layers at the cave spans millennia of changing ritual practice. Among the cave paintings, the greatest distinctions between abstract, symbolic pictographs and figural, polychrome paintings are their individual versus collaborative authorship, as well as their periodicity, artistic practice, paint technology, and economy, and not necessarily in the specialized ritual knowledge of the maker. Like El Manatí, Oxtotitlán functioned as a topographic shrine on multiple levels—from that of individuals to statecraft. Although the predominant character of Oxtotitlán as topographic shrine activated by art was formulated in the Early Formative, and this role intensified in the first millennium BCE, the cave paintings are cumulative, and contextual adjacency is meaningful; layering was intentional for centuries thereafter. For example, I believe that Panels 4-05/06 were placed in such a way that the figures were to be seen engaging the ancient artworks and visages of culturally distant (but not unimportant) nonhuman agents. Elsewhere, numerous ladderlike symbols in white and yellow were painted on top of the polychrome Panel C-1, across the seated figure's body and costume, which were clearly added at a later date than the original composition. Although it is less appealing to the academic eye, modern graffiti might not always be defacement but engagement of the topographic shrine—certainly the modern altars and offerings suggest as much.

Within the boundaries of cities and villages, topographic shrines were created in the construction of pyramids and the erection of monuments (see Prufer and Brady 2005;

Stone 1992; Taube 1986, 2004). In considering the construction of Late Formative sacred landscapes, Julia Guernsey Kappelman rejects the notion of "static stone monuments that commemorated ritual events" in favor of conceptualizing stela-altar pairs as material forms of ritual "that were re-activated and continually reinvested with meaning through the movements and performance of rulers" (2000, 82). Painting is also a material form of ritual practice that was active, not static. At San Bartolo, the Las Pinturas pyramid functioned as such, with layers of sacred architecture, offerings, and paintings one atop the other (Taube et al. 2010, 5–10). In the San Bartolo murals, maize god imagery associated with origin mythology adorned various phases of architecture; each phase was in use for a short time before it was broken and the images taken off view but not forgotten. New paintings would engender these concepts into the topographic shrine yet again. Similarly, the cave of Oxtotitlán continued as a sacred place, yet new paintings reference earlier, still visible works, and the act of painting engenders the shrine. Unlike the comparatively restricted social, political, and temporal practice that created San Bartolo's paintings, the sacred place of Oxtotitlán never goes out of use. At Oxtotitlán, ritual practice of petitioning, honoring, engaging, and negotiating crossed centuries of productive harvest and drought, political stability and upheaval, autonomy and subjugation. The great gulf coast Olmec centers of San Lorenzo and then La Venta both rose and fell during the time jaguar and avian aspects dominated Oxtotitlán's painted works, which featured human actors in transformation. Recent investigations and reevaluation of radiocarbon dates focused on the Middle Formative period are asking new questions about the political dynamics

in regions outside of the gulf lowlands (see Inomata et al. 2013), and Guerrero cannot be overlooked in this interregional interaction. Scholars working in the fourteenth through eighteenth centuries often note that Guerrero is characterized by erratic agrarian yields yet had a long history of providing support to power centers located in Central Mexico (Kyle 2003; Megged 2017). The study of settlement patterns, economic networks, and agrarian practice of the colonial period also shows local conflict and competition. Better understanding the local as well as interregional history is key to understanding the changing role of Oxtotitlán as a topographic shrine that continues to be in use.

While the role of Oxtotitlán as a sacred place associated with rain petitioning has been documented for both the Formative period and in contemporary practice, less attention has been given to other aspects of community ritual practice and "all the social and political baggage that ritual implies" (Prufer and Brady 2005, 2). The recent radiocarbon dates of pigments and redocumentation of several cave paintings provide renewed focus on the non-Formative period pictographs at Oxtotitlán. The painting of a shield-bearer and another standing human figure as large-scale public artworks likely from the third or fourth century are surely multivalent in their meaning but suggest that this special topographic place was used to claim land tenure and/or negotiate alliances at this time. The imperative to create new paintings reflects changing ritual practice at a topographic shrine; Oxtotitlán's function within a network of shrines can help us better understand the changing social and cultural landscape from the Formative period to the present.

In this chapter, I have presented evidence regarding the use of Oxtotitlán as a topographic shrine activated by artmaking as one form of ritual practice that occurred there. The stylistic, symbolic, and chemical evidence records layers of both individual, direct artworks and collaborative, large-scale paintings that span millennia. By reillustrating the Oxtotitlán pictographs, we have begun to decipher the artistic practice that occurred throughout the cave from the Middle Formative and into the Classic period, including the overlapping brushstrokes within a single image and adjacencies of figural forms over time. In some respects, the cave might be described as a palimpsest; however, this prioritizes the narrative or image above all else. Instead, consideration for the topophilic relationship to the dynamic cave—both attraction and obligation—also prioritizes the community activities where relationships with nonhuman agents meet at a threshold, and the materiality of rock, scaffold, pigment, and soot of artmaking is one part of successful negotiation.

A second outcome of this project has been the refinement of the line quality and iconographic detail of several Oxtotitlán paintings from the Formative period, which better represents their character as outstanding calligraphic works and clarifies their association to other Mesoamerican mural traditions. Guerrero not only had a distinct regional style but also provides evidence for specialized technological expertise of artist-scribes working in painted media. Future investigation into particular paint recipes and techniques may provide a way to understand the localized production of knowledge in Guerrero and the institutions and social movements that transmitted technological practice from cave walls to later plastered walls.

## Notes

1   The Urban Origins Project at Quiotepec-Oxtotitlán, Guerrero, uses "panel" to distinguish various areas of rock art at Oxtotitlán and describes the rock art using either *pictograph* or *painting* employing the following vocabulary: *mural* refers to a painting on a prepared substrate that is an architectural surface (*muro* = wall). In reference to painted rock art, the term *pictograph* or *painting* is used, as neither imply placement (such as restricted within a cave) but include technology (in other words, not engraved). *Petroglyph* would refer to any engraved image (carving that reveals unweathered rock below to produce an image).

2   Topographic shrines are sacred sites in the landscape, such as caves, rocky outcrops, or springs. These shrines are highly varied as community boundaries, thresholds to access nonhuman agents, and places of sacred geography but often include associated deposits of offerings and/or material culture from ritual practice (see Stone 1992; Brown 2004).

3   The concept of Flower Mountain is a place of origin and celestial paradise associated with the sun, gods, and ancestors that is depicted as a zoomorphic cave within a wild and fertile mountain (Taube 2004). Karl Taube identifies this as a widespread Mesoamerican belief that is also shared with the American Southwest.

## References

Boone, Elizabeth Hill. 2000. *Stories in Red and Black: Pictorial Histories of the Aztecs and Mixtecs.* Austin: University of Texas Press.

Brown, Linda A. 2004. "Dangerous Places and Wild Spaces: Creating Meaning with Materials and Space at Contemporary Maya Shrines on El Duende Mountain." *Journal of Archaeological Method and Theory* 11 (1): 31–58.

Brown, Linda A., and Kitty F. Emery. 2008. "Negotiations with the Animate Forest: Hunting Shrines in the Guatemalan Highlands." *Journal of Archaeological Method and Theory* 15 (4): 300–337.

Carrasco, Davíd. 1990. *Religions of Mesoamerica: Cosmovisions and Ceremonial Centers.* Long Grove, IL: Waveland Press.

Claassen, Cheryl. 2011. "Waning Pilgrimage Paths and Modern Roadscapes: Moving through Landscape in Northern Guerrero, Mexico." *World Archaeology* 43 (3): 493–504.

Clark, John E., and Mary E. Pye, eds. 2000a. *Olmec Art and Archaeology in Mesoamerica.* Studies in the History of Art 58. Washington, DC: National Gallery of Art.

Clark, John E., and Mary E. Pye. 2000b. "The Pacific Coast and the Olmec Question." In Clark and Pye 2001a, 216–51.

Coe, Michael D. 1965. "The Olmec Style and Its Distribution." In *Archaeology of Southern Mesoamerica, Part 2*, edited by Gordon R. Willey, 739–75. Austin: University of Texas Press.

Coe, Michael D., Richard A. Diehl, David A. Freidel, Peter T. Furst, F. Kent Reilly III, Linda Schele, Carolyn E. Tate, and Karl Taube. 1995. *The Olmec World: Ritual and Rulership.* Princeton, NJ: Princeton University Art Museum.

Coe, Michael D., and Rex Koontz. 2002. Mexico: *From the Olmecs to the Aztecs.* New York: Thames and Hudson.

Covarrubias, Miguel. 1942. "Origen y desarrollo del estilo artístico 'Olmeca.'" In *Mayas y Olmecas: Segunda reunión de mesa redonda sobre problemas antropológicos de México y Centro América, Tuxtla Gutiérrez*, by Sociedad Mexicana de Antropología, 46–49. Mexico City: Talleres de la Editorial Stylo.

Covarrubias, Miguel. 1946. *Mexico South: The Isthmus of Tehuantepec.* New York: Alfred A. Knopf.

Cruz, Sandra. 2009. "Hallazgos recientes en las pinturas rupestres de Oxtotitlán, Guerrero: Aportes del registro y trabajos de conservación." Report submitted to the Coordinación Nacional de Conservación del Patrimonio Cultural del INAH, Mexico City.

Cyphers Guillén, Ann. 1994. "Three New Olmec Sculptures from Southern Veracruz." *Mexicon* 16 (2): 30–32.

Díaz Vázquez, Rosalba. 2003. *El ritual de lluvia en la tierra de los hombres-tigre: Cambio sociocultural en una comunidad náhuatl (Acatlán, Guerrero, 1998–1999).* Mexico City: Consejo Nacional para la Cultura y las Artes.

Diehl, Richard A. 2004. *The Olmecs: America's First Civilization.* New York: Thames and Hudson.

Finamore, Daniel, and Stephen D. Houston, eds. 2010. *Fiery Pool: The Maya and the Mythic Sea.* Salem, MA: Peabody Essex Museum; New Haven, CT: Yale University Press.

Florescano, Enrique. 2009. *Los orígenes de poder en Mesoamérica.* Mexico City: Fondo de Cultura Económica.

Florescano, Enrique. 2017. *Quetzalcóatl y los mitos fundadores de Mesoamérica.* 2nd ed. Mexico City: Penguin Random House Grupo Editorial.

Furst, Peter T. 1995. "Shamanism, Transformation, and Olmec Art." In Coe et al. 1995, 69–81.

Gay, Carlo T. E. 1967. "Oldest Paintings of the New World." *Natural History* 76 (4): 28–35.

Gay, Carlo T. E. 1973. "Olmec Hieroglyphic Writing." *Archaeology* 26 (4): 278–88.

Grove, David C. 1969. "Olmec Cave Paintings: Discovery from Guerrero, Mexico." *Science* 164 (3878): 421–23.

Grove, David C. 1970. *The Olmec Paintings of Oxtotitlan Cave, Guerrero, Mexico*. Studies in Pre-Columbian Art and Archaeology 6. Washington, DC: Dumbarton Oaks Research Library and Collection.

Grove, David C. 1989. "Chalcatzingo and Its Olmec Connection." In *Regional Perspectives on the Olmec*, edited by Robert J. Sharer and David C. Grove, 122–47. Cambridge: Cambridge University Press.

Grove, David C. 1997. "Olmec Archaeology: A Half Century of Research and Its Accomplishments." *Journal of World Prehistory* 11 (1): 51–101.

Guernsey, Julia, John E. Clark, and Barbara Arroyo, eds. 2010. *The Place of Stone Monuments: Context, Use, and Meaning in Mesoamerica's Preclassic Tradition*. Washington, DC: Dumbarton Oaks Research Library and Collection.

Guernsey Kappelman, Julia. 2000. "Late Formative Toad Altars as Ritual Stages." *Mexicon* 22 (4): 80–84.

Gutiérrez, Gerardo. 2015. "Indigenous Coats of Arms in Títulos Primordiales and Techialoyan Códices: Nahua Corporate Heraldry in the Lienzos de Chiepetlan, Guerrero, Mexico." *Ancient Mesoamerica* 26 (1): 51–68.

Gutiérrez, Gerardo, and Mary E. Pye. 2007. "Conexiones iconográficas entre Guatemala y Guerrero: Entendiendo el funcionamiento de la ruta de comunicación a lo largo de la planicie costera del Océano Pacífico." In *XX Simposio de Investigaciones Arqueológicas en Guatemala, 2006*, edited by Juan Pedro Laporte, Barbara Arroyo, and Héctor Mejía, 921–43. Guatemala City: Museo Nacional de Arqueología y Etnología.

Gutiérrez, Gerardo, and Mary E. Pye. 2010. "Iconography of the *Nahual*: Human-Animal Transformations in Preclassic Guerrero and Morelos." In Guernsey, Clark, and Arroyo 2010, 27–54.

Hoopes, John W. 2014. "Conclusion: Undressing the Formative." In *Wearing Culture: Dress and Regalia in Early Mesoamerica and Central America*, edited by Heather Orr and Matthew G. Looper, 447–78. Boulder: University Press of Colorado.

Hurst, Heather. 2009. "Murals and the Ancient Maya Artist: A Study of Art Production in the Guatemalan Lowlands." PhD diss., Yale University, New Haven, CT.

Hurst, Heather, and Caitlin O'Grady. 2015. "Maya Mural Art as Collaboration: Verifying Artists' Hands at San Bartolo, Guatemala through Pigment and Plaster Composition." In *Beyond Iconography: Materials, Methods, and Meaning in Ancient Surface Decoration*, edited by Sarah Lepinski and Susanna McFadden, 35–57. Boston: Archaeological Institute of America.

Inomata, Takeshi, Daniela Triadan, Kazuo Aoyama, Victor Castillo, and Hitoshi Yonenobu. 2013. "Early Ceremonial Constructions at Ceibal, Guatemala, and the Origins of Lowland Maya Civilization." *Science* 340 (6131): 467–71.

Jiménez Padilla, Blanca, and Samuel Villela Flores. 2003. "Rituales y protocolos de posesión territorial en documentos pictográficos y títulos del actual estado de Guerrero." *Relaciones* 24 (95): 93–112.

Joyce, Rosemary A., and John S. Henderson. 2010. "Being 'Olmec' in Early Formative Period Honduras." *Ancient Mesoamerica* 21 (1): 187–200.

Kubler, George. 1962. *The Art and Architecture of Ancient America: The Mexican, Maya, and Andean Peoples*. Baltimore, MD: Penguin Books.

Kubler, George. 1975. *The Art and Architecture of Ancient America: The Mexican, Maya, and Andean Peoples*. 2nd ed. Baltimore, MD: Penguin Books.

Kyle, Chris. 2003. "Land, Labor, and the Chilapa Market: A New Look at the 1840s' Peasant Wars in Central Guerrero." *Ethnohistory* 50 (1): 89–130.

Lambert, Arnaud F. 2012. "Three New Rock Paintings from Oxtotitlán Cave, Guerrero." *Mexicon* 34 (1): 20–23.

Liebmann, Matthew J. 2017. "From Landscapes of Meaning to Landscapes of Signification in the American Southwest." *American Antiquity* 82 (4): 642–61.

Martínez Donjuán, Guadalupe. 1985. "El sitio olmeca de Teopantecuanitlan en Guerrero." *Anales de Antropología* 22 (1): 215–26.

Martínez Donjuán, Guadalupe. 1994. "Los olmecas en el estado de Guerrero." In *Los olmecas en Mesoamérica*, edited by John E. Clark, 143–46. Mexico City: El Equilibrista.

McPeak, Joseph, Jon Russ, Mary D. Pohl, Christopher L. von Nagy, Heather Hurst, Marvin W. Rowe, and Eliseo F. Padilla Gutiérrez. 2013. "Physicochemical Study of Black Pigments in Prehistoric Paints from Oxtotitlán Cave, Guerrero, Mexico." In *Archaeological Chemistry VIII*, edited by Ruth A. Armitage and James H. Burton, 123–43. Symposium Series Volume 1147. Washington, DC: American Chemical Society.

Megged, Amos. 2017. "Salvaging Recurring Themes of Historical Memory in the Cohuixca Province of Tepecoacuilco (Cohuixcatlacapan), Guerrero, Mexico, 1460 to 1580." *Ancient Mesoamerica* 28 (2): 383–401.

Niederberger, Christine. 2000. "Ranked Societies, Iconographic Complexity, and Economic Wealth in the Basin of Mexico toward 1200 B.C." In Clark and Pye 2001a, 169–91.

Niederberger, Christine, and Rosa M. Reyna Robles, eds. 2002. *El pasado arqueológico de Guerrero.* Mexico City: Consejo Nacional para la Cultura y las Artes.

Ortíz, Ponciano, and María del Carmen Rodríguez. 2000. "The Sacred Hill of El Manatí: A Preliminary Discussion of the Site's Ritual Paraphernalia." In Clark and Pye 2001a, 74–93.

Paradis, Louise I. 1981. "Guerrero and the Olmec." In *The Olmec and Their Neighbors: Essays in Memory of Matthew W. Stirling,* edited by Elizabeth P. Benson, 195–208. Washington, DC: Dumbarton Oaks Research Library and Collection.

Pool, Christopher A. 2009. "Asking More and Better Questions: Olmec Archaeology for the Next 'Katun.'" *Ancient Mesoamerica* 20 (2): 241–52.

Prufer, Keith M., and James E. Brady, eds. 2005. *Stone Houses and Earth Lords: Maya Religion in the Cave Context.* Boulder: University Press of Colorado.

Pye, Mary E., and Gerardo Gutiérrez. 2017. "Ritual Landscapes and Cave Networks of Eastern Guerrero, Mexico." Paper presented at the 82nd Annual Meeting of the Society for American Archaeology, Vancouver, British Columbia.

Reilly, F. Kent, III. 1989. "The Shaman in Transformation Pose: A Study of the Theme of Rulership in Olmec Art." *Record of the Art Museum, Princeton University* 48 (2): 5–21.

Reilly, F. Kent, III. 1995. "Art, Ritual, and Rulership in the Olmec World." In Coe et al. 1995, 27–45.

Rosenswig, Robert M. 2012. "Materialism, Mode of Production, and a Millennium of Change in Southern Mexico." *Journal of Archaeological Method and Theory* 19 (1): 1–48.

Rosenswig, Robert M., and Ricardo López-Torrijos. 2018. "Lidar Reveals the Entire Kingdom of Izapa during the First Millennium BC." *Antiquity* 92 (365): 1292–1309.

Russ, Jon, Mary D. Pohl, Christopher L. von Nagy, Karen L. Steelman, Heather Hurst, Leonard Ashby, Paul Schmidt, Eliseo F. Padilla Gutiérrez, and Marvin W. Rowe. 2017. "Strategies for ¹⁴C Dating the Oxtotitlán Cave Paintings, Guerrero, Mexico." *Advances in Archaeological Practice* 5 (2): 170–83. doi:10.1017/aap.2016.10.

Saturno, William A., David Stuart, and Boris Beltrán. 2006. "Early Maya Writing at San Bartolo, Guatemala." *Science* 311 (5765): 1281–83.

Saturno, William A., Karl A. Taube, and David Stuart. 2005. *The Murals of San Bartolo, El Petén, Guatemala, Part I: The North Wall.* Ancient America

7. Barnardsville, NC: Boundary End Archaeology Research Center.

Saunders, Nick. 1984. "Jaguars, Rain and Blood: Religious Symbolism in Acatlán, Guerrero, Mexico." *Cambridge Anthropology* 9 (1): 77–81.

Schmidt Schoenberg, Paul. 2008. "El contexto de Oxtotitlan, Acatlán, Guerrero." *Thule* 22/23–24/25 (April/October): 277–92.

Stirling, Matthew W. 1943. *Stone Monuments of Southern Mexico.* Bureau of American Ethnology Bulletin 138. Washington, DC: Smithsonian Institution.

Stone, Andrea J. 1992. "From Ritual in the Landscape to Capture in the Urban Center: The Recreation of Ritual Environments in Mesoamerica." *Journal of Ritual Studies* 6 (1): 109–32.

Stone, Andrea J. 1995. *Images from the Underworld: Naj Tunich and the Tradition of Maya Cave Painting.* Austin: University of Texas Press.

Taube, Karl A. 1986. "The Teotihuacan Cave of Origin: The Iconography and Architecture of Emergence Mythology in Mesoamerica and the American Southwest." *RES* 12 (Autumn): 51–82.

Taube, Karl A. 1992. *The Major Gods of Ancient Yucatan.* Studies in Pre-Columbian Art and Archaeology 32. Washington, DC: Dumbarton Oaks Research Library and Collection.

Taube, Karl A. 1996. "The Olmec Maize God: The Face of Corn in Formative Mesoamerica." *RES* 29/30 (Spring/Autumn): 39–81.

Taube, Karl A. 2004. "Flower Mountain: Concepts of Life, Beauty, and Paradise among the Classic Maya." *RES* 45 (Spring): 69–98.

Taube, Karl A. 2017. "The Ballgame, Boxing and Ritual Blood Sport in Ancient Mesoamerica." In *Ritual, Play and Belief in Evolution and Early Human Societies,* edited by Colin Renfrew, Iain Morley, and Michael Boyd, 264–301. Cambridge: Cambridge University Press.

Taube, Karl A., William A. Saturno, David Stuart, and Heather Hurst. 2010. *The Murals of San Bartolo, El Petén, Guatemala, Part 2: The West Wall.* Ancient America 10. Barnardsville, NC: Boundary End Archaeology Research Center.

Tuan, Yi-Fu. 1974. *Topophilia: A Study of Environmental Perception, Attitudes, and Values.* Englewood Cliffs, NJ: Prentice-Hall.

Tuan, Yi-Fu. 2014. "Space, Place, and Nature: The Farewell Lecture." Yi-Fu Tuan (website). Accessed May 23, 2019. http://www.yifutuan.org/dear_colleague.htm.

Villela Flores, Samuel L. 1997. "De vientos, nubes, lluvias, arco iris: Simbolización de los elementos naturales en el ritual agrícola de la Montaña de Guerrero (México)." In *Antropología del Clima en*

el Mundo Hispanoamericano: Tomo 1, edited by
Marina Goloubinoff, Esther Katz, and Annamaria
Lammel, 225–36. Quito: Ediciones Abya-Yala.

**Willey, Gordon R.** 1962. "The Early Great Styles
and the Rise of the Pre-Columbian Civilizations."
American Anthropologist 64 (1): 1–14.

**Zorich, Zach.** 2008. "Fighting with Jaguars,
Bleeding for Rain." Archaeology 61 (6): 46–52.

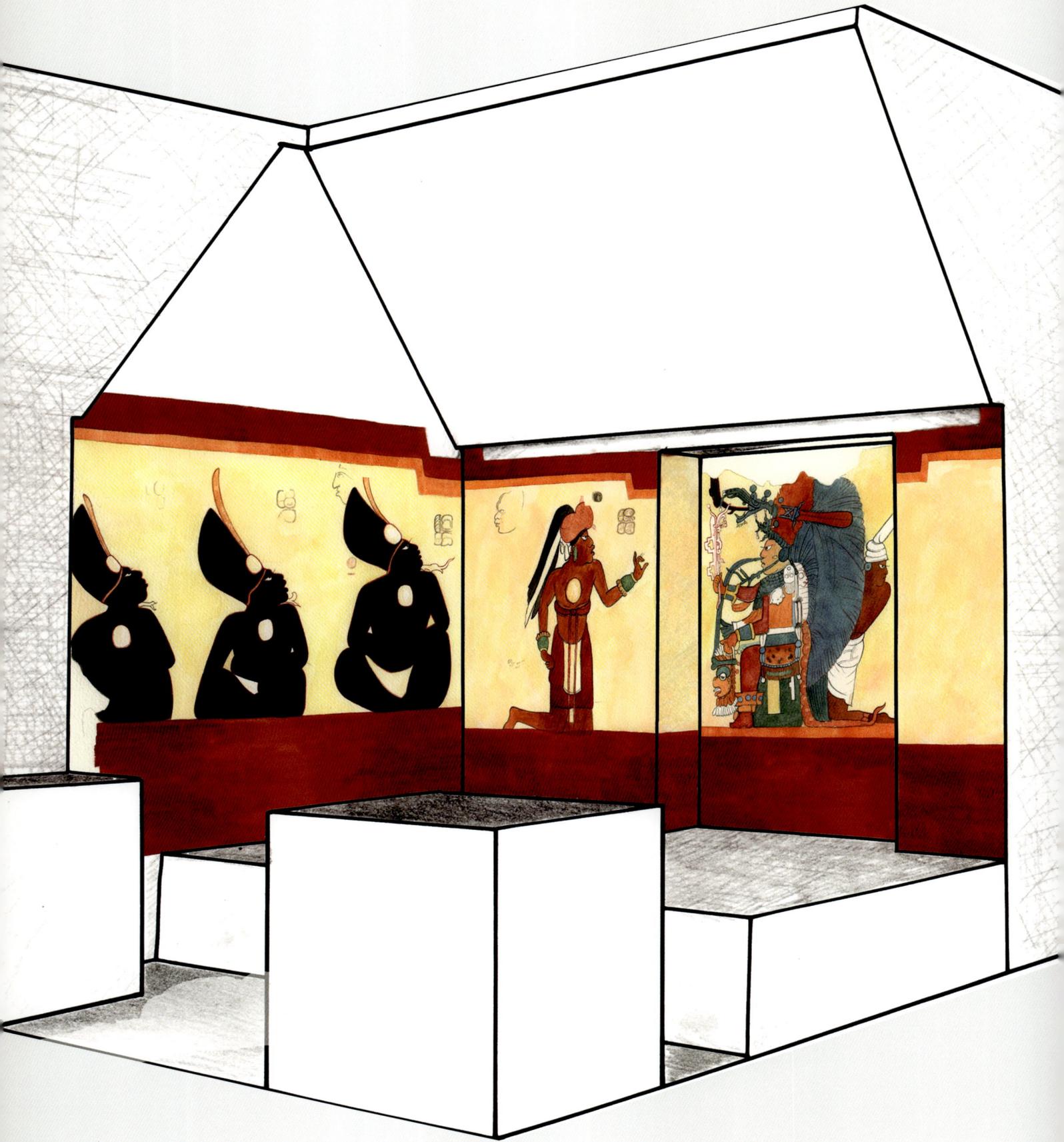

FRANCO D. ROSSI

# Murals and the Archaeological Inquiry into Ancient Maya Education

In 2010, an undergraduate student found a mural in a Classic period (200–900 CE) Maya residence called Los Sabios (fig. 1). Located at the site of Xultun, Guatemala, this unexpected find bears evidence of having been an active workspace for the formulation and inscription of Maya sciences and codex books and revealed the existence of a uniformed and ranked order of individuals known as *taaj*, or "obsidians."[1] It allowed us to anchor a chronology for the ruler it depicts, Yax We'nel Chan K'inich, and ponder the interactive nature of his image, which, rendered within a niche in the wall, had clearly been curtained off at times and revealed at others. There are also different handwritings evident on the mural walls, which show how a multiplicity of variably skilled authors regularly worked on the micro-texts within the room. Even the way in which the mural paints and pigments were mixed and applied proved of interest, providing insight into the materiality of colorants as influencing use patterns that extended beyond a color's appearance alone (Hurst 2013).

However, perhaps the most important aspect of the Los Sabios mural context was that it could serve as a fulcrum for bringing together these diverse observations and other sets of data; archaeological, epigraphic, artistic, and ethnographic research could be combined to analyze and understand the individuals routinely moving in the mural space alongside the range of interactions these individuals were having with the mural itself. With the curtained-off image of the local ruler, the graffiti-like sketches, and the plaster-layered east wall with tiny mathematical texts inscribed or incised (sometimes skillfully, sometimes poorly), it became apparent that the Los Sabios mural

*Opposite:* Detail of fig. 15.

*Below:* Fig. 1. *(Left)* Los Sabios mural: *(a)* west wall (illustration by Heather Hurst); *(b)* north wall (illustration by Heather Hurst; glyphic text by David Stuart); *(c)* east wall (illustration by Heather Hurst; image by William A. Saturno and Franco D. Rossi). *(Right)* Cutaway architectural reconstruction of Los Sabios Room 2, Structure 10K2 (illustration by Heather Hurst).

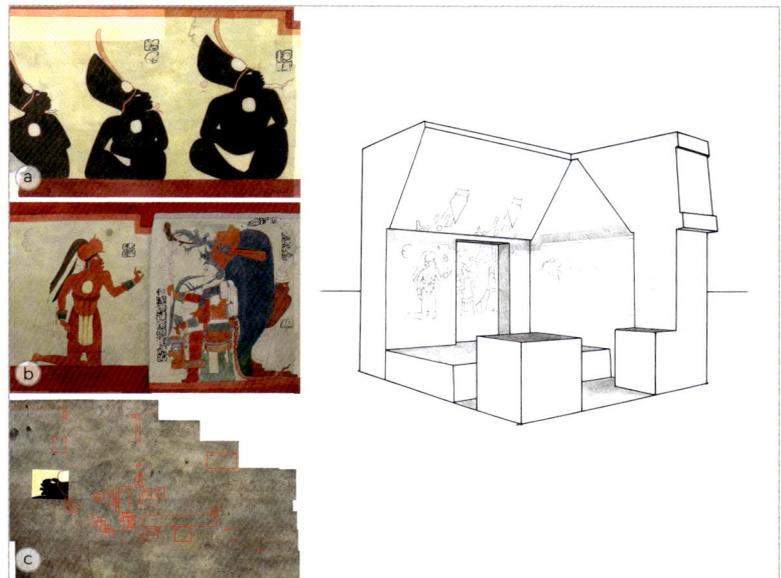

functioned as *interactive* media, and the mural room emerged as a place where people were learning and experimenting—a place in which controlled knowledge was both generated and transmitted, and sociopolitical norms of the day were produced and reinforced. In this chapter, I consider the artistic and archaeological evidence for such engagements within the Los Sabios mural room and what such evidence might suggest not only about the nature of specialized knowledge practice, production, and transmission at Xultun but also across Maya society during the eighth century.

As in many societies, both ancient and modern, the Classic period Maya were a highly ritualized society in which monumentality and public spectacle were key instruments for expressing and reaffirming political authority (Inomata 2006). Kingly and elite endeavors were often tethered to historically, calendrically, or astronomically significant dates and celestial cycles, elevating human endeavors to a cosmic stage for public consumption and establishing a king's authority by strategically aligning it with the very cycles of nature (Aveni 1989; Freidel and Schele 1988). The orchestration and choreography of such events required work, as did the active tinkering and reinvention of the local histories underpinning their ritual narratives. Beyond naturalizing inequality, these specialized forms of knowledge were also politically very important in that they framed and structured many key aspects of social, political, and religious life and appear to have helped shape public understandings of causality (Milbrath 1999; Rice 2004; Wells and Davis-Salazar 2007). Yet the varied actors who crafted such forms of knowledge remain obscure, and evidence pertaining to the facilities in which they worked, interacted, and taught others has proven equally difficult to identify. Los Sabios provides a fresh opportunity to examine

the contexts and material remains of such processes. This, in turn, allows us to construct a working framework not only for identifying similar pedagogical contexts across the Maya area but also to parse the social and gendered nuances of daily habitus as it played out in space that was both residential and educational (see Bourdieu 1996).

It is no secret that education is key to shaping society. Controlled forms of knowledge have long been closely connected to the socialization of individuals and the naturalization of cultural, political, and economic norms. Thus, understanding the diversity of these forms of knowledge within a society, as well as the different ways in which such knowledges were generated, controlled, and dispersed within socially constructed spaces, constitutes a vital anthropological approach for examining how power, systems of inequality, cultural difference, and structures of violence were produced, normalized, and reinforced in societies across time. However, these processes of education are largely ephemeral and intangible aspects of society, particularly in terms of material evidence. I consider the Los Sabios mural as but one among many educational tools available to the Maya, albeit one that actually endured through time to the present. As such, it is important to treat the mural itself as an interactive artifact rather than static artwork and to consider the ways it was embedded in ever-shifting contexts of human use, message, and purpose. The archaeology carried out at the Los Sabios residential group serves as a rare instance in which various evidentiary threads can be brought together to contextualize this mural artifact in a way that allows broader questions of Classic Maya education to be broached systematically, before being conceptually expanded to consider potential educational contexts and arrangements elsewhere.

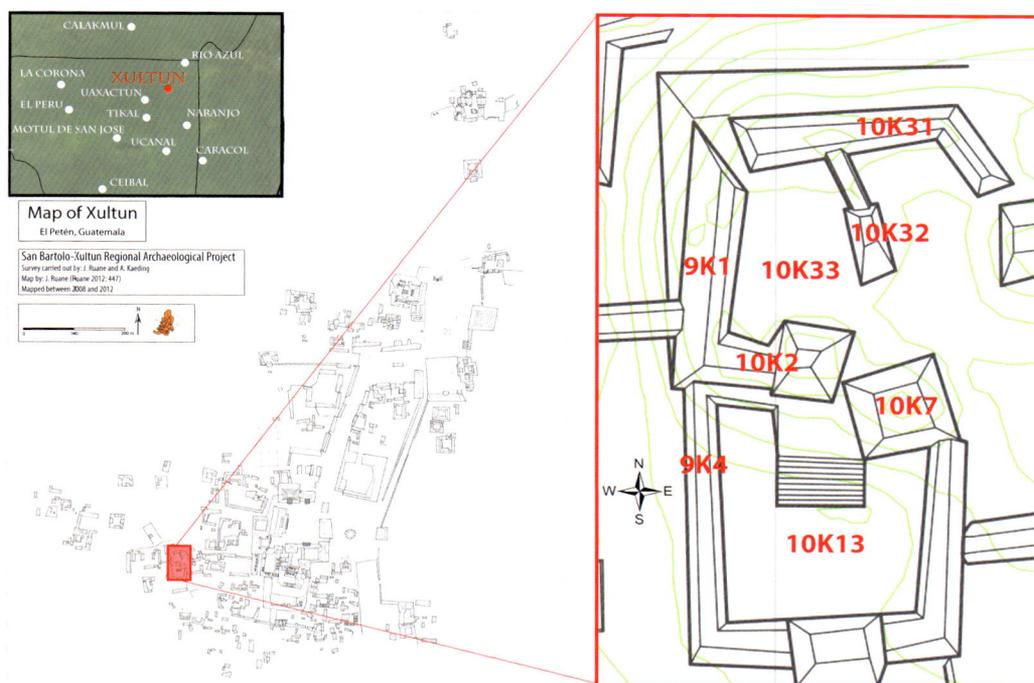

Fig. 2. *(Left)* Map of Xultun (by Jonathan Ruane and Adam Kaeding); *(Right)* map of Los Sabios (by Jonathan Ruane and Franco D. Rossi; image courtesy of San Bartolo/Xultun Regional Archaeology Project).

## Context of the Los Sabios Mural

Xultun, Guatemala, is a pre-Columbian Maya urban center located a short distance northeast of the site of Tikal. In 2010, the mural was discovered at Los Sabios, a Classic period, high-status residential complex (fig. 2; Saturno et al. 2015). Between 2010 and 2012, extensive excavations were undertaken throughout the residential complex. The mural room was excavated, documented, and conserved over the course of three field seasons (2010, 2011, 2012) before being backfilled in 2014 (see Rossi 2015 for full account).

The Los Sabios complex was built on a high point in the city, located roughly 300 m (984.25 ft.) southwest from Xultun's southern ceremonial core and equidistant due west from the royal palace complex. In its final architectural phase, the entire Los Sabios group consisted of at least twelve vaulted masonry buildings, each with multiple small rooms containing benches and arranged around five small patios. The location and plan of Los Sabios are extremely

similar to elite residences at other Classic period centers like Copán (Hendon 1987; Fash 1991; Sheehy 1991; Webster 1989), Tikal (Becker 1999; Haviland 1985), and many others (see Chase and Chase 1992). Los Sabios also contained all the archaeological hallmarks of a Classic period Maya elite residence: chert and obsidian tools involved in daily living, the artifacts of domestic ritual, dedicatory offerings marking key construction events and mortuary remains, termination offerings, and diverse mortuary demography and burial patterns (mostly beneath interior floors), as well as refuse deposits, all in addition to the size and location expected for such residences. Barkbeaters (tools for making paper) and "stucco smoothers" were recovered in various locations throughout the Los Sabios group, which, though not diagnostic of residences, are not uncommon in household contexts (Aoyama 2009; Rice 1987; Rovner and Lewenstein 1997). It is, in fact, the polychrome mural discovery that makes this

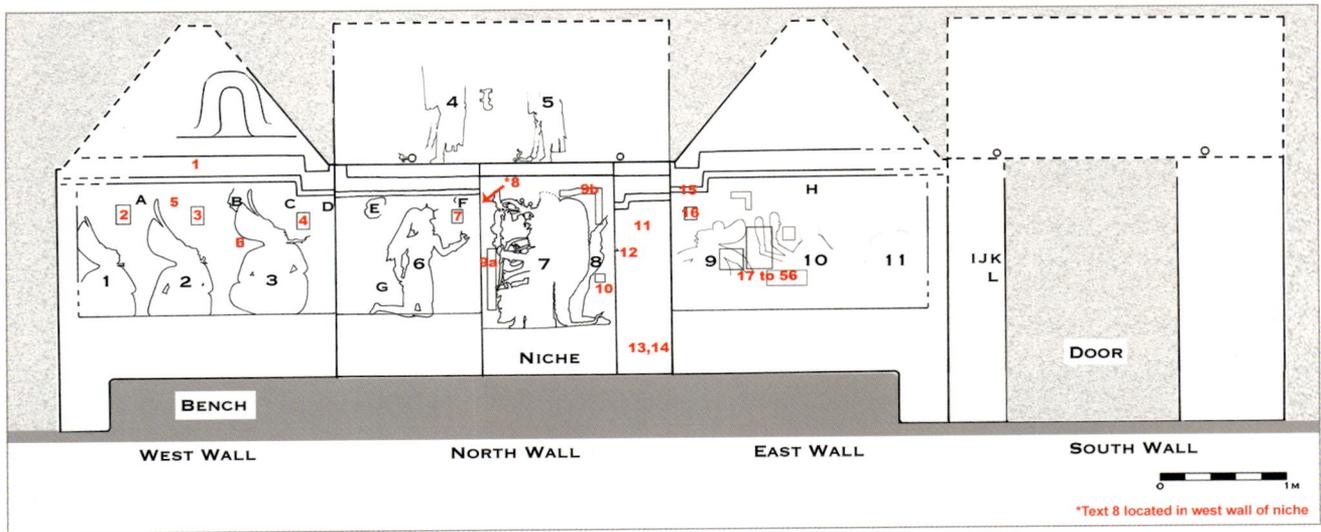

Fig. 3. Architectural schematic and mural map of Room 2 (mural room), Structure 10K2. Figures are numbered in black, sketches are lettered in black, and texts are numbered in red (image by Heather Hurst with modifications by Franco D. Rossi).

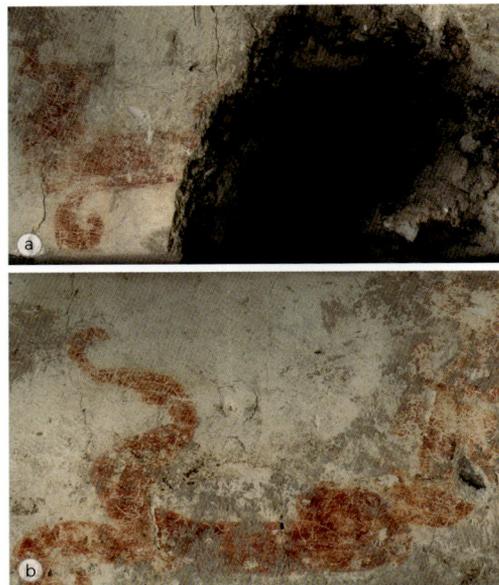

Fig. 4. Reconstruction painting of north wall, Room 2, Structure 10K2 (illustration by Heather Hurst, text renderings by David Stuart).

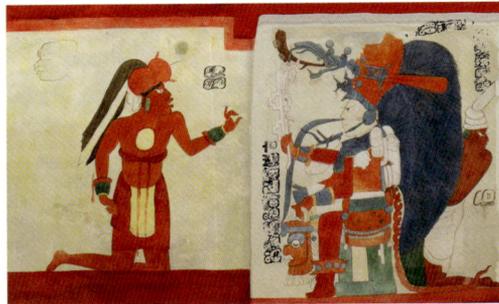

Fig. 5. Scorpion tails of figs. 4 and 5, North vault, Room 2, Structure 10K2; (a) beam socket integrated into fig. 4 imagery; (b) same imagery on fig. 5 without beam socket (images by Franco D. Rossi and Jon Roll).

otherwise standard elite residential group atypical.

The Los Sabios mural is painted across three interior walls and one-half of the sloped interior vault of a small room in a limestone masonry structure designated 10K2 (fig. 3). Its narrative scene once depicted as many as eleven individuals, though only nine are now clearly visible to naked eye. The ruler of Xultun, named Yax We'nel Chan K'inich, is featured prominently within a niche (formerly a doorway) in the north wall of the room, accompanied by a hieroglyphic text explaining the ritual scene and by a depiction of his *baahtz'am* (a kind of royal attendant) (fig. 4).

The niche text begins with the Calendar Round (CR) date 11 Oc 13 Pop, most likely corresponding to the Long Count date 9.15.17.13.10, or February 12, 749 CE (Saturno et al. 2017, 426). Following this CR record, the text goes on to recount an event in which Yax We'nel Chan K'inich invoked the deity named First Wind-Maize with Obsidian (Hun Ik' Ixiim ti Taaj). The king wears a scorpion tail. Above him, adorning the sloped

vault, two scorpion-tailed individuals with shields stand at attention, facing west (fig. 5). The scorpion imagery seems to dually reference both the obsidian wielded in the portrayed ceremony and a Maya scorpion constellation under which the depicted scene took place (Rossi and Stuart 2015, 355–56).

The long caption text may also reference a ballgame-related ritual title, which is followed by the name and honorific titles of the ruler. Taken together, the caption glyphs and scene indicate that the Xultun ruler is performing a calendrical ceremony that colleagues and I have interpreted elsewhere as related to the New Year, the sky (the scorpion constellation referenced in the Paris Codex), and agricultural abundance along with the obsidian-drawn sacrifice necessary to ensure it (Rossi and Stuart 2015, 353–58). On the same north wall, but outside of the niche, an individual labeled *itz'in taaj*, or "junior obsidian," kneels and engages with the ruler. The individuals on the west and east walls sit in a specific order and look on at the interaction on the north wall. Two curtain tiebacks demonstrate that at times the image of the Xultun ruler (and his baahtz'am) in the niche would have been covered, leaving only the itz'in taaj visible on the north wall (figs. 4 and 6).

The painted onlookers sit in uniform dress and visibly evoke obsidian blades. Several of these figures are glyphically labeled with ranked titles ending with the word "taaj," or "obsidian," perhaps presaging the kinds of ranked civil-religious orders documented ethnohistorically and ethnographically (fig. 7; Rossi 2015). On the west wall, three "obsidian" figures sit in line (fig. 8). At the fore sits the *sakun taaj*, or "senior obsidian," and behind him sit two *ch'ok*, or "youths," diminutively depicted in comparison with their senior and seated neatly in line. Just visible at the northern end

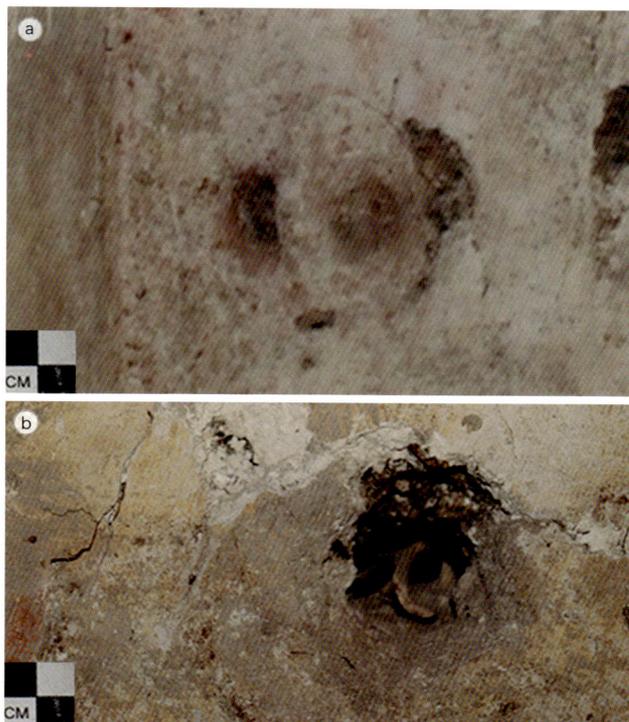

Fig. 6. Curtain tiebacks, Room 2, Structure 10K2; *(a)* east wall tieback; *(b)* north wall tieback incorporating long bone (photos by Franco D. Rossi).

of the east wall, another "obsidian" figure looks toward the north wall and is labeled *tek'eet taaj*. These ranked obsidian figures share many of the layered meanings—and in some cases, regalia—with ritual specialists depicted at other times and in other parts of Mesoamerica. All in all, the painted scene is primarily about the taaj specialists and their involvement in the featured ritual performance being carried out by the ruler.

However, the narrative scene is only one component of the mural room program. Another significant feature of the mural room is the many painted and incised calendrical and astronomical micro-texts adorning its interior walls and interspersed among the painted figures of the mural scene (see fig. 3). These inscriptions are separate from the narrative scene. There are at least fifty-six distinct texts

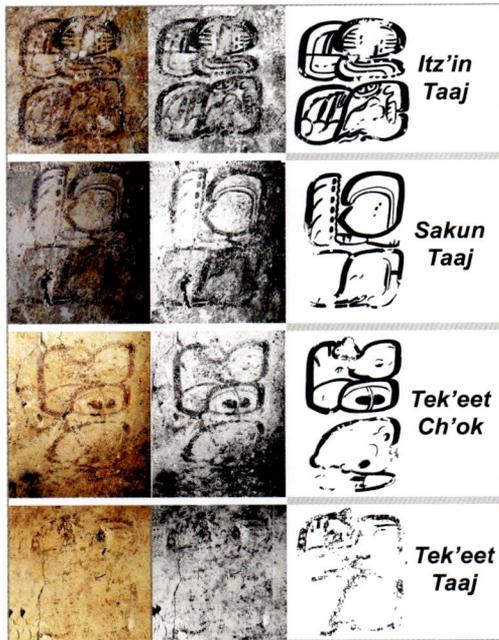

Fig. 7. The taaj titles, Room 2, Structure 10K2 (images by Franco D. Rossi; texts drawn by David Stuart and Franco D. Rossi).

*Itz'in Taaj*

*Sakun Taaj*

*Tek'eet Ch'ok*

*Tek'eet Taaj*

Fig. 8. Reconstruction painting of west wall, Room 2, Structure 10K2 (illustration by Heather Hurst; text renderings by David Stuart).

dispersed throughout the room: eight of these are captions in the courtly mural scene; one is the highly eroded dedicatory formula running above the scene; two are short texts that seem to mark important localized, ritual events; and the more than forty-six others are assorted mathematical micro-texts. Non-textual graffiti is also inscribed throughout the room (fig. 9).

A burial designated Burial 11 is important when considering the link between these micro-texts and the narrative scene—two seemingly disconnected bodies of work painted within the mural room. The individual and artifacts of Burial 11 connect the taaj figures painted in the mural scene to the micro-text and graffiti activity that was being carried out in the mural room. Placed beneath a decorative

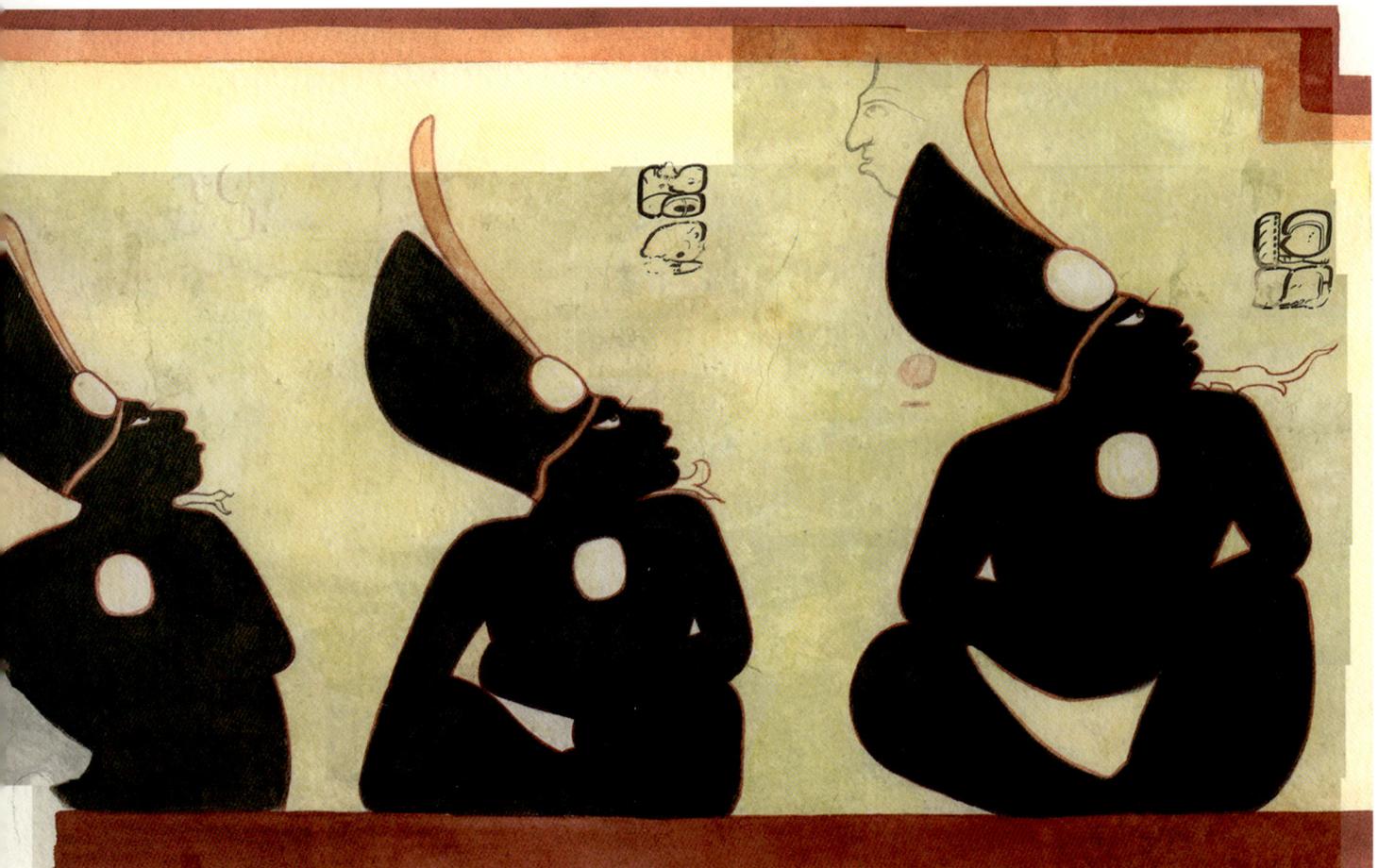

masonry addition constructed off the north exterior wall of the 10K2 mural room, the man in Burial 11 was interred in a semi-seated position with an heirloom vessel and, most notably, two ceramic discs: one perforated for suspension around the neck and one unperforated, ostensibly for placement in a headdress as pictured on the mural scene figures (fig. 10). These discs, also formerly covered in a thin layer of plaster, provide the strong material connection between the individual in Burial 11 and the uniform taaj figures and their ranked order portrayed on the mural (Rossi, Saturno, and Hurst 2015). This material connection, in turn, allows us to populate Los Sabios with at least one agent from the taaj order and place these taaj with the inscribed micro-text activities evident in the mural room. Thus, these micro-text activities were able to be folded into the purview of the taaj and could then be applied to the role of such taaj as they appeared in the texts of other Maya sites.

## The Archaeology of Maya Education

Scholars have long been working to understand educational systems in ancient societies. Primary historical documents and inscribed texts have been vital in these endeavors, providing crucial sources for the kinds of data—curricula, patronage information, student/teacher demography, et cetera—that often elude archaeologists when considering formalized instruction (Beck 1964; Gilliot 2012; Lucas 1979; Siu 1993; Williams 1972). As these studies make clear, much of the early formal education that we know of is both linked to and sourced in written documents and inscribed objects, with non-inscribed archaeological data and material objects related to contexts and agents of learning often difficult to identify. In Mesoamerica, writing, graffiti, and artistic works have also unsurprisingly been at the center of archaeological inquiries into the transmission of literacy and other specialized forms of knowledge in Classic Maya society (Houston 2018; Coe 1973; Houston and

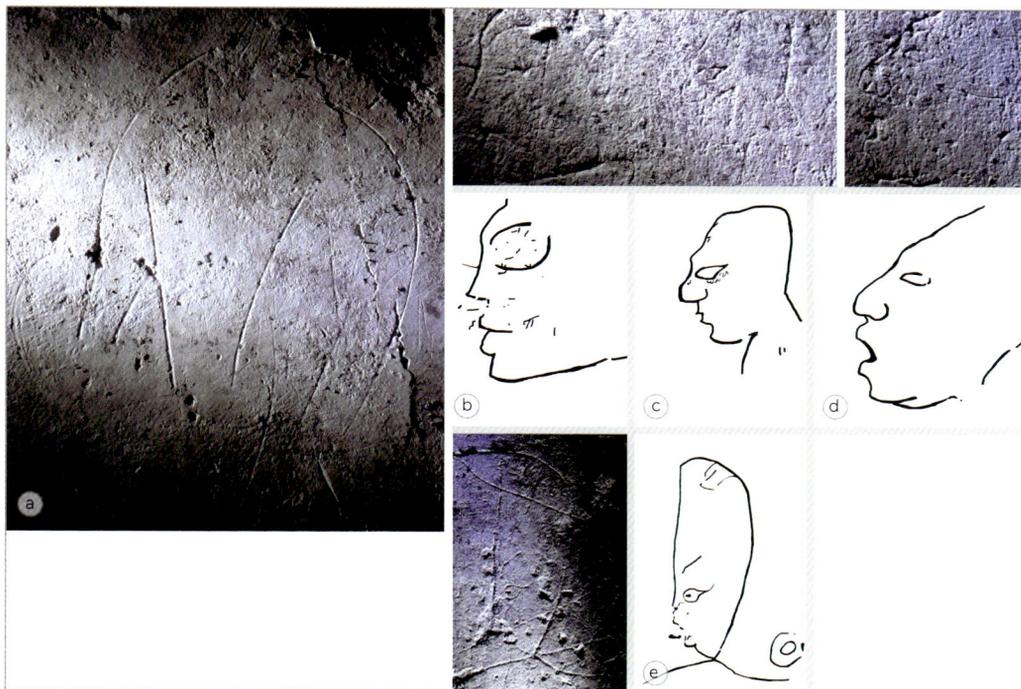

Fig. 9. Informal sketches, Room 2, Structure 10K2: (a) Torso and arms, east wall; (b) Face in profile with large eye, south wall; (c) Head and shoulders in profile, south wall; (d) Head in profile with open mouth, south wall; (e) Head in profile wearing headdress evocative of taaj figures on mural, south wall (images and illustrations by Franco D. Rossi).

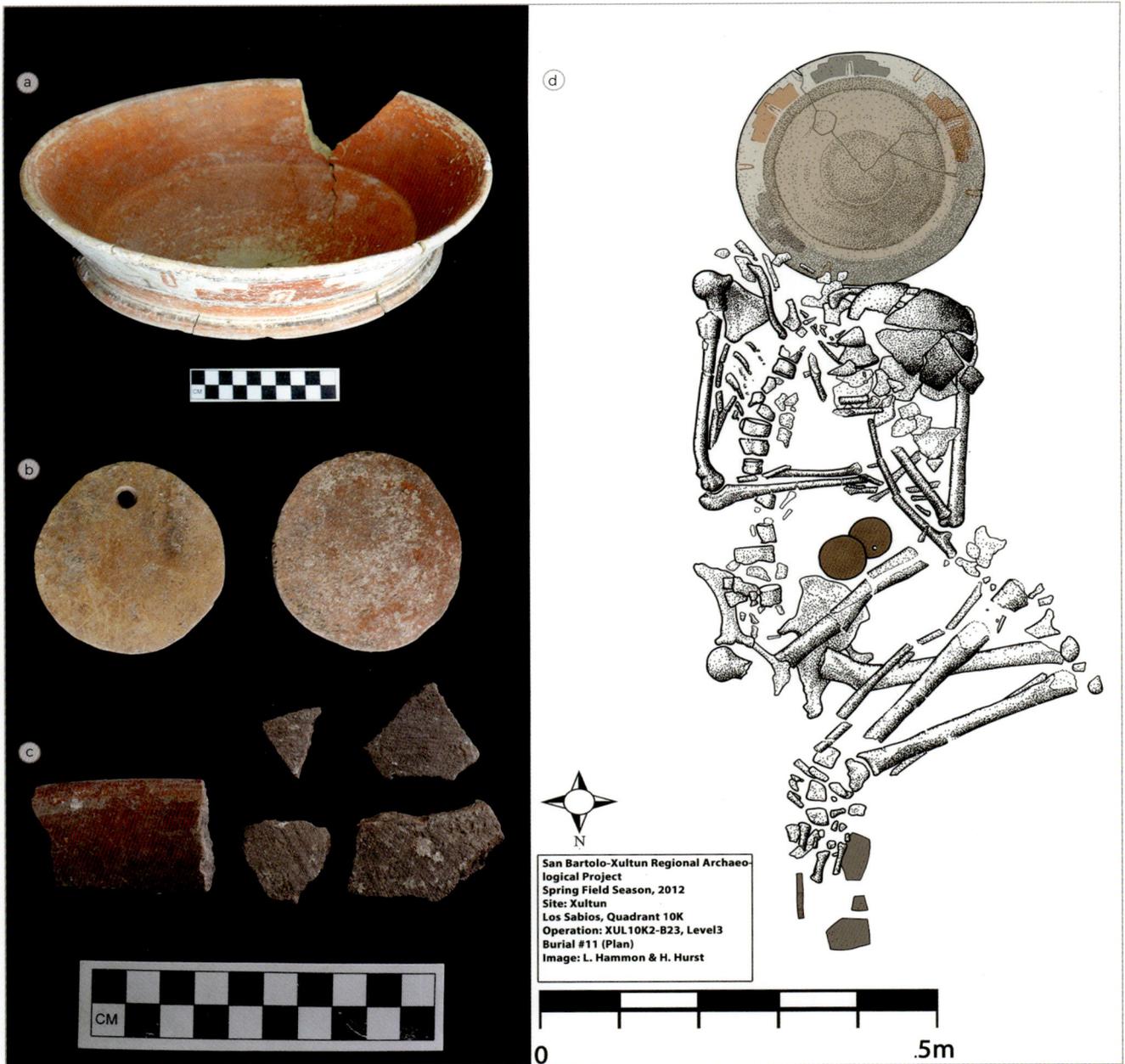

Fig. 10. (a) Yaloche cream basal-flange bowl with step-pyramid motif; (b) ceramic pendant adornments, one perforated, one unperforated; (c) Late Classic ceramic sherds at feet of burial; (d) drawing of Burial 11 in situ (photos by Franco D. Rossi; illustration by Leah Hammon, Heather Hurst, and Franco D. Rossi).

Stuart 1992; Vail 2015). Scholarly approaches to these specialized forms of knowledge often bring together material analyses of craft production with ethnographic, epigraphic, and iconographic inquiries into certain classes of material objects. These include polychrome ceramics, murals, stelae, and codex books that were crafted by individuals known by their artistry and craft: as scribes, artisans, carvers, or scribal specialists (Hurst 2009; Inomata 2001; Satterthwaite 1965; Stuart 1989).

Peter D'Arcy Harrison (1970) made one of the first *archaeological* attempts to identify Classic Maya schools in place and time, focusing on the Central Acropolis at Tikal. He argued that three structures may have operated as a kind of *telpuchcalli*—which he termed a "boys' pre-marriage house"—and that as many as five different structures may have served as priestly residences and schools similar to the Aztec *calmecac* (Harrison 1970, 267–72). It is important to point out, however, that Harrison admitted the evidence for his arguments was rather tenuous, largely dependent on graffiti content, architectural features related to size and sleeping quarters, and (in the priestly school instance) an absence of burials. Since this important initial work, there have been subsequent attempts to identify Maya "schools." However, these have often come up against the similar problem of whether diagnostic evidence of learning exists, and if so, whether it is distinct from the general artifacts of residential elite life (Cheek and Spink 1986; Cohodas 1976).

Pulling from a much broader corpus of graffiti documented at Tikal, Scott Hutson (2011) recently built on Harrison's initial argument that Maya graffiti imagery could sometimes serve as a diagnostic of learning. While graffiti is found in a variety of contexts that were clearly not schools, it also occurs (and would even be expected) in contexts of education. By centering the interactive nature of graffiti, Hutson envisions such evidence as remnants of intersubjective learning processes, in which "beginners and those with more experience work and play together informally" (Hutson 2011, 422). However, it is Stephen Houston (2000, 2009, 2012, 2018) who has explored questions of Maya education and socialization more than any other. His work not only deploys a variety of analytical methods to locate sites of formal and informal instruction on the Maya landscape but also explores various ways in which Maya youths were socialized. Ancillary (artistic or textual) evidence is key to his approach, and my own work on ancient education seeks to build on and add to this previous scholarship.

## Murals as Interactive and Didactic Spaces

The objectives of education are widely varied and culturally bound, but state involvement in such systems has the tendency to conflate moral order with political order within sponsored educational systems (Bourdieu 1984, 319–30). In understanding these processes among Mesoamerican peoples, ethnohistoric data from Central Mexico is particularly detailed and helpful. Miguel León-Portilla (1978, 135) summarizes Postclassic Aztec education as serving a twofold purpose: "First, to form and develop the individual as a person and, second, to incorporate him into the life of the community." The moral path was one in which Aztecs lived "morally and virtuously," and in order to do this, "it was necessary to have rigorous discipline, austerity, and continuous work in things beneficial to the state" (Sahagún 1981, 3:242–43). This was the morality imparted to children by parents and rigorously ingrained into youths as they attended either the telpuchcalli or calmecac, where "the manner of respecting and

obeying the state and its administrators" was emphasized (Sahagún 1981, 3:245).

In Aztec education, hierarchy and order within the collectivity were key components of state organization and instructional policy (see Sahagún 1978, 4:51–70; León-Portilla 1978, 104–76; Berdan 2014, 176–214). Spanish friar Bartolomé de Las Casas (1967, 2:507) writes of a similar "morality" inculcated into colonial-era Maya youths, meant to assure individuals would comport themselves properly in society; pay suitable respect to elders, ancestors, and gods; and live life according to the "right" path—a notion expressed in Yukateko Mayan as *toh*. This far-reaching Maya conception of "rightness" has been thoroughly discussed by archaeologists Houston and Takeshi Inomata (2009, 30–32), who explore the term and its close links with deeply seated cultural ideas of correctness related to properly ordered entities, political hierarchies, and suitable behaviors.

In ancient Maya contexts, these concepts of rightness, or "moral narratives," turn up expectedly as projections (verbal, artistic, textual, or otherwise) of what is the correct or properly ordered path for individuals within a society. Thinking about the Los Sabios mural narrative as an idealized projection helps to shed light on the ways and settings in which some children were socialized and the familial and institutional frameworks within which such socialization occurred. Murals could sometimes serve as important media for conveying storylines that affirm culturally (and oftentimes politically) embedded narratives of "rightness" across generations—as we see in the murals of San Bartolo (Structure Sub 1A) and Bonampak (Structure 1). Houston discusses these two mural contexts among his suggested examples of potential educational spaces. Though separated in time by nearly a thousand years, Houston argues the finished murals of both

places occur within intimate, restrictive settings and emphasize didactic "moral narratives" on themes of royal duty and obligation and local historicity (Houston 2012, 153; see also Miller and Brittenham 2013; Saturno 2009). Both examples also contain evidence of inscribed interactivity in the form of subsequent graffiti-like sketching, unrelated to the mural programs.

Different emphases within mural narratives would be expected depending on the context, the intended audience, or time period in the same way such variability within the same narratives exists today. As interactive artworks, murals often contain "a hint of didacticism . . . for future instruction, exposition and proof of past merit" (Houston 2009, 171)—with narratives that would likely evolve and with which novice viewers and experts could engage in different ways through time. Summarizing his interpretation of the Bonampak murals, Houston remarks:

*They offer a specific account of a prince's career, assisted by two young peers, a primer for the skills and accomplishments of a suitable heir, a vertical account of generational interplay at times of transition, and a horizontal lesson, too, that a good prince both leads and relies on brothers, close kin and courtiers for collective success. (Houston 2012, 153)*

In his analysis, any potential didactic elements seem directed toward the ruling family, specifically the heir, looking toward strategies of success "through vertical and horizontal support" (2012, 170). Ritual duty through blood sacrifice is another key theme present in the Bonampak mural program, explicitly included as part of the narrative of dynastic success. This is emphasized in the San Bartolo murals as well. There, the sacrificial bloodletting from the "first ruler" is what destroys the avian monster and

makes the creation of civilized human space—the city—possible (Saturno 2009; Taube et al. 2010). The sacrifice of the maize god is what makes humanity's birth from the gourd possible (Saturno et al. 2005). The lesson of each mural, if part of their intent, was a visual one seemingly tailored to particular audiences.

Looking to Los Sabios, the mural scene recalls the examples above, and when viewed as moral narrative, the scene's structure lays bare the proper ordering and consequently the appropriate deferential practices for ranked individuals within the taaj order, all of whom exist under the authority of the ruler. Like Bonampak and San Bartolo, the Los Sabios mural projects a certain idealized didactic vision, serving as a constant *visual* guide and reminder of correct order and hierarchy to both an adult and student body of onlookers. Explicit and metaphorical visual hierarchies of this kind are quite common in Classic Maya art and hieroglyphic texts (Meskell and Joyce 2003, 51–52; Loughmiller-Newman 2008; O'Neil 2012, 4; Reents-Budet 1994). Ethnographically, the importance of correct ordering is implicit in the ranked titles of civil-religious orders such as the Santa Eulalia "prayermakers," the *cofradías* of the Guatemala highlands, the *maestros cantores* of colonial Yucatán, or what Suzanne Miles (1957) calls the "priestly offices" among the colonial Pokomam (Cancian 1965; Colby and Colby 1981; Collins 1977; LaFarge and Byers 1931). Evon Vogt discusses the hierarchies evident in seating behaviors amongst the Tzotzil Maya of Zinacantan. During Tzotzil ritual meals, strict requirements regulate the order of how members of the "cargo system" sit at the table, with the highest ranked pair of individuals placed furthest to the east and with each lesser-ranked pair seated slightly westward of the ranked pair that came before it—senior and junior members along opposing long sides

of the table (Vogt 1969, 240, fig. 90). Such hierarchies are echoes of Classic Maya scenes of courtly gathering, as rulers "assemble" *(tz'ak)* their people. In one case, the act of "assembling" brings contentment to a Palenque king's heart (Houston, Stuart, and Taube 2006, 189). Whether it is subordinates or captives being assembled and ordered, an internal hierarchy is implicit in the imagery, as we see on Piedras Negras Stela 12, where the principal captive is positioned highest relative to the king of nine total captives depicted (Schele and Grube 1994, 3). On the well-known "Vase of the Seven Gods," the aged God L sits on his jaguar throne in the darkness.[2] The text glosses that on the day of creation, the gods of the sky and gods of the earth were assembled. The names of these deities follow, one by one, in an intentional order, suggesting—alongside the order in which they sit relative to one another and to God L—that hierarchy is inherently built into this "assembling," and that mythically, it may be a requisite act for creation to take place. On the Los Sabios mural, the seated and properly ordered hierarchy mirrors the seated deities in this mythological scene and recalls the ways ethnographically attested orders behave in contexts related to duty.

An interesting detail within the Los Sabios mural room that differs from these other contexts, however, lies in an unusual piece of evidence: a curtain once covered the image of the king. The hiding and revealing of sacred images is a widespread and globally attested practice throughout history—and as Maya scholars have shown, images of Classic period rulers (especially in moments of deity impersonation as on the mural) were oftentimes perceived as animate and powerful in their own right (Stuart 1996; Houston and Stuart 1996). However, this evidence within so active a space suggests a certain kind of interactivity with this

royal image not necessarily documented in other mural contexts. Intriguingly, the "hiding" of the Xultun king would visually elevate the itz'in taaj to the most prominent position in the mural scene, a hierarchy perhaps more reflective of everyday reality—as the rulers' regular physical presence within the Los Sabios group and as part of daily actions of taaj order members was likely limited.[3]

Sitting on the mural room bench, one might feel as if he or she has joined the painted and seated taaj figures relative to the king, and is thus reminded of not only the correct order of things but of one's proper place within that order. At Los Sabios, the rhetoric of the mural image extends beyond a mere reflection or portrayal of Classic Maya organizational structure to project the prevailing hierarchical framework among the taaj relative to one another and to the king. In this sense, the imagery bears some semblance to a didactic tool in and of itself, reminding its viewers of what is toh within the taaj order and of what constitutes internal hierarchy and deferential order from most exalted to least—k'uhul ajaw (meaning "divine lord") and his baahtz'am, itz'in taaj, sakun taaj,

tek'eet taaj, and ch'ok. Considered from this perspective, the Los Sabios mural not only showcased the kinds of events those working within the mural chamber facilitated but also semiotically reaffirmed key hierarchies of the order and the state.

## Activities in the Los Sabios Mural Room

While the mural scene and curtained niche offer tantalizing clues about the interactions taking place within Structure 10K2 at Los Sabios, the ephemerality of such interactions precludes any discussion that is not largely speculative. However, other, more permanent evidence of interaction and instruction also exist within Structure 10K2 in the form of micro-texts and graffiti. As previously mentioned, micro-texts and graffiti, mostly mathematical and astronomical in focus, adorn the walls of the mural room—painted over or around the figures of the narrative mural scene. Both painted and incised with hands of varying skill, the full corpus of these micro-texts is still under collaborative analysis (for more detailed discussions of individual texts, see Saturno et al. 2012; Aveni, Saturno,

Table 1. Legible Dates in Room 2, Structure 10K2

| Inscribed Date | Full Maya Date (LC and CR) | Julian Calendar Date (584283) | Text Number |
|---|---|---|---|
| 13 Men 13 Sek | 9.16.11.2.15 13 Men 13 Sek | 30 April 762 CE | 8 |
| 11 Ok 13 Pop | 9.15.17.13.10 11 Ok 13 Pop | 12 February 749 CE | 9a |
| 9.16.10.3.12 | 9.16.10.3.12 8 Eb 15 Xul | 22 May 761 CE | 11 |
| 9.16.10.3.14 | 9.16.10.3.14 10 Ix 17 Xul | 24 May 761 CE | 11 |
| 9.16.8.12.0 | 9.16.8.12.0 2 Ajaw 13 Muwaan | 17 November 759 CE | 14 |
| 13 Imix 19 Mak | 9.17.7.15.1 13 Imix 19 Mak | 9 October 778 CE (~6 October 790 CE) | 33 |
| 9.16.10.0.6 | 9.16.10.0.6 7 Kimi 9 Sip | 21 March 761 CE | 43 |

and Stuart 2013; Bricker, Aveni, and Bricker 2014; Rossi and Stuart 2015). However, a few key texts prove especially important for this discussion in that they (1) allow us to date the activity within the mural room epigraphically, (2) establish meaningful parallels with Maya codex books that survive from the Late Postclassic and after (thirteenth century to sixteenth century), (3) display the kinds of key conjunctions between celestial bodies and human time that indigenous specialists working on behalf of the state sought to calculate and commensurate, and (4) reveal different levels of knowledge and skill, mathematical experimentation, and active reworking.

There are at least six secure dates among the collective texts, which reveal that the bulk of writing activity took place within the mid- to late eighth century. This date range fits well with the ceramic chronology, architectural sequence, and period associated with Yax We'nel Chan K'inich (Rossi 2015, ch. 3). Two dates are Long Counts, and the rest are CR dates. Collectively, these dates show that the mural room was at its most active between 749 and 778 CE (table 1), as Classic Maya civilization on the whole was reaching new heights in population, number of independent kingdoms, amount of art and texts being produced, and wars being waged—all immediately preceding what has come to be known as the "Maya collapse." At this time, Xultun was experiencing a prosperous period—successfully waging several wars, erecting considerable monuments and buildings, and enjoying what seems to have been an autonomy it had not known for centuries (Rossi, Stuart, and Saturno 2015). The taaj at Los Sabios were thus working during what looks to have been a rare moment of prosperity and stability at Xultun, excellent conditions for the practice, progression, and transmission of the arts and sciences.

The second feature of the micro-texts that I highlight here is their strong parallels with passages within surviving Maya codices, or screenfold books. Codex books were widespread among Maya populations at the time of the Spanish conquest, but their production and use was slowly extirpated in subsequent decades because the content was deemed idolatrous by colonial church officials. Codices were made by pounding the cortex of *Ficus* trees with grooved barkbeaters, drying the resulting material, folding the dried material like an accordion, applying a limestone-based plaster coating to the pages, and filling those pages with imagery and text (von Hagen 1944, 31–65). Only four Maya codex books survive today, and none of

Fig. 11. Calligraphic "Area B" texts, east wall, Room 2, Structure 10K2 (images by Franco D. Rossi and William A. Saturno).

0    1    2    3 cm

them possess an archaeological provenience. These surviving books were painted sometime during the Late Postclassic and Early Colonial periods (ca. 1200–1600 CE) and deal almost exclusively with the intricacies of the Maya calendar, seasonal almanacs, and various astronomical phenomena (Vail 2006, 503–6). Yet evidence at Los Sabios and beyond clearly supports the widespread production of such books during earlier periods in Maya history (Carter and Dobreiner 2016; Kidder 1935, 112; Coe 1973).

The finished mathematical and astronomical sequences, tables, and almanacs in surviving codices are built out of the exact kinds of calculations and reckonings we see in the Los Sabios mural room. In some cases, mural room texts constitute the *only* Classic period examples of particular formulations we see in later codices (Saturno et al. 2012). Many Los Sabios micro-texts were painted with a calligraphic skill that evokes the scale and style of codex texts (fig. 11). Most of the micro-texts are composed of painted glyphs less than 2 cm across, and several are so tiny that they only measure 1 cm across. This size is quite unusual

for what we know of Maya murals but fits nicely in scale for the pages of codices. Also, these micro-texts are painted in red and black, just as we see in codex books.

The micro-texts contain elaborate mathematical mechanisms for calculating significant base dates from which to launch calendrical or astronomical tables, just as we see in the codex books. These mathematical mechanisms include "ring numbers" (fig. 12; Willson 1924; Saturno et al. 2012, 715–17);[4] "Long Round," or what Floyd Lounsbury (1978) calls "super," numbers (fig. 13; Saturno et al. 2012, 716; Aveni, Saturno, and Stuart 2013, 9–13);[5] and a possible example of a "pictun format"[6] distance number being used to deduce pre-era base dates during the Classic period (Rossi and Stuart 2015; see Bricker and Bricker 2011, 402). There is also a lunar table spanning some thirteen years—part of a calculation tool used for the prediction of lunar phenomena through the grouping of lunar months into 177- or 178-day "lunar semesters" (fig. 14; Saturno et al. 2012, 715; see also Teeple 1930). It is evident that by the Late Classic period, occupants of Los Sabios possessed the expertise to write

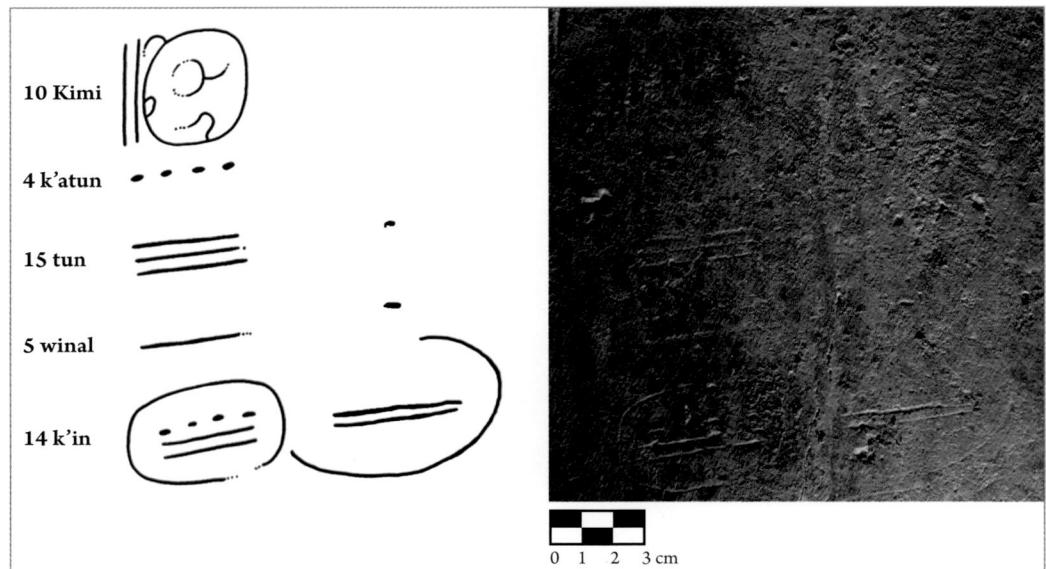

Fig. 12. "Ring Numbers," incised on east wall, Room 2, Structure 10K2 (image by Franco D. Rossi; illustration by David Stuart and Franco D. Rossi).

10 Kimi

4 k'atun

15 tun

5 winal

14 k'in

0  1  2  3 cm

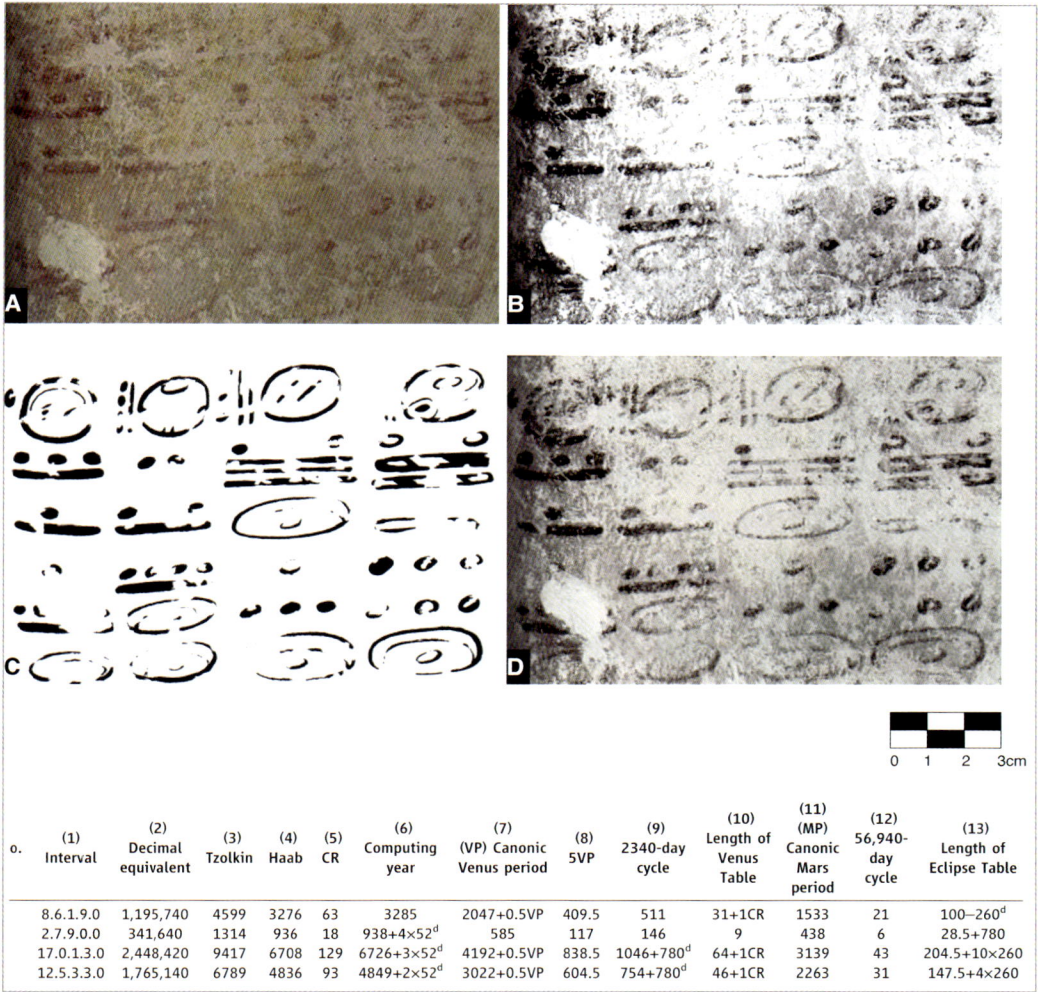

Fig. 13. "Long Rounds," north wall, Room 2, Structure 10K2; (a) Actual appearance, painted in red on north wall; (b) and (d) images processed to draw out details of text; (c) drawing of text (by David Stuart); (e) table revealing extent of calendrical and astronomical correlations (after Saturno et al. 2012).

| o. | (1) Interval | (2) Decimal equivalent | (3) Tzolkin | (4) Haab | (5) CR | (6) Computing year | (7) (VP) Canonic Venus period | (8) 5VP | (9) 2340-day cycle | (10) Length of Venus Table | (11) (MP) Canonic Mars period | (12) 56,940-day cycle | (13) Length of Eclipse Table |
|---|---|---|---|---|---|---|---|---|---|---|---|---|---|
| | 8.6.1.9.0 | 1,195,740 | 4599 | 3276 | 63 | 3285 | 2047+0.5VP | 409.5 | 511 | 31+1CR | 1533 | 21 | 100−260$^d$ |
| | 2.7.9.0.0 | 341,640 | 1314 | 936 | 18 | 938+4×52$^d$ | 585 | 117 | 146 | 9 | 438 | 6 | 28.5+780 |
| | 17.0.1.3.0 | 2,448,420 | 9417 | 6708 | 129 | 6726+3×52$^d$ | 4192+0.5VP | 838.5 | 1046+780$^d$ | 64+1CR | 3139 | 43 | 204.5+10×260 |
| | 12.5.3.3.0 | 1,765,140 | 6789 | 4836 | 93 | 4849+2×52$^d$ | 3022+0.5VP | 604.5 | 754+780$^d$ | 46+1CR | 2263 | 31 | 147.5+4×260 |

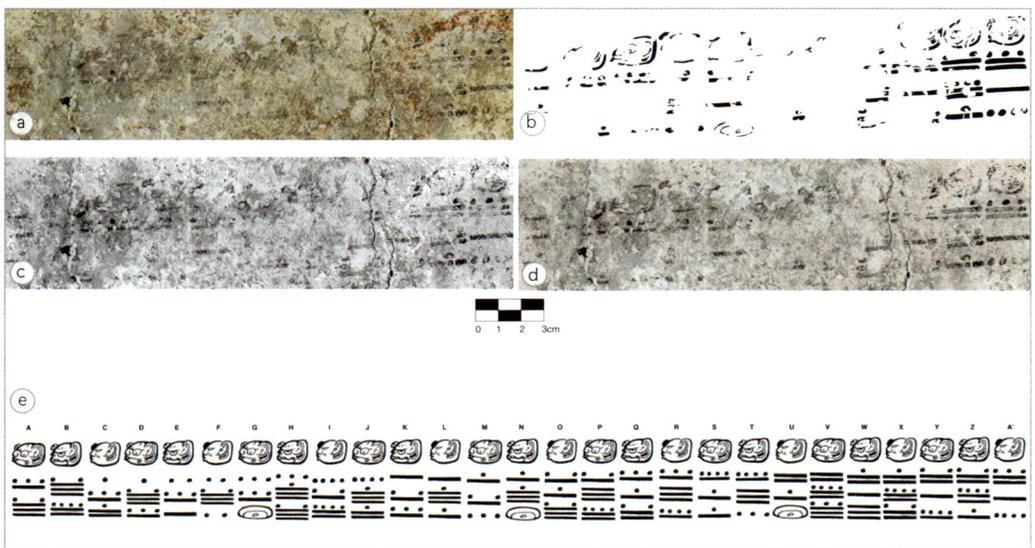

Fig. 14. "Lunar Table," east wall, Room 2, Structure 10K2; (a) actual appearance, painted in black on east wall; (b) drawing of text (by David Stuart); (c) and (d) images processed to draw out details of text; (e) reconstruction of full table (after Saturno et al. 2012; illustration by David Stuart).

and calculate elaborate calendrical information rooted in astronomical observation. This evidence alone has been enough to suggest a link between the Los Sabios calendrical inscriptions and those found in codices as possible copies of one another (Saturno et al. 2012, 717). In fact, it could be argued that the mural micro-texts constitute perhaps the closest artifact we currently have to an intact Classic period codex.

The likelihood of on-site codex book production is supplemented by other archaeological findings at Los Sabios as well. Limestone barkbeaters and stucco smoothers were discovered on-site, making it clear that not only the expertise but also the tools necessary for creating codex books were present at Los Sabios. One of the barkbeaters was discovered as the only offering beneath the plastered interior floor of the mural room (fig. 15). Deposited along the

central axis in the south entryway of the mural room, the barkbeater was placed as part of the construction effort to renovate the space from a two-door passageway into the mural chamber. It suggests the room's renovation had been planned in advance with the intended purpose of paper-making activities, like codex book production (Rossi, Saturno, and Hurst 2015).

Furthermore, in the mural room, the wall surfaces themselves reveal a workspace in which plasters were maintained and reapplied, showing an easy familiarity with plastering as well as writing (both necessary for codex book production). In the area of densest micro-text concentration on the lower east wall, there is evidence of at least three layers to these texts, rendered over successively applied thin plaster patches and indicating that individuals working in the mural room inscribed texts, plastered

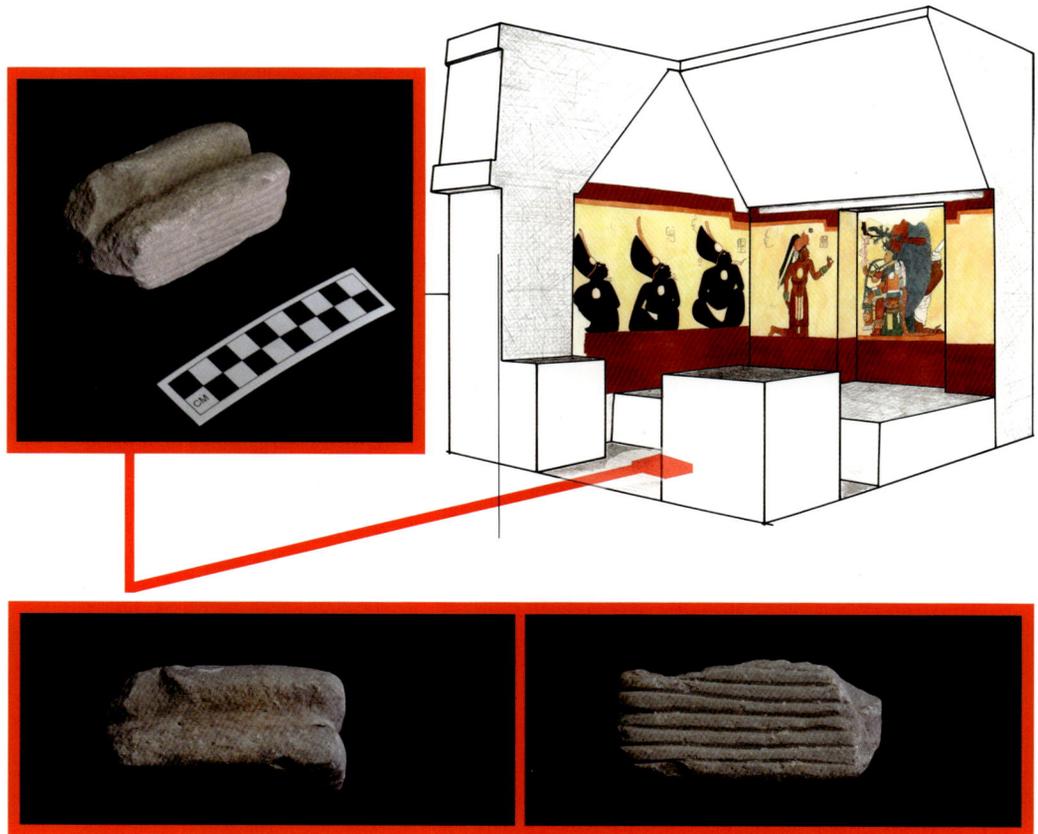

Fig. 15. The mural room barkbeater and its original context (photos by Franco D. Rossi; illustration by Heather Hurst).

over these texts, and inscribed anew—treating this area as a literal palimpsest (fig. 16). In the afternoon, the sun shines through the open south doorway of the room and illuminates this very patch of the east wall where the inscriptions are densest, suggesting residents preferred writing there because of this excellent natural light source. Seated on the bench in the afternoon light, this would have been an ideal place to copy, inscribe, and experiment with the mathematical tabulations and ritual formulae still evident on the east wall surface today.

The third feature of these texts is that many bridge the content from later Maya codices with Classic period monuments and monumental art (Aveni, Saturno, and Stuart 2013; Zender and Skidmore 2012). In fact, certain texts demonstrate exactly how the taaj residents of Los Sabios were contributing to the political and ritual narratives of state authority through observing and tinkering with cycles of time and celestial motion in order to create meaning—structuring moments through what Aveni, Saturno, and Stuart (2013, 11) call the "principle of commensuration." This principle of commensuration concerns the revealing of the numerical relationships between cycles of historical, calendrical, seasonal, and celestial time by finding numbers that could be evenly broken down into cycles of all three. It is a principle well known from the later codices. One set of east-wall texts in particular demonstrates this principle. These three texts are discussed in print as the texts of "Area B" (fig. 11; Aveni, Saturno, and Stuart 2013, 5–8; Bricker, Aveni, and Bricker 2014, 162–65). Together, the three texts tabulate and link movements of the calendar and the moon not only with one another but also with the constellations Orion (represented as three stones, glyph 3 in central text) and the Pleiades (represented as three [rattle] snakes, glyph 4 in central text). One

Fig. 16. Plaster layering and reinscription; three images of same wall section with variable light, east wall, Room 2, Structure 10K2 (photos by Franco D. Rossi).

of these three texts in particular reveals an imperfect and experimental system, as residents calculated a date commensurate with other celestially important features that fell just a few days short of an actual historical eclipse (Anthony F. Aveni, pers. comm.; see also Bricker, Aveni, and Bricker 2014, 163–64).

This evidence of active negotiation with observational science lays bare the interactive nature of the wall surfaces and complements the variety of different handwritings evident on the east wall of the mural room. Inscribed and incised texts and images clearly show people of diverse skill levels were working within the room. Though some might gloss potential incised texts as "graffiti," potentially added to the walls after abandonment, this would have been impossible since the mural room was filled, sealed, and converted into a shrine when

Fig. 17. Selected images of *diseños pintados* (painted designs) and mural fragments from Group 5E-11, Tikal: *(a)* Diseño Pintado C, Lámina 10; *(b)* fragments of fallen mural; *(c)* Diseño Pintado B, Lámina 10; *(d)* Diseño Pintado E, Lámina 10; *(e)* horizontal numerical count, Lámina 4G (images courtesy of Miguel Orrego Corzo; from Orrego Corzo and Larios Villalta 1983).

Burial 11 was interred. Rather, it is clear that the diverse content was inscribed when the room was routinely being occupied during the eighth century, rather than after.

For these reasons, the micro-texts of Los Sabios provide a tangible intermediary body of inscriptions and "rough drafts" that lie somewhere between the codex inscriptions of the time and the contemporaneous astronomical inscriptions of royally commissioned monuments—providing clear connections between bodies of inscribed content (codical and monumental) that have often been approached separately by scholars. This is a key link not only because the mural texts reveal the antiquity of these practices but because they provide a firm context through which we can track how these codex sciences were intricately intertwined with the knowledge of certain officials, translated into politico-ritual performative rhetoric, woven into moral narratives, and transmitted through specialized pedagogy toward the end of the Classic period.

Finding numerical relationships, predicting when they would occur, and weaving those moments into narratives crafted by state authorities would have been a powerful aspect

of public ceremony, as its inner workings were figured and refigured within the Los Sabios group; and the mural narrative scene seems a depiction of just such a ceremony. In the scene, we are observing an idealized representation of the handiwork of the resident taaj that is itself instructive. Irony would have it that the fragmentary, and in many cases unfinished, drafts on the mural wall would outlast the finished Classic period codices likely produced in the same context.

This emphasis on interactivity within Los Sabios provides a productive framework for revisiting other archaeological contexts as potential educational spaces. Here I highlight one suggestive context in particular, Group 5E-11 at Tikal, excavated by Miguel Orrego Corzo and Rudy Larios Villalta. This archaeological context parallels Los Sabios in several ways (Rossi 2015, 193–94). Although no mural scene survives at Group 5E-11 as it does at Los Sabios, there are a series of fine painted mural fragments suggesting a comprehensive mural scene once adorned the interior walls of one of its buildings (fig. 17b). There are also not only various crudely drawn images dispersed across several buildings but many texts that

are expertly rendered, revealing not only a degree of interactivity with the walls akin to Los Sabios but similar disparities in the skill levels of inscribing hands (fig. 17a–d). Several texts feature finely crafted calendrical dates and texts. Several less skillfully rendered scenes are accompanied by glyphic captions (Orrego Corzo and Larios Villalta 1983, 106, lámina 3) that seem to reference specific historical figures and events. Another pair of texts, seemingly copies of one another (Orrego Corzo and Larios Villalta 1983, 107, lámina 4F and G), are starkly reminiscent of the Los Sabios calendrical inscriptions (fig. 17e). The text of Lámina 4G (fig. 17e) is even arranged horizontally akin to the lunar table of the 10K2 east wall. The architectural arrangement of this group at Tikal as well as inscriptions and art representative of semi- and full literacies and interactivity hints at the possibility of it having been an educational space akin to Los Sabios, likely one of many such spaces throughout Tikal.

In general, it makes sense that the individuals generating knowledge would be the ones to transmit it to others, and elsewhere, I more fully argue that it was within this context of specialized knowledge production and codex book manufacture that a kind of formal pedagogy was taking place at Los Sabios. This assertion is based in part on the evidence discussed above but also pulls from archaeological, epigraphic, ethnographic, linguistic, and historic evidence, fully recounted in other publications (see Rossi 2018, 2015). But it is important to emphasize that it was the micro-texts, residues of engaged scientific practice at Los Sabios, that initially allowed us to think about the mural's narrative scene in a way that moved beyond image and text to focus instead on the potential interactive qualities of the content—especially in light of the larger educational context of the room.

## What Murals Leave Out

Among the archaeological evidence at Los Sabios supporting bookmaking is Burial 7, in which an individual was found with the tools used to make the actual plastered paper media that constituted codex books (fig. 18). The discovery of this individual opens larger questions about gender, work, and artisanship (and contemporary assumptions about these fields) in facilitating the kind of specialized knowledge we see at Los Sabios—particularly because the individual in Burial 7 holding these tools was a woman (see Suzuki [2013] and Rossi [2015] for archaeological and osteological details). Specifically, she was a female between twenty-five and thirty years of age at time of death who stood at around 5 ft., 1 in. Her head had been modified during life, a widespread practice throughout the pre-Columbian Americas and common across status and gender within Classic Maya society (Tiesler 2011, 2012, 2014). Her remains suggest a sedentary lifestyle and that she was possibly right-handed. She was found with a barkbeater, necessary for making paper, and a flat-faceted limestone stucco smoother (Aoyama 2006; Rovner and Lewenstein 1997, 61), necessary for smoothing plaster surfaces. This woman's burial with the tools for making codex books is of particular importance for considering the realities of education within a residential group, as well as the contradictions the material record serves to draw out. When we read various colonial documents, see Classic period images, or remember how the taaj order of Los Sabios depicted itself on the mural, we largely see and read only of men. I emphasize the discovery of this woman buried at Los Sabios precisely because it presents something the mural narrative left out—and emphasizes how the choices underpinning what was intentionally omitted bring to light some of the self-definitions and gendered

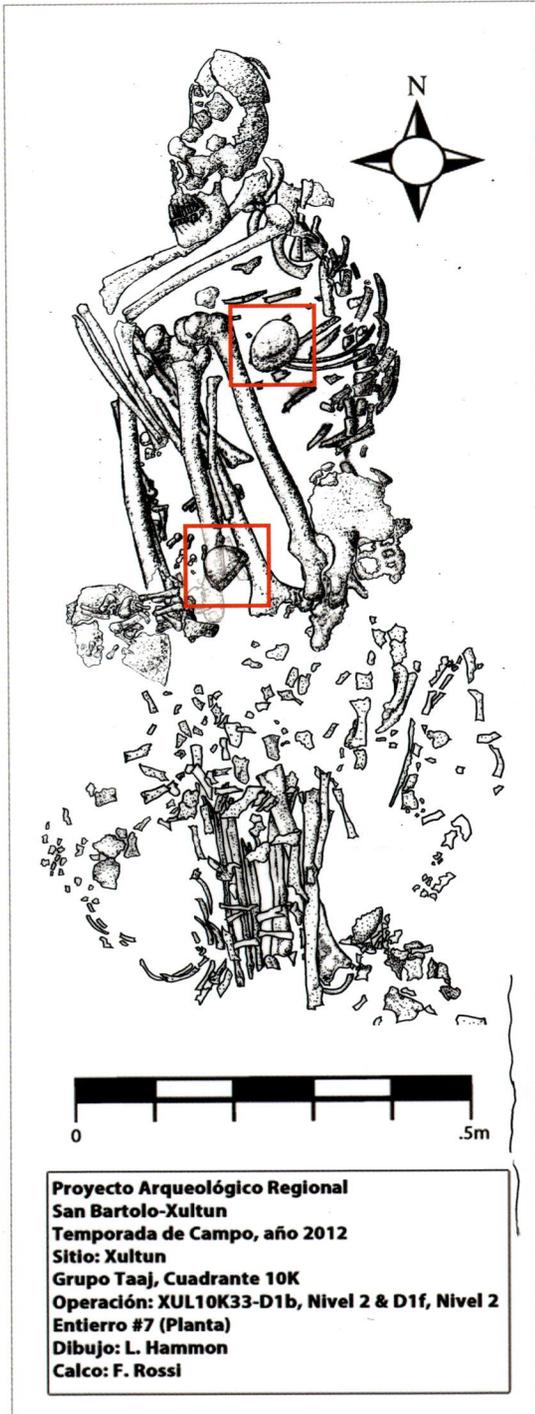

Fig. 18. (*Left*) Burial 7 drawn in situ with grave goods (illustration by Leah Hammon and Franco D. Rossi); (*Right*) Burial 7 barkbeater and stucco smoother (photo by Franco D. Rossi).

erasures that must have been commonplace in didactic spaces of Classic Maya society.

The discovery of these tools associated with paper production raises the possibility of these two media forms—murals and books—being inscribed and viewed simultaneously within the mural room space as a kind of specialized scholarly "multi-crafting," as the paper medium itself was prepared in adjacent spaces, perhaps by resident women. However, the presence of this woman also illuminates an intriguing question of accessibility to specialized knowledge as it would have unfolded in a mixed gendered household that doubled as a place of learning.

This is especially interesting to contrast with Aztec educational structures and their distinct stratifications along the lines of gender and class. Within the Aztec system, girls grew up in the family home (not within educational institutions like the boys), learning those abilities culturally gendered as female in the home (Sahagún 1969, 7:211; Berdan 2014, 203). In this way, the two sexes were educated separately in markedly different locales, in accordance with different curricular goals and cultural roles—for the sexes in Aztec culture were ideologically cast as a kind of complementary opposition, a social order reinforced by the educational system in place.

While the institutions of the Aztec educational system are often celebrated for allowing a certain social mobility between classes within male institutions, those same gendered institutions perhaps upheld stratifications of their own. It is possible that in Maya society, stratifications along the lines of gender may have become at times unexpectedly fluid by taking place in the context of a household, rather than in a centralized state institution wholly separate from the domestic sphere (see Joyce 2001; Hendon 1996). It is possible that mixing residential and niche pedagogical spaces in contexts such as Los Sabios at Xultun may have contributed to unexpected mobilities and occasional opportunities for women to participate in these controlled forms of knowledge within the highest echelons of society. And, indeed, when one begins to think through what is known about gender in Maya society, it is striking that there are several examples of women who turn up in positions of prominent political power or craft knowledge more commonly associated with men—whether this is Maya queens depicted as warriors or women serving as scribes, sculptors, or other courtly officers. We often think of models of Aztec statecraft as more horizontal and Maya as more vertical, but archaeological particulars like this can add nuance to how these broad directionalities may have played out in particular social spheres like education, whose "moral narratives" were perhaps not always as rigid as routinely represented. Approaching ancient mural scenes as interactive and embedded within human contexts thus allows to us draw out these important contradictions and nuances that accompanied education and art making then as they do today.

⊙ ⊙ ⊙

## Notes

**1** Such ranked organizations, though documented by much later ethnohistorians and ethnographers, were hitherto unattested during the Classic period. Subsequently, more intensive epigraphic research quickly yielded confirmation that this taaj title was actually widespread during the Classic period—expanding the relevance of these previously unidentified officials and their ranked order beyond Xultun (Saturno et al. 2017).

**2** See Justin Kerr's file no. 2796 on the Maya Vase Database: An Archive of Rollout Photographs, http://research.mayavase.com/kerrmaya_list.php?_allSearch=&hold_search=&x=36&y=11&vase_number=2796&date_added=&ms_number=&site=. Accessed May 9, 2019.

**3** An epigraphic analysis presented elsewhere (Saturno et al. 2017) does suggest that the itz'in taaj was the most publicly visible of the taaj order, despite possessing the "junior" rank.

**4** Known from the codices, ring numbers are named for the ring that surrounds them, usually painted red and complete with ribbon (Willson 1924). They function as part of the method by which scribes calculated the base (or start) dates for calendrical or astronomical tables. The day, or *k'in*, coefficient was placed within the ring, while the *winal* and *tun* coefficients (and in the Xultun case, *k'atun* coefficients) were each stacked above it (see Bricker and Bricker 2011, 398–400). Ring numbers serve as the first of two steps in calculating a particular table's base date and are usually a multiple of whatever cycle constitutes the table (Aveni, Saturno, and Stuart 2013, 7). A ring number passage encodes two things: that its representative number of days (with those stacked above the ring factored into the total) should be counted backward in time and that the date *from* which it should be counted backward is 13(0).0.0.0.0 4 Ajaw 8 Kumk'u. This 4 Ajaw 8 Kumk'u date is the start date of the Long Count calendar, sometimes called the "eral base" since it is the date on which the thirteen baktuns (or thirteen four-hundred-year periods in which the entirety of Classic Maya history took place) first began (Bricker and Bricker 2011, 76). In examples of ring number calculations in the codices, sometimes there is only a ring number and a winal coefficient, though oftentimes there is a tun coefficient as well. There are never k'atun coefficients in the codices, however, making the Los Sabios ring numbers unique in this regard. Also in the codices, scribes commonly provide the eral base (CR date 4 Ajaw 8 Kumk'u) from which the ring number passages count backward immediately beneath the ring numbers. This is not done in the Xultun examples.

**5** Long Round numbers are used to calculate forward to a base date from a pre-era date that is usually provided by means of a ring number calculation (the Long Round number is the "second step" in calculating table or almanac base dates [Bricker and Bricker 2011, 76]).

**6** Like ring numbers, pictun format dates calculate backward from 4 Ajaw 8 Kumk'u (0.0.0.0.0 in the Long Count) to a pre-era date from which Long Round numbers would be used to calculate forward to a table or almanac base date (see Bricker and Bricker 2011, 401–3). But unlike ring numbers, pictun dates are tabulated using the same kind of Distance Numbers we see on Classic period monuments.

## References

**Aoyama, Kazuo.** 2006. "Political and Socioeconomic Implications of Classic Maya Lithic Artifacts from the Main Plaza of Aguateca, Guatemala." *Journal de la Société des Américanistes* 92 (1–2): 7–40.

**Aoyama, Kazuo.** 2009. *Elite Craft Producers, Artists, and Warriors at Aguateca: Lithic Analysis.* Monographs of the Aguateca Archaeological Project First Phase 2. Salt Lake City: University of Utah Press.

**Aveni, Anthony F.** 1989. *Empires of Time: Calendars, Clocks, and Cultures.* New York: Basic Books.

**Aveni, Anthony F., William A. Saturno, and David Stuart.** 2013. "Astronomical Implications of Maya Hieroglyphic Notations at Xultun." *Journal for the History of Astronomy* 44 (1): 1–16.

**Beck, Frederick A. G.** 1964. *Greek Education 450–350 B.C.* London: Methuen.

**Becker, Marshall.** 1999. *Excavations in Residential Areas of Tikal: Groups with Shrines.* Tikal Reports 21. Philadelphia: University of Pennsylvania Museum.

**Berdan, Frances F.** 2014. *Aztec Archaeology and Ethnohistory.* Cambridge World Archaeology. New York: Cambridge University Press.

**Bourdieu, Pierre.** 1984. *Distinction: A Social Critique of the Judgement of Taste.* Translated by Richard Nice. Cambridge, MA: Harvard University Press.

**Bricker, Harvey M., and Victoria R. Bricker.** 2011. *Astronomy in the Maya Codices.* Memoirs of the American Philosophical Society 265. Philadelphia, PA: American Philosophical Society.

**Bricker, Victoria R., Anthony F. Aveni, and Harvey M. Bricker.** 2014. "Deciphering the Handwriting on the Wall: Some Astronomical Interpretations of the Recent Discoveries at Xultun, Guatemala." *Latin American Antiquity* 25 (2): 152–69.

**Cancian, Frank.** 1965. *Economics and Prestige in a Maya Community: The Religious Cargo System*

*in Zinacantan.* Stanford, CA: Stanford University Press.

**Carter, Nicholas P., and Jeffrey Dobereiner.** 2016. "Multispectral Imaging of an Early Classic Maya Codex Fragment from Uaxactun, Guatemala." *Antiquity* 90 (351): 711–25.

**Chase, Diane Z., and Arlen F. Chase, eds.** 1992. *Mesoamerican Elites: An Archaeological Assessment.* Norman: University of Oklahoma Press.

**Cheek, Charles D., and Mary L. Spink.** 1986. "Excavaciones en el Grupo 3, Estructura 223 (Operación VII)." In *Excavaciones en el área urbana de Copán,* vol. 1, edited by William T. Sanders, 27–154. Tegucigalpa: Instituto Hondureño de Antropología e Historia.

**Coe, Michael D.** 1973. *The Maya Scribe and His World.* New York: Grolier Club.

**Cohodas, Marvin.** 1976. "The Identification of Workshops, Schools, and Hands at Yaxchilan: A Classic Maya Site in Mexico." In *Actes du XLII Congrès International des Américanistes,* vol. 7, 301–13. Paris: Société des Américanistes.

**Colby, Benjamin N., and Lore M. Colby.** 1981. *The Daykeeper: The Life and Discourse of an Ixil Diviner.* Cambridge, MA: Harvard University Press.

**Collins, Anne C.** 1977. "The Maestros Cantores in Yucatán." In *Anthropology and History in Yucatán,* edited by Grant D. Jones, 233–50. Austin: University of Texas Press.

**Fash, William L.** 1991. *Scribes, Warriors and Kings: The City of Copán and the Ancient Maya.* New York: Thames and Hudson.

**Freidel, David A., and Linda Schele.** 1988. "Kingship in the Late Preclassic Maya Lowlands: The Instruments and Places of Ritual Power." *American Anthropologist* 90 (3): 547–67.

**Gilliot, Claude, ed.** 2012. *Education and Learning in the Early Islamic World.* Burlington, VT: Ashgate.

**Harrison, Peter D'Arcy.** 1970. "The Central Acropolis, Tikal, Guatemala: A Preliminary Study of the Functions of Its Structural Components during the Late Classic Period." PhD diss., University of Pennsylvania, Philadelphia.

**Haviland, William.** 1985. *Excavations in Small Residential Groups of Tikal, Groups 4F-1 and 4F-2.* Tikal Reports 19. Philadelphia: University of Pennsylvania Museum of Archaeology and Anthropology.

**Hendon, Julia.** 1987. "The Uses of Maya Structures: A Study of Architecture and Artifact Distribution at Sepulturas, Copán, Honduras." PhD diss., Harvard University, Cambridge, MA.

**Hendon, Julia.** 1996. "Archaeological Approaches to the Organization of Domestic Labor: Household Practice and Domestic Relations." *Annual Review of Anthropology* 25:45–61.

**Houston, Stephen D.** 2000. "Into the Minds of Ancients: Advances in Maya Glyph Studies." *Journal of World Prehistory* 14 (2): 121–201.

**Houston, Stephen D.** 2009. "A Splendid Predicament: Young Men in Classic Maya Society." *Cambridge Archaeological Journal* 19 (2): 149–78.

**Houston, Stephen D.** 2012. "The Good Prince: Transition, Texting and Moral Narrative in the Murals of Bonampak, Chiapas, Mexico." *Cambridge Archaeological Journal* 22 (2): 153–75.

**Houston, Stephen D.** 2018. *The Gifted Passage: Young Men in Classic Maya Art and Text.* New Haven, CT: Yale University Press.

**Houston, Stephen D., and Takeshi Inomata.** 2009. *The Classic Maya.* Cambridge World Archaeology. New York: Cambridge University Press.

**Houston, Stephen D., and David Stuart.** 1992. "On Maya Hieroglyphic Literacy." *Current Anthropology* 33 (5): 589–93.

**Houston, Stephen D., and David Stuart.** 1996. "Of Gods, Glyphs, and Kings: Divinity and Rulership among the Classic Maya." *Antiquity* 70 (268): 289–312.

**Houston, Stephen D., David Stuart, and Karl A. Taube.** 2006. *The Memory of Bones: Body, Being, and Experience among the Classic Maya.* Austin: University of Texas Press.

**Hurst, Heather.** 2009. "Murals and the Ancient Maya Artist: A Study of Art Production in the Guatemalan Lowlands." PhD diss., Yale University, New Haven, CT.

**Hurst, Heather.** 2013. "Análisis microscópico y químico del estuco y pigmento de Xultun: Muestras de la pintura mural 10K-2 y contextos de comparación." Report submitted to the Departamento de Monumentos Prehispánicos y Coloniales, Instituto de Antropología e Historia de Guatemala, Guatemala City.

**Hutson, Scott R.** 2011. "The Art of Becoming: The Graffiti of Tikal, Guatemala." *Latin American Antiquity* 22 (4): 403–26.

**Inomata, Takeshi.** 2001. "The Power and Ideology of Artistic Creation: Elite Craft Specialists in Classic Maya Society." *Current Anthropology* 42 (3): 321–49.

**Inomata, Takeshi.** 2006. "Plazas, Performers, and Spectators: Political Theaters of the Classic Maya." *Current Anthropology* 47 (5): 805–42.

**Joyce, Rosemary A.** 2001. *Gender and Power in Prehispanic Mesoamerica.* Austin: University of Texas Press.

**Kidder, Alfred V.** 1935. *Notes on the Ruins of San Agustín Acasaguastlan, Guatemala.* Contributions

to American Archaeology 15. Washington, DC: Carnegie Institution of Washington.

**LaFarge, Oliver, II, and Douglas Byers.** 1931. *The Year Bearer's People.* New Orleans, LA: Tulane University.

**Las Casas, Bartolomé de.** 1967. *Apologética historia sumaria.* 2 vols. Mexico City: Universidad Nacional Autónoma de México.

**León-Portilla, Miguel.** 1978. *Aztec Thought and Culture: A Study of the Ancient Nahuatl Mind.* Translated by Jack Emory Davis. Norman: University of Oklahoma Press.

**Loughmiller-Newman, Jennifer.** 2008. "Canons of Maya Painting: A Spatial Analysis of Classic Period Polychromes." *Ancient Mesoamerica* 19 (1): 29–42.

**Lounsbury, Floyd G.** 1978. "Maya Numeration, Computation, and Calendrical Astronomy." In *Dictionary of Scientific Biography*, vol. 15, supplement 1, edited by Charles C. Gillespie, 759–818. New York: Charles Scribner and Sons.

**Lucas, Christopher J.** 1979. "The Scribal Tablet-House in Ancient Mesopotamia." *History of Education Quarterly* 19 (3): 305–32.

**Meskell, Lynn M., and Rosemary A. Joyce.** 2003. *Embodied Lives: Figuring Ancient Maya and Egyptian Experience.* New York: Routledge.

**Milbrath, Susan.** 1999. *Star Gods of the Maya: Astronomy in Art, Folklore, and Calendars.* Austin: University of Texas Press.

**Miles, Suzanne W.** 1957. "The Sixteenth Century Pokom-Maya: A Documentary Analysis of Social Structure and Archaeological Setting." *Transactions of the American Philosophical Society* 47 (4): 735–81.

**Miller, Mary Ellen, and Claudia Brittenham.** 2013. *The Spectacle of the Late Maya Court: Reflections on the Murals of Bonampak.* Austin: University of Texas Press.

**O'Neil, Megan.** 2012. *Engaging Maya Sculpture at Piedras Negras, Guatemala.* Norman: University of Oklahoma Press.

**Orrego Corzo, Miguel, and Rudy Larios Villalta.** 1983. *Reporte de las investigaciones arqueológicas en el Grupo 5E-11: Tikal.* Guatemala City: Instituto de Antropología e Historia de Guatemala.

**Reents-Budet, Dorie.** 1994. *Painting the Maya Universe: Royal Ceramics of the Classic Period.* Durham, NC: Duke University Press.

**Rice, Prudence M.** 1987. *Macanché Island, El Petén, Guatemala: Excavations, Pottery, and Artifacts.* Gainesville: University Press of Florida.

**Rice, Prudence M.** 2004. *Maya Political Science: Time, Astronomy, and the Cosmos.* Austin: University of Texas Press.

**Rossi, Franco D.** 2015. "The Brothers Taaj: Civil-Religious Orders and the Politics of Expertise in Late Maya Statecraft." PhD diss., Boston University, Boston, MA.

**Rossi, Franco D.** 2018. "Pedagogy and State: An Archaeological Inquiry into Classic Maya Educational Practice." *Cambridge Archaeological Journal* 28 (1): 85–102.

**Rossi, Franco D., William A. Saturno, and Heather Hurst.** 2015. "Maya Codex Book Production and the Politics of Expertise: Archaeology of a Classic Period Household at Xultun, Guatemala." *American Anthropologist* 117 (1): 116–32.

**Rossi, Franco D., and David Stuart.** 2015. "An Epigraphy of Los Sabios, Preliminary Readings." Appendix B, in Rossi 2015, 330–58.

**Rossi, Franco D., David Stuart, and William A. Saturno.** 2015. "Una exploración epigráfica del sitio Xultún." In *XXVIII Simposio de Investigaciones Arqueológicas en Guatemala, 2014*, edited by Bárbara Arroyo, Luis Méndes Salinas, and Lorena Paiz, 663–74. Guatemala City: Instituto de Antropología e Historia de Guatemala.

**Rovner, Irwin, and Suzanne M. Lewenstein.** 1997. *Maya Stone Tools of Dzibilchaltún, Yucatán, and Becán and Chicanná, Campeche.* New Orleans, LA: Tulane University Middle American Research Institute.

**Ruane, Jonathan.** 2012. "Mapeo en el sitio arqueológico Xultún." In *Informe preliminar No. 11, temporada de campo año 2012*, edited by Patricia Rivera Castillo and William A. Saturno, 437–50. Guatemala City: Instituto de Antropología e Historia de Guatemala.

**Sahagún, Bernardino de.** 1969. *The Florentine Codex: A General History of the Things of New Spain, Book 6: Rhetoric and Moral Philosophy.* 13 vols. Translated by Charles E. Dibble and Arthur J. O. Anderson. Santa Fe, NM: SAR Press.

**Sahagún, Bernardino de.** 1978. *The Florentine Codex: A General History of the Things of New Spain, Book 3: The Origin of the Gods.* 13 vols. Translated by Charles E. Dibble and Arthur J. O. Anderson. Santa Fe, NM: SAR Press.

**Sahagún, Bernardino de.** 1981. *The Florentine Codex: A General History of the Things of New Spain, Book 2: The Ceremonies.* 13 vols. Translated by Charles E. Dibble and Arthur J. O. Anderson. Santa Fe, NM: SAR Press.

**Satterthwaite, Linton.** 1965. "Maya Practice Stone-Carving at Piedras Negras." *Expedition* 7 (2): 9–18.

**Saturno, William A.** 2009. "Centering the Kingdom, Centering the King: Maya Creation and Legitimization at San Bartolo." In *The Art of Urbanism: How Mesoamerican Kingdoms Represented Themselves in Architecture and Imagery*, edited by William L. Fash and Leonardo

López Luján, 111–34. Washington, DC: Dumbarton Oaks Research Library and Collection.

**Saturno, William A., Heather Hurst, Franco D. Rossi, and David Stuart.** 2015. "To Set Before the King: Residential Mural Painting at Xultun, Guatemala." *Antiquity* 89 (343): 122–36.

**Saturno, William, Franco D. Rossi, David Stuart, and Heather Hurst.** 2017. "A Maya *Curia Regis:* Evidence for a Hierarchical Specialist Order at Xultun, Guatemala." *Ancient Mesoamerica* 28 (2): 423–40.

**Saturno, William A., David Stuart, Anthony F. Aveni, and Franco D. Rossi.** 2012. "Ancient Maya Calendrical Tables from Xultun, Guatemala." *Science* 336 (6082): 714–17. https://doi.org/10.1126/science.1221444.

**Saturno, William A., Karl A. Taube, and David Stuart.** 2005. *The Murals of San Bartolo, El Petén, Guatemala, Part 1: The North Wall.* Ancient America 7. Barnardsville, NC: Boundary End Archaeology Research Center.

**Schele, Linda, and Nikolai Grube.** 1994. "Notes on the Chronology of Piedras Negras Stela 12." *Texas Notes on Precolumbian Art, Writing, and Culture* 70.

**Sheehy, James J.** 1991. "Structure and Change in a Late Classic Maya Domestic Group at Copan, Honduras." *Ancient Mesoamerica* 2 (1): 1–20.

**Siu, Man-Keung.** 1993. "Proof and Pedagogy in Ancient China: Examples from Liu Hui's Commentary on Jiu Zhang Suan Shu." *Educational Studies in Mathematics* 24 (4): 345–57.

**Stuart, David.** 1989. "The Maya Artist: An Iconographic and Epigraphic Analysis." BA thesis, Princeton University, Princeton, NJ.

**Stuart, David.** 1996. "Kings of Stone: A Consideration of Stelae in Ancient Maya Ritual and Representations." *RES* 29/30 (Spring/Autumn): 147–71.

**Suzuki, Shintaro.** 2013. "Informe del estudio bioarqueológico de los restos encontrados en el sitio arqueológico Xultun, Petén, temporada 2012." In *Informe de Resultados de Investigaciones, Año 2013,* edited by Patricia Rivera Castillo and William A. Saturno. Guatemala City: Instituto de Antropología e Historia de Guatemala.

**Taube, Karl A., William A. Saturno, David Stuart, and Heather Hurst.** 2010. *The Murals of San Bartolo, El Petén, Guatemala, Part 2: The West Wall.*

Ancient America 10. Barnardsville, NC: Boundary End Archaeology Research Center.

**Teeple, John.** 1930. *Maya Astronomy.* Contributions to American Archaeology Vol. 2, No. 1. Washington, DC: Carnegie Institution of Washington.

**Tiesler, Vera.** 2011. "Becoming Maya: Infancy and Upbringing through the Lens of Pre-Hispanic Head Shaping." *Childhood in the Past* 4 (1): 117–32.

**Tiesler, Vera.** 2012. "Studying Cranial Vault Modifications in Ancient Mesoamerica." *Journal of Anthropological Sciences* 90:1–26.

**Tiesler, Vera.** 2014. *The Bioarchaeology of Artificial Cranial Modifications: New Approaches to Head Shaping and Its Meanings in Pre-Columbian Mesoamerica and Beyond.* Interdisciplinary Contributions to Archaeology. New York: Springer.

**Vail, Gabrielle.** 2006. "The Maya Codices." *Annual Review of Anthropology* 35: 497–519.

**Vail, Gabrielle.** 2015. "Scribal Interaction and the Transmission of Traditional Knowledge: A Postclassic Maya Perspective." *Ethnohistory* 62 (3): 445–68.

**Vogt, Evon.** 1969. *Zinacantan: A Maya Community in the Highland of Chiapas.* Cambridge, MA: Harvard University Press.

**von Hagen, Victor Wolfgang.** 1944. *The Aztec and Maya Papermakers.* New York: J. J. Augustin.

**Webster, David, ed.** 1989. *The House of the Bacabs, Copan, Honduras.* Studies in Pre-Columbian Art and Archaeology 29. Washington, DC: Dumbarton Oaks Research Library and Collection.

**Wells, E. Christian, and Karla L. Davis Salazar, eds.** 2007. *Mesoamerican Ritual Economy: Archaeological and Ethnological Perspectives.* Boulder: University Press of Colorado.

**Williams, Ronald J.** 1972. "Scribal Training in Ancient Egypt." *Journal of the American Oriental Society* 92 (2): 214–21.

**Willson, Robert W.** 1924. *Astronomical Notes on the Maya Codices.* Papers of the Peabody Museum of American Archaeology and Ethnology Vol. 6, No. 3. Cambridge, MA: Harvard University Press.

**Zender, Marc, and Joel Skidmore.** 2012. "Unearthing the Heavens: Classic Maya Murals and Astronomical Tables at Xultun, Guatemala." Mesoweb Reports. San Francisco, CA: Precolumbia Mesoweb Press. http://www.mesoweb.com/reports/Xultun.pdf.

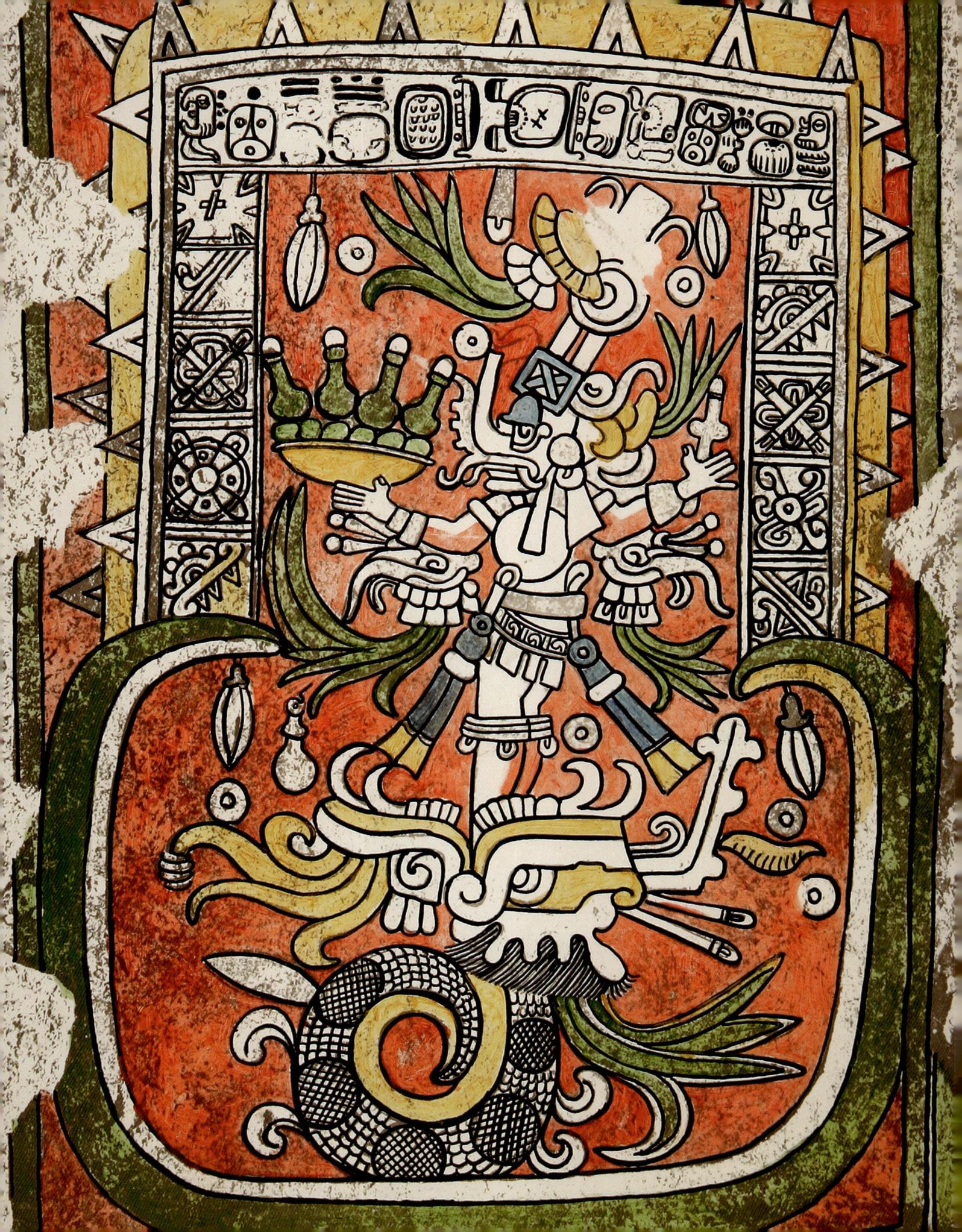

CLAUDIA BRITTENHAM

# In the Land of the Rainbow Serpent
## Murals from Chichen Itza

**B**etween 850 and 1100 CE, Chichen Itza, located in Mexico's Yucatán peninsula, was one of the centers of the known world, attracting goods and pilgrims from all over Mesoamerica and lands beyond. A city that emerged during a time of great upheaval, Chichen Itza is distinctive for the way it created new things out of existing Mesoamerican tradition. In art, architecture, and urban planning, the city displays notable continuities with the Classic lowland Maya city-states whose fall precipitated Chichen Itza's rise, although it often transformed Classic Maya traditions in significant ways. At the same time, Chichen Itza was integrated into larger Mesoamerican networks and symbol systems. Proof of this integration is to be found in the strong resemblances between Chichen Itza and the city of Tula, Hidalgo, in Central Mexico, and in the influence Chichen Itza had on later art throughout Mesoamerica (for recent approaches to Chichen Itza, see Cobos 2016; García Moll and Cobos 2011; Kowalski and Kristan-Graham 2007; Ringle 2009; Volta and Braswell 2014; Wren et al. 2017).

Like so many other Mesoamerican centers, Chichen Itza was a painted city. Murals dominated highly significant interior and exterior spaces throughout the city; what's more, both architectural sculpture and wall murals were painted using the same techniques and color palette, collapsing distinctions between painted and modeled surfaces (for Chichen Itza murals, see A. Morris 1931; Coggins 1984; Lombardo de Ruiz 2001, 125–38; for technique, see Magaloni Kerpel 2001; for color, see Houston et. al 2009, 92). Only a fraction of the city's painting survives, and even many of the murals exposed during the twentieth century are now best studied through painted copies, as the originals have deteriorated and, in some cases, have even disappeared completely.

One important theme of murals at Chichen Itza is a spiky serpent that contains the colors of the rainbow within its striped body (figs. 1 and 2). Although more attention has been paid to the role of the feathered serpent at Chichen Itza (Ringle, Gallareta Negrón, and Bey 1998), in terms of sheer scale and square footage, the rainbow serpent dominates mural painting at the site (fig. 3). This poorly understood supernatural creature exemplifies the city's central place within Mesoamerican history. Like so many other

*Opposite:* Detail of fig. 16.

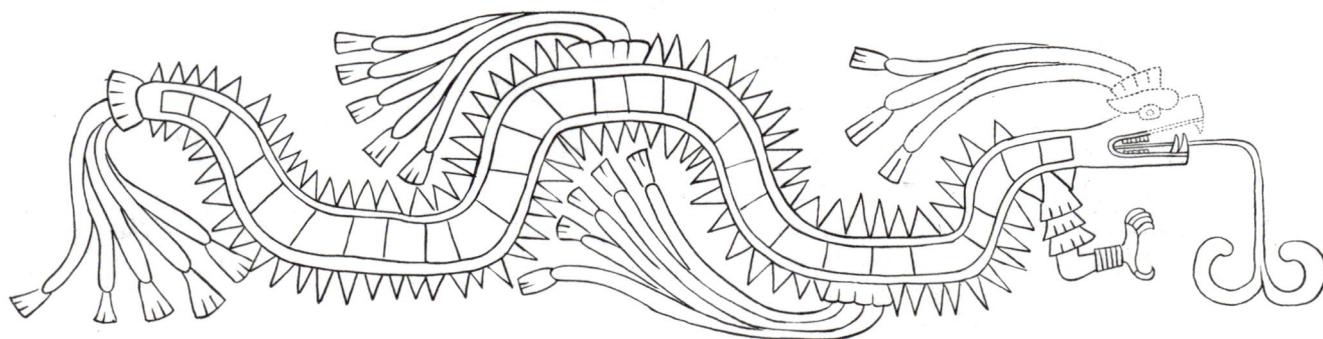

Fig. 1. Detail of rainbow serpent from the inner room of the Temple of the Chac Mool, Chichen Itza, ca. 900–1000 CE (detail of fig. 7). Reconstruction painting by Jean Charlot, 1926–30. Courtesy of the Peabody Museum of Archaeology and Ethnology, Harvard University, PM# 33-46-20/75037.

Fig. 2. Reconstruction of rainbow serpent from Temple of the Chac Mool, Chichen Itza, ca. 900–1000 CE (from Morris, Charlot, and Morris 1931, fig. 259).

elements of Chichen Itza's art and culture, this creature has its roots at Teotihuacan, the most populous Mesoamerican city of the first millennium CE, which remained a powerful model for other centers even centuries after its decline. It is also likely a precursor of the supernatural serpent that the Aztecs called the Xiuhcoatl, a being associated with fire, comets, and time in the centuries before the Spanish invasion in 1519 (see fig. 25). The first part of this chapter considers the rainbow serpent in context at Chichen Itza, and the second part examines how the qualities of this creature developed and changed over time throughout Mesoamerica. I will argue that Chichen Itza was a crucial step in the evolution of the Xiuhcoatl, but not the only step necessary to move from the Teotihuacan being to the Aztec supernatural.

## The Rainbow Serpent at Chichen Itza

On the walls of several important buildings, the rainbow serpent undulates in gentle U-shaped curves, its body made up of segmented bars of different colors: red, yellow, white, blue, and green (see fig. 1). The body of the serpent is lined with projecting triangular spikes both above and below, colored in the same hues as the serpent's body, and panaches of flowers or perhaps blue feathers with yellow tips emerge at periodic intervals from its body. Most uncharacteristically, this serpent had small, clawed front legs, which appear to be ornamented with jade-green cuffs. Its head was colored blue, with a long tongue emerging from its mouth to end in a bifurcated curl.

This is emphatically not the feathered serpent that features so prominently in

architectural sculpture and other media at Chichen Itza. That serpent is represented with flexible feathers covering its entire body, except for the ventral scales of its underbelly, which are usually painted yellow; the feathers are typically green, and it does not have forelimbs (see fig. 17). The prominence of other kinds of serpents may require us to reassess theories of Terminal Classic religion that place exclusive emphasis on the importance of the feathered serpent. But before turning to these larger implications, I will review each iteration of the rainbow serpent at Chichen Itza, in order to give a sense of the scale and extent of its presence at the city, and then discuss their iconography in light of other art from the city.

## Temple of the Chac Mool

The earliest manifestations of the rainbow serpent at Chichen Itza come from the Temple of the Chac Mool, a building partially destroyed and buried underneath the later Temple of the Warriors (fig. 4). Here, brightly colored rainbow serpents lined the walls of the inner and outer rooms, integrating the architectural space as their bodies curled around the corners (fig. 5; see also figs. 1 and 2). Archaeologists reconstruct four serpents in each room, arrayed two on each side, facing in opposite directions so that their tails met at the center of the side wall and a viewer walked between serpent mouths at the doorways.[1] The serpents thus framed ritual movement both into and out of these sacred spaces. In the inner room, the two serpents converged on a central space on the rear wall, framing an area where a different painting of small figures against a turquoise background has unfortunately been largely destroyed; archaeologists propose that an altar or bench originally sat underneath these paintings but was removed before the building was buried (A. Morris 1931, 363–65; E. Morris

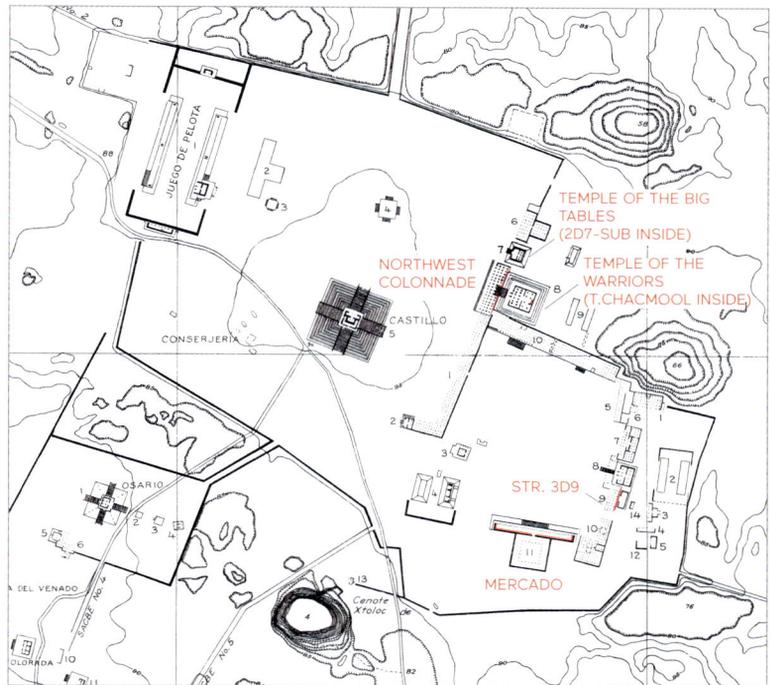

Fig. 3. Plan of Chichen Itza, showing the locations of the rainbow serpent murals. After map in Ruppert 1952, with modifications by the author.

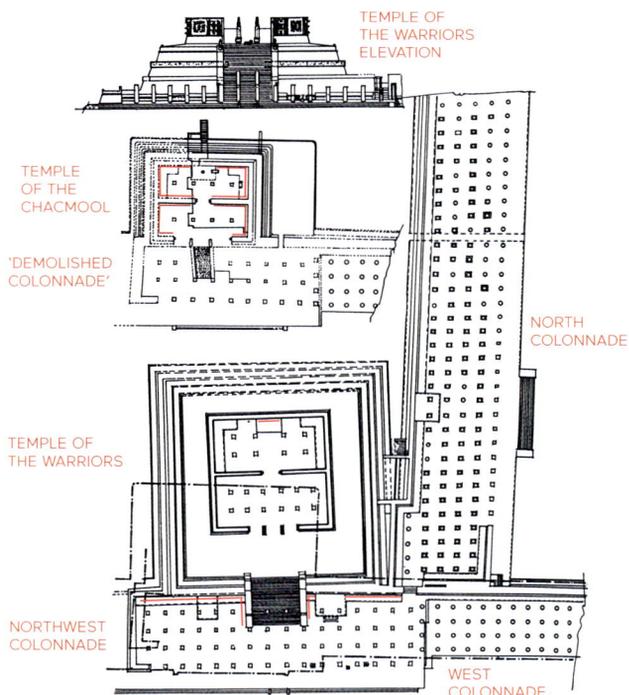

Fig. 4. Plan of the Temple of the Chac Mool (above, dotted lines are reconstructed areas) and plan of the Temple of the Warriors (below, dashed line shows placement of Temple of the Chac Mool). Locations of the rainbow serpent murals are indicated. Drawing by Linda Schele, after Marquina 1951, with modifications by the author.

been taller still before the walls of the temple were truncated (A. Morris 1931, 363).[3] The serpents begin 1.23 m (or nearly 4 feet) off the ground; below them, the wall was painted black to a height of 81 cm, then topped by horizontal bands of red, yellow, and blue. The background behind the rainbow serpents was colored red. When complete, the serpents would have towered above the viewer, their very scale connoting a kind of supernatural alterity (A. Morris 1931, 363).

Ann Axtell Morris, who was charged with the study and reconstruction of the murals during the Carnegie Institution of Washington excavations in the 1920s, signals the advantages of scale and legibility for such a bold motif:

*These huge, richly colored serpents are an exceedingly appropriate and effective subject for temple murals. From a purely practical point of view, the extensive stretches of wall were decorated to a far better advantage by drawings done to a large scale than they would have been by the multitude of tiny figures which covered the walls of the Temple of Warriors. When the problem of lighting is taken into consideration, although the outer room would have been adequately illumined by the doorways when the obscuring curtains were lifted, the Inner Sanctuary must have been shrouded in a perpetual gloom only relieved by the uncertain flicker of torches. For*

1931, 73–74). Rainbow serpents may also have decorated the shadowy vaults of the ceiling above: Earl Morris observed that "the vaults of the buried temple bore some similar pattern, large, boldly and comparatively carelessly executed, to judge from detached stones with small areas of adhering plaster found among the fill" (1931, 76). The rainbow serpents in the inner and outer rooms appear to have been painted by different artists, with notable differences not only in the forms but also in the technical qualities of the application of paint (figs. 6 and 7; A. Morris 1931, 365).[2]

The depictions of the rainbow serpents were massive paintings. Each of the serpents was nearly 7 m long; the surviving portions of the bodies are a meter tall and would have

*this purpose, heavily colored paintings, enormous in size, would serve the purpose far better than the minute drawings of the later structure.*
(A. Morris 1931, 365–66)

Both the medium of painting and the scale of the murals appear perfectly adapted to the representation of this wondrous supernatural creature.

The rainbow serpents were but one part of a rich and complex decorative program. Although little about the outside decoration of the Temple of the Chac Mool is clear today, the wide outer doorway was supported by a pair of serpent columns, with feathers painted red in the final iteration (E. Morris 1931, 72–73, pl. 14). Inside, carved and painted pillars pictured warriors, priests, and dignitaries, while in the inner room, the risers of the benches were painted with seated figures facing toward the now absent altar. Due to their large size and prominent placement, the rainbow serpents were one of the most visible elements of this opulent and colorful environment.

## Temple of the Warriors

When the Temple of the Chac Mool was replaced by the Temple of the Warriors sometime in the mid-tenth century, the rainbow serpent was one of the many elements that provided continuity between the old and new spaces (see fig. 4).[4] The Temple of the Warriors largely replicated the plan and decorative program of the Temple of the Chac Mool at a more grandiose scale, but there were a few significant changes between the buildings (Morris, Charlot, and Morris 1931; Ballou 2016). Chief among them was a change in the interior painting program: where giant rainbow serpents had covered the walls and vaults of the Temple of the Chac Mool, smaller multifigure scenes lined the vaults of the Temple of the Warriors (A. Morris 1931, 365, 382–430). The paintings began only above eye level, at 1.68 m (or 5 ft., 6 in.) up the wall; below that, the walls were painted solid black for 1 m, with bands of blue, red, yellow, and black above (A. Morris 1931, 383).

Rainbow serpents were once again present at the Temple of the Warriors, painted directly above the central altar in the rear room,

Fig. 6. Reconstruction of rainbow serpents from the outer room of the Temple of the Chac Mool, Chichen Itza, ca. 900–1000 CE. Painting by Jean Charlot, 153.67 × 74.93 cm (60½ × 29½ in.). Courtesy of the Peabody Museum of Archaeology and Ethnology, Harvard University, PM# 33-46-20/75038.

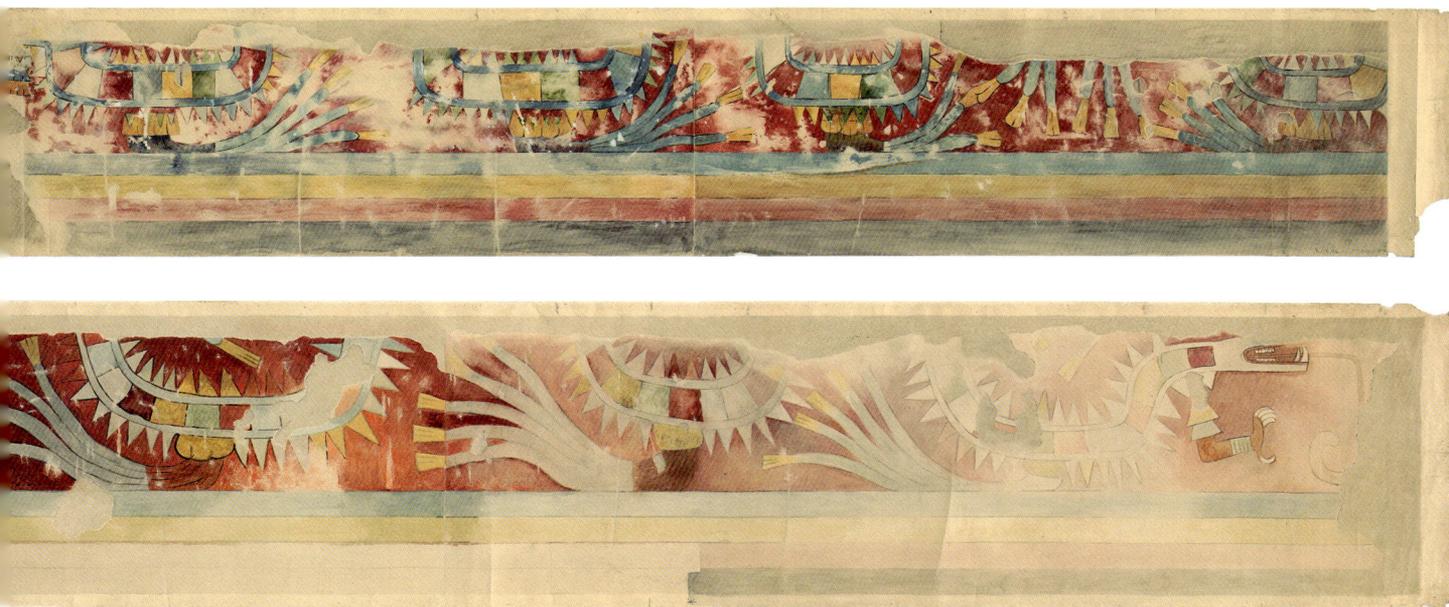

contrasting with the smaller narrative scenes on the other walls (A. Morris 1931, 414–15). The surviving parts of the painting, which lacked either head or tail, were 60 cm tall and over 4 m wide.[5] A. Morris excoriated the painting as "wretchedly executed," "inept," and "lack[ing] every element of artistic propriety," concluding that "without doubt, this bit is the worst Maya mural that has ever come to light" (1931, 415). Painted against a red background, the mural featured the undulating body of a serpent with yellow body segments separated by black dividers, with green feathers emerging at irregular intervals from its body. Although the painting does not survive, the line drawing (fig. 8) seems to bear out A. Morris's negative assessment. The wormlike creature is not immediately recognizable as a rainbow serpent, lacking either spikes or multicolored body segments, but the irregular placement of the bunches of feathers and the trapezoidal divisions of the body are still more reminiscent of the rainbow serpent than the feathered serpent. The poorly executed form suggests that the artist may not have understood the image he was reproducing, or perhaps that the form and execution mattered less than the sheer presence of the motif in this dark interior space.

Although the painted rainbow serpent was no longer the principal protagonist of the inner walls of the temple, the creature manifested in other ways at the complex. First, there were the painted rainbow serpents on the rear wall of the Northwest Colonnade at the entrance to the building (see fig. 10, discussed below). In addition, the relief sculptures on the exterior walls of the Temple of the Warriors likely show a frontal view of the same entity (fig. 9). This frontal creature, sometimes indecisively termed the "Jaguar-Serpent-Bird" (Kubler 1967, 7), wears an elaborate feathered headdress and opens its maw to disgorge a human head. This

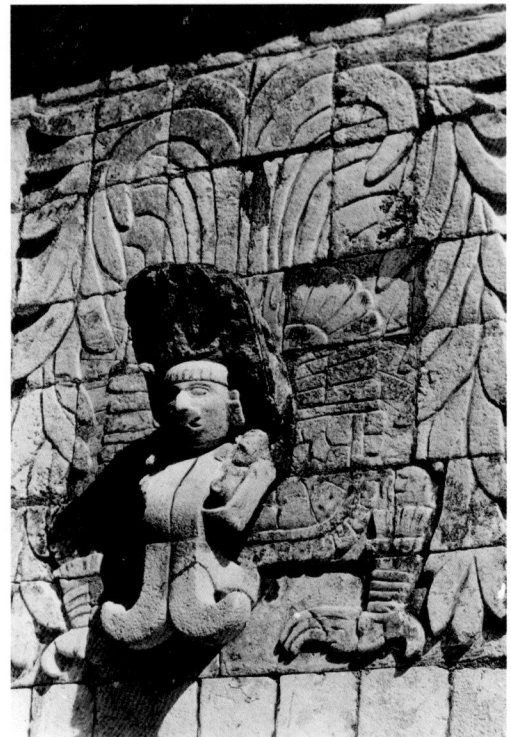

Fig. 8. Reconstruction of undulating serpent from above the altar in the rear room of the Temple of the Warriors, Chichen Itza, ca. 900–1050 CE (from Morris, Charlot, and Morris 1931, fig. 284).

Fig. 9. Frontal serpent from the exterior of the Temple of the Warriors, Chichen Itza, ca. 900–1050 CE. Image from the 1932 Sigvald Linné archaeological expedition at Teotihuacan, Mexico: "Krigarnas tempel. Chichén Itzá. Utgrävningar i Teotihuacan (1932)," Världskultur Etnografiska muséet, Göteborg, Sweden, 0307.f.0069.b, CC0 1.0, https://commons.wikimedia.org/w/index.php?curid=54019058.

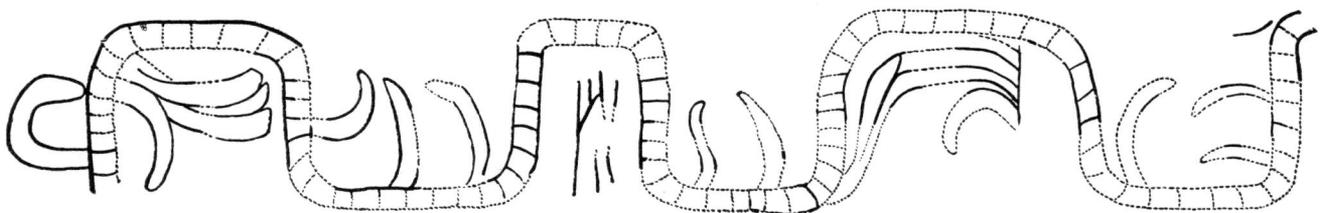

creature has a complicated and contested history. Eduard Seler ([1909] 1998, 127) identified it as a version of Quetzalcoatl; Alfred M. Tozzer (1957, 116–17) described it as Tlalchitonatiuh, an aspect of the night sun; and Karl A. Taube (2000, 280–301; 2012) has more recently identified it as a version of the Teotihuacan "War Serpent" and a precursor to the Aztec Xiuhcoatl. Several features connect it to the profile view of the rainbow serpent: both have clawed forelegs and bifurcated tongues. Especially decisive are the bracelets and triangular projections that decorate the clawed forelegs of the sculpted creatures at the Temple of the Warriors, markedly similar to the configuration on the mural from the Temple of the Chac Mool.[6] The frontal view, so prevalent in architectural sculpture, gives no hint as to the spiky radiance or multicolored panoply of the creature's bodies, although when the sculptures were originally painted, they would have been more brightly colored.

If the rainbow serpent is indeed the profile view of the "Jaguar-Serpent-Bird" or "War Serpent" on the outside of the Temple of the Warriors superstructure, the creature announced itself in different media and from different perspectives, seeming to burst forth from the building that contained its painted representation. Although the façade of the Temple of the Chac Mool is not well preserved, it does not seem to have featured images of the spiky rainbow serpent, so the more public articulation of this image at the Temple of the Warriors appears to be a significant change.[7] Indeed, one might even be tempted to argue that the decorative program announces the Temple of the Warriors as a structure dedicated to the rainbow war serpent.

### Northwest Colonnade

Rainbow serpents became more publicly visible in other ways at the Temple of the Warriors

complex; for example, they adorned the Northwest Colonnade directly in front of the temple (see fig. 4 for plan). Against a red background, great undulating rainbow serpents with projecting spikes, their bodies painted yellow, blue, red, green, and white, covered the entire rear wall of the Northwest Colonnade, even turning the wall to continue onto the south side of the stair ramp (fig. 10; A. Morris 1931, 438). Again, this painting covered a huge expanse of space. The Northwest Colonnade ran for over 48 m (E. Morris 1931, 52); although the painting was poorly preserved, fragments of it were found in so many places that it seems likely that it once spanned the entire rear wall of the colonnade "from dado to arch" (A. Morris 1931, 438). Below it, the wall was painted with horizontal bands of black, blue, red, and yellow, recalling the decorative program of the Temple of the Chac Mool (E. Morris 1931, 59; A. Morris 1931, 438). But the public, plaza-level presence of this supernatural was a change in decorative program: the remains of walls of the "Demolished Colonnade" associated with the Temple of the Chac Mool were painted with horizontal bands of red, blue, and yellow, with no figural decoration (A. Morris 1931, 438–39). The presence of the rainbow serpent on the rear wall of the Northwest Colonnade entailed a dramatic expansion of its scope and visibility. Yet the serpent was still only imperfectly visible: the rear wall of the colonnade was shadowed by the deep vaulted roof, and from nearly any vantage point, columns interrupted the view of the massive creatures. It may be that

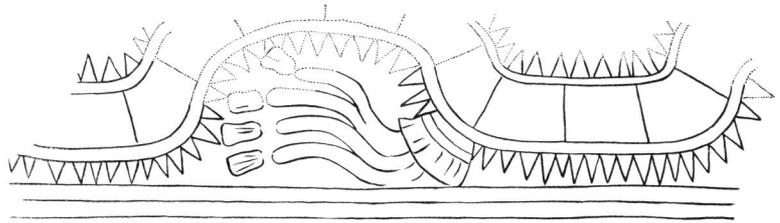

Fig. 10. Reconstruction of spiky rainbow serpent from the Northwest Colonnade, Chichen Itza, ca. 900–1050 CE (from Morris, Charlot, and Morris 1931, fig. 294).

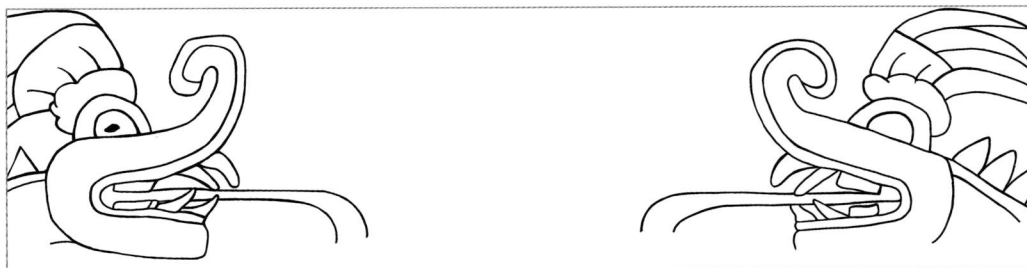

Fig. 11. Serpent heads from Structure 2D7-sub. Drawing by Magdalena Glotzer, after Castillo Borges 1998, fig. 54.

the shadowed and fragmented vision of the rainbow serpents lent them a sense of movement and vitality.

In sum, three mural iterations of the rainbow serpent survive at the Temple of the Warriors complex. The first graced the interior walls of the Temple of the Chac Mool, a space of restricted access. The space above the altar in the Temple of the Warriors was also decorated with this motif, its visibility again limited to only select audiences. But in the Northwest Colonnade, the rainbow serpent became far more widely visible, even possible to glimpse between the columns if standing on the plaza. The frontal iterations of the creature in carved relief on the exterior of the Temple of the Warriors and on the base of each column within the Northwest Colonnade further multiplied and increased its visibility. Thus, the pattern is one of increasing public access to what had begun as a very restricted kind of image.

### Structure 2D7-sub, Substructure under the Temple of the Big Tables

Directly to the north of the Temple of the Warriors compound, the Temple of the Big Tables replicates the serpent-column temple plan on a smaller scale (see fig. 3). And like the Temple of the Warriors, the Temple of the Big Tables also houses another structure inside it. Although this substructure was at ground level, rather than on a platform, it also contained pillars figured with brilliantly colored warriors

supporting the vaults of a multiroom enclosure. Its vaults were also decorated with the same kind of spiky rainbow serpents that ornamented the walls and vaults of the Temple of the Chac Mool (fig. 11). Peter Schmidt writes, "The vaults of this earlier temple are painted with gigantic polychrome serpents or 'dragons.' These reptilian creatures are supposed to have small spindly arms and lack feathered bodies, but instead are adorned with triangular spikes. They closely resemble the painted serpents from the Temple of the Chacmool" (2007, 165).[8] As at the Temple of the Chac Mool, these murals were painted against a red background, and two serpents faced toward one another, guiding movement into the center of the room (Castillo Borges 1998, 168). The heads of these serpents were well preserved, and in addition to sharp teeth, bifurcated tongues, and crests of feathers on their heads, they show an upcurving snout that recalls the form of the later Aztec Xiuhcoatl (Castillo Borges 1998, fig. 54).[9]

### Structure 3D9, Thompson's Temple

Yet another iteration of the spiky rainbow serpent occurs in Structure 3D9, or Thompson's Temple, located on the eastern edge of the Group of the Thousand Columns, just to the south of the Temple of the Little Tables. Very little information about this painting survives, but from the photo reproduced in figure 12, it appears very similar to the murals in the Temple of the Chac Mool, showcasing the undulating curves of the spiky rainbow serpent

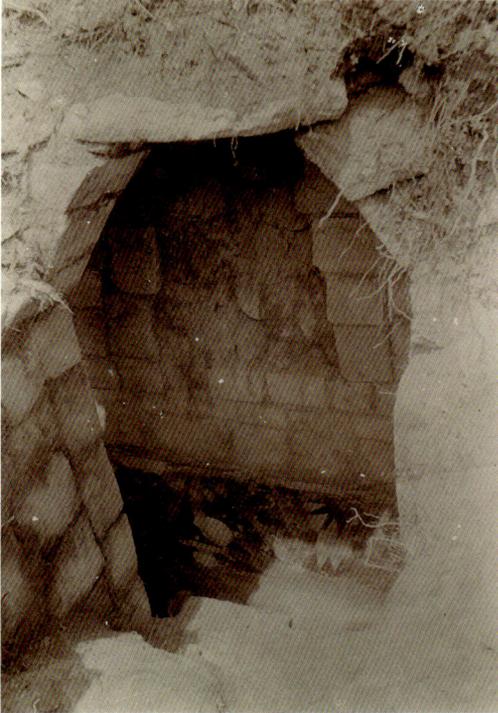

Fig. 12. Rainbow serpent murals from Structure 3D9, Chichen Itza, ca. 900–1050 CE. Carnegie Institution of Washington photograph. Courtesy of the Peabody Museum of Archaeology and Ethnology, Harvard University, PM# 2004.29.7027.

The expanse of the painting may have been considerable. Seler writes, "Of this ancient building, the 10 m. long north wall of a vault is still standing, oriented east-west; it is made of large boulders covered by stucco and painted in many colors, similar to the Temple of the Small Table of the Gods" ([1909] 1998, 133). Seler's text thus also suggests that a similar painting may have once decorated the Temple of the Little Tables, but I have been unable to locate any other information to substantiate this claim.

Although the information is fragmentary, the evidence from Structure 3D9 describes a now familiar pattern: the undulating spiky rainbow serpents covered large expanses of wall, rounding the corners and integrating architectural space. These paintings survived on the rear walls of a deep colonnade and seem to correspond to a relatively early moment in the history of the building.

### The Mercado

A final iteration of the rainbow serpent is even less well preserved. Like the paintings at the Northwest Colonnade or Structure 3D9, this was another large and semi-public mural, lining the rear wall of the gallery at the Mercado, a late building on the southern end of the Group of the Thousand Columns (see fig. 3 for site plan). Only the smallest hints of painting survive, but they are diagnostic: triangular spikes, painted white, delineating the curving shape of a serpent against a red background (fig. 13; Ruppert 1943, 244, fig. 6). There is a hint that the body of the serpent was painted green, conceptually similar to the turquoise outline of the serpents at the Temple of the Chac Mool. The serpent was placed above a dado painted black or in some places above bands of varied colors: "The plaster on the gallery wall above the step had been painted in horizontal bands of green,

with colorful divisions within the body and panaches of feathers or flowers extending from it. The mural is placed above a low dado painted a solid color. Seler reports finding remains of the painting on the east and north walls of the building ([1909] 1998, 128, captions to figs. 253 and 254), suggesting that the motif again surrounded the viewer, rounding the corners of the space. The caption on a photo in the Peabody Museum of Archaeology and Ethnology describes the painting being in a "sealed chamber," perhaps underneath the stair leading up to the temple above (Peabody Museum object record 2004.29.7027), while Seler describes part of the painting lying on the "western side of the north wall running under the upper building" (Seler [1909] 1998, 128, caption to fig. 254).[10] Both this placement and the truncated state of the painting suggest that it corresponds to an earlier stage of construction in this complex and multistage building (see Ruppert 1952, 68–69).

yellow, black, red, and blue" (Ruppert 1943, 244), and "the walls retain traces of banding with added painting of large figures, apparently writhing serpents" (Ruppert 1943, 230). Tatiana Proskouriakoff's reconstruction offers a vision of the space (fig. 14).

Here, again, it is likely that the serpents covered a great deal of wall space. The triangular spikes were found midway down the inner wall of the colonnade, between Columns 6 and 7, but other traces of paint remained on the walls meeting at the southeast corner. This corner painting fragment consisted of five rounded orange forms, the farthest one beginning to curve upward; it is possible that this was the remains of something similar to the rounded yellow base of the panache of feathers or flowers at the Temple of the Chac Mool (Ruppert 1943,

244). Assuming that the entire rear and side walls of the Mercado gallery were painted with these creatures, the rainbow serpents would have occupied an expanse of over 70 m (Ruppert 1943, 242). From the outside, the view of the serpents would have been fragmented by the columns in front of it, as at the Northwest Colonnade, but the inside of the unusually deep colonnaded vault offered effective oblique views of the creatures. As at the Temple of the Chac Mool and Structure 3D9, the rainbow serpents appear to have been an early intervention at the Mercado (although the Mercado is a relatively late building): the bench that was later added to the space covered the lower portion of the painting, and there were several stages of repainting of the bench after it was added (Ruppert 1943, 244).

## The Iconography of Radiance at Chichen Itza

Massive spiky rainbow serpents were one of the most prominent themes of mural painting at Chichen Itza, occupying literally hundreds of meters of wall space in at least six significant architectural contexts. It is possible that there may once have been even more murals depicting this creature; the existing examples span multiple decades of construction. All of the surviving examples of the painted rainbow serpent are found on the east side of the Gran Nivelación, associated with the Temple of the Warriors and the colonnades (see fig. 3; see also Navarro 2008, 2013).[11] No such paintings have been found in buildings built before or during the reign of K'ak'upakal K'awiil (ca. 864–889); they are associated with the radical changes of "New Chichen," sometime after 900, when the ritual center of the city moved north to the Gran Nivelación and the city became visibly more cosmopolitan. Innovative architectural and sculptural forms,

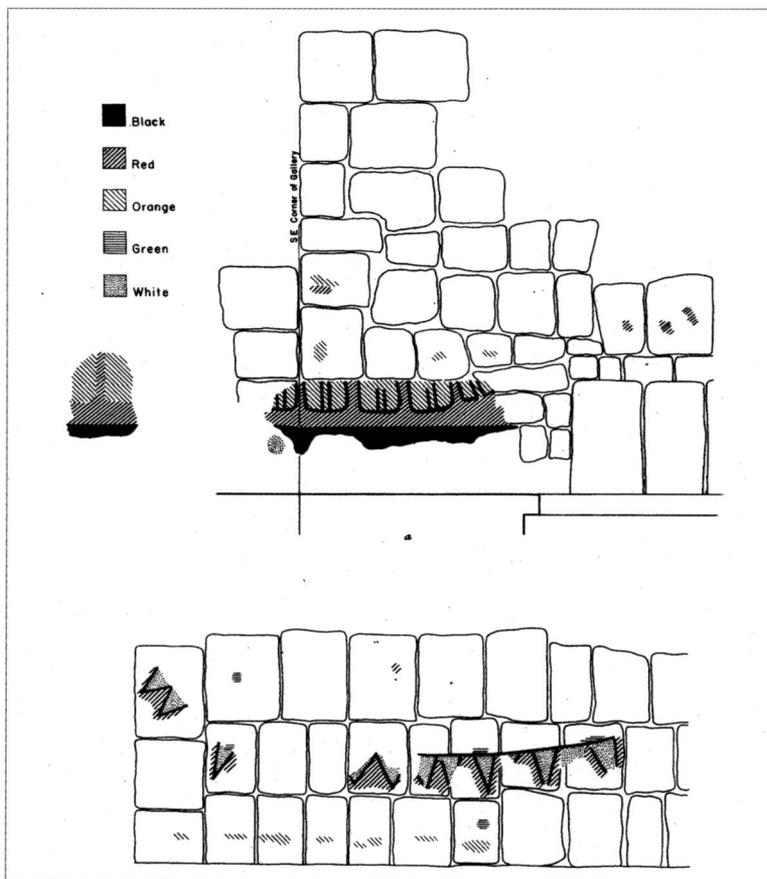

Fig. 13. Remains of spiky serpents from the Mercado, Chichen Itza, ca. 950–1100 CE (from Ruppert 1943, fig. 6).

such as the colonnades in front of the Temple of the Warriors complex or the serpent columns that decorated many temples, signal a departure from previous tradition and a greater integration with the broader Mesoamerican world (Kubler 1982; Stone 1999). The rainbow serpent was part of this transformation.

Equally important, there appear to be changes over time in the display and context of the rainbow serpent. In its earliest manifestation at the Temple of the Chac Mool, the creature is represented only in the interior of the building, but in the subsequent Temple of the Warriors and other later structures, paintings move into more public contexts. Glimpsed through the columns on the rear walls of the Northwest Colonnade, the Mercado, and elsewhere, the rainbow serpent became an entity for public consumption at plaza level, not just a mystery reserved for elites within

Fig. 14. Reconstruction of the gallery of the Mercado, Chichen Itza, ca. 950–1100 CE. Painting by Tatiana Proskouriakoff, 55.8 × 75.8 cm (21 5/16 × 29 13/16 in.). Courtesy of the Peabody Museum of Archaeology and Ethnology, Harvard University, PM# 50-63-20/18494.

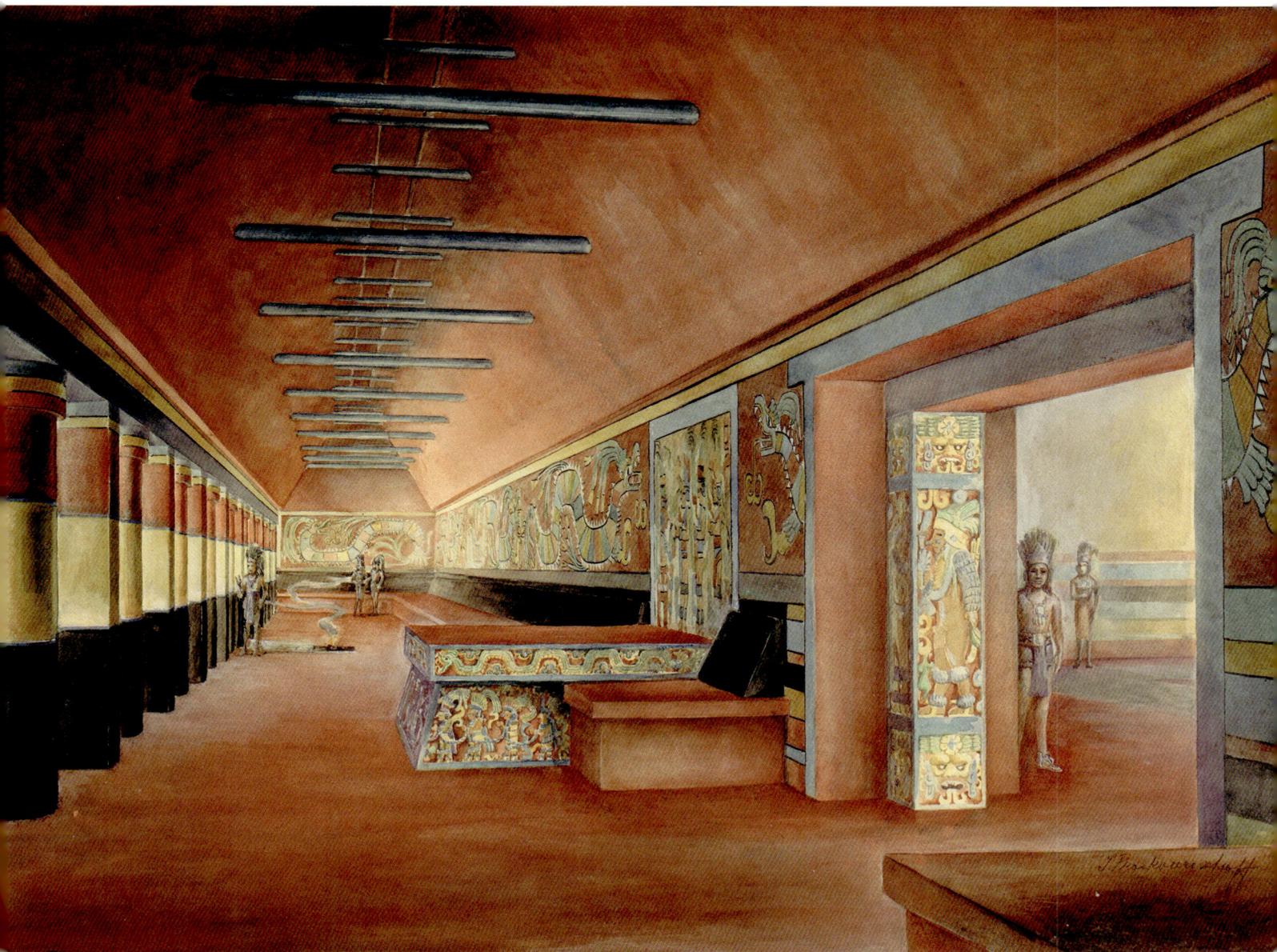

temple confines. Sculpted images of the Jaguar-Serpent-Bird/War Serpent only multiplied the effect. But even in its most public iterations, the rainbow serpent was at the same time immediately recognizable and difficult to see in its entirety. With the view interrupted by columns and by shifting shadows, the creature seemed to move in the distance.

What did the rainbow serpent mean at Chichen Itza? Before looking for explanations outside of the city, it will be helpful to review its symbolism in local context. One of the most distinctive characteristics of the rainbow serpent is its colorful body, filled with the five basic colors of all Chichen Itza painting: red, yellow, white, blue, and green (Houston et al. 2009, 92–93; see also Ringle 2009, 27–30).[12] Many shades of these colors, and additional

hues besides, were available to the Chichen Itza painters: Diana Magaloni Kerpel reports twenty-four different pigment combinations from the Chichen Itza murals, although no more than fifteen or sixteen are used in any given painting (2001, 173), and even in the other remaining paintings of the Temple of the Chac Mool, a much wider range of hues were deployed (A. Morris 1931, 353–56). Thus, the selection of these five colors is not mere happenstance but instead articulates an important discourse about color: these are foundational colors, which may stand as synecdoche for the entire spectrum or evoke an effect of shifting iridescence (Houston et al. 2009, 92–93). With black, these are also the colors most frequently associated with color-directional ritual (Houston et al. 2009, 27–28). Further,

Fig. 15. Sun disks with radiating triangles; details of murals on the *(a)* north, *(b)* south, *(c)* southwest, and *(d)* northwest walls of the Upper Temple of the Jaguars, Chichen Itza, ca. 950–1100 CE. Reconstruction painting by Adela Breton. © Bristol Culture / Bristol Museums, Galleries & Archives.

everywhere where documentation is available, the rainbow serpents were painted against a red background, in association with solid horizontal bands of black, red, yellow, and blue, reinforcing the deliberate rhetoric of color in the murals.

Another significant characteristic of these serpents is the triangular spikes that radiate out from their bodies. In the murals of the Temple of the Chac Mool, these spikes were colored in the same five basic colors as the bodies of the serpents, but at the Mercado, the spikes appear to have been white. These spikes appear to be closely related to solar iconography at Chichen Itza: triangles radiate out from sun disks on scenes from the Lower Temple of the Jaguars, the lintels and murals of the Upper Temple of the Jaguars, and elsewhere at Chichen Itza, part of a new way to represent the sun and its dazzling light that seems to have been consolidated at the city (fig. 15; Coggins 1984; A. Miller 1977; Taube 1992a, 140–43; 1994, 223–26; 2010, 147, 149, 161–71; 2015, 101–9; Tozzer 1957, 119–22, figs. 269–89).[13] Indeed, Taube has argued that "there is good evidence to suggest that [the Aztec sun god] Tonatiuh derives from Early Postclassic portrayals of a Maya solar king at Chichén Itzá" (2010, 147).

What is especially significant is that in the murals of the Upper Temple of the Jaguars, the sun disks are always represented in polychrome, featuring the same set of colors—red, yellow, blue, and green—as the spiky rainbow serpents. A much wider range of colors occurs elsewhere in the murals of the Upper Temple of the Jaguars, so the selection of these four colors seems significant, as if Maya painters understood the radiant light of the sun to contain the basic colors of all painting. This, in turn, prompts us to consider the possibility that the rainbow serpents are themselves

bright and radiant, transmitting something like solar heat through their undulating passage.[14]

Another use of projecting triangles occurs on a capstone from the Temple of the Owls in the Initial Series Group in the southern part of the site (fig. 16; Martin 2006, 174–76; Taube 1994, 226–28; Von Winning 1985, 74–80). Like many other capstones in the Yucatán region, this one features K'awiil, the god of lightning and abundance, holding a plate full of foodstuffs and precious jade beads. K'awiil emerges from the jaws of a serpent in a U-shaped space, suggesting the underworld or a cenote, and rises into an area bounded by a skyband and glyphic inscription, bordered by two rows of projecting triangular spikes (for Maya skybands, see Carlson and Landis 1985).[15] Together, the overall impression is of the sky or celestial serpent pictured as a radiant being, which for all its distinctive form and closer ties to Classic Maya iconography, resonates greatly with the sun disks and rainbow serpents elsewhere at Chichen Itza.[16]

Significantly, the rainbow serpent at Chichen Itza is only represented in this way in mural painting.[17] In other media, the view is different, from the frontal War Serpent creature on the walls of the Temple of the Warriors or on the Venus Platform to the stylized head with squared nose rendered in mosaic on turquoise disks found at the Temple of the Chac Mool, the Castillo, and elsewhere at Chichen Itza (García Moll and Cobos 2011, 90–91; V. Miller 2018, 184–87; E. Morris 1931, frontis., 186–98).[18] Why did this serpent take two such very different forms in sculpture and in mural painting? What could painting do that other media could not? Surely the relative ease with which large expanses of wall could be painted made it an ideal medium to represent the superhuman scale of this powerful creature. But perhaps there is also something

Fig. 16. Capstone, Temple of the Owls, Chichen Itza, ca. 900 CE. Hand-colored photograph by T. A. Willard, ca. 1920. Braun Research Library Collection, Autry Museum, Los Angeles; P.27114F.

special about the way that mural painting can capture color that made it the perfect medium to capture the shining radiance of this elusive, magnificent beast.

The prominence of the rainbow serpent at Chichen Itza matters because it complicates accounts of the feathered serpent as the dominant supernatural at the site. Feathered serpents are prominent in all media at Chichen Itza, from the feathered serpent columns decorating many of the city's most prominent buildings (Kubler 1982) to gold disks and other items of personal adornment extracted from the Sacred Cenote (Lothrop 1952; Coggins and Shane 1984, 50, 55), as well as reliefs and murals depicting this supernatural creature, frequently twining around a human male (fig. 17; Ringle 2009, 30–36). William Ringle, Tomás Gallareta Negrón, and George Bey (1998) have suggested that a cult of the feathered serpent became a new world religion during the period of Chichen Itza's rise, a force driving pan-Mesoamerican interaction (Ringle 2004; see also López Austin and López Luján 2000).

However, not all serpents at Chichen Itza have feathers. As Alexandre Guida Navarro (2008) has recently highlighted, several different kinds of serpents populated the art of Chichen Itza. In addition to the feathered serpent, there is a white serpent with cloudlike tendrils curling off its body (fig. 17; see also Ringle 2009, 32–36), as well as the spiky rainbow serpent that is the focus of this chapter.[19] Numerically, feathered serpents outnumber rainbow serpents and cloud serpents by an order of magnitude (Navarro 2008, 32). But images of the feathered serpent play secondary roles in the art of Chichen Itza, as borders, architectural supports, or vehicles for figures incorporated into larger and more complex scenes. Images of the cloud serpent play similarly subsidiary roles. By contrast, the

Fig. 17. Feathered serpent and cloud serpent, twining around human warriors, from the Upper Temple of the Jaguars, Chichen Itza, ca. 950–1100 CE. Watercolor by Adela Breton. © Bristol Culture / Bristol Museums, Galleries & Archives.

rainbow serpent seems to function in a different way: rendered at a grand scale, it is the sole focus of attention on painted walls; it never twines around human actors.[20] It appears to be a different kind of entity. More importantly, the prominence of these other creatures suggests that the feathered serpent was not the sole driver of religious change at Chichen Itza. On the contrary, Chichen Itza may have been a place where several new gods were forged.

## The Rainbow Serpent beyond Chichen Itza

New ideas rarely arise out of nothing. In standardizing feathered serpent iconography, formulating a new kind of solar symbolism, rethinking War Serpent imagery, or creating the rainbow serpent, artists at Chichen Itza drew on existing tradition in different ways. Of course, the works of art are only traces of ideas, beliefs, and practice, which may have been more fluid than the images themselves. Like so many other things at Chichen Itza, the rainbow

serpent had its origins at Teotihuacan, as did broader ideas about the War Serpent/Xiuhcoatl with which it is associated. But the rainbow serpent took a slightly different trajectory than this broader supernatural complex, which has been amply explored by Taube (1992b, 59–83; 2000, 285–327; 2012). In contrast to these widely diffused images, images of the rainbow serpent are relatively rare outside Chichen Itza, with the closest parallels occurring within the pages of the Mixtec Codex Nuttall. This may be, as I have suggested above, because it was an entity supremely suited to the medium of painting, which does not survive as well as other, more durable forms, but it may also be that this was always a lesser-known creature. The divergent histories of the feathered serpent, Xiuhcoatl, and rainbow serpent suggest different means of transmission and different ways of relating with the Teotihuacan past.

## Teotihuacan

Some of the closest predecessors for the Chichen Itza rainbow serpent occur at the great city of Teotihuacan. The most powerful metropolis of the first centuries CE, with a population of over one hundred thousand, Teotihuacan had been lying in ruins for several centuries by the time of Chichen Itza's apogee: the cataclysmic burning of Teotihuacan took place circa 550 CE, while Chichen Itza did not begin its meteoric rise until the mid-ninth century.[21] Yet Teotihuacan was by no means forgotten. A sizeable population continued to live on the edges of the site, perhaps thirty thousand to forty thousand people, making it still one of the largest cities in Mesoamerica even after the cataclysm, perhaps comparable in population to Chichen Itza itself (Cowgill 1997, 157; Diehl 1989, 12–16; Gómez Chávez and Cabrera Castro 2006; Sanders, Parsons, and Santley 1979, 457–61; for Chichen Itza

population, see García Moll and Cobos 2011, 42; Volta, Peniche May, and Braswell 2017, 43). Yet the population at Teotihuacan was fragmented, living around the margins of the former city, and did not produce much in the way of monumental art.

However, the idea of Teotihuacan continued to exert considerable power well beyond the borders of the city long after its collapse. In the Maya lowlands, eighth-century kings wore mosaic headdresses that recalled the Teotihuacan War Serpent, a deity introduced to the Maya area with the arrival, or entrada, of Teotihuacan warriors into the Maya region in the fourth and fifth centuries CE (Stone 1989; Stuart 2005, 391–93; Taube 1992b, 60–65, 68–74; 2000, 271–78). Much of the regalia of Chichen Itza likewise derived from the memory of Teotihuacan, filtered through the lowland Maya city-states, where later revivals of Teotihuacan costume came to allude to the Maya dynastic past as well as to the foreign center (Brittenham and Miller 2016; Coggins 2002). Teotihuacan was an especially important model for Chichen Itza, another city that constructed itself with cosmic ambition.

At Teotihuacan, it is in the medium of wall painting that the clearest precursors to the Chichen Itza rainbow serpent are to be found. One key mural is found in the elite apartment compound of Zona 5-A, part of the Pyramid of the Sun complex. Here, in Room 1, the lower portions of the walls were decorated with coiled serpents, their bodies outlined in blue and filled with alternating red and yellow segments, separated by stepped diagonal lines (fig. 18; A. Miller 1973, 76; de la Fuente 1995, 1:59–60). Radiating from the bodies of the serpents are yellow and red step-frets, recalling the colorful diagonal divisions and projections from the body of the Chichen Itza rainbow serpent. The Teotihuacan serpent's tail ends

in rattlesnake rattles, and its head has a curved horn and a diagonal marking descending from the eye, traits that may recall the characteristics of the horned sidewinder rattlesnake, *Crotalus cerastes*, whose present-day habitat includes southern California, Utah, New Mexico, and northern Sonora and Baja California.[22]

Another potential parallel for the Chichen Itza rainbow serpent is a spiky serpent found in the border of a group of mural fragments, probably looted from the Tlacuilapaxco apartment compound and now scattered among museum collections around the world (fig. 19; Millon 1988).[23] Rendered in the red-on-red style that Magaloni Kerpel has argued evokes nocturnal vision in the murals of Teotihuacan (2003, 188–201; 2010, 57–58), this serpent has little of the color variation of the rainbow serpent at Chichen Itza, although it does have dark red dots within its pink body, and the triangular spikes radiating out from its body likewise vary in hue. This is a bicephalic serpent with a long bifurcating tongue, whose body undulates in curves reminiscent of the rainbow serpent from Chichen Itza. Some elements

link this serpent to the more colorful serpents of the Zona 5-A compound: both have spiky hornlike projections on the forehead and a diagonal band marking the eye; in addition, the border framing the Zona 5-A scene features a horizontal row of alternating red and yellow step-frets, framed by projecting triangles (A. Miller 1973, fig. 102).

In the murals thought to be from Tlacuilapaxco, the spiky serpent forms the border for a scene of priests wearing coyote headdresses and walking between bundles in which oversized maguey spines have been stuck upright. While there are differing interpretations of the scene, one is that it may represent bundles of years, predecessors to the Aztec *xiuhmolpilli*, a bundle made during the New Fire Ceremony at the end of a fifty-two-year calendrical cycle (Millon 1988, 199–200; for New Fire at Teotihuacan, see Fash, Tokovinine, and Fash 2009). If so, this association of spiky serpent and calendrical ritual may foreshadow the tight connection between the Xiuhcoatl and the solar year in Aztec times. It is important to emphasize, however, that neither Teotihuacan

Fig. 18. Mural from Zona 5-A Room 1, Teotihuacan, ca. 300–550 CE. Museo de Sitio de Teotihuacán. Photo by the author.

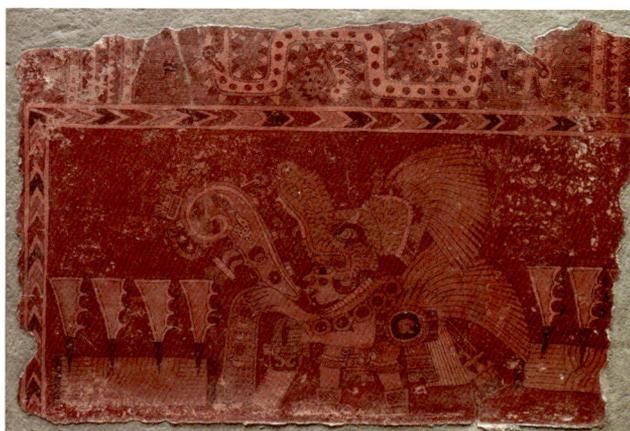

Fig. 19. Mural showing priests, bundles pierced with maguey spines, and a spiky serpent border, from the Tlacuilapaxco apartment compound, Teotihuacan, ca. 300–550 CE. Fresco on wall fragment, 83.2 × 116.2 cm (32¾ × 45¹¹⁄₁₆ in.). Cleveland Museum of Art, Purchase from the J. H. Wade Fund 1963.252. © The Cleveland Museum of Art.

serpent is identical to the Chichen Itza rainbow serpent. In addition to the differences in pattern and coloration, neither kind of Teotihuacan serpent has forelegs, which seem crucial to the Chichen Itza iteration, and neither wears the feather panaches that ornament the Chichen Itza serpents.

This is not the only context in which the spiky triangular motif occurs at Teotihuacan. Hasso Von Winning identified small triangles as a motif associated with fire (1987, 2:16–19), an impression that finds reinforcement in the Old Fire God, or Huehueteotl, sculpture recently discovered in an ancient looter's trench at the summit of the Pyramid of the Sun (fig. 20; Robb 2017b, 284; for Huehueteotl, see Robb 2007, 2017a). The brazier borne atop the Old Fire God's head is decorated around its border with a series of triangles framing undulating central lines. This figure was originally quite colorful, painted with red, white, yellow, green, and black pigments (Robb 2017b, 284). Here, the triangles point toward the undulating lines rather than radiating out from them,

and there is no indication that the undulation was originally a serpent body, but the formal parallel is still striking. Indeed, triangular forms also occur on the bundles of years or torches found near the Adosada of the Pyramid of the Sun (Fash, Tokovinine, and Fash 2009, 206–9; Robb 2017b, 290–91). There seems to be an association between triangular forms and fire, perhaps even the calendrical ritual of the New Fire Ceremony.

Another kind of spiky, projecting form occurs on the outstretched arms and bodies of a group of more predominantly feline images, which Taube has identified as images of the Teotihuacan War Serpent (2012, 117–20). As Taube writes, "Although the Classic Maya War Serpent is strongly serpentine, at Early Classic Teotihuacan it bears more attributes of the jaguar" (2012, 117). A sculptural mosaic from the Xalla apartment compound features a jaguar-like creature whose outstretched arms have serrated points on them; similar forms, like stacked trapezoids, lie behind the eyes (fig. 21; Robb 2017b, 416). Notably, the Xalla jaguar also has a band of red and yellow triangles in its headdress, both color and form linking them to the murals discussed earlier. Other examples of this "War Jaguar" were made out of precious stone, including a tecali receptacle now in the British Museum (Matos Moctezuma and Solís Olguín 2002, 106, 405) and a green tecali feline found in the Quetzalpapalotl Palace (Robb 2017b, 322). This Teotihuacan creature, too, was an important precursor to the Aztec Xiuhcoatl (Taube 2012, 117–20).

It is not clear if the Teotihuacanos perceived the links that I have just suggested among these serpent and feline forms. The spiky serpent from the murals does not have forelegs, the form of the triangular projections on the arms of the feline creatures is distinct, and no iconography discovered at Teotihuacan

Fig. 20. Old Fire God sculpture from the Pyramid of the Sun, Teotihuacan, ca. 500–600 CE. Andesite and pigments. 61 × 66 × 50 cm (24 × 26 × 19¾ in.). Zona de Monumentos Arqueológicos de Teotihuacán, Proyecto Pirámide del Sol. Photo by the author.

Fig. 21. Mosaic jaguar from the Xalla apartment compound, Teotihuacan, ca. 400 CE. Volcanic stone, stucco, and pigments. 97.5 × 235.5 × 74.5 cm (38⅜ × 92¾ × 29¼ in.). Museo Nacional de Antropología, Mexico, 10-626269. Photo by the author.

to date connects the two. As Taube writes, "There are no known Teotihuacan examples of the War Serpent with a serpent body, and for this reason, the creature could perhaps more accurately be considered a 'War Jaguar' for Teotihuacan" (2012, 117). These may have been different classes of ideas, associated for the first time after Teotihuacan's fall, perhaps at Chichen Itza itself.

### Transmission of the Rainbow Serpent and the Feathered Serpent

It is difficult to identify any intervening forms between the Teotihuacan spiky serpents and the Chichen Itza rainbow serpent. In contrast to frontal images of the War Serpent/Xiuhcoatl, which have a wider distribution, no other manifestation of the profile rainbow serpent survives in any medium at any other Terminal Classic city: not Tula, not Cacaxtla, not Xochicalco, not Seibal.[24] The absence of intermediate forms raises the possibility that people with ties to Chichen Itza might have learned about the

spiky serpent through travel to the ruined city of Teotihuacan. The evidence is largely speculative. To date, no Teotihuacan objects have been found at Chichen Itza, and no objects from Chichen Itza at Teotihuacan; there is no concrete evidence of a connection between the two sites. But Pachuca, just to the north of Teotihuacan, remained an important source of obsidian for Chichen Itza (Braswell 2003, 140; Braswell and Glascock 2002, 38–42), and Teotihuacan does not lie far from some of the turquoise trade routes that took on increasing importance during this period (see King et al. 2012). Teotihuacan was still remembered and accessible, and people may have traveled to its ruins for pilgrimage or inspiration. Of course, it is also important to acknowledge the role that perishable materials, such as books and painted cloth *lienzos*, as well as oral tradition, might have played in the transmission of this knowledge.

Importantly, the rainbow serpent appears to have had a different route of transmission

than that of the feathered serpent, which appears with a new force and frequency in the Epiclassic city-states like Cacaxtla, Xochicalco, and El Tajín, which flourished after Teotihuacan's fall in the sixth century. The diversity of these early feathered serpent manifestations, as well as their formal distance from Teotihuacan images of the same creature, suggests not the propagation of a centralized cult but a variety of different reformulations of a Teotihuacan theme—as if shaped by varying recollections of the Teotihuacan homeland (Brittenham 2015, 57–62; for more on post-Teotihuacan feathered serpents, see Nicholson 2000; Ringle, Gallareta Negrón, and Bey 1998; Sugiyama 2000). The origins of the feathered serpent images might lie in the personal recollections of Teotihuacanos who fled the failing city to the new city-states that were rising as Teotihuacan collapsed.

Chichen Itza was an important part of this post-Teotihuacan world of peer city-states. But it's important to stress that it was a late entrant into that world. Feathered serpent imagery from the Epiclassic city-states—be it the Pyramid of the Feathered Serpent at Xochicalco or the Serpent Corridor at Cacaxtla—likely anticipated the earliest examples of the theme at Chichen Itza by a century or more, and may even have served as conceptual models for the Chichen Itza images (Brittenham 2015, 53–73, 183–200; Smith 2000). Artists at Chichen Itza did make important contributions to the evolving iconography and ideology of the feathered serpent: notably, the concept of the serpent column (Kubler 1982) and the ongoing standardization of feathered serpent imagery. Chichen Itza was the place where many of the representational conventions that dominated the Postclassic period (1000–1521 CE) seem

to have coalesced. In contrast to the rainbow serpent, which seems like an innovation at Chichen Itza, when it came to the feathered serpent, artists at Chichen Itza seem to have standardized or synthesized already circulating ideas. Ideas from Teotihuacan reached Chichen Itza, centuries later, via many different routes.

## The Afterlife of the Rainbow Serpent

It is difficult to say what happened to the rainbow serpent after Chichen Itza. No images of the creature survive for the next several centuries. But when the form reemerges in the fifteenth and sixteenth centuries, it is clear that absence in the archaeological record is not the same as absence in Mesoamerican tradition. The rainbow serpent in the Codex Nuttall—and the echoes of the rainbow serpent in the Aztec Xiuhcoatl—are so similar to the Chichen Itza creature that the resemblance cannot merely be attributed to chance. Traditions associated with the feathered serpent must have been transmitted, perhaps through books and perhaps through oral tradition, transforming over time.

## Mixtec Codices

The closest parallel for the Chichen Itza rainbow serpent is found in the pages of the Codex Nuttall, a Mixtec manuscript created in the Oaxaca highlands around 1500 CE. On page 3 of the obverse of the Codex Nuttall, a being named 7 Serpent descends, his face and arms emerging from the body of a spiky rainbow serpent (fig. 22; Hermann Lejarazu 2008, 18–19; Williams 2013, 40). This serpent has trapezoidal bands of green, red, blue, yellow, and purplish dark red within its body, each band separated from its neighbors by an area of black and white stripes. The body is bordered with radiating triangular spikes, red at the base and white at their tips.[25] The serpent has an

upturned snout with a panache of feathers at its tip and another panache of feathers at its tail. The mouth opens wide to emit the head of the figure named 7 Serpent, and his arms, holding a shield and an atlatl, eclipse or replace the forelegs of the serpent.[26] The strong similarity to the rainbow serpents at Chichen Itza (first noted by A. Morris [1931, 364]) and the absence of similar representations elsewhere suggests some kind of transfer of knowledge between Chichen Itza and the Mixteca. However, because the Codex Nuttall was created centuries after Chichen Itza's collapse, this isolated example may simply highlight how much evidence about ancient Mesoamerica has been lost.

The Codex Nuttall is of interest not only because it represents the rainbow serpent but also because it represents related entities in at least three additional ways. On the reverse of the screenfold codex, a fire serpent is shown in a form much closer to the Xiuhcoatl found in Aztec images from the Valley of Mexico. On pages 46, 76a, and 79, a fire serpent embraces the contours of a hill sign, apparently part of a place-name (fig. 23; Hermann Lejarazu 2006, 24–25, 84–85, 92–93; Williams 2013, 164–66, 204–7, 210–11). This serpent's body is composed of trapezoidal plaques colored red, blue, and yellow projecting out from the body in a ridged pattern. This creature has forelegs, a curving tail with a red and white stinger, and a rising squared-off nose that very much resembles the diagnostic muzzle of the Aztec Xiuhcoatl.

Other related forms also appear in the Codex Nuttall. As Taube has noted, the Aztec Xiuhcoatl has similarities with the Zapotec Xicani and the Mixtec Yahui, both supernatural turtle- or lizard-like creatures with squared and upturned snouts (Taube 2001, 2012, 119–20; see also Hermann Lejarazu 2011). The Yahui

is often shown with human characteristics, as if suggesting that specially trained priests might assume the qualities of this supernatural. Page 69 of the Codex Nuttall reverse shows a particularly Xiuhcoatl-like Yahui priest in battle (Hermann Lejarazu 2006, 70–71), while page 44 shows a dead Yahui priest with a more traditional turtle carapace (Hermann Lejarazu 2006, 20–21), and a Yahui with a turtle carapace is also shown as part of the place-name Yuta Yahui, or Yahui River, on page 12 (Hermann Lejarazu 2008, 36–37). The diversity of forms suggests that many different ideas about fiery supernaturals coexisted in Late Postclassic Oaxaca.[27]

Fig. 22. Rainbow serpent, Codex Nuttall obverse, page 3. Mixtec, ca. 1300–1500 CE. British Museum Am1902,0308.1.

Fig. 23. Xiuhcoatl as part of place-name, Codex Nuttall reverse, page 76a. Mixtec, ca. 1300–1500 CE. British Museum Am1902,0308.1.

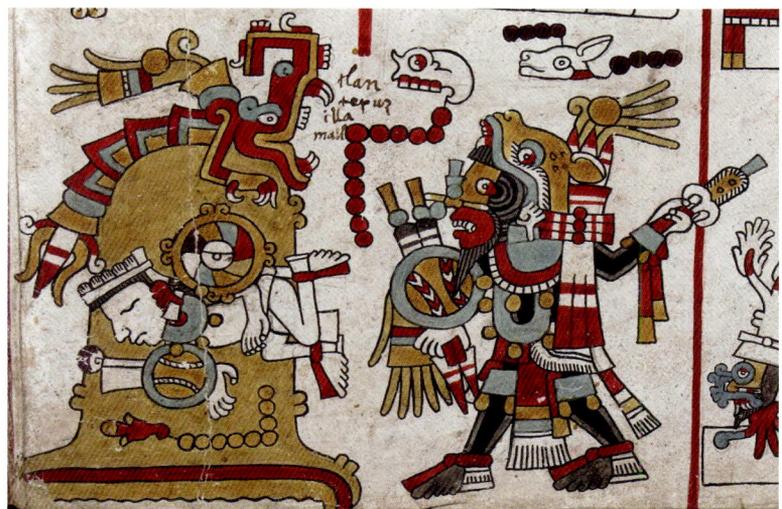

The Nuttall obverse and reverse were created at different moments by different artists. Unfortunately, the codex cannot be used to pin down a transition from rainbow serpent to Xiuhcoatl: the Nuttall reverse was probably painted before the obverse (Troike 1987; Hermann Lejarazu 2006, 10–12), so that the Aztec-like fire serpent is earlier than the Chichen Itza-like rainbow serpent. Different forms of Yahui creatures coexisted on the earlier face of the document. Because these supernaturals are deployed in such different contexts—as actors in the narrative and as place-names—it is difficult to be sure if they are in any way equivalent. For example, one might wonder if the older rainbow serpent form was intentionally deployed in the War of Heaven narrative at the beginning of the obverse to signal the antiquity of the figures involved in this past event (for the War of Heaven, see Byland and Pohl 1994, 11–14, 109–19; Hermann Lejarazu 2008, 18–21; Williams 2013, 40–42). Likewise, perhaps the choice of the Xiuhcoatl-like form for Fire

Serpent Hill on the Nuttall reverse might signal that it was a place closer to, or more closely aligned with, Aztec territory, and that the Xiuhcoatl-like appearance of the fire serpent offers some information about the location of this place. But other possibilities exist: that no resemblance was perceived among the various forms, that both forms are equally valid and perfectly interchangeable, that one has more Central Mexican and the other more Maya overtones, or that their active correlation takes place in the Mixteca. What we can say with certainty is that several forms were in circulation in the Mixteca during the fifteenth century. The Mixteca may indeed be a key, but neglected, region in the Mesoamerican interchange of ideas.

It may also be that there are more rainbow serpents to be discovered. A large Mixtec vessel in the collection of the Denver Art Museum, for example, seems to feature an iteration of this being, an undulating serpent with spikes and patterned compartments within its body, as colorful as the medium of fired clay might allow (fig. 24). A tripod bowl of uncertain date and provenance in the collection of the Field Museum unequivocally features this creature, the post-fire Mesoamerican cloisonné technique permitting its forms to be expressed in brilliant color (Field Museum 167587). Another pseudo-cloisonné vessel, of a shape associated with Central Mexico and decorated with a similar figure, was found in the Sacred Cenote at Chichen Itza, suggesting that pilgrimage may have helped spread the idea of the rainbow serpent (Coggins and Shane 1984, 101). There may even be faint resemblances to the rainbow serpent in ceramics as far afield as the Greater Nicoya and Coclé regions in Central America (Alanna Radlo-Dzur, pers. comm., 2018; Helms 1995, fig. 6).[28] Surely

Fig. 24. Unknown artist, urn with supernatural serpent, Postclassic International Style, ca. 1300–1500 CE. Slip painted ceramic, 11½ × 15¼ in. Oaxaca or Puebla, Mexico. Denver Art Museum: Gift of Morton D. May, 1968.152. Photography © Denver Art Museum.

there are more examples still waiting to be identified.

## Aztec Xiuhcoatl

One culmination of these Mesoamerican processes of exchange and transformation was the Aztec Xiuhcoatl. The Aztec Xiuhcoatl could take many forms, from the atlatl held by the god Huitzilopochtli, decorated with seven starry eyes, to a sinuous creature with curving snout and pointed tail (fig. 25). The two flaming serpents that border the sun disk on the Aztec Calendar Stone are another prominent example of this fiery supernatural, associated with meteors and other celestial fire. As Taube (2000, 2012) has demonstrated, many of the creature's key attributes can be traced to the Teotihuacan War Serpent, while other aspects, such as the upturned snout, seem more typical of the Zapotec Xicani or the Mixtec Yahui. However, the long segmented body and spindly forelegs also bear a resemblance to the Chichen Itza rainbow serpent, and it is possible that many of the rainbow serpents at Chichen Itza also had curving upturned snouts, as they do at Structure 2D7-sub (see fig. 11), hinting at still other moments of contact and exchange of ideas. The Aztec fire serpent thus combines within it ideas from Teotihuacan, Teotihuacan ideas filtered through Chichen Itza, ideas from Oaxaca, and surely other influences still yet unidentified. But it also transforms them: the radiant spikes of the Chichen Itza serpent have been replaced with more literal flames, and the colorful panoply of the rainbow serpent reduced to the color of turquoise. In fact, one translation of the name Xiuhcoatl is "turquoise serpent." Still, some continuities remain: on the Aztec Calendar Stone, the bodies of the Xiuhcoatl were colored red and yellow, with only the heads and tails blue, and in this

coloration, more closely resemble the rainbow serpent (see reconstructions in Villela and Miller [2010, 152, 157, 161], as well as Sieck Flandes [2010, 181–84] and Solís [2010, 297]). Perhaps the Aztec Xiuhcoatl owes more to Chichen Itza than we imagine.

Fig. 25. Xiuhcoatl, Aztec, Texcoco, ca. 1512 CE. Basalt, 77 × 60 cm (30⁵/₁₆ × 23⁵/₈ in.). British Museum Am1825,1210.1. Photo by the author.

## Conclusions

Mesoamerica was always interconnected. People were constantly on the move, bringing with them new ideas and the artistic forms in which ideas could be materialized. Yet because of Mesoamerica's great interconnection and cultural diversity, the transfer of ideas was rarely a simple or unidirectional process. On the contrary, a new idea might find resonance with past and present practice, or recombine with concepts from different regions to create something altogether new. Such is the case with the Chichen Itza rainbow serpent, a creature that may have had its origins at Teotihuacan

but combined with Classic Maya ideas at the Terminal Classic city to create something that Mesoamerica had never before seen. The importance of this supernatural has been previously unrecognized because its predominant realization was in murals, a medium that survives poorly today but was ideal for capturing the size, color, and shifting radiance of this splendid creature. But it is important to remember that, ephemeral though the murals of the rainbow serpent may have been, what they indexed has been more ephemeral still. They are only the traces that remain of a tradition of religious belief and practice, of minds animated by ideas that were even more evanescent, blazing in passage like the rainbow serpent itself.

◎ ◎ ◎

## Acknowledgments

Thanks to Victoria Lyall for the invitation to present at the symposium that gave rise to this volume and to the other participants for their splendid papers and insightful comments. Alanna Radlo-Dzur was on the trail of rainbow serpents far and wide, and Mary Miller and Virginia Miller also offered helpful comments, as did colleagues at the Midwest Mesoamericanist meetings. Thanks also to Julie Wilson, Jesse Laird Ortega, Maya Allen-Gallegos, and the rest of the team for their administrative and editorial support.

## Notes

**1**    It is assumed here that the decorative program was bilaterally symmetrical, following the lead of the initial excavators (A. Morris 1931, 363; E. Morris 1931, 70–76). The northern half of the structure was almost entirely destroyed, with only enough of the central wall surviving to give the approximate dimensions of the building (see fig. 4). Thus, it is also possible that the northern half of the Temple of the Chac Mool had a different decorative program than the surviving southern half. It is tempting to imagine a different kind of serpent decorating its walls, although the evidence of Structure 2D7-sub suggests identical serpents on both walls (discussed later). It is also important to note that the tails of the serpents, if they existed, would have been in the upper part of the mural, which is now also destroyed. Judging from the nearly uniform pattern of curves in figure 7, it also seems possible that instead of two serpents, each half of the inner room featured only a single bicephalic serpent, which might be compared to the bicephalic spiky serpent from Teotihuacan illustrated in figure 19.

**2**    Interestingly, Ann Axtell Morris suggests that the inner serpents were painted by a less skilled and technically adept painter than the more visible outer ones, as if the best artists were chosen for the part of the mural that was most visible or public. She writes, "The color [in the outer room] is very brilliant, having been mixed so carefully that the pigment and medium were completely amalgamated. The result was a thick, opaque application of great intensity. The segmented body colorations were not arranged in exact sequence, as they were in the other room, and on the whole the quality of drawing reveals a superior degree of skill. The great curves are more elegant, and the shapes of the smaller details, such as the yellow roots of the *panache,* were handled with far greater care" (1931, 365). The assessment may be more complicated than Morris suggests. While

it's now impossible to comment on the quality the color, since the paintings have been largely destroyed, the treatment of the feather panaches seems to tell the opposite story. In the inner room, the panaches emerge directly from the serpent's body, in spaces that have been planned for them (fig. 7), in the outer room, colored triangles have been painted over those panaches, and red paint then added over the bases of the triangles (fig. 6), a series of changes indicating doubt about the proper form of the creature.

**3**  This calculation is based both on the dimensions of the rooms of the Temple of the Chac Mool, reported in E. Morris (1931, 70–74), and on measurement of the images reproduced in Morris, Charlot, and Morris (1931, pl. 132), which are described as being one-twentieth actual size. These two calculations roughly coincide.

**4**  Chichen Itza chronology is notoriously complex and controversial. For recent reviews, see Volta and Braswell (2014) and Ringle (2017). Hieroglyphic texts dating to the reign of K'ak'upakal K'awiil between 864 and 889 attest to the rapid growth of "Old Chichen" during this period, but the radical changes of "New Chichen," assumed to occur after K'ak'upakal's reign, are harder to date. No hieroglyphic texts on the Gran Nivelación, or "Great Plaza," at the heart of "New Chichen" aid in the dating of the constructions there (the Great Ballcourt Stone, dated 864, is the only hieroglyphic monument on the Gran Nivelación, and it is a portable monument whose unclear find context is almost certainly not its original stratigraphic placement). Virtually the only chronological certainty on the Gran Nivelación is that the Temple of the Chac Mool is earlier than the Temple of the Warriors; it seems likely that the Temple of the Warriors (and probably the Temple of the Chac Mool as well) postdate K'ak'upakal's reign, and thus it is unlikely that the Temple of the Chac Mool is much earlier than 900 CE. Regarding the lapse of time between the Temple of the Chac Mool and the Temple of the Warriors, there is one piece of suggestive evidence that the Temple of the Chac Mool was not visible for long: only fifteen coats of plaster line the outside of the building, while at least 131 such layers covered the exterior of the Temple of the Warriors (A. Morris 1931, 383, 433; E. Morris 1931, 35–36, 43, 77, 87, 160–61).

**5**  This calculation assumes that the drawing in figure 284 of A. Morris's report (reproduced as fig. 8 here) is a complete and accurate reconstruction, relatively to scale, as she did not report the length of the mural, of which she only found fragments (see A. Morris [1931, 414–15] for discussion).

**6**  Note that the orientation of the trapezoidal plaques is reversed. These plaques can be traced back to the more feline predecessors of this creature at Teotihuacan; for example, at the Xalla compound. See figure 21 and Taube (2012, 118–20) for further discussion.

**7**  Little of the exterior of the Temple of the Chac Mool survives, but some fragments found in the construction fill of the Temple of the Warriors suggest that it may have been decorated with birds and butterflies hovering amid flowers and vines (E. Morris 1931, 148–50, pl. 19).

**8**  Schmidt continues, "Other motifs include glyph-like deity heads" (2007, 165). Note that Victor Castillo Borges, in his *tesis de licenciatura* on the excavations at Structure 2D7, describes the paintings as feathered serpents (1998, 165, 168–69), but the illustrations in the thesis correspond better to a spiky serpent with a panache of green feathers on its head.

**9**  Note that the upper portion of the heads of the serpents at the Temple of the Chac Mool were not preserved: this upturned snout may be a better approximation of how these heads would have originally looked than the flat heads in the reconstructions reproduced in figure 1, figure 2, and figure 6.

**10**  The other caption describes paintings in the "southern corner of the east wall" (Seler [1909] 1998, 128, caption to fig. 254). From a close comparison, it seems that Seler's drawings and the Peabody photos may document different portions of the mural, which may once have been quite extensive.

**11**  While Alexandre Guida Navarro's spatial analysis is helpful, I would suggest that several of his categories—serpents with long feathers ("serpientes con plumas largas"), serpents with hooked feathers ("serpientes con plumas en forma de gancho"), and serpents with spiky feathers ("serpientes con plumas en forma de espina") (2008)—simply represent different stylistic approaches to representing the feathered serpent. In addition, Navarro links the undulating spiky rainbow serpent with the serrated motif at the Inner Castillo pyramid, the Monjas compound, and other Puuc-style buildings at the site, while I consider these different phenomena. (See note 17 for further discussion.) If one considers the Jaguar-Serpent-Bird/War Serpent to be a frontal manifestation of the rainbow serpent, the spatial expanse of the motif is slightly widened to include the Venus Platform on the Gran Nivelación, the late Venus Platform associated with the Osario (or "High Priest's Grave"), and numerous colonnades at the site. Still, this creature is also primarily associated with "New Chichen." For chronology, see note 4.

**12**  These are also the basic colors of Aztec painting several centuries later (López Luján et al. 2005). While part of this is dictated by the pragmatic availability of pigments, these colors also have ideological resonance in color-directional systems and elsewhere (Houston et al. 2009, 27–28, 94).

**13**  Early archaeologists recognized the solar aspect of the rainbow serpents; in 1931, discussing the Northwest Colonnade murals, Earl Morris wrote,

"The two upturned arcs, composed of blocks of white, blue, yellow and red, bordered with fringes of triangles, were at first thought to represent solar disks, but subsequent findings in the Temple of the Chac Mool indicate that they were portions of the body whorls of a variant of the Plumed Serpent motif" (1931, 59).

**14** One of the sun disks on the northwest wall at the Upper Temple of the Jaguars also has four square-nosed serpents radiating out from it, perhaps an even closer link with Xiuhcoatl imagery (see fig. 15d). Triangular points also decorate the star skirts of warriors in these murals and elsewhere (V. Miller 1989; Tozzer 1957, figs. 287–89).

**15** While the projecting triangles are not colored in T. A. Willard's hand-colored photo, reproduced in figure 16, Jean Charlot's reconstruction of the same capstone shows the spikes to be yellow and green in color (Peabody Museum 62-11-20/25212). Maya skybands are frequently bicephalic, like the spiky serpents at the Tlacuilapaxco apartment compound at Teotihuacan; recall that it is also possible that the serpents in the Temple of the Chac Mool had two heads (see note 1). The compartments of the skyband in the capstone are full of triangular rhymes, notably in the glyph for *k'in*, or sun, and also in the serrated teeth of Cipactli, the crocodilian earth monster.

**16** Radiating triangles like this are also associated with solar symbolism in Aztec art and in the International Style of the Late Postclassic more broadly, where they also alternate with triangles with curved ends, which Taube has convincingly argued derive from representations of darts in Teotihuacan art (2015, 103). A monument like the Aztec Calendar Stone thus looks bilingual, combining two different sets of vocabulary for radiance.

**17** The one exception might be the serrated borders on Puuc architecture, which Navarro identifies with the spiky rainbow serpent (2008, 42). I am inclined to interpret this as a purely decorative border, perhaps derived from a textile pattern. However, on the Codz Pop at Kabah, this kind of serrated border may be associated with a corner piece depicting a serpent's head (see Pollock 1980, fig. 364; Rubenstein 2015, 60–61, 68, 153–54; Taube 2010, fig. 25b), although the carvings are in different styles and their juncture is not always clear (I am grateful to Meghan Rubenstein for drawing my attention to these reliefs). A similar pattern occurs on the medial molding of the Iglesia structure at the Monjas compound at Chichen Itza (Bolles 1977, 154). Still, I remain hesitant to assume that all serrated architectural patterns refer to the rainbow serpent.

**18** One further example, a wooden Xiuhcoatl extracted from the Sacred Cenote (García Moll and Cobos 2011, 95), likely dates to the later period of Cenote ritual, since the rounded upturned snout with circular protrusions looks more like the Postclassic Aztec Xiuhcoatl than anything recovered from the Terminal Classic period occupation of the site. But do note the small creature that Taube has identified as a Xiuhcoatl, apparently used as a name glyph on Column 28 of the Northwest Colonnade (Morris, Charlot, and Morris 1931, pl. 96; Taube 2012, 126).

**19** For comments on Navarro's categories, see note 11.

**20** For a possible exception on a bench from Structure 5C11 in the Initial Series Group, see Ringle (2009, fig. 14g). Note that I distinguish the rainbow serpent manifestation from the frontal manifestation of the Jaguar-Serpent-Bird/War Serpent, which does serve as a basal image on columns in the Northwest Colonnade and elsewhere.

**21** For Teotihuacan chronology, see López Luján et al. (2006, 30–32), though see Cowgill (2017, 25–26) for a dissenting opinion, placing Teotihuacan's collapse closer to 600–650. For Chichen Itza chronology, see note 4.

**22** Note that Navarro has also suggested that the *Crotalus cerastes* is the prototype for the horned feathered serpents on the columns at the entrance to the Temple of the Warriors at Chichen Itza (2013, 93–96). It is suggestive that this serpent is endemic in the region where Mesoamerican turquoise originates, given the connections between xiuhcoatls and turquoise that were already beginning to develop at Chichen Itza. Also of note is that, with age, the scales of the *Crotalus cerastes* can come to form triangular projections from the body of the snake.

**23** Fragments include Cleveland Museum of Art 63.252; Fine Arts Museums of San Francisco 1985.104.4; Art Institute of Chicago 1962.702; Kimbell Museum of Art AP 1972.16, Rijksmuseum voor Volkenkunde, Leiden, RV-3999-1; and American Museum of Natural History 30.3/1155. Part of the painting was found in situ (Millon 1988, 195). Examples of a related series of murals (without evidence of spiky serpent borders) are in the collections of the Museo Nacional de Antropología, Mexico, 10-229199; Fine Arts Museums of San Francisco 1981.10a–b; Chrysler Museum of Art 76.23.81; Denver Museum of Natural History; and Museo Rufino Tamayo. I am grateful to Matthew Robb for his assistance in gathering accession numbers; for the history of collecting, see Robb (2018).

**24** The closest parallel might be the jaguar serpent with forelegs from the murals of Structure A at Cacaxtla (Brittenham 2015, fig. 277). To be clear, this is the case with the rainbow serpent, and not with the broader Xiuhcoatl complex. Although this is also relatively rare at Epiclassic sites, we do see Maya warriors wearing the War Serpent headdress and know that the Maya called this creature Waxaklajun U B'aah Kaan, or "eighteen are the faces of the serpent." But there is no Maya image before

Chichen Itza that shows the spiky rainbow body of this creature. See note 17 for Kabah.

**25** The pointed spikes on the body of the Cipactli, or crocodilian earth monster, also have this red and white patterning in Central Mexican manuscripts.

**26** It is also possible that this is a hybrid creature, both human and serpent. 7 Serpent would be a particularly auspicious name for such a beast, if it were associated with the seven stars of the Pleiades, as the Xiuhcoatl was for the Aztecs (Taube 2000, 324–25).

**27** In addition, the Teotihuacan step-fret serpent illustrated in figure 18 also has echoes in the Mixtec codices. In the Codex Nuttall, for example, a place-name on pages 15, 18, and 19 includes a coiled serpent with vestigial forearms, disgorging a ballcourt from its open jaws. From the body of this serpent radiate colorful stepped patterns.

**28** Note that for Mary Helms, writing about Coclé ceramics, the "rainbow serpent" is a red-tailed boa constrictor, prominent in local and South American mythology (1995, 12–13, 18–21, 89, 105). This representational tradition has deep roots predating Chichen Itza, and its bicephalic serpents are not likely to represent a wholesale adoption of Chichen Itza iconography. However, it is possible that people perceived and cultivated a relationship between this supernatural and the Chichen Itza one.

## References

**Ballou, Peter.** 2016. "The Temple of the Warriors and its Substructure." BA thesis, University of Chicago.

**Bolles, John S.** 1977. *Las Monjas: A Major Pre-Mexican Architectural Complex at Chichén Itzá.* Norman: University of Oklahoma Press.

**Braswell, Geoffrey E.** 2003. "Obsidian Exchange Spheres." In *The Postclassic Mesoamerican World*, edited by Michael E. Smith and Frances F. Berdan, 131–58. Salt Lake City: University of Utah Press.

**Braswell, Geoffrey E., and Michael D. Glascock.** 2002. "The Emergence of Market Economies in the Ancient Maya World: Obsidian Exchange in Terminal Classic Yucatán, Mexico." In *Geochemical Evidence for Long-Distance Exchange*, edited by Michael D. Glascock, 33–52. Westport, CT: Bergin and Garvey.

**Brittenham, Claudia.** 2015. *The Murals of Cacaxtla: The Power of Painting in Ancient Central Mexico.* Austin: University of Texas Press.

**Brittenham, Claudia, and Virginia Miller.** 2016. "El triple legado de Teotihuacán en Chichén Itzá." Paper presented at the 10th Congreso Internacional de Mayistas, Izamal, Yucatán, Mexico.

**Byland, Bruce E., and John M. D. Pohl.** 1994. *In the Realm of 8 Deer: The Archaeology of the Mixtec Codices.* Norman: University of Oklahoma Press.

**Carlson, John B., and Linda B. Landis.** 1985. "Bands, Bicephalic Dragons, and Other Beasts: The Skyband in Maya Art and Iconography." In *Fourth Palenque Round Table, 1980*, edited by Merle Greene Robertson and Elizabeth P. Benson, 115–40. San Francisco: Pre-Columbian Art Research Institute.

**Castillo Borges, Victor Rogiero.** 1998. "Liberación y restauración de la Estructura 2D7 o Templo de las Grandes Mesas de Chichén Itzá." Tesis de licenciatura, Universidad Autónoma de Yucatán, Mérida, Mexico.

**Cobos, Rafael, ed.** 2016. *Arqueología en Chichén Itzá: Nuevas explicaciones.* Mérida, Mexico: Ediciones de la Universidad Autónoma de Yucatán.

**Coggins, Clemency Chase.** 1984. "Murals in the Upper Temple of the Jaguars, Chichén Itzá." In *Cenote of Sacrifice: Maya Treasures from the Sacred Well at Chichén Itzá*, edited by Clemency Chase Coggins and Orrin C. Shane, 157–65. Austin: University of Texas Press.

**Coggins, Clemency Chase.** 2002 "Toltec." *RES* 42 (Autumn): 34–85.

**Coggins, Clemency Chase, and Orrin C. Shane.** 1984. *Cenote of Sacrifice: Maya Treasures from the Sacred Well at Chichén Itzá.* Austin: University of Texas Press.

**Cowgill, George L.** 1997. "State and Society at Teotihuacan, Mexico." *Annual Review of Anthropology* 26:129–61.

**Cowgill, George L.** 2017. "A Speculative History of Teotihuacan." In *Teotihuacan: City of Water, City of Fire*, edited by Matthew H. Robb, 20–27. Berkeley: University of California Press.

**Diehl, Richard.** 1989. "A Shadow of Its Former Self: Teotihuacan during the Coyotaltelco Period." In *Mesoamerica After the Decline of Teotihuacan, A.D. 700–900*, edited by Richard Diehl and Janet Catherine Berlo, 9–18. Washington, DC: Dumbarton Oaks Research Library and Collection.

**Fash, William, Alexandre Tokovinine, and Barbara Fash.** 2009. "The House of New Fire at Teotihuacan and its Legacy in Mesoamerica." In *The Art of Urbanism: How Mesoamerican Kingdoms Represented Themselves in Architecture and Imagery*, edited by William L. Fash and Leonardo López Luján, 201–29. Washington, DC: Dumbarton Oaks Research Library and Collection.

**de la Fuente, Beatriz, ed.** 1995. *La Pintura mural prehispánica en México I: Teotihuacán.* 2 vols. Mexico City: Universidad Nacional Autónoma de México Instituto de Investigaciones Estéticas.

García Moll, Roberto, and Rafael Cobos. 2011. *Chichén Itzá: Patrimonio de la Humanidad*. Mexico City: Grupo Azabache.

Gómez Chávez, Sergio, and Rubén Cabrera Castro. 2006. "Contextos de la ocupación coyotlatelca en Teotihuacán." In *El fenómeno coyotlatelco en el centro de México: Tiempo, espacio y significado: Memoria del Primer Seminario-Taller sobre Problemáticas Regionales*, edited by Laura Solar Valverde, 231–56. Mexico City: Instituto Nacional de Antropología e Historia.

Helms, Mary. 1995. *Creations of the Rainbow Serpent: Polychrome Ceramic Designs from Ancient Panama*. Albuquerque: University of New Mexico Press.

Hermann Lejarazu, Manuel A., ed. 2006. "Códice Nuttall Lado 1: La vida de 8 Venado." Special issue, Edición Especial Códices 23, *Arqueología Mexicana*.

Hermann Lejarazu, Manuel A., ed. 2008. "Códice Nuttall: Segunda parte. Lado 2: La historia de Tilantongo y Teozacoalco." Special issue, Edición Especial Códices 29, *Arqueología Mexicana*.

Hermann Lejarazu, Manuel A. 2011. "La serpiente de fuego (*xiuhcóatl o yahui*) y algunas comparaciones con la iconografía del arte maya." In *Texto, imagen e identidad en la pintura maya prehispánica*, edited by Merideth Paxton and Manuel A. Hermann Lejarazu, 109–45. Mexico City: Universidad Nacional Autónoma de México.

Houston, Stephen D., Claudia Brittenham, Cassandra Mesick, Alexandre Tokovinine, and Christina Warinner. 2009. *Veiled Brightness: A History of Ancient Maya Color*. Austin: University of Texas Press.

King, Jonathan C. H., Max Carocci, Caroline Cartwright, Colin McEwan, and Rebecca Stacey, eds. 2012. *Turquoise in Mexico and North America: Science, Conservation, Culture and Collections*. London: Archetype Publications in association with the British Museum.

Kowalski, Jeff Karl, and Cynthia Kristan-Graham, eds. 2007. *Twin Tollans: Chichén Itzá, Tula, and the Epiclassic to Early Postclassic Mesoamerican World*. Washington, DC: Dumbarton Oaks Research Library and Collection.

Kubler, George. 1967. *The Iconography of the Art of Teotihuacán*. Studies in Pre-Columbian Art and Archaeology 4. Washington, DC: Dumbarton Oaks Research Library and Collections.

Kubler, George. 1982. "Serpent and Atlantean Columns: Symbols of Maya-Toltec Polity." *Journal of the Society of Architectural Historians* 41 (2): 93–115.

Lombardo de Ruiz, Sonia. 2001. "Los estilos en la pintura mural maya." In *La pintura mural prehispánica en México II: Área Maya—Tomo III: Estudios*, edited by Beatriz de la Fuente and Leticia Staines Cicero, 85–154. Mexico City: Universidad Nacional Autónoma de México Instituto de Investigaciones Estéticas.

López Austin, Alfredo, and Leonardo López Luján. 2000. "The Myth and Reality of Zuyuá: The Feathered Serpent and Mesoamerican Transformations from the Classic to the Postclassic." In *Mesoamerica's Classic Heritage: From Teotihuacan to the Aztecs*, edited by Davíd Carrasco, Lindsay Jones, and Scott Sessions, 21–84. Boulder: University Press of Colorado.

López Luján, Leonardo, Giacomo Chiari, Alfredo López Austin, and Fernando Carrizosa. 2005. "Línea y color en Tenochtitlan: Escultura policromada y pintura mural en el recinto sagrado de la capital mexica." *Estudios de cultura náhuatl* 36:15–45.

López Luján, Leonardo, Laura Filloy Nadal, Barbara Fash, William Fash, and Pilar Hernández. 2006. "The Destruction of Images in Teotihuacan: Anthropomorphic Sculpture, Elite Cults, and the End of a Civilization." *RES* 49/50 (Spring/Autumn): 12–39.

Lothrop, Samuel K. 1952. *Metals from the Cenote of Sacrifice, Chichén Itzá, Yucatán*. Memoirs Vol. 10, No. 2. Cambridge, MA: Peabody Museum of Archaeology and Ethnology, Harvard University.

Magaloni Kerpel, Diana Isabel. 2001. "Materiales y técnicas de la pintura mural maya." In *La pintura mural prehispánica en México II: Área Maya—Tomo III: Estudios*, edited by Beatriz de la Fuente and Leticia Staines Cicero, 155–98. Mexico City: Universidad Nacional Autónoma de México Instituto de Investigaciones Estéticas.

Magaloni Kerpel, Diana Isabel. 2003. "Teotihuacán: El lenguaje del color." In *El color en el arte mexicano*, edited by Georges Roque, 163–203. Mexico City: Universidad Nacional Autónoma de México Instituto de Investigaciones Estéticas.

Magaloni Kerpel, Diana Isabel. 2010. "The Hidden Aesthetic of Red in the Painted Tombs of Oaxaca." *RES* 57/58 (Spring/Autumn): 55–74.

Marquina, Ignacio. 1951. *Arquitectura Mesoamericana*. Mexico City: Instituto Nacional de Antropologia e Historia.

Martin, Simon. 2006. "Cacao in Ancient Maya Religion: First Fruit from the Maize Tree and Other Tales from the Underworld." In *Chocolate in Mesoamerica: A Cultural History of Cacao*, edited by Cameron L. McNeil, pp. 154–83. Gainesville: University Press of Florida.

Matos Moctezuma, Eduardo, and Felipe Solís Olguín, eds. 2002. *Aztecs*. London: Royal Academy of Arts.

Miller, Arthur G. 1973. *The Mural Painting of Teotihuacán*. Washington, DC: Dumbarton Oaks Research Library and Collection.

Miller, Arthur G. 1977. "Captains of the Itza: Unpublished Mural Evidence from Chichén Itzá." In *Social Process in Maya Prehistory: Studies in Honor of Sir Eric Thompson*, edited by Norman Hammond, 197–225. New York: Academic Press.

Miller, Virginia E. 1989. "Star Warriors at Chichen Itza." In *Word and Image in Maya Culture: Explorations in Language, Writing, and Representation*, edited by William F. Hanks and Don S. Rice, 287–305. Salt Lake City: University of Utah Press.

Miller, Virginia E. 2018. "The Castillo-sub at Chichen Itza: A Reconsideration." In *Landscapes of the Itza: Archaeology and Art History at Chichen Itza and Neighboring Sites*, edited by Linnea Wren, Cynthia Kristan-Graham, Travis Nygard, and Kaylee Spencer, 171–97. Gainesville: University Press of Florida.

Millon, Clara. 1988. "Maguey Bloodletting Ritual." In *Feathered Serpents and Flowering Trees: Reconstructing the Murals of Teotihuacán*, edited by Kathleen Berrin, 195–205. San Francisco, CA: Fine Arts Museums of San Francisco; Seattle: University of Washington Press.

Morris, Ann Axtell. 1931. "Murals from the Temple of the Warriors and Adjacent Structures." In *The Temple of the Warriors at Chichen Itzá, Yucatan,* by Earl H. Morris, Jean Charlot, and Ann Axtell Morris, 347–484. Washington, DC: Carnegie Institution of Washington.

Morris, Earl H. 1931. "Description of the Temple of the Warriors and Edifices Related Thereto." In *The Temple of the Warriors at Chichen Itzá, Yucatan,* by Earl H. Morris, Jean Charlot, and Ann Axtell Morris, 11–227. Washington, DC: Carnegie Institution of Washington.

Morris, Earl H., Jean Charlot, and Ann Axtell Morris. 1931. *The Temple of the Warriors at Chichen Itzá, Yucatan.* Publication 406. Washington, DC: Carnegie Institution of Washington.

Navarro, Alexandre Guida. 2008. "Distribución espacial de las imágenes de serpientes emplumadas en Chichén Itzá." *Domínios da Imagem* 2 (1): 29–44.

Navarro, Alexandre Guida. 2013. "Cuando las serpientes se empluman: Cognición y organización espacial en Chichén Itzá." In *La espacialidad en arqueología: Enfoques, métodos y aplicación*, edited by Inés Gordillo and José María Vaquer, 75–99. Quito: Ediciones Abya-Yala.

Nicholson, Henry B. 2000. "The Iconography of the Feathered Serpent in Late Postclassic Central Mexico." In *Mesoamerica's Classic Heritage: From Teotihuacan to the Aztecs*, edited by David

Carrasco, Lindsay Jones, and Scott Sessions, 145–64. Boulder: University Press of Colorado.

Pollock, Harry Evelyn Dorr. 1980. *The Puuc: An Architectural Survey of the Hill Country of Yucatan and Northern Campeche, Mexico*. Memoirs Vol. 19. Cambridge, MA: Peabody Museum of Archaeology and Ethnology, Harvard University.

Ringle, William M. 2004. "On the Political Organization of Chichen Itza." *Ancient Mesoamerica* 15 (2): 167–218.

Ringle, William M. 2009. "The Art of War: Imagery of the Upper Temple of the Jaguars, Chichen Itza." *Ancient Mesoamerica* 20 (1): 15–44.

Ringle, William M. 2017. "Debating Chichen Itza." *Ancient Mesoamerica* 28 (1): 119–36.

Ringle, William M., Tomás Gallareta Negrón, and George J. Bey. 1998. "Return of Quetzalcoatl: Evidence for the Spread of a World Religion during the Epiclassic Period." *Ancient Mesoamerica* 9 (2): 181–232.

Robb, Matthew H. 2007. "The Construction of Civic Identity at Teotihuacan, Mexico." PhD diss., Yale University, New Haven, CT.

Robb, Matthew H. 2017a. "The Old Fire God." In *Teotihuacan: City of Water, City of Fire*, edited by Matthew H. Robb, 144–49. Berkeley: University of California Press.

Robb, Matthew H., ed. 2017b. *Teotihuacan: City of Water, City of Fire.* Berkeley: University of California Press.

Robb, Matthew H. 2018. "Tracing the History of the Techinantitla Murals." *Ixiptla* 4:80–91.

Rubenstein Dankenbring, Meghan Lee. 2015. "Animate Architecture at Kabah: Terminal Classic Art and Politics in the Puuc Region of Yucatán, Mexico." PhD diss., University of Texas, Austin.

Ruppert, Karl. 1943. *The Mercado, Chichen Itza, Yucatán.* Contributions to American Anthropology and History 43. Washington, DC: Carnegie Institution of Washington.

Ruppert, Karl. 1952. *Chichen Itza: Architectural Notes and Plans.* Publication 595. Washington, DC: Carnegie Institution of Washington.

Sanders, William T., Jeffery R. Parsons, and Robert S. Santley. 1979. *The Basin of Mexico: Ecological Processes in the Evolution of a Civilization.* New York: Academic Press.

Schmidt, Peter J. 2007. "Birds, Ceramics, and Cacao: New Excavations at Chichén Itzá, Yucatan." In *Twin Tollans: Chichén Itzá, Tula, and the Epiclassic to Early Postclassic Mesoamerican World*, edited by Jeff Karl Kowalski and Cynthia Kristan-Graham, 151–203. Washington, DC: Dumbarton Oaks Research Library and Collection.

Seler, Eduard. (1909) 1998. "The Ruins of Chichen Itza in Yucatan." In *Collected Works in Mesoamerican Linguistics and Archaeology*, Vol. VI, edited by J. Eric S Thompson and Francis B. Richardson, 41–165. Culver City, CA: Labyrinthos.

Sieck Flandes, Roberto. 2010. "How Was the Stone Called the *Aztec Calendar Stone* Painted? (1942)." In *The Aztec Calendar Stone*, edited by Khristaan Villela and Mary Ellen Miller, 181–84. Los Angeles: Getty Research Institute.

Smith, Virginia. 2000. "The Iconography of Power at Xochicalco: The Pyramid of the Plumed Serpents." In *Archaeological Research at Xochicalco, Volume 2: The Xochicalco Mapping Project*, edited by Kenneth G. Hirth, 57–82. Salt Lake City: University of Utah Press.

Solís, Felipe. 2010. "The *Stone of the Sun* (2000)." In *The Aztec Calendar Stone*, edited by Khristaan Villela and Mary Ellen Miller, 293–97. Los Angeles: Getty Research Institute.

Stone, Andrea. 1989. "Disconnection, Foreign Insignia, and Political Expansion: Teotihuacan and the Warrior Stelae of Piedras Negras." In *Mesoamerica after the Decline of Teotihuacan, A.D. 700–900*, edited by Richard A. Diehl and Janet C. Berlo, 153–72. Washington, DC: Dumbarton Oaks Research Library and Collection.

Stone, Andrea. 1999. "Architectural Innovation in the Temple of the Warriors at Chichén Itzá." In *Mesoamerican Architecture as a Cultural Symbol*, edited by Jeff Karl Kowalski, 298–319. Oxford: Oxford University Press.

Stuart, David. 2005. "A Foreign Past: The Writing and Representation of History on a Royal Ancestral Shrine at Copan." In *Copán: The History of an Ancient Maya Kingdom*, edited by E. Wyllis Andrews and William L. Fash, 373–94. Santa Fe, NM: SAR Press.

Sugiyama, Saburo. 2000. "Teotihuacan as an Origin for Postclassic Feathered Serpent Symbolism." In *Mesoamerica's Classic Heritage: From Teotihuacan to the Aztecs*, edited by Davíd Carrasco, Lindsay Jones, and Scott Sessions, 117–43. Boulder: University Press of Colorado.

Taube, Karl A. 1992a. *The Major Gods of Ancient Yucatan*. Studies in Pre-Columbian Art and Archaeology 32. Washington, DC: Dumbarton Oaks Research Library and Collection.

Taube, Karl A. 1992b. "Temple of Quetzalcoatl and the Cult of Sacred War at Teotihuacán." *RES* (Spring) 21: 53–87.

Taube, Karl A. 1994. "Iconography of Toltec Period Chichén Itzá." In *Hidden among the Hills: Maya Archaeology of the Northwest Yucatan Peninsula*, Acta Mesoamericana 7, edited by Hanns J. Prem, 212–46. Möckmühl, Germany: Verlag von Flemming.

Taube, Karl A. 2000. "The Turquoise Hearth: Fire, Self-Sacrifice, and the Central Mexican Cult of War." In *Mesoamerica's Classic Heritage: From Teotihuacan to the Aztecs*, edited by Davíd Carrasco, Lindsay Jones, and Scott Sessions, 269–340. Boulder: University Press of Colorado.

Taube, Karl A. 2001. "Yahui." In *The Oxford Encyclopedia of Mesoamerican Cultures*, edited by Davíd Carrasco, 359–60. New York: Oxford University Press.

Taube, Karl A. 2010. "At Dawn's Edge: Tulúm, Santa Rita, and Floral Symbolism in the International Style of Late Postclassic Mesoamerica." In *Astronomers, Scribes, and Priests: Intellectual Interchange between the Northern Maya Lowlands and Highland Mexico in the Late Postclassic Period*, edited by Gabrielle Vail and Christine Hernández, 145–91. Washington, DC: Dumbarton Oaks Research Library and Collection.

Taube, Karl A. 2012. "The Symbolism of Turquoise in Ancient Mesoamerica." In *Turquoise in Mexico and North America: Science, Conservation, Culture and Collections*, edited by J. C. H. King, Max Carocci, Caroline Cartwright, Colin McEwan, and Rebecca Stacey, 117–34. London: Archetype Publications in association with the British Museum.

Taube, Karl A. 2015. "The Huastec Sun God: Portrayals of Solar Imagery, Sacrifice, and War in Late Postclassic Huastec Iconography." In *The Huasteca: Culture, History, and Interregional Exchange*, edited by Katherine A. Faust and Kim N. Richter, 98–127. Norman: University of Oklahoma Press.

Tozzer, Alfred M. 1957. *Chichén Itzá and Its Cenote of Sacrifice: A Comparative Study of Contemporaneous Maya and Toltec*. Memoirs Vols. 11–12. Cambridge, MA: Peabody Museum of Archaeology and Ethnology, Harvard University.

Troike, Nancy P. 1987. "Introduction: Notes on the Codex Zouche-Nuttall." In *Codex Zouche-Nuttall (British Museum Add. MSS 39671)*. Graz, Austria: Akademische Druck-u. Verlagsanstalt.

Villela, Khristaan, and Mary Ellen Miller, eds. 2010. *The Aztec Calendar Stone*. Los Angeles: Getty Research Institute.

Volta, Beniamino, and Geoffrey E. Braswell. 2014. "Alternative Narratives and Missing Data: Refining the Chronology of Chichen Itza." In *The Maya and Their Central American Neighbors: Settlement Patterns, Architecture, Hieroglyphic Texts, and Ceramics*, edited by Geoffrey E. Braswell, 356–402. London: Routledge.

Volta, Beniamino, Nancy Peniche May, and Geoffrey E. Braswell. 2017. "The Archaeology of Chichen Itza: Its History, What We Like to Argue About, and What We Think We Know." In *Landscapes of the Itza: Archaeology and Art History at Chichen Itza and Neighboring Sites*, edited by Linnea Wren,

Cynthia Kristan-Graham, Travis Nygard, and Kaylee Spencer, 28–64. Gainesville: University Press of Florida.

**Von Winning, Hasso.** 1985. *Two Maya Monuments in Yucatan: The Palace of the Stuccoes at Acanceh and the Temple of the Owls at Chichén Itzá.* Los Angeles: Southwest Museum.

**Von Winning, Hasso.** 1987. *Iconografía de Teotihuacán: Los dioses y los signos.* 2 vols. Mexico City: Universidad Nacional Autónoma de México Instituto de Investigaciones Estéticas.

**Williams, Robert Lloyd.** 2013. *The Complete Codex Zouche-Nuttall: Mixtec Lineage Histories and Political Biographies.* Austin: University of Texas Press.

**Wren, Linnea, Cynthia Kristan-Graham, Travis Nygard, and Kaylee Spencer, eds.** 2017. *Landscapes of the Itza: Archaeology and Art History at Chichen Itza and Neighboring Sites.* Gainesville: University Press of Florida.

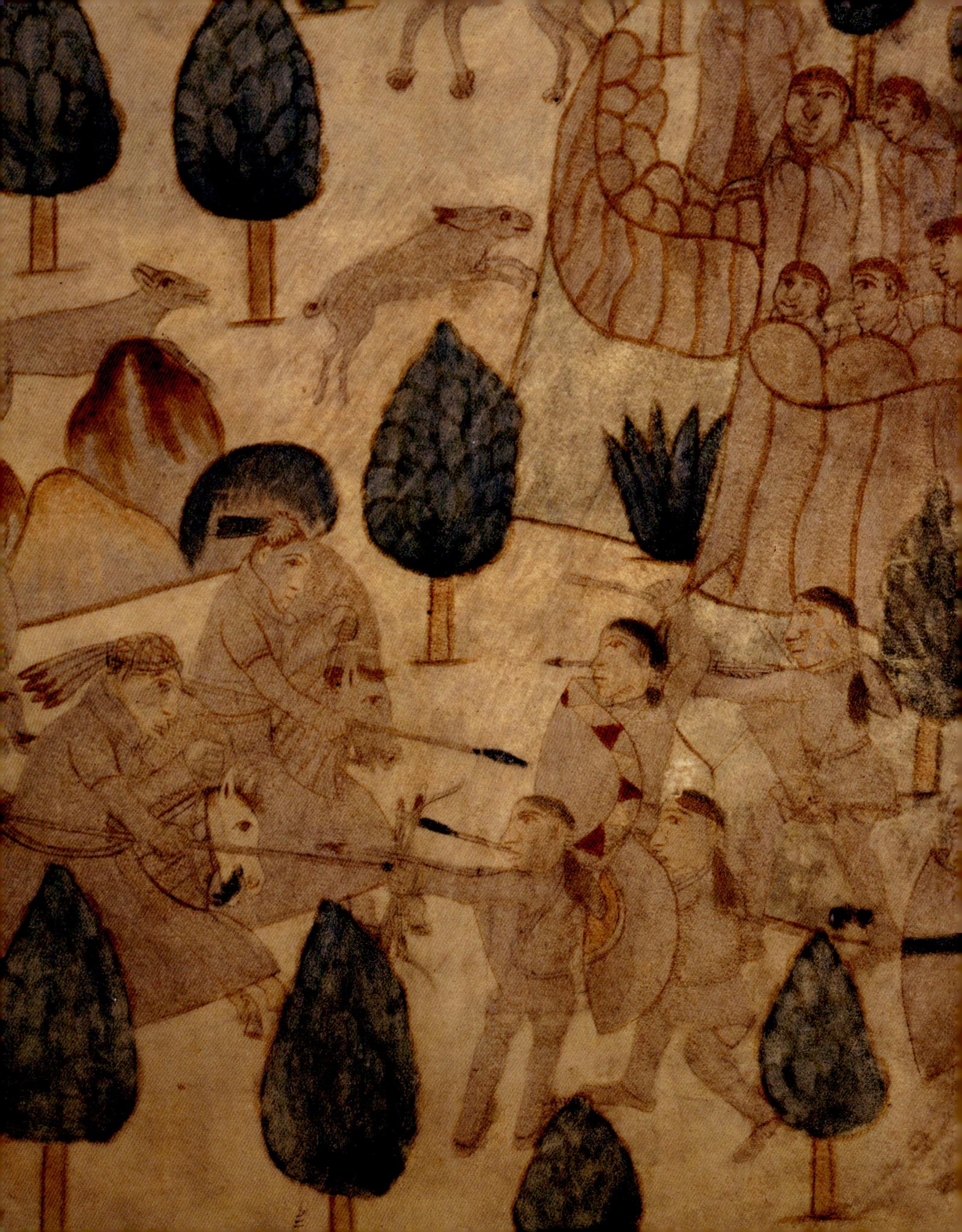

SEVERIN FOWLES AND LINDSAY A. MONTGOMERY

# Rock Art Counter-Archives of the American West

The production of history in the American West, as in most parts of the world, remains an overwhelmingly textual endeavor. We see this most bluntly expressed in the widespread tradition of referring to the millennia that preceded the arrival of European pens and parchment as a sinking iceberg of "prehistory," as if writing was the very content of history and not just a means of representing it. Some even invoke a "protohistoric" period to cordon off those portions of the past when textual reports were still few and far between. "History" in its strictest sense, we are told, only commenced with full-blown colonialism and the traffic of governmental missives that European metropoles used to maintain control of indigenous bodies and lands from a distance.

Suffice it to say that this position not only equates "history" with written documents but also with a distinctive form of European cultural imperialism that modern anthropologists, archaeologists, and historians still struggle to overcome. And this has led a growing chorus of scholars to advocate for a deeper engagement with the alternative knowledge systems of indigenous communities, which typically involve highly developed oral traditions of historical production. As others have observed, Native oral histories differ from Western written histories in more than just how they are conveyed; their themes, narrative structures, moral orientations, social functions, and modes of evaluation can all be quite distinct (see, in particular, Basso 1996). But such differences do not justify dismissing indigenous knowledge as mere mythological fantasy. On the contrary, those who have seriously studied oral traditions quickly discover that they are no less historical and no less faithful to former times than their written counterparts. "Prehistory," then, never existed in the Americas; there has always been a robust indigenous discourse about the past.

And yet, when placed alongside textual reports, oral histories do have a fundamental disadvantage—namely, the way they are stored and assembled into archives. Individuals and groups often accumulate oral narratives and pass them down as memorized speech acts to subsequent generations, but much of the power of the oral tradition derives from its ability to grow and change in response to the shifting circumstances of the present. As such, we are usually unable to refer back to earlier verbal performances and consider, for example, how

*Opposite:* Detail of fig. 6 *(a)*.

Native communities of the fifteenth century narrated their lives, even though we may know a good deal about what their modern descendants find noteworthy.

This draws our attention to yet another way that text maintains its historiographic privilege, for it is only when oral accounts are written down and anchored in ink—typically by non-Native anthropologists—that they become admissible as part of our dominant modes of knowledge production. Efforts to transcribe indigenous oral histories in the American West really only commenced at the close of the nineteenth century, resulting in a regrettably shallow archive. Moreover, as Native colleagues frequently emphasize, the very act of textualization transforms a narrative's meaning; the account is necessarily stripped of the vital contextual details embedded within the speaker's body language and tonal inflections. Textualization also detaches oral histories from the physical places where they were performed, removing implicit references to landscape features, architecture, surrounding material culture, and perhaps also to other stories told in the same physical setting. Of course, most transcribed indigenous oral histories end up circulating as English translations of accounts originally expressed in other languages, which shifts the meaning of the message further still. Inevitably, we are drawn much further away from the accounts of past orators than we are from past writers. The latter, at least, typically intended their accounts to be consumed as words on pages, more or less in the same medium as they appear to us today.

Is a genuinely revisionist history of the American West possible, then? Certainly, we have much to learn from contemporary descendant communities. But how can we seriously engage indigenous perspectives *from the past* and reimagine our accounts in response?

To what extent can we overcome the privilege accorded to European and Euro-American written documents, which continue to be regarded as the only surviving firsthand accounts of events prior to the twentieth century when tribes also began producing written records of their histories?

Here is where close attention to visual culture has the potential to make vital contributions. Indeed, past indigenous actors not only narrated events in oral performances but also created iconographic records, many of which have survived into the present. This is particularly true of indigenous rock art, which can be found in great abundance across much of the American West. Despite—or perhaps because of—its appeal to the general public, rock art still does not receive the scholarly attention it deserves. But a canyon filled with, say, a few hundred panels emerges as a rich Native archive as soon as the historicity of the glyphs comes into view.

Consider the so-called Procession Panel, pecked onto a rock face in southeastern Utah by an Ancestral Pueblo individual or group at some point between 650 and 800 CE (fig. 1). Long lines of humans and animals can be seen converging on a circular enclosure in this complex image, which Wilshusen, Ortman, and Phillips (2012) interpret as either a dance ground or a ceremonial structure known as a great kiva, the latter of which had only recently been introduced into the local architectural tradition. "It is a narrative, a visual 'telling' of at least two social groups coming together from different directions," they write. "Of course, it also may be a composite story of several repeated gatherings at the same place involving the same groups of people" (Wilshusen, Ortman, and Phillips 2012, 210). Either way, the panel seems to offer a firsthand perspective on a time period when the scale

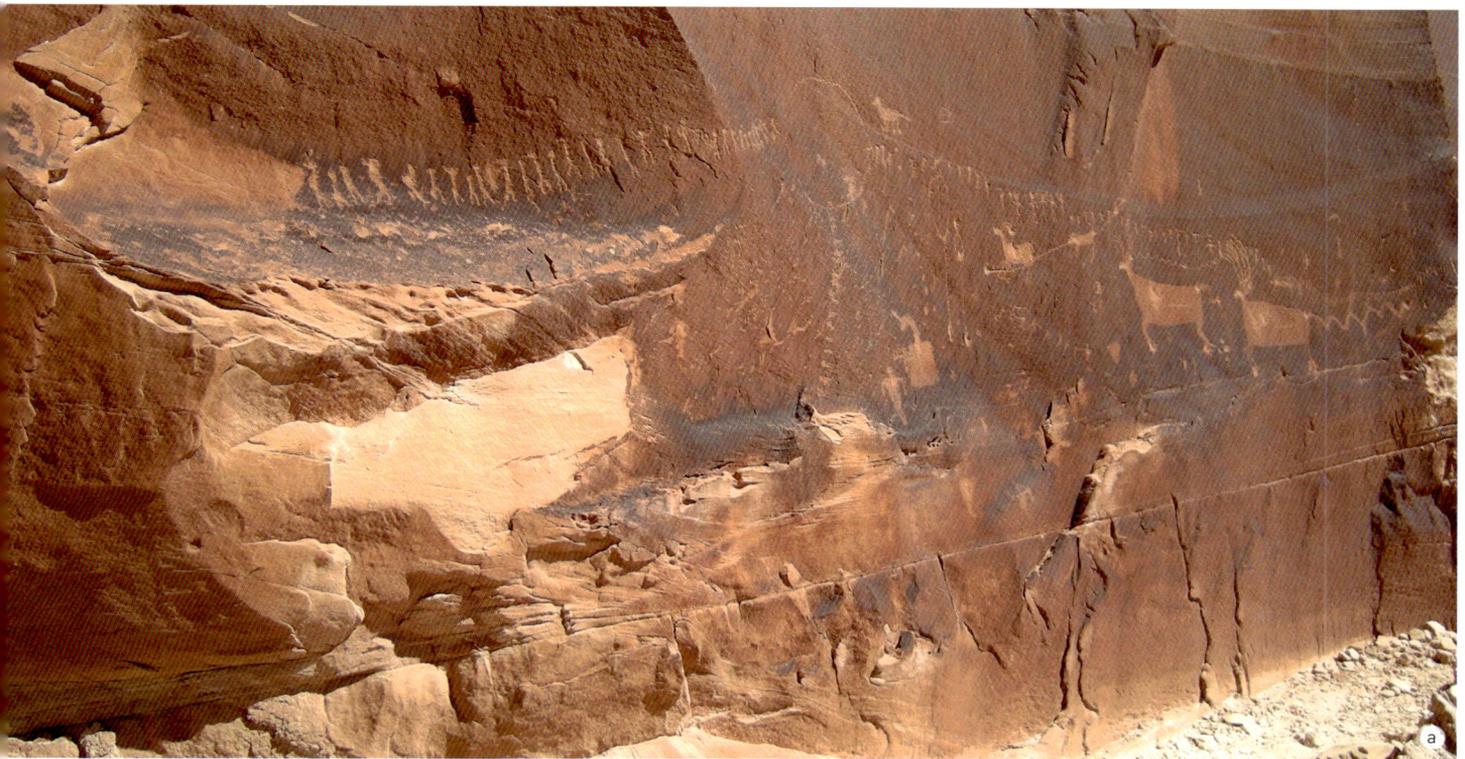

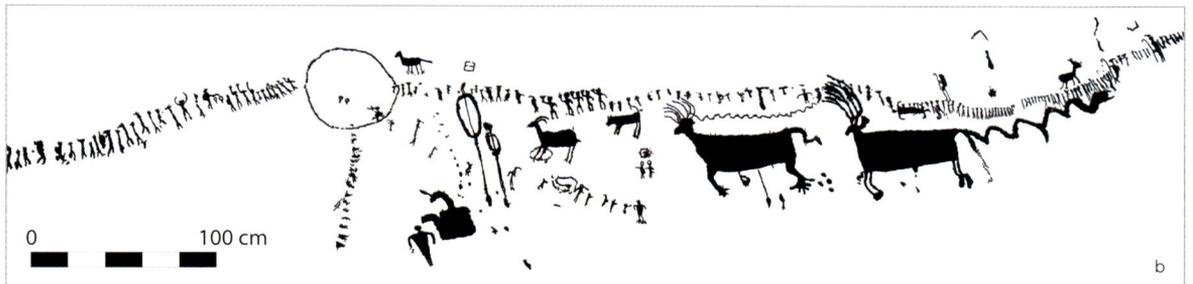

Fig. 1. Pre-colonial narrative rock art. (*a*) "Procession Panel" in southeast Utah. Photograph by Joe Burleson. (*b*) Simplified rendering including only the primary pecked glyphs, based on photographs and figure 11.5 in Wilshusen, Ortman, and Phillips (2012).

Fig. 2. A panel depicting migration dots at site LA-5948 in the Rio Grande Gorge (simplified rendering including only the primary pecked glyphs based on photographs).

and complexity of communities were rapidly changing.

Other pre-colonial rock art images from the region narrate events in more abstract or conventionalized ways. Figure 2, for instance, depicts a progression of dots rather than human figures. This panel was pecked onto a large boulder in northern New Mexico, most likely between 1000 and 1500 CE. On the surface, it seems semantically impenetrable. However, a consultant from nearby Taos Pueblo recommended that we read the panel as a historical record of places where Pueblo ancestors temporarily stopped and built a settlement in the course of their migrations. Each pecked dot, our consultant observed, might be regarded as a place signifier whose name and story would have been narrated to an audience using the rock art as a mnemonic device. Viewed this way, the seemingly abstract panel is transformed into a historical account of two peoples traveling alongside one another from place to place, as well as of a third people who briefly crossed their path long ago.

Of course, these are not historical documents like those privileged within traditional Euro-American scholarship. They are not signed and dated, and archaeologists who study such images are therefore only able to make very general evaluations of their cultural affiliations and temporal sequence. On the other hand, rock art images—like murals more generally—are impressively locatable in place, far more so than the written records within colonial archives. We may know that a letter to the viceroy was written on March 4, 1542, for instance, but we usually only have a very vague sense of where the letter was composed (e.g., somewhere in northern New Spain). The reverse is true in the case of rock art, in which the images have stayed put throughout the ages, providing a highly specific record of what was produced where, even though the date of production can only be narrowed down to a few hundred years (e.g., somewhere between 650 and 800 CE, as in the Procession Panel). There are different strengths and weaknesses when rock art and textual archives are compared, then, and the exegetical project must be adjusted accordingly.

In what follows, we focus on one rock art tradition that holds a special potential to transform our understanding of the history of the American West. The Plains Biographic Tradition (hereafter, simply the Biographic Tradition or Biographic) was a distinctive mode of image production that began to spread widely during the first half of the eighteenth century, eventually taking hold on the Great Plains and along the Rocky Mountains from Canada to Mexico (Keyser 2004; Keyser

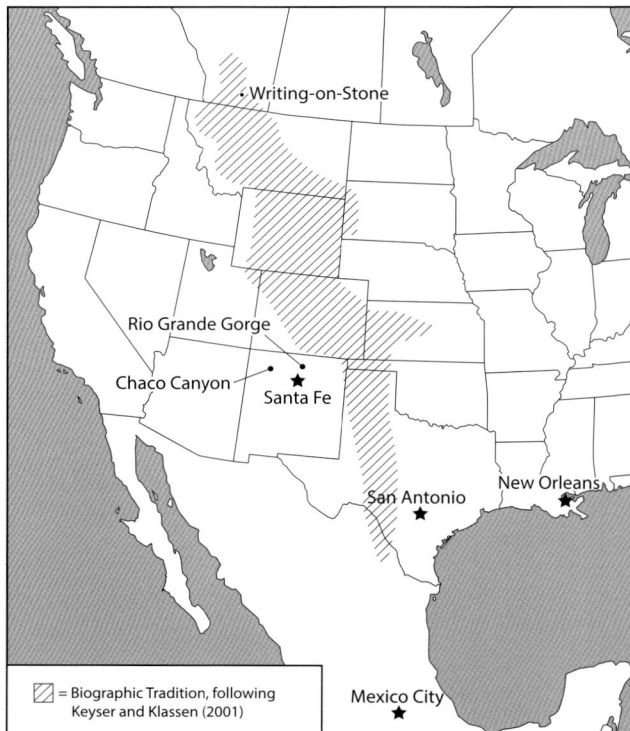

Fig. 3. Map of the American West, highlighting the distribution of the Plains Biographic Tradition as reconstructed by Keyser and Klassen (2001).

Fig. 4. (*a*) Attributed to Standing Bear (Minneconjou), *Tipi*, about 1880. Paint and canvas on wood frame, 184 × 252 × 156 in. Denver Art Museum: Native Arts acquisition funds, 1963.271; (*b*) Rotated detail of tipi.

and Klassen 2001; Loendorf 2008) (fig. 3). Many different ethnic groups participated in the production of Biographic art; in fact, it appears to have served as a visual lingua franca that could be "read" and interpreted by Native peoples across much of North America. As its name implies, the tradition had a strongly "biographical" flavor insofar as historical events were often depicted that were consequential to the careers of Plains leaders. The art, then, came to be dominated by certain iconic themes that broadly defined the Plains Indian culture area during the colonial period: militarism, equestrianism, bison hunting, horse stealing, and the quest for honor through individual acts of bravery.

For our purposes, the most significant aspect of Biographic rock art is the potential it holds to complicate and reframe orthodox histories of the eighteenth and nineteenth centuries, which continue to be built around Spanish, French, and American written documents. Indeed, the number of Biographic rock art panels produced far exceeded the number of European/Euro-American textual records right up to the end of the nineteenth century. Such images, then, should be regarded as a rich counter-archive for our consideration: a set of firsthand Native commentaries on a world that was being rapidly transformed by the spread of European-introduced horses and guns, by the movement of peoples, and by the emergence of new economic and political systems. As we will see, all these themes and more are repeatedly discussed in the Biographic imagery.

## The Plains Biographic Tradition

With thousands of recorded examples, stone is clearly the dominant medium in the surviving corpus of Biographic images, but the tradition was hardly limited to rock art. The best-known— surely the most beautiful—examples were produced with pigments on animal hides.

Most painted hides have not survived, but ethnographic collections assembled during the period of US imperial consolidation west of the Mississippi give us a partial view of what we are missing. Late nineteenth-century examples of bison robes were adorned with elaborate battles in progress. Images of raiders pursuing horses danced across tipis (fig. 4). From the portraits painted by George Catlin in the 1830s, we learn that prominent men even wore hide shirts covered with scenes of hand-to-hand combat in which they, presumably, participated. One senses that eighteenth- and nineteenth-century Plains communities lived within a swirl of imagery that traveled with them as portable visual archives.

Much of what we know about the Biographic Tradition as a mode of communication comes from its final incarnation as "ledger art," so-named due to the frequency with which pages of reused ledger books served as canvases for drawings. As is true of the Biographic images scratched on rock or painted on hides, those drawn in ledger books were primarily narrative celebrations of the feats of particular warriors. By this point, however, the sociology of the art had changed dramatically. Earlier Biographic imagery had been produced as a means of building prestige and authority within indigenous Plains communities. A warrior may have fought valiantly on the battlefield or stolen many horses from an enemy camp, but his deeds, on their own, would mean little until they were related to and accepted by the wider community. Image production, oral narration, theatrical reenactment—these had all been performative strategies of converting military actions into social capital. Ledger art, in contrast, was generally produced during the early decades of the reservation era at the request of non-Native individuals interested in collecting mementos of a vanquished people and their

former way of life (Keyser 1987, 2000; see also Keyser 1996). No doubt the production of ledger art was a poignant experience for many indigenous individuals, very unlike the swagger and bravado that surrounded image making in former times.

Because ledger art was generally created under the supervision of white Americans, it was also frequently annotated with written commentaries. Consequently, the study of such documents has been instrumental in helping modern scholars understand the conventions that once governed iconographic production across a wide swath of interior North America. James D. Keyser (1987, 2000; see also Keyser 1996), whose research has defined the Biographic Tradition as such, describes ledger art as a kind of Rosetta Stone insofar as it made possible the development of an iconographic lexicon that now guides our reading of earlier rock art.

Consider Keyser's interpretation of figure 5, a late eighteenth- or early nineteenth-century Biographic panel from the famous Writing-on-Stone site in southern Alberta:

*The pedestrian force represents a group of horse raiders engaged in battle by the occupants of the tipi camp. Tracks show a long journey from the raiders' camp to the scene of the fight, and horse tracks show the path of the camp's mounted defenders. Although the uppermost rider uses his spear to kill one pedestrian (as indicated by blood flowing from a stomach wound, the dead man's posture, and the unfired gun), all the horsemen were subsequently killed by the raiders. Bullets from two guns kill three horsemen, and the central sword-wielding warrior dispatches a fourth. This swordsman's tracks also indicate that he ran up and seized his opponent's gun. The four noncombatants either represent captives or coups counted on the dead riders (Keyser and Klassen 2001, 252–53).*

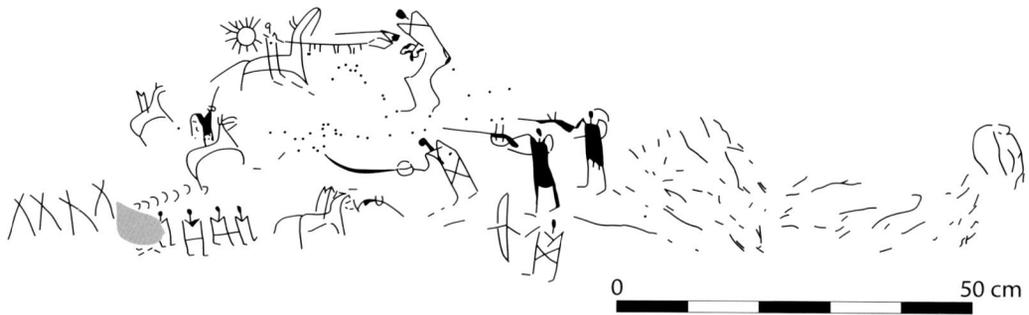

Fig. 5. The "Rocky Coulee Battle Scene" panel at the Writing-on-Stone site in southern Alberta (redrawn from Keyser and Klassen 2001, 252).

0    50 cm

The original artist would have relayed additional details in his or her explanation of the image (crucially, the specific identities of the various combatants), and those who initially viewed the panel surely brought a great deal of their own contextual knowledge to the interpretative process. Nevertheless, the broad outlines of this pictorial narrative were probably similar to Keyser's reconstruction. Insofar as the broad outlines of the pictorial narrative were also similar to on-the-ground events witnessed by the artist, the panel is able to function for the modern historian as a true archival document of indigenous authorship.

Biographic imagery assumed its characteristically historical form during the early eighteenth century, when European horses and guns began to circulate through indigenous networks, transforming local ways of hunting, fighting, moving, doing politics, reckoning prestige, and, indeed, making history. The tradition has particularly deep roots in the northwestern plains, in the vicinity of Wyoming, Montana, and southwestern Alberta, where stylistically related images of human figures, heraldic shields, and animals were incised onto the local sandstone and limestone cliffs for centuries prior to the eruption of Biographic art. This earlier imagery is sometimes referred to as a distinct Ceremonial Tradition, as a way of indicating that it seems to be more narrowly concerned with vision quests, medicine

powers, and access to the spirit world (Keyser 2004, 81). Of course, spiritual concerns didn't disappear during the colonial period—and neither did spiritual imagery. But the Biographic art that took hold during the eighteenth century was more than just an add-on to an existing iconographic tradition. Rather, it cohered as a truly novel art form in at least three ways.

First, the iconographic range of the art greatly expanded. It rapidly came to incorporate images of horses, bison, tipis, guns, tally marks, and colonial-era material culture of various sorts. By and large, these new rock art panels celebrated warfare, hunting, and raiding to an unprecedented degree. While the individual remained the focal point of artistic production, the overall sense one gets is that this was part of a major shift in the content of Plains imagery away from privately experienced visions and toward publicly recognized historical events (cf. Greene's [1985, 22–23] discussion of the difference between what she refers to as "visionary" vs. "pictographic" Plains art). This iconographic transition reflects a wider series of shifts in Plains society, which became increasingly hierarchical over the course of the eighteenth century.

Second, the geographic range of the rock art greatly expanded as well. Similar themes, compositions, and techniques of production came to be shared at a continental scale for the first time (see fig. 3). As such, the art announces

the emergence of a new regional system, one that gained coherence not only through shared imagery but also through the shared use of Plains Indian Sign Language (PISL), which had an essentially identical distribution and was also a conventionalized means of nonverbal communication that easily crossed ethnic borders (see Davis 2010). In fact, Biographic Tradition iconography and PISL probably sprang from a common source, functioning as two aspects of a gestural lingua franca that served as the foundation of political discourse across the plains during the colonial era.

The third and most significant innovation of Biographic Tradition rock art was that it came to be characterized, as we have observed, by a strongly narrative orientation in which the deeds and accomplishments of prominent individuals were celebrated. One can find plenty of narrative moments in pre-colonial rock art, similar to the panels illustrated in figures 1 and 2, but the Biographic Tradition took narrativity to a level far beyond anything previously seen in Native North American figuration. All of a sudden, we can legitimately talk about "reading" the imagery to derive specific details about consequential events. Moreover, the human agents of history—particular individuals acting in particular ways—now stride boldly into the foreground, marking a major divergence from essentially all pre-colonial artistic traditions in which either nonhumans take center stage (e.g., animals or spirit beings) or humans are prominent but generically rendered.

What was the source of this radical new approach to historical representation? The dominant interpretation is that it arose locally out of the "Ceremonial" rock art traditions of the northern plains during late pre-colonial times, just prior to the arrival of Europeans (Keyser and Klassen 2001, 238).

We consider this unlikely, however (see Fowles and Montgomery, forthcoming). The Plains Biographic Tradition has clear affinities with the European genre of history painting, and no known examples unambiguously predate the colonial period. True, many early Biographic panels were produced far to the north, at a significant distance from Spanish, French, and British centers, in regions where non-Native settlers arrived at a comparatively late date. But indigenous people and ideas were highly mobile, and we regard it as far more plausible that the Biographic tradition initially developed as a Native appropriation of European styles of historical representation. These new styles would have first been encountered in Spanish New Mexico and French Louisiana, but they appear to have rapidly spread up and down the Plains corridor along with the horse trade.

To understand how such an artistic transfer may have taken place, we need only look to the well-known example of the Segesser hide paintings, which were commissioned in New Mexico, apparently as a pictorial documentation of Pedro de Villasur's ill-fated expedition onto the plains in 1720 to avenge recent Comanche raids (Chávez 1990). While Spanish officers led the charge, such campaigns primarily involved battles between Native warriors: some as colonial allies, others as colonial opponents, and still others who were fighting for purely intertribal reasons. In the case of the Villasur expedition, for instance, we know that the Apache, Pawnee, Oto, and Comanche, as well as Pueblo groups, were all involved. It is not surprising, then, that the iconography of the Segesser hides is filled with indigenous actors, most of whom are depicted with such close attention to ethnic detail that one suspects various indigenous consultants had a hand in the design (fig. 6). In fact, it is likely that indigenous auxiliaries and Spanish officials

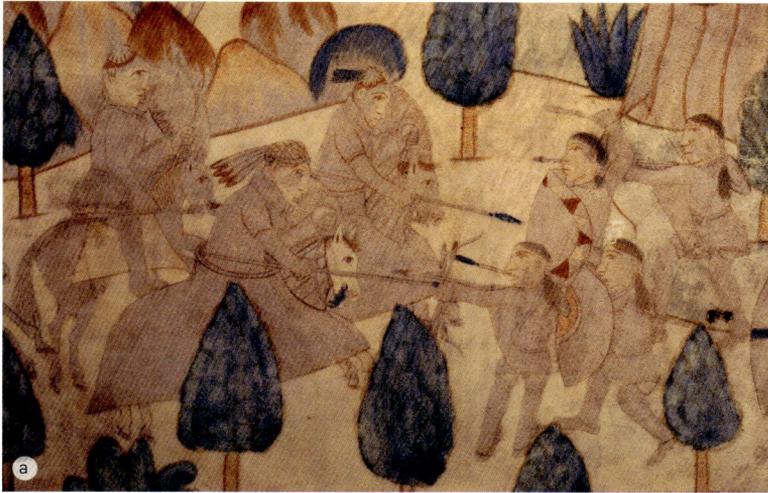

Fig. 6. (a) Segesser I hide painting (detail), 1720–1729. Courtesy of the Palace of the Governors Photo Archives (NMHM/DCA), 149798; (b) Outlined detail of the Segesser I hide painting, depicting a Spanish military campaign onto the plains with Native auxiliaries during the early eighteenth century.

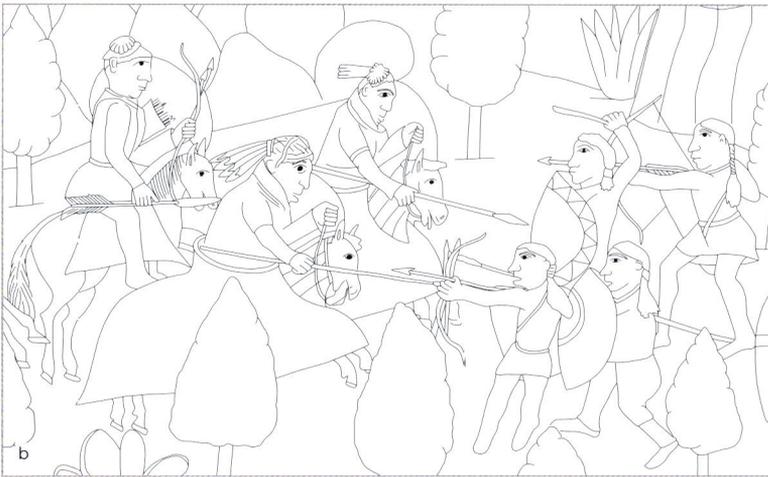

regularly depended on "picture writing" as a means of communication. Regardless, we can assume that images similar to those painted on the Segesser hides circulated through colonial networks from quite early on. And they seem to have made an especially strong impression. Historically based art, in this sense, may have been like horses: a foreign introduction that was appropriated by Plains communities and quickly reimagined according to Native priorities.

## Comanche Rock Art of the Rio Grande Valley

How, then, might Biographic rock art be employed to compose alternative histories of the American West? To answer this question, we turn to a group of images recently discovered along the Rio Grande in northern New Mexico, not far from modern Taos. At the start of the eighteenth century, the Taos region was a key node in an emerging macroeconomy that drew together Spanish colonists, local Pueblo communities, and a shifting cast of visitors from the Rocky Mountains and Great Plains. The trade fairs held at Taos Pueblo were among the largest economic events in the American West, but the region was also a regular target of raids by mobile Native bands in search of horses, captives, and retribution. The Apache were already well established in

the region when Spanish settlers arrived at the close of the sixteenth century, occupying the interstitial regions between the major Pueblo centers (Eiselt 2012; Fowles and Eiselt 2019). At the start of the eighteenth century, Ute and Comanche bands became regular visitors as well, drawn to New Mexico from their traditional homelands to the north. By the middle of the eighteenth century, the Comanche emerged as a politically dominant force, after relocating their base of operations to the southern plains, just over the mountains from Taos, where they bred large horse herds, lived off the seemingly endless bison populations, and took advantage of the easy access to New Mexican markets (see, in particular, Hämäläinen 2008; Kavanagh 1999). Indeed, Comanche parties embarked on frequent campaigns in the Taos region during the eighteenth century, and recent research has concluded that it was during these visits that they began to enthusiastically participate in the creation of Biographic-style rock art (Fowles et al. 2017).

The densest concentration of Comanche rock art has been found in the rugged recesses of the Rio Grande Gorge, in direct association with the remains of old tipi camps. The imagery is lightly scratched and abraded on hard basalt boulders and can be very difficult to discern today, some three centuries after it was created.

In fact, it would never have been particularly vibrant, certainly not in comparison with the pecked rock art produced by Pueblo, Apache, and Ute artists. This, in itself, is revealing, for it underscores the notion that these were images produced by visiting Comanche artists who were more accustomed to the softer sandstone of their southern Wyoming homeland. In other words, this was a sandstone-based art form, awkwardly transferred to a new medium. The same artistic gesture that normally produced a deep and highly visible incised line now only produced a shallow and faintly visible scratch.

The gestural performance of the art during its production, however, may have been more important than the look of the resulting images (Fowles and Arterberry 2013). It was common, for instance, for the Comanche to scratch a serpentine line or series of lines on the boulders of the Rio Grande Gorge, sometimes right alongside or even superimposed on a pecked serpent glyph made by a prior artist. This is the case in figure 7, where an earlier Pueblo awanyu, or horned serpent, glyph appears on the left, to which has been added a scratched and much more gestural serpent on the right, likely by a Comanche visitor. Rather than critique the Comanche serpent for its informality, we must attune ourselves to the fact that the movement of the artist's hand in a serpentlike

Fig. 7. Panel depicting two serpents—an earlier Pueblo awanyu, or horned serpent, and a later scratched serpent—at site LA-75749 in the Rio Grande Gorge. (Gray areas indicate inconsistences in rock face.)

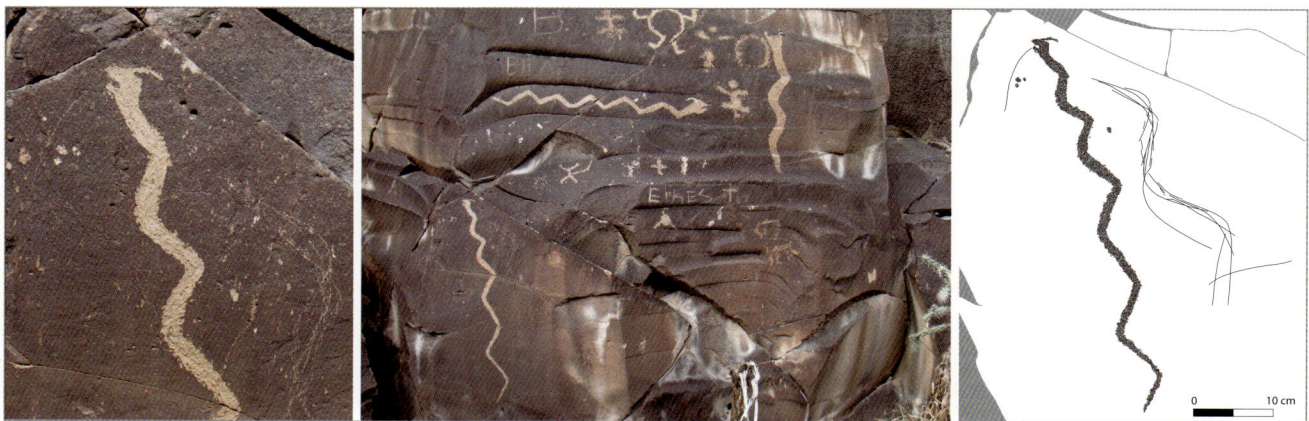

trajectory would have effectively reproduced the sign for "Comanche" in PISL. Along with their Shoshone relatives to the north, the Comanche were known as the "Snakes," signified by a serpentine movement of the hand across the chest (Wallace and Hoebel [1952] 1986, 5). Had the Comanche artist opted to peck another snake glyph, it would have indeed been more boldly visible after the fact. But the staccato impacts of pecking would not have performed the Comanche hand sign. And it was this gestural performance—rather than the finished image—that seems to have been of greatest importance.

A similar observation might be made regarding the depiction of horses. A number of Comanche panels in the Rio Grande Gorge feature sweeping lines that only vaguely resemble the tail, body, and head of a horse. Sometimes two short lines are added as ears, as if to clarify that the subject matter is equine. This is the case in figure 8, where a group of stylized Plains warriors with flowing bonnets are superimposed on a tangle of arcing lines. As finished icons, these arcing lines may only vaguely look like horses. However, if we view them instead as the gestural traces of an artistic performance, we begin to sense that the artist was more concerned with capturing the galloping movement of the horses through his own hand motions than with creating the likeness of a static equine body. In fact, these gestures may have had a double meaning insofar as the sign for "many" in PISL was made by a similar galloping movement of the right hand up the left arm. We seem to be confronting, then, a gestural commemoration of a raid in which Comanche warriors valiantly stole "many" horses.

Depictions such as these, in which a horse raid or some other significant event is fore-grounded, signals the emergence of an art form that is already oriented toward the storied careers

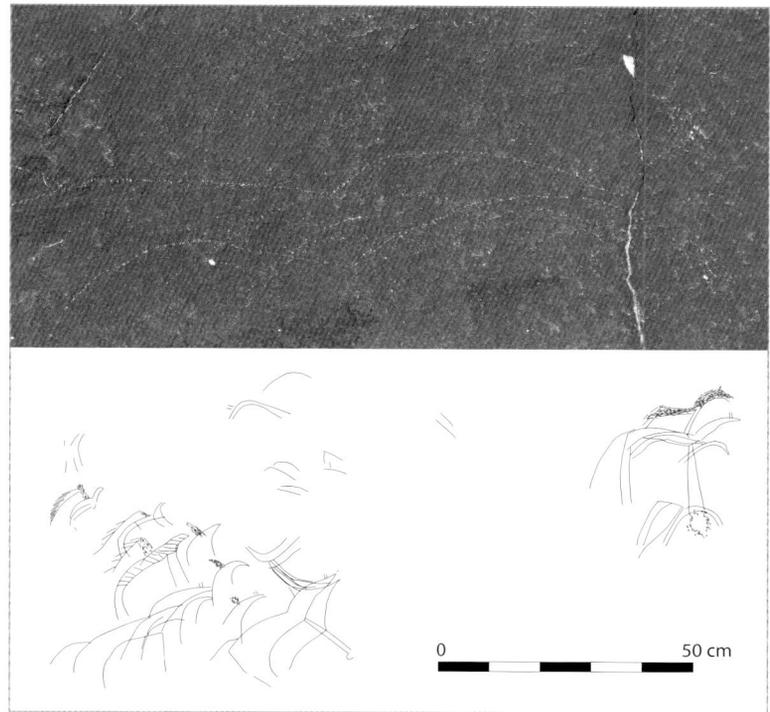

Fig. 8. Panel depicting a horse raid at site LA-75747 in the Rio Grande Gorge.

of Plains warriors. Other eighteenth-century panels along the Rio Grande are even more overtly biographical. In figure 9, for instance, we confront a combat image scratched on a prominent boulder at the edge of what was once a large eighteenth-century tipi encampment. To the right of the tracing, we have added a photograph of the panel itself, taken while one of our Comanche consultants was reenacting the gestures of her ancestors and offering her own theatrical reading of the embedded history. Here is the narrative she and others offered in response to the image (see also Fowles and Arterberry 2013): it is a tale of a major military encounter between a Comanche party (represented by the large shield-bearing warrior in the center) and a Pueblo party (represented by the diminutive warrior in the upper left). The Comanche party was clearly dominant. They had Ute allies with them (represented by the shield bearer at lower right), they wielded superior weaponry (represented by the recurved bow in the hands

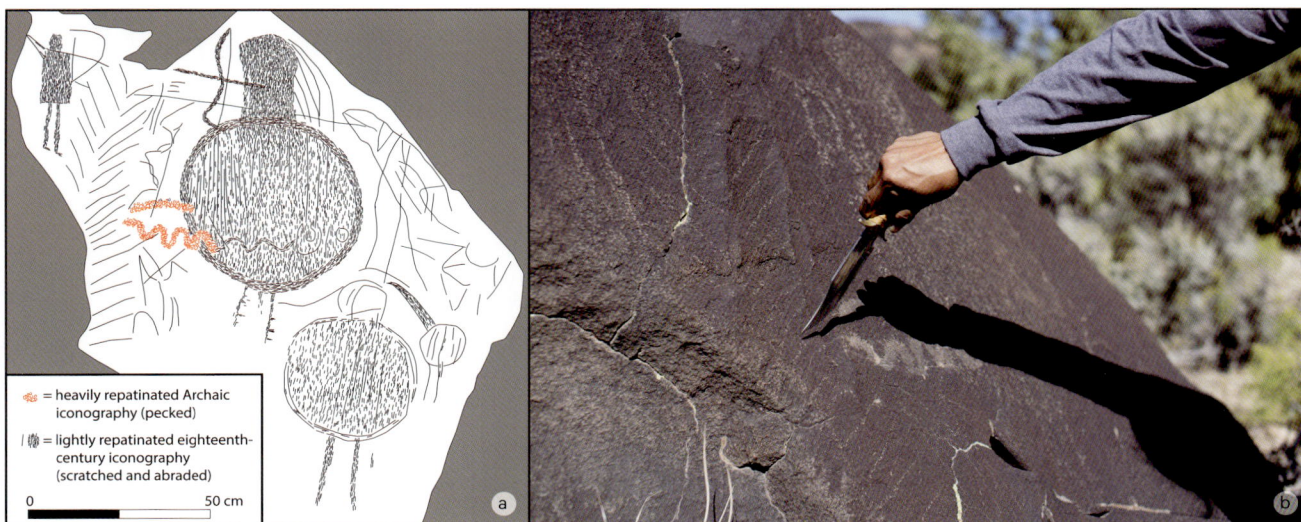

Fig. 9. *(a)* Panel depicting combat between two indigenous groups at site LA-75747 in the Rio Grande Gorge. *(b)* A Comanche tribal member narrates the rock art panel illustrated in figure 9, using her knife as a pointer. Photograph by Jason Ordaz.

of the central warrior), and they had spiritual support in the form of bear medicine (represented by the vaguely bear-like tangle of lines in the upper right of the panel). The outcome of the battle, then, comes as little surprise. Seven tally marks on the left side indicate the number of Pueblo arrows that successfully met their mark; twenty-five tally marks on the right side indicate the number of successful Comanche arrows—and perhaps also the number of Pueblo individuals killed. The Comanche and their Ute allies prevailed.

Three additional observations might be added to enrich our historical interpretation of figure 9. First, the image was created on a rock face adorned with a pecked serpentine image that was already millennia old when the Comanche artist arrived. As in figure 7, this seems to have been the very thing that drew the "Snakes"—that is, the Comanche—to the panel in the first place, an attraction they acknowledged by abrading a new extension to the serpent's body and incorporating the expanded glyph into the warrior's shield. A conscious effort, then, was made to specify the Comanche identity of the warrior. Second, the image depicts a *pedestrian* battle scene in

which the older, full-body shields are employed. This suggests we are looking at a scene that unfolded sometime before horses and guns had a chance to transform indigenous modes of warfare on the plains, probably during the late seventeenth or early eighteenth century. Third, the only actors depicted in the battle are Natives, which means it may very well commemorate an incident the Spanish colonists knew nothing about.

The latter possibility is particularly significant. The first mention of the Comanche in Spanish texts occurred in July 1706 when Taos Pueblo conveyed its fear of an imminent Ute and Comanche attack to Sergeant-Major Juan de Ulibarri ([1706] 1935). Consequently, most Western historians use 1706 as a beginning date for the Comanche's story in New Mexico. And yet, it stands to reason that Pueblo communities already feared the tribe because they had interacted with them at some point previously. Figure 9 may be giving us a view into one of those earlier incidents, perhaps a battle that took place locally, in the Taos area, during the Pueblo Revolt period (1680–92) when the Spanish—and their written modes of documentation—were in exile.

As an archive, in fact, the corpus of Plains Biographic rock art in the Rio Grande Gorge presents us with a view of the eighteenth century in which Spanish colonists are minor players. Only one of the dozens of panels depicting military encounters actually includes a European soldier. Figure 10 is dominated by a large pedestrian warrior, roughly 60 cm tall, with a full-body shield, a feathered war bonnet, and a lance held erect. The panel presumably commemorates this individual's actions. Off to the right we see the action itself. Ten shield-bearing warriors are confronting what would have then been an exotic new creature in the Greater Southwest: the six-footed, human-plus-horse hybrid machine of the Spanish military. Key identifying details have been added to mark this strange figure. A simple line scratched across the forehead, for instance, signified "hat" and therefore "white man" in Plains iconography, as it did throughout much of the colonized world. The gestural act of drawing the hat line in figure 10 would have had an extra significance for the Comanche artist, however, insofar as it mimetically rehearsed the PISL sign for "white man," which entailed a physical movement of a finger across the forehead (Mallery 1881, 494).

Other details are less clear. The Spaniard may be carrying a shield, but the curved line extending off the left side of his body more likely depicts a hand on the hip—that distinctively European bodily stance (i.e., arms akimbo) that has been used as a signifier of "white man" in indigenous rock art across the colonized world.[1] Be that as it may, the most important iconographic details in figure 8 are the lines that extend out from one of the indigenous warriors to touch the head of the Spaniard and the lines that extend out in an arm- or gun-like fashion from the Spaniard to touch the foot of his opponent. Blows were clearly exchanged. Or

to put it in a Plains idiom, coups were counted.[2] And as in figure 9, the presence of the full-body pedestrian shields suggests the action took place during the Comanche's early forays into the Taos region, sometime around 1700. Indeed, the panel may well have commemorated one of the earliest Comanche encounters with the Spanish—or more importantly, with Spanish horses, which the Comanche quickly appropriated for their own purposes.

Fast-forward a few decades. By the mid-eighteenth century, the Comanche had transitioned from a little-known and seemingly inconsequential group of nomadic interlopers from the north to an economic and military powerhouse that was now based on the southern plains and exerted major sway over the fortunes of both indigenous and settler communities throughout the American West. Much of the Comanche's success derived from their newfound equestrianism and their burgeoning horse herds, partly obtained as plunder in the course of their ongoing raids in and around Taos. But it also derived from the vast grassland ecology of the southern plains itself, which fueled not only large horse herds but also a seemingly endless sea of bison (Hämäläinen 2010). Bison were a cornerstone

Fig. 10. Panel depicting shield bearers attacking a Spaniard at site LA-75747 in the Rio Grande Gorge.

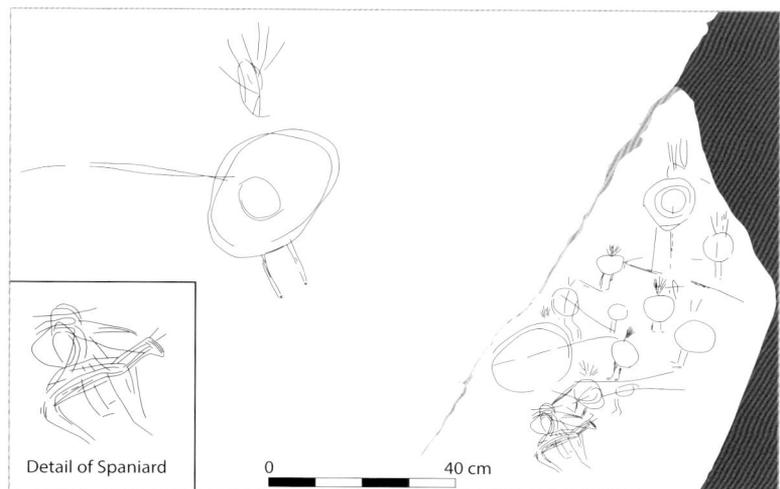

Detail of Spaniard

0                    40 cm

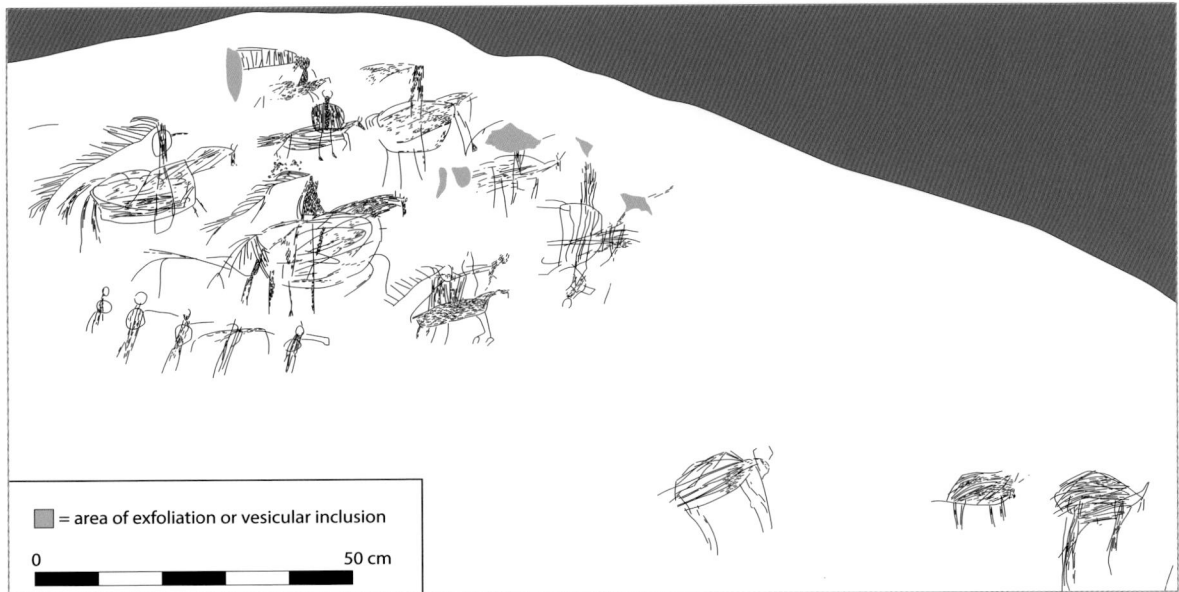

Fig.11. Panel depicting armored horses at site LA-75747 in the Rio Grande Gorge.

of the Comanche economy, providing both food and the valuable hides that Comanche bands traded widely.

This chapter in Comanche history is also documented in the rock art left behind during their eighteenth-century visits to the Taos region. Figure 11, for instance, appears to commemorate an early step along this path. A cavalry of eight dominates the panel. Most are depicted with long, flowing war bonnets, signifiers of each individual's past valor on the battlefield as well as his commitment to acting bravely in future struggles. One warrior dons a buffalo-horn headdress and has an oversize shield, again reminding us of the importance of biographical specificity within this artistic tradition. From a chronological perspective, perhaps the most important detail is the depiction of body armor on each of the horses. The Comanche are known from scattered colonial reports to have used thick, overlapping pieces of bison hide to armor their horses during the early eighteenth century (Secoy 1951, 532; Wallace and Hoebel [1952] 1986, 39). It was a military technique

that imitated the equestrian mail armor used by the Spanish, and it conveniently dates this panel to a moment prior to the 1750s, when the widespread use of firearms in indigenous warfare rendered hide armor an ineffective means of defense (Mitchell 2004, 116; see also Greer and Greer 2018, 63). Just below the cavalry is a line of five pedestrian fighters with small shields and lances or clubs, suggesting that the war party was not entirely mounted. This type of mixed equestrian/pedestrian scene further assists in confirming an early eighteenth-century date.

Off in the lower right-hand portion of the panel, three bison have been scratched in the same artistic hand, presumably as part of the same composition. As we have emphasized, bison hunting, equestrianism, warfare, and new forms of status signaling through bodily ornaments like feathered bonnets were all interrelated components of a new Comanche world that burst on the scene in the early 1700s. And yet, figure 11 is curious insofar as warfare and hunting seem to be fundamentally conflated. After all, one would never go hunting astride a

horse weighted down with heavy body armor; nor would pedestrian shield bearers ever set off in pursuit of bison wielding war clubs. The panel may conflate two separate events undertaken by the same actors. Or perhaps there is a metaphoric referent here that we are not yet attuned to but that additional research may illuminate (bison as stand-ins for human opponents?). Regardless, the panel has clearly been designed to convey historical information. For instance, the equestrian warrior on the right-hand side has been rotated ninety degrees and seems to be diving into the ground. Read in light of the wider Biographic Tradition lexicon, this would imply that the depicted individual died in the fray.

The eighteenth-century Comanche rock art of the Rio Grande Gorge is filled with imagery of this sort, and most panels almost certainly commented on a particular campaign or other notable event within the historical experience of the artist (for additional examples, see Fowles and Arterberry 2013; Fowles et al. 2017). These were not timeless images whose power was "ceremonial," in other words. They were politically motivated historical records, very much of their time: "This is what happened in Cuerno Verde's recent raid on Pecos Pueblo, here is a tally of the horses he stole, and over here is a record of who counted coup and of who died trying"—this is the sort of testimony the panels seem designed to offer those who know how to read them.

Let us take one more historical leap forward and consider two Biographic Tradition rock art panels likely created during the nineteenth century in the Rio Grande Gorge. As before, we are dating these panels primarily based on their iconographic content, but it is also the case that they exhibit a style (fine line work, iconographic detail, fill patterns, and so on) that is more characteristic of later Biographic Tradition art. Both speak to a complicated

colonial world marked by greater US influence, which of course went hand-in-hand with a newly devastating assault on indigenous ways of life. They may well have been produced by the Comanche, who still visited the Taos region, though now much more often as part of trading expeditions than military campaigns. Regardless, the images are clearly part of the wider archival project in the Rio Grande Gorge that we have been considering.

We discovered the first panel along the Rio Grande north of Taos, near an important river crossing (fig. 12). Many have passed by and added their mark to this rock face over the years: R.P. in 2007, Bob Boggs in 1940, Manuel Rael on junio 28, 1911. But beneath this modern graffiti (and therefore predating 1911), executed in scratched lines that are a good deal more heavily repatinated than the overlying text (lines that therefore predate 1911 by many decades), are two dozen or so glyphs that speak to us in an iconographic language about which we still have much to learn. The

Fig. 12. Panel depicting ciboleros in the Rio Grande Gorge near Arroyo Hondo. (Gray areas indicate inconsistences in rock face.)

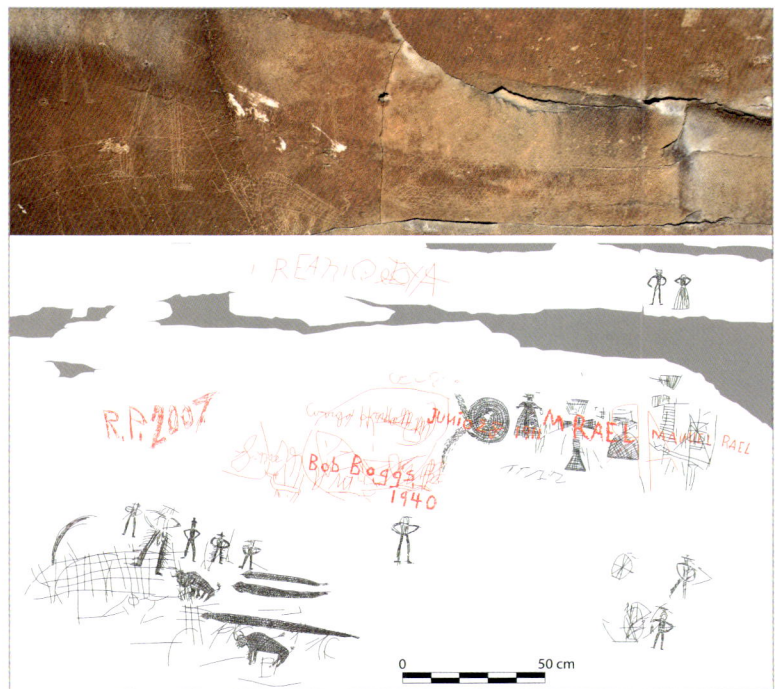

glyphs in the upper right of the panel—beneath Manuel Rael's tag—are faint and enigmatic; they include two cruciform icons (which may be Latin crosses), a human figure in a long robe or dress (very much in the style of a doll or figurine), a coiled icon (perhaps a coiled serpent or matting), a beehive structure of sorts, and other ambiguous details. The glyphs have been arranged in a line and seem to jointly comprise a tally of some sort. At least, we can say they "go together" and would have been read collectively.

The rest of the panel is dominated by a series of more recognizable icons: humans, bison, serpents, and circular glyphs that may be either shields or wagon wheels. All the humans are "white" insofar as the artist has emphatically depicted them with hat lines across their heads (in two cases, an entire hat has been added) and with arms akimbo, again in reference to the authoritative pose that Natives found so hubristically characteristic of Europeans. Interestingly, the only figure without a hat line wears the long dress of a colonial woman; she and another figure (her husband?) are set apart in the upper-right corner of the panel. All the other human figures, one assumes, are "white men"—perhaps Spanish, Mexican, French, or American individuals, or more likely, given the time period, a group with mixed Old and New World backgrounds who were nevertheless living settler colonial lifestyles. ("White," needless to say, is a slippery category, particularly in the colonial Southwest.) Be that as it may, there can be no doubt that we are looking at a Native portrayal of non-Native others, an inversion of the gaze one classically finds in textual reports from the time period.

But what are we to make, then, of the fact that two of these "white men" are wearing fringed leather leggings in classic Plains Indian style? Or that the main group in the lower left is associated with bison, at least one of which has been hunted down, as indicated by the lance stuck in his hump? We are, in short, not looking at generic settlers but rather a specific group known as *ciboleros* (see Padilla 2013). Ciboleros were Hispano buffalo hunters of the nineteenth century who effectively became de-Hispanicized insofar as they took up Comanche ways of dress, ways of hunting, and social conventions as a means of gaining access to the key hunting territories of the southern plains, which were then still firmly under Comanche and Kiowa control. Indeed, two individuals have stylized quivers on their shoulders, and another is depicted with

Fig. 13. Panel depicting a bison hunt in the Rio Grande Gorge near Pilar, New Mexico: (a) Pre-colonial pecked serpent; (b) Overlying nineteenth-century hunting scene; (c) Overlying twentieth-century graffiti. (Gray areas indicate inconsistences in rock face.)

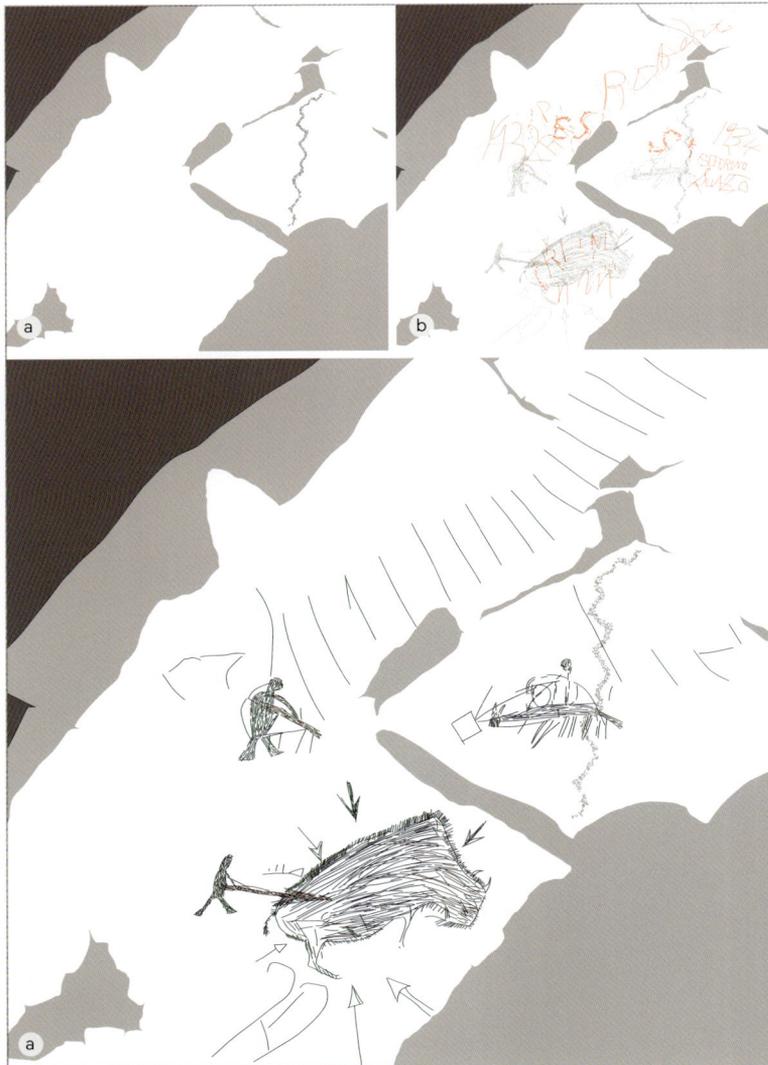

three lances, all of which were bison-hunting technologies that the ciboleros had appropriated from the surrounding Native communities by the mid-nineteenth century (see Gregg [1844] 1954, 90).

One last image: another nineteenth-century rock art panel from the Rio Grande Gorge, this time encountered south of Taos on the outskirts of a small Hispano community then known as Cieneguilla (now Pilar, New Mexico). As in figure 12, the panel reproduced in figure 13 was targeted by relatively recent graffitists—Robert in 1932 and Seferino Suazo in 1934—clearly establishing a terminus ante quem for the underlying imagery. As we have seen, however, the tendency for early art to attract later artists to the same rock face existed well before modern traditions of graffiti production. In this case, beneath the 1930s tags, a complex Biographic Tradition scene of a bison hunt was itself scratched and abraded superimposed on a much older pecked serpent. By now, of course, this is a familiar pattern (see figs. 7 and 9), consistent with the Comanche practice of appropriating existing serpentine imagery to signal that they, the Snakes, were the authors of the revised panel.

Figure 13 centers on the carefully scratched image of arrows raining down on a bison. To the left, a human figure on foot thrusts a lance directly into the bison's rump. This dangerous move may have been necessitated when the individual lost his gun, indicated by the addition of a reversed gun icon floating above the lance. Above and to the right of the bison, a figure shoots an arrow while seated astride his horse (or perhaps his mule, given the long ears). This latter hunter is quite likely Comanche, given that he appears directly superimposed on the pecked serpent glyph. And just over his shoulder, the artist has added tally lines to denote, we assume, the number of bison either

the Comanche hunter or perhaps his hunting party killed on the outing in question.

Then there is the hunter positioned just above the bison. We are given no clear ethnic signifiers to determine his identity—neither snake nor hat line—but this may have been because his actions speak loudly enough on their own. He is taking aim with the barrel of his rifle propped up on cross sticks, in a manner that was unique to the American "buffalo hunters" of the 1870s, whose long-range guns and economic avarice conspired to bring an end to the vast bison herds that formerly roamed the plains. Perched on a high point overlooking a herd, a single buffalo hunter could kill dozens or even hundreds of bison in a single day, skinning the beasts, leaving the carcasses to rot, and shipping the hides by rail to eastern cities where they would be industrially tanned to meet the growing demand for leather in European markets. It also marked a new point of confluence between capitalism, industrialism, and US imperialism insofar as overhunting doubled as a military strategy to eliminate the economic base of the Plains tribes that stood in the way of the United States' western expansion (Smits 1994). Whether or not the artist who created figure 13 already sensed this impending fate is unclear, but surely there is something ominous about the long tally of kills that extends from the buffalo hunter all the way to the edge of the boulder.

## Conclusions

Like any system of communication, Biographic Tradition imagery was built upon conventions and contexts that are difficult to reconstruct now that it is no longer actively part of a community of practice. Many details in the rock art panels we have considered remain enigmatic. What was signified by the square glyph scratched in front of the horseman's arrow in figure 13, for instance, or the snakes

alongside the ciboleros in figure 12? We need anthropologists and art historians to devote sustained research attention to such imagery so that we may more fully understand the narratives conveyed in these and thousands of other Biographic Tradition rock art panels awaiting interpretation across the American West.

The value of such research should already be clear, however: taken as an archival corpus, the images are a sweeping record of indigenous priorities and viewpoints across the colonial era. Even in just the rock art panels we have documented in the Rio Grande Gorge—which is, of course, just one small corner of the Biographic Tradition's range—we already gain a sense of what this shift of perspective can offer. The panels portray conscious acts of making history by a Plains-based community that was engaged in a dramatic period of cultural transformation. These are the images of a hot society, enchanted with the new possibilities of equestrianism and consumed with the storied careers of great men (and a few great women, though the vast majority of eighteenth- and nineteenth-century Plains women led difficult and uncelebrated lives).

Perhaps most significantly, they are also images that reverse the gaze of our dominant text-based histories, presenting Native views of colonizers and the colonial project. Against the common understanding of eighteenth-century New Mexico as a Spanish domain, for instance, the Comanche portrayed a region in which early European settlers were bit players, largely irrelevant to Native politics, except as a source of horses and guns. The nineteenth-century panels make their own interventions. Here, settlers have a much stronger presence, but one that is filtered through a distinctively Plains Indian set of historical experiences. The focus on the ciboleros in figure 12, for instance, draws us into the mid-nineteenth-century stories of settlers who were actively taking up indigenous styles and cultural practices, an inversion of the common story of Hispanicization. And it is difficult not to read the American buffalo hunter in figure 13 as having been drawn with bitter irony insofar as the long tally—previously a signifier of boldness, bravery, and social honor—now indexes the destruction of the great bison herds by stationary men seated on the sidelines, risking nothing, and killing with the movement of a single finger.

It is in this sense that Biographic Tradition art has the potential to serve as a Native counter-archive. Our proposition, in the end, is that a truly revisionist history of the American West must seriously engage such documents, thereby subverting the epistemological privilege of text through a new prioritization of the image.

◎ ◎ ◎

## Notes

**1** For a South African example of the link between whiteness and arms akimbo in indigenous rock art, see Ouzman (2003); for an example from aboriginal Australia, see Patel (2011, 36).

**2** Counting coup, a phrase associated with Plains warriors, can be understood as the striking of an enemy during battle. In order to strike an opponent during battle, a warrior would have to risk his own well-being to attain the necessary physical proximity and thus showcase his own daring and skill. If the warrior succeeded in exchanging blows or disabling his enemy, it would be counted as a coup, one of the highest honors warriors could receive. *http://plainshumanities.unl.edu/encyclopedia/doc/egp.war.013*

## References

**Basso, Keith H.** 1996. *Wisdom Sits in Places: Landscape and Language Among the Western Apache.* Albuquerque: University of New Mexico Press.

**Chávez, Thomas E.** 1990. "The Segesser Hide Paintings: History, Discovery, Art." *Great Plains Quarterly* 10 (2): 96–109.

**Davis, Jeffrey E.** 2010. *Hand Talk: Sign Language among American Indian Nations.* New York: Cambridge University Press.

Eiselt, B. Sunday. 2012. *Becoming White Clay: A History and Archaeology of Jicarilla Apache Enclavement*. Salt Lake City: University of Utah Press.

Fowles, Severin, and Jimmy Arterberry. 2013. "Gesture and Performance in Comanche Rock Art." *World Art* 3 (1): 67–82.

Fowles, Severin, Jimmy Arterberry, Lindsay Montgomery, and Heather Atherton. 2017. "Comanche New Mexico: The Eighteenth Century." In *New Mexico and the Pimería Alta: The Colonial Period in the American Southwest*, edited by John G. Douglass and William M. Graves, 157–86. Boulder: University Press of Colorado.

Fowles, Severin, and B. Sunday Eiselt. 2019. "Apache, Tiwa, and Back Again: Ethnic Shifting in the American Southwest." In *The Continuous Path: Pueblo Movement and the Archaeology of Becoming*, edited by Samuel Duwe and Robert W. Preucel, 166–94. Tucson: University of Arizona Press.

Fowles, Severin, and Lindsay Montgomery. Forthcoming. "The Rio Grande Origins of the Plains Biographic Tradition." In *Proceedings of the 2018 Southwest Symposium*, edited by Scott G. Ortman. Boulder: University Press of Colorado.

Greene, Candace S. 1985. "Women, Bison, and Coup: A Structural Analysis of Cheyenne Pictographic Art." PhD diss., University of Oklahoma, Norman.

Greer, Mavis, and John Greer. 2018. "Northwestern Plains Contact-Era Warfare as Reflected in Ethnohistory and Rock Art Studies." In *Archaeological Perspectives on Warfare on the Great Plains*, edited by Andrew J. Clark and Douglas B. Bamforth, 37–65. Boulder: University Press of Colorado.

Gregg, Josiah A. (1844) 1954. *The Commerce of the Prairies*. Norman: University of Oklahoma Press.

Hämäläinen, Pekka. 2008. *The Comanche Empire*. New Haven, CT: Yale University Press.

Hämäläinen, Pekka. 2010. "The Politics of Grass: European Expansion, Ecological Change, and Indigenous Power in the Southwest Borderlands." *William and Mary Quarterly* 67 (2): 173–208.

Kavanagh, Thomas W. 1999. *The Comanches: A History, 1706–1875*. Lincoln: University of Nebraska Press.

Keyser, James D. 1987. "A Lexicon for Historic Plains Indian Rock Art: Increasing Interpretive Potential." *Plains Anthropologist* 32 (115): 43–71.

Keyser, James D. 1996. "Painted Bison Robes: The Missing Link in the Biographic Art Style Lexicon." *Plains Anthropologist* 41 (155): 29–52.

Keyser, James D. 2000. *The Five Crows Ledger: Biographic Warrior Art of the Flathead Indians*. Salt Lake City: University of Utah Press.

Keyser, James D. 2004. *Art of the Warriors: Rock Art of the American Plains*. Salt Lake City: University of Utah Press.

Keyser, James D., and Michael A. Klassen. 2001. *Plains Indian Rock Art*. Seattle: University of Washington Press.

Loendorf, Lawrence L. 2008. *Thunder and Herds: Rock Art of the High Plains*. Walnut Creek, CA: Left Coast Press.

Mallery, Garrick. 1881. "Sign Language among North American Indians Compared with that among Other Peoples and Deaf-Mutes." In *First Annual Report of the Bureau of Ethnology to the Secretary of the Smithsonian Institution, 1879–1880*, 263–552. Washington, DC: Government Printing Office.

Mitchell, Mark D. 2004. "Tracing Comanche History: Eighteenth-Century Rock Art Depictions of Leather-Armoured Horses from the Arkansas River Basin, South-Eastern Colorado, USA." *Antiquity* 78 (299): 115–26.

Padilla, Jerry A. 2013. "Taos *Ciboleros*: Hispanic Bison Hunters." In *Taos: A Topical History*, edited by Corina A. Santistevan and Julia Moore, 105–12. Santa Fe: Museum of New Mexico Press.

Patel, Samir S. 2011. "Reading the Rocks: Aboriginal Australia's Painted History." *Archaeology* 64 (1): 32–37, 68.

Ouzman, Sven. 2003. "Indigenous Images of a Colonial Exotic: Imaginings from Bushman Southern Africa." *Before Farming* 1 (6): 1–17.

Secoy, Frank Raymond. 1951. "The Identity of the 'Paduca': An Ethnohistorical Analysis." *American Anthropologist* 53 (4): 525–42.

Smits, David D. 1994. "The Frontier Army and the Destruction of the Buffalo: 1865–1883." *Western Historical Quarterly* 25 (3): 312–38.

de Ulibarri, Juan. (1706) 1935. "The Diary of Juan de Ulibarri to El Cuartelejo, 1706." In *After Coronado: Spanish Exploration Northeast of New Mexico, 1696–1727*, edited and translated by Alfred Barnaby Thomas, 59–77. Norman: University of Oklahoma Press.

Wallace, Ernest, and E. Adamson Hoebel. (1952) 1986. *The Comanches: Lords of the South Plains*. Norman: University of Oklahoma Press.

Wilshusen, Richard H., Scott G. Ortman, and Ann Phillips. 2012. "Processions, Leaders, and Gathering Places: Changes in Early Pueblo Community Organization as Seen in Architecture, Rock Art, and Language." In *Crucible of Pueblos: The Early Pueblo Period in the Northern Southwest*, edited by Richard H. Wilshusen, Gregson Schachner, and James R. Allison, 198–219. Los Angeles: Cotsen Institute of Archaeology.

KELLEY HAYS-GILPIN

# Grand Journeys
## Hopi Mural Paintings from Ancient to Modern

The Grand Canyon is important as a sacred place of origin for many Hopi clans. Many Hopi say that the people who were to become the Hopi tribe emerged from the chaos of the underworld into this world in the Grand Canyon. Life below had become dysfunctional and dangerous, a state known as *koyaanisqatsi*, life out of balance. Those who sought a return to balance escaped by climbing a reed into this upper world, where they encountered the guardian of this earth, a humble farmer who charged them with stewardship of the land. He instructed them to travel far and wide to learn everything they would need to know to care for the land and each other, leaving their footprints in the form of potsherds, petroglyphs, and ruins as messages for those who would come later. Then they were to gather in their destined center place, the Hopi Mesas, to live by values of hard work by hand, humility, respect, and generosity.

For this reason, during its expansion of tourist-oriented attractions in the 1930s, the National Park Service planned to include Hopi traditions in several buildings on the Grand Canyon's South Rim. Architect Mary Colter was hired to design Hopi-inspired buildings (Grattan 2007), which include the Desert View Watchtower that overlooks the Colorado River and hosts interpretive exhibits. Colter designed the tower to echo the forms of ancient masonry towers in Hovenweep National Monument, in southeastern Utah, viewed by some Hopi clans and other Pueblo people as ancestral sites, and she hired Fred Kabotie, a Hopi painter, to create mural paintings on the tower's interior (Welton 2005, 2006).

This chapter discusses the artwork of modern Hopi muralists Fred Kabotie and his son Michael, who drew extensively from the imagery of their ancestors—ancient murals recovered during recent memory by archaeological excavations and disseminated via books and articles—to create new works for contemporary Hopi people. (Fred's grandson, Ed Kabotie, continues the tradition of his father and grandfather and offers his own story in the following chapter.) Imagery in many of these colorful dry fresco paintings illustrates complex ecological relationships among humans, ancestors, holy personages, plants, animals, rain, and groundwater. Both ancient and modern Hopi artists engage with themes of emergence and migration, balance and imbalance, destruction

*Opposite:* Detail of fig. 14.

Cañon de Chelly —

Estufa in "Mummy Cave"

Sheet 2.

white applied over
red — in lines about
3/16 inch wide —

Victor Mindeleff

## Archaeological Discovery of Mural Paintings in the Southwest

Is Hopi mural painting today the result of an unbroken tradition that goes back to time immemorial? Not necessarily—archaeological and ethnographic evidence is complicated. Written ethnographic records from the 1880s to the present offer little to no evidence that Hopi people were or are creating mural paintings in kivas during this period. Kivas are subterranean to semi-subterranean structures that represent the womb of emergence and are the localities for ritual activities as well as weaving, carving, and other mostly masculine tasks. Simple figures were painted for some specific ceremonies, but elaborate imagery seems to have been reserved for painted wooden kiva altar backdrops or for ritual paraphernalia and offerings, not plaster walls. The Spanish mission program of the 1600s likely suppressed mural painting along with other forms of indigenous ritual expression. Thus, these painted backdrops would have been easier to disassemble and conceal from prying priests than fixed walls.

Archaeological excavations conducted during the 1880s to 1960s, however, recovered examples of mural painting from ancestral sites that were more elaborate than those being made historically. Hopi and other Pueblo artists were well aware of these discoveries, and some, like Fred Kabotie, took active roles in excavation and documentation. While their work drew on both the archaeological murals as well as the painted media they encountered in ritual contexts within their home communities, cultural prohibitions on the public sharing of present-day ritual knowledge and practice restricted their use of images found in their home communities. Ancestral images, however, existed outside of these strictures and intrigued the artists; many of them reinterpreted the images in new artworks.

In the 1880s, the Smithsonian Institution deployed brothers Victor and Cosmos Mindeleff to Arizona and New Mexico to document ancient architecture and map archaeological sites (Mindeleff 1891). Victor recorded a painted kiva in Mummy Cave, Canyon de Chelly (fig. 1). A geometric pattern rendered in red on white, similar to that on pottery bowls of the 1100s and 1200s, encircles the bench of the structure. He also copied red, gray, and white geometric patterns on room walls in a site they named "Ruin 3." In 1901, Walter Hough of the Smithsonian Museum-Gates Expedition excavated a partial wall mural at the site now known as Kawàyka'a on Antelope Mesa (the same site excavated later by Harvard University's Peabody Museum of Archaeology and Ethnology). Hough's mural depicts a

*Opposite:* Fig. 1. Painted kiva in Mummy Cave, Canyon de Chelly National Park, Arizona, by Victor Mindeleff. Arizona Historical Society, Riordan Family Misc. Materials ca. 1888–1938, AHS 4, Box 9, Folder 5.

*Right:* Fig. 2. Kiva mural at Kawàyka'a, Hopi Mesas, recorded by Walter Hough in 1901 (Hough 1903, pl. 89).

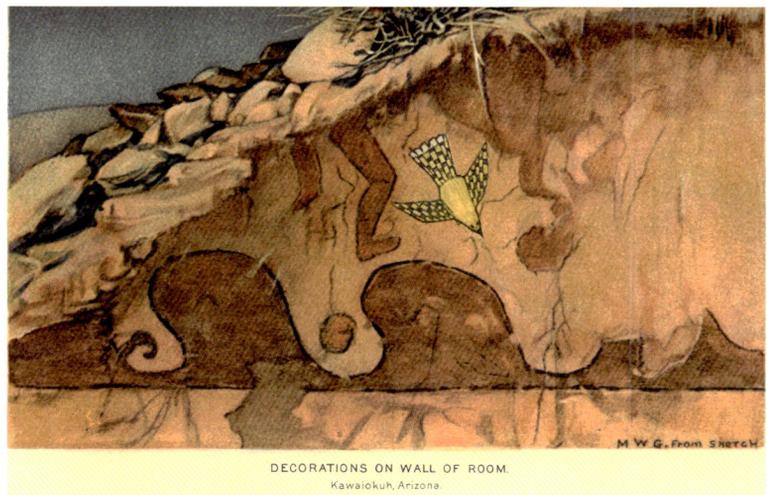

DECORATIONS ON WALL OF ROOM.
Kawaiokuh, Arizona.

M W G. from Sketch

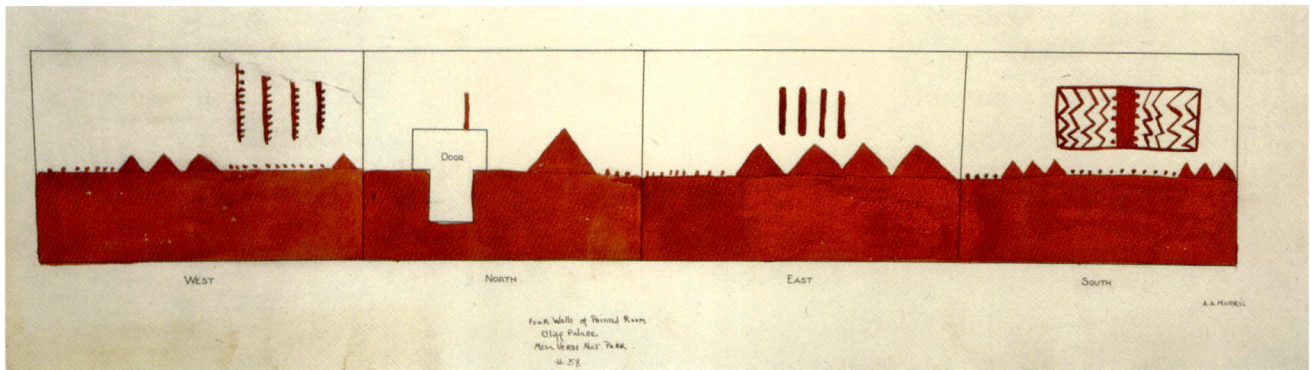

Fig. 3. Cliff Palace tower mural documentation. Pictograph paintings by A. A. Morris, 1930, Folder 5. Courtesy of the Division of Anthropology, American Museum of Natural History.

yellow-and-black bird descending toward a red base band alongside a pair of human legs and feet. The upper part of the human figure was weathered away (fig. 2; Hough 1903, pl. 89).

To the north, on Mesa Verde, Ann Axtell Morris, then of the American Museum of Natural History, documented a mural in an upper-story tower room at Cliff Palace in the late 1920s. The mural comprises a red dado (base band) with triangles that possibly represent mountains and a series of dots that have been interpreted as markers for sunrise and sunset—a horizon calendar (Newsome 2005). A rectangular blanket design "floats" in the white "sky" on an upper wall; other walls have dot and line patterns that might also be calendrical tallies (fig. 3).

Fortunately, the tower has been stabilized, and the mural, which probably dates to the 1200s, is still visible to visitors today.

Between 1935 and 1939, archaeologists from the Peabody Museum excavated the ancestral Hopi villages of Awat'ovi and Kawàyka'a (Smith 1952). The team uncovered many layers of dry fresco mural paintings in kivas (figs. 4 and 5). At the same time Harvard was exploring Hopi country, Museum of New Mexico archaeologists were searching for evidence of early Spanish encounters with Pueblo people along the Rio Grande. In 1935, Gordon Vivian discovered a painted kiva at the site of Kuaua, north of Albuquerque near Bernalillo. Here, too, are multiple layers of painted plaster

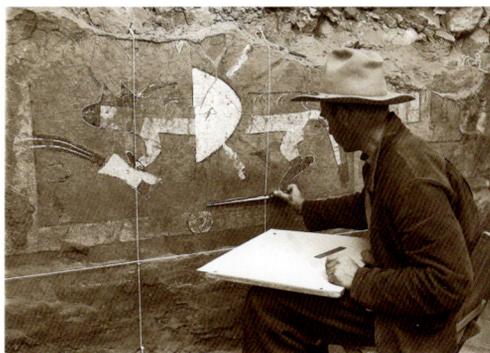

Fig. 4. Watson Smith, a Peabody Museum archaeologist, records a kiva mural at Awat'ovi, Hopi Mesas, in 1938. Room 788, Layer 8. Courtesy of the Harvard Peabody Museum of Archaeology and Ethnology, negative no. 38-204.

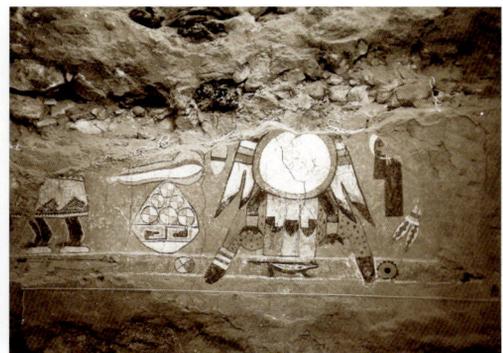

Fig. 5. Kiva mural in situ, Awat'ovi, Hopi Mesas. Room 788, Layer 5. This mural fragment was successfully removed from the ancient wall, mounted on Masonite, and transported to the Museum of Northern Arizona for display. Courtesy of the Harvard Peabody Museum of Archaeology and Ethnology, negative no. 38-197.

with elaborate polychrome figures (Dutton 1963). These murals probably date to the 1500s–1600s, probably overlapping in time with the Spanish entrada but with no evidence of European influence.

The last excavations of a significant number of kiva murals took place between 1958 and 1961. Frank Hibben of the University of New Mexico excavated Pottery Mound, on the Rio Puerco of the East, on land that now belongs to the Pueblo of Isleta. This large village contained fifteen painted kivas, some with as many as thirty-eight painted plaster layers (Hibben 1975; Schaafsma 2007). These murals probably date to the 1400s, contemporaneous with those of Awat'ovi and Kawàyka'a and a little earlier than those at Kuaua. These four sites—two in Arizona, two in New Mexico—provide a record of the most elaborate imagery yet recorded in the Southwest (figs. 6, 7, and 8). In addition, a few murals were excavated at Picuris Pueblo on the northern Rio Grande in 1965 by Herbert Dick of Southern Methodist University (Crotty 1999). These contain bold polychrome figures such as clouds and rainbows but none of the elaborately dressed figures like those to the south and west at Pottery Mound, Kuaua, Awat'ovi, and Kawàyka'a.

Fred Kabotie worked with Edgar Lee Hewett at Las Humanas Pueblo in the mid-1920s, but no murals were reported at that time. After the site became part of Gran Quivira National Monument (now Salinas National Monument) in the mid-1960s, National Park Service archaeologists excavated several painted rooms and kivas; these were not published until much later (Peckham 1981). These paintings, which date to the mid-1400s–1600s, depict corn plants, birds, rows of dots, cloud altars, probable blankets, and a few human figures.

A few other kiva and room murals here and there round out the known fourteenth- to

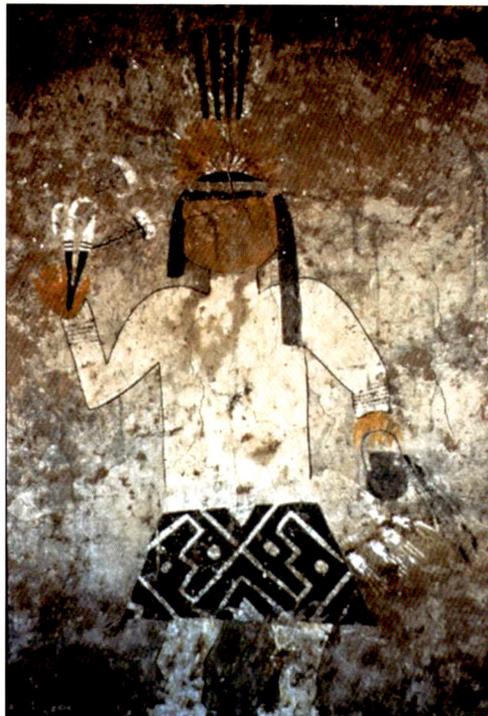

Fig. 6. Pottery Mound, New Mexico, dry fresco mural depicting a human figure carrying prayer feathers and a water jug and wearing a resist-dye kilt, cotton sash, and feather headdress. Probably fifteenth century. Field photo of original painting. Catalog no. PM42_0031. Courtesy of the Maxwell Museum of Anthropology, University of New Mexico.

sixteenth-century Pueblo mural corpus. Avocational archaeologist Gordon Pond (1966) discovered a mural painting in a kiva at Homol'ovi II, near Winslow, Arizona, that depicts the feet and kilts of several human figures, but the upper part of the mural was weathered away. Since then, only a few additional murals have been discovered, including a few simpler figures at Homol'ovi II (Adams 2002, 161) and a small katsina-like face in a kiva near Santa Fe's main plaza. Additionally, a great many earlier and less elaborate wall paintings have been discovered that date as early as the 1000s, particularly in Canyon de Chelly and Chaco Canyon national parks. Most resemble rock paintings, with simple geometric motifs, animal figures, and flute players. Banded designs that encircle an entire room tend to date to the 1200s, such as the kiva at Lowry Ruin in southwest Colorado. A fourteenth-century geometric polychrome pottery–like design was discovered on a wall in

the ancestral Zuni and Acoma site of Heshoda Yalta (Atsinna Pueblo) in El Morro National Monument (Brody 1991, pl. 12).

To summarize, the prehispanic and early contact period record of Pueblo mural painting, an early (Pueblo II–III period, or 750–1300 CE) monochrome to bichrome tradition of simple petroglyph-like figures and banded pottery–like geometric designs, often with simple red dados, gave way to a much more elaborate, but geographically varied, polychrome tradition sometime in the 1300s, which persisted into the early Spanish mission period in a few sites in the late 1500s. Characteristics of these Pueblo IV period (or 1300–ca. 1600 CE) murals include dados (sometimes) and base bands (often), flat colors, frequent outlining in black, figures in rows, and sometimes all-over geometric patterns. Frequent and widespread figures include cloud altars, birds, animals, corn plants, lightning, flowers, and elaborately adorned personages, possibly deities or holy individuals, katsinas, priests, or other ritual practitioners.

## Fred Kabotie: Ambassador, Explorer, Statesman

Fred Kabotie (1900–1986) was born in the Hopi village of Songòopavi on Second Mesa, Hopi Reservation, Arizona. He belonged to his mother's Bluebird Clan, a high-ranking clan whose traditional roles include serving as historians. Fred told his son Michael that he recalled accompanying his mother to Old Songòopavi, a ruined village below the mesa edge from the present-day mesa-top settlement, to dig for grinding stones that could be reused. As he and his mother dug in an old structure, the sand fell away to reveal a painted wall. He said he never forgot the image

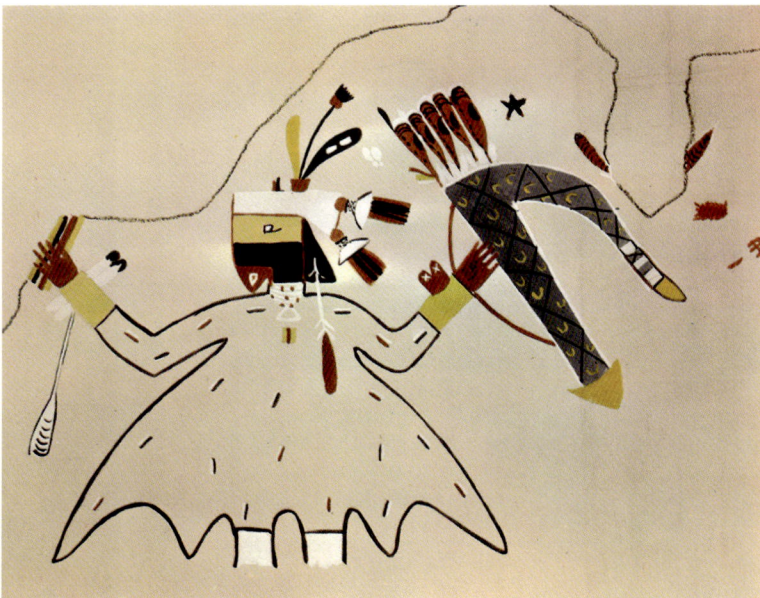

Fig. 7. Kuaua mural reproduction. Bertha Dutton's Zuni consultants identified this figure as the "universal deity." She used it as the frontispiece of her book *Sun Father's Way: The Kiva Murals of Kuaua, a Pueblo Ruin, Coronado State Monument, New Mexico* (Dutton 1963).

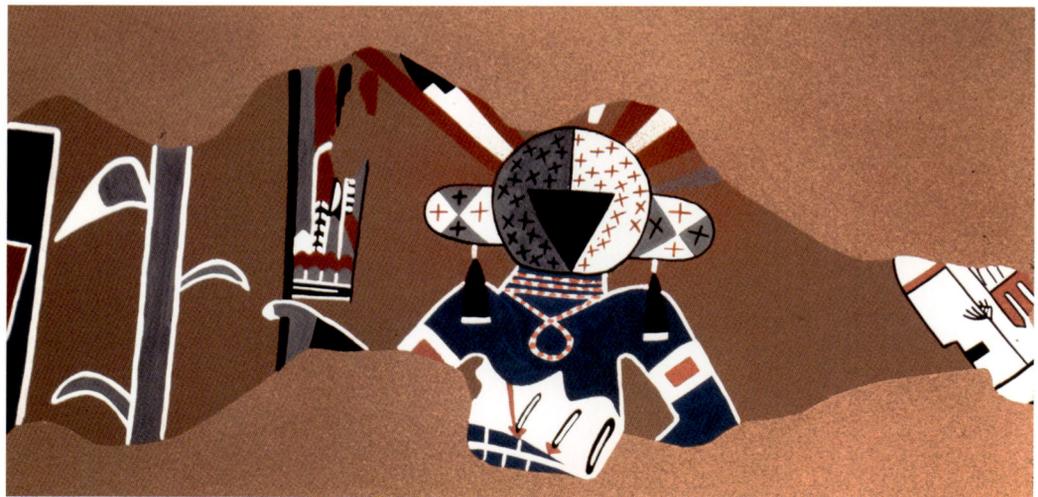

Fig. 8. Reproduction of kiva mural at Awat'ovi Room 788, Layer 4; image depicting the germinator and a corn plant. Courtesy of the Museum of Northern Arizona, catalog no. NA820. R788.1A/23101D.

of a large water bird, perhaps a crane. This memory perhaps influenced his later interests in painting and archaeology.

Kabotie attended the Santa Fe Indian Boarding School in New Mexico from 1915 to 1921. There, he studied painting with Elizabeth Willis DeHuff, who encouraged her students to paint dances and other cultural activities of their home communities. She commissioned Kabotie to illustrate books and to paint works for private collectors and museums, and Edgar Lee Hewett commissioned him to paint Indian dance scenes at the School for American Research. He spent summer vacations on excavations with Museum of New Mexico archaeologists, including Hewett (Welton 2014).

Kabotie was already an accomplished painter when he moved back to Songòopavi in 1930, and he began work on the Desert View Watchtower murals in 1932. For his subject, he chose the Snake Clan origin story (fig. 9). Each Hopi clan hands across the generations a narrative of its travels from the emergence place to the Hopi Mesas, including accounts of how it got its name and ceremonial responsibilities. The people who were to become the Hopi Snake Clan were living near Toko'navi, today called Navajo Mountain, on the Colorado River. In an effort to seek a way to end a severe drought, the chief's son, Tiyo, crafts a log boat and floats down the river (see fig. 9, top right) through the Grand Canyon, assisted by Spider Grandmother. He ends up far to the south, where the rattlesnake people teach him a ceremony to bring rain. He marries the Snake chief's daughter and brings her back home to the north (see fig. 9, bottom panels), where their offspring become the Hopi Snake Clan (Secakuku 2005). As the first man to float the length of the Colorado River, Tiyo has a special place in the history of the canyon, especially for career boatmen. His journey is thus a fitting

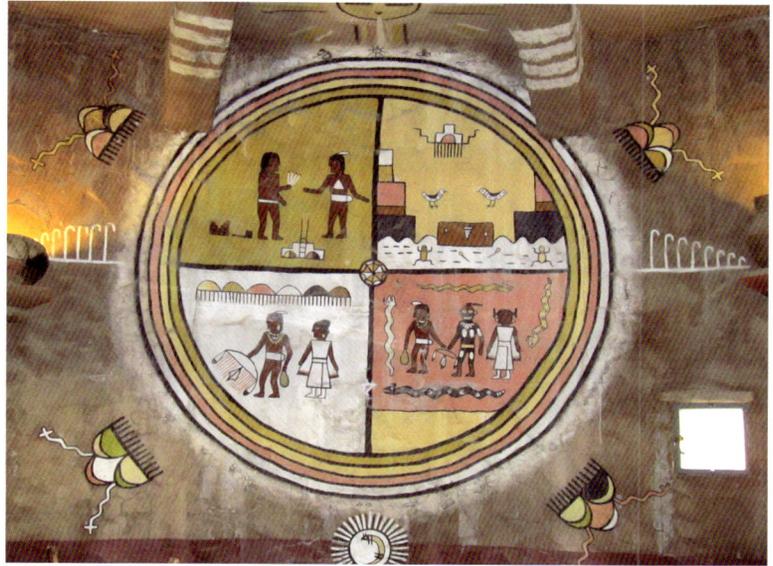

Fig. 9. Fred Kabotie's Snake Clan origin journey painting in the Desert View Watchtower. Courtesy of Rupestrian CyberServices and the National Park Service.

subject for the tower overlooking the canyon with a clear view of the river.

Back home again on the Hopi Mesas, Kabotie encountered archaeologists from the Peabody Museum who were excavating the ancestral Hopi villages of Awat'ovi and Kawàyka'a (Smith 1952). The team uncovered many layers of dry fresco mural paintings in kivas (see figs. 4 and 5). Kabotie was fascinated with the elaborate imagery and spent time watching the excavation and recording of the murals.

At the 1939 Golden Gate International Exposition, Kabotie, who was there as an easel painter (Seymour 1988, 344), befriended Miguel Covarrubias, the Mexican artist and art historian, who had been commissioned to create a series of murals for the fair (Welton 2014, 26–27). Covarrubias studied pre-Columbian Mesoamerican artwork and incorporated ancient imagery in his work, and the two must have found a great deal of common ground. Covarrubias included a mural from the Harvard excavations at Kawàyka'a in his 1954 survey of Indian art of the Americas

Fig. 10. Victor Coochwyetwa (b. 1922), Fred Kabotie (about 1900–86),
Herbert Komayouse (active mid-twentieth century), and Charles Loloma
(1921–91), *Mountain Lion*, 1938. Hopi, sand on clay and wood. Denver Art
Museum: Gift of the Indian Arts and Crafts Board: 1953.435A-C.

Fig. 11. Victor Coochwyetwa (b. 1922), Fred Kabotie (about 1900–86),
Herbert Komayouse (active mid-twentieth century), and Charles Loloma
(1921–91), *Garfish*, 1938. Hopi, sand on clay and wood. Denver Art
Museum: Gift of the Indian Arts and Crafts Board: 1953.437A-C.

(Covarrubias 1954, 152). In 1940, René d'Harnoncourt, director of the US Indian Arts and Crafts Board, hired Kabotie to make reproductions of some of the Awat'ovi mural paintings that Harvard had unearthed for an exhibition at the Museum of Modern Art in New York, *Indian Art of the United States* (1941). Frederic Douglas, the Denver Art Museum curator of Indian art, co-curated the exhibition with d'Harnoncourt, and several of these reproductions are now at the Denver Art Museum (figs. 10 and 11).

Later on, about 1949, Kabotie painted a few more murals for the National Park Service, including a complicated account of a Hopi expedition to gather salt at the Zuni Salt Lake (fig. 12). Located in the Painted Desert Inn in Petrified Forest National Park, these murals include designs from Mimbres pottery, Fourmile Polychrome, and other ancient pottery traditions. The pottery designs can be matched to archaeological reports, suggesting that Kabotie drew on publications as much as his own observations of the potsherds scattered about ancient village sites. The Salt Lake mural's composition echoes some of the conventions of pre-Columbian Mesoamerican mural and codex painting, as well as the work of Mexican muralists such as Covarrubias, Diego Rivera, José Clemente Orozco, and David Alfaro Siqueiros. For example, Kabotie depicted the salt trail as a symmetrical but meandering path or road, a common convention in Mesoamerican codices, *lienzos,* and murals. Kabotie's amusing parody of Grand Canyon tourists in the Bright Angel Lodge, painted in 1958, also shows some Mexican influence and comments on indigenous-white relationships and identities (Welton 2006).

Fred Kabotie engaged with ancestral imagery linked to landscape and history, from his initial childhood encounter with an ancient mural fragment near his home, to archaeological excavations and the representation of ancient murals in contemporary art museums, then to Mexican murals by fellow artists who were also exploring indigenous and colonial identities. Kabotie cast a wide net for ancestral images, exploring multiple media and expanding the geographic and temporal scope of his source materials but always coming back to the Hopi Mesas.

## Michael Kabotie: Trickster, Sacred Clown, Visionary

The Awat'ovi and Kawàyka'a murals on the Hopi Mesas not only inspired Fred Kabotie but also his son Michael. Born in 1942, Michael Kabotie went to boarding school and later art school, eventually returning home to his Hopi village of Songòopavi. He joined the Hopi Arts and Crafts Guild, which Fred had founded to teach silversmithing to veterans after World War II and continued to help Hopi artists develop and market their work (Hays-Gilpin 2011). In the early 1970s, Michael joined fellow Hopi artists Delbridge Honanie, Milland Lomakema Sr., Neil David Sr., and

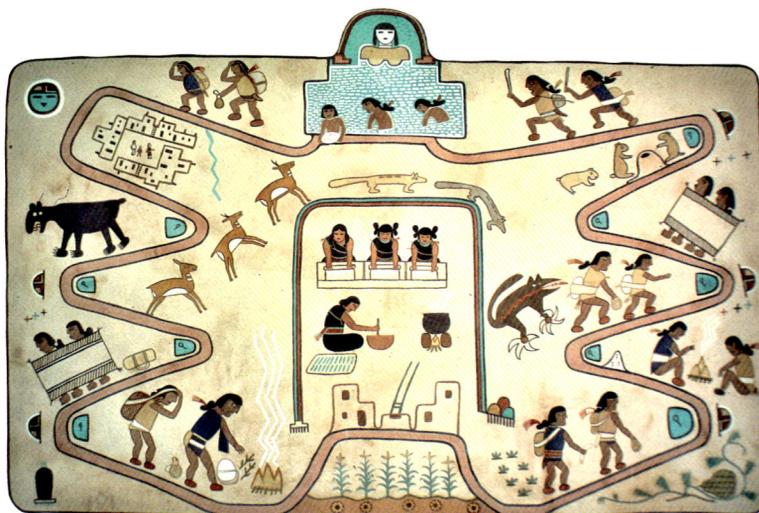

Fig. 12. Fred Kabotie's Hopi Salt Lake mural at the Painted Desert Inn, Petrified Forest National Park, Arizona. Courtesy of the National Park Service.

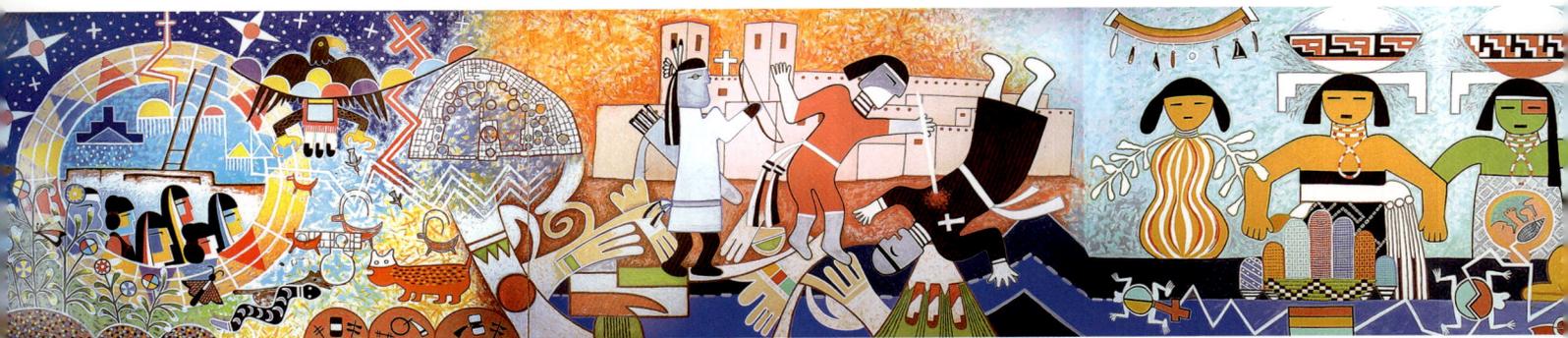

Fig. 13. Lomawywesa (Michael Kabotie; 1942–2009) and Coochsiwukioma (Delbridge Honanie; 1946–2017), *Journey of the Human Spirit*, 2001. Hopi, American, acrylic on canvas, 5 × 46 ft., six panels. Courtesy of the Museum of Northern Arizona, catalog nos. C2407A–F. Photo by Gene Balzer; composite by Robert Mark, Rupestrian CyberServices.

Terrence Talaswaima to form Artist Hopid. The group's mission was to share Hopi spirituality with the world. The group visited Awat'ovi often and studied Watson Smith's (1952) publication of the mural paintings there. They viewed Awat'ovi as "something we Hopis and others should learn from" (Lomawywesa and Coochsiwukioma 2010, 183).

Awat'ovi, more than any other Hopi village, embodied a history of missionization, oppression, liberation, and destruction: Spaniards founded a mission there in 1629 and built their church over one of the largest painted kivas, Room 788 (see figs. 4, 5, and 8). Hopis killed the mission's priests in the Pueblo Revolt of 1680, but missionaries returned in 1700, and Hopis from other villages destroyed Awat'ovi rather than allow a return to Catholic oppression. Some say the destruction of Awat'ovi was done in collaboration with some of its own leaders (Montgomery, Smith, and Brew 1949). These events are still clearly recalled with sadness today. Michael explained that this history shows that all of humanity carries its unhealed side within. He said, "We pray for life and harmony for all living things,

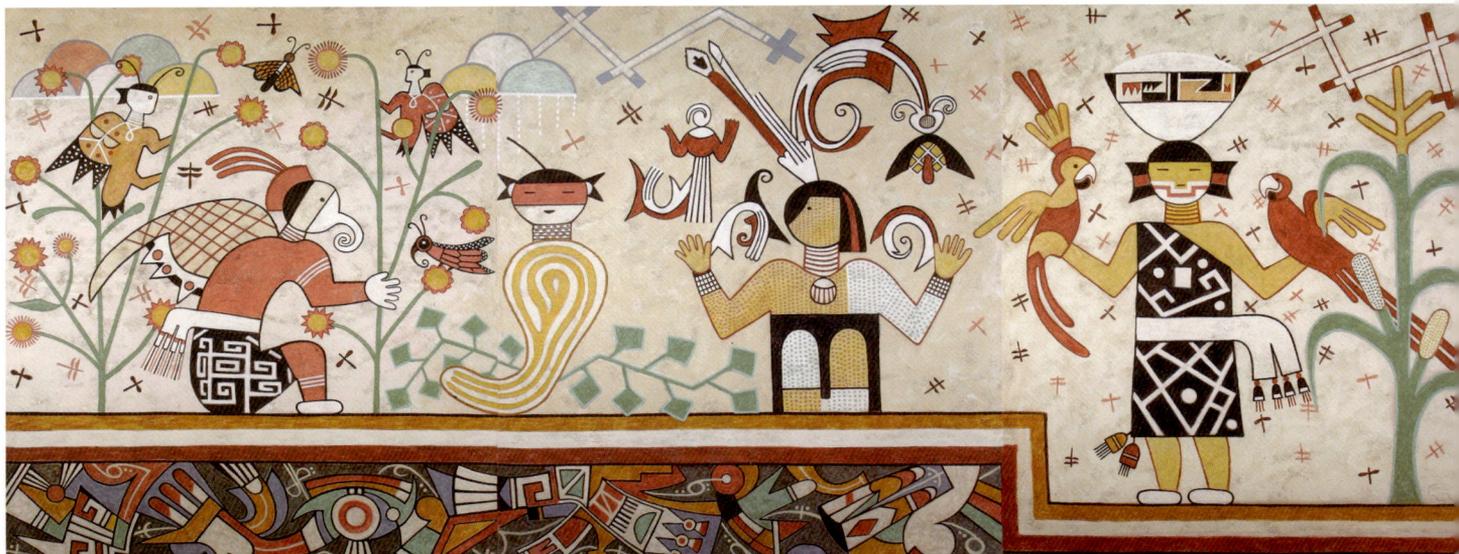

Fig. 14. Lomawywesa (Michael Kabotie; 1942–2009) and Coochsiwukioma (Delbridge Honanie; 1946–2017), *Pottery Mound: Germination*, 2002. Hopi, American, acrylic on canvas, 6 × 15 ft., three panels. Courtesy of the Museum of Northern Arizona, catalog nos. C2417A–C. Photo by Gene Balzer; composite by Robert Mark, Rupestrian CyberServices.

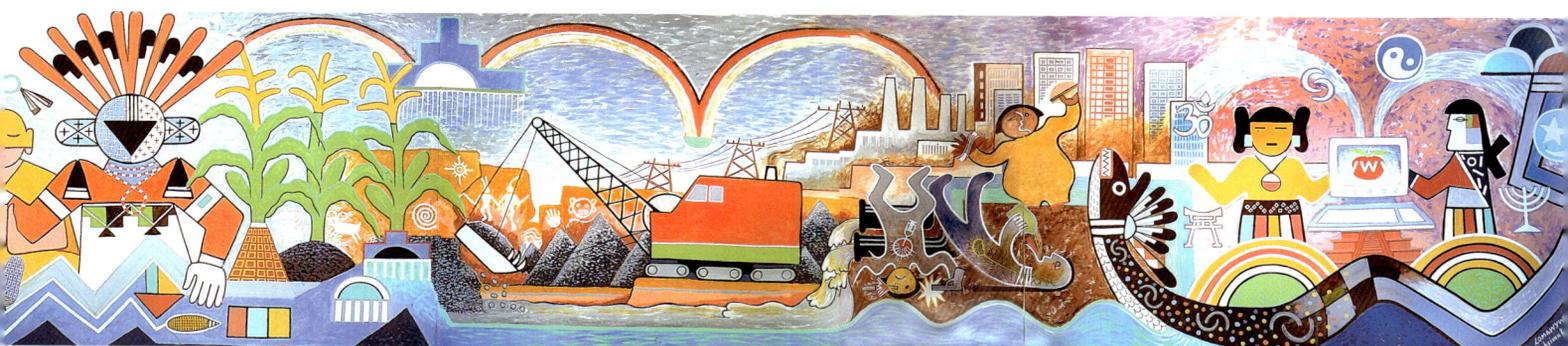

yet we destroyed our own people at Awat'ovi. And that's a contradiction" (Lomawywesa and Coochsiwukioma 2010, 183). Artist Hopid members themselves work through their unhealed sides and contradictions, in struggles with alcohol, broken families, recovery, and balancing the individualistic nature of the art market with collective Hopi religious practice.

Later in his career as a successful painter and jeweler, Michael embarked on a new phase of his journey to understand the long sweep of Hopi history. He studied world religions, particularly Buddhism, and archaeology. He traveled to ancient cities in Mexico and became particularly fond of Teotihuacan. He traveled to ancestral Pueblo sites with archaeologists and with Hopi elders.

In 1999, the Museum of Northern Arizona (MNA) and the Peabody Museum of Archaeology and Ethnology launched the Hopi Mural Project with a Getty Foundation grant to conserve original mural fragments housed in both museums and to study the mural imagery and related imagery on painted pottery in consultation with Hopi cultural experts. I was the ceramic specialist on the project. Michael Kabotie and fellow Artist Hopid member Delbridge Honanie worked as artists-in-residence at MNA, where they created the epic six-panel *Journey of the Human Spirit*, a "modern kiva mural," in 2001 (fig. 13). This contemporary kiva mural depicts emergence from the underworld, migration, the Pueblo Revolt of 1680, restoration of Hopi values, today's dysfunctional exploitation of land and water (coal mining, power generation, groundwater pumping), human dysfunction (alcoholism, obesity, suicide), and return to balance. The Water Serpent teaches responsible truths to the brother-sister twins who are united by all spiritual traditions and the potential of technology to unite us. The two men also created two triptychs inspired by Pottery Mound murals in 2002 (figs. 14 and 15). In *Germination* (fig. 14), the colorful, abstract forms in the dado, based on ancient Sikyatki Polychrome pottery designs, represent both decay and creativity in the underworld, from which new life grows and flourishes, such as butterflies, flowers, a squash maiden, a corn maiden, and a girl with scarlet macaws, symbols of the sun, warmth, and the summer growing season. In *Meeting of the Hunting and Agricultural People* (fig. 15), the artists interpreted this rather realistic rendering of a kiva mural from Pottery Mound, New Mexico, as a conference between two groups of migrating Hopi ancestors who bring together their contrasting knowledge and experience to live together in harmony.

MNA formalized a relationship with the Hopi Cultural Preservation Office in 2005 and renamed the project the Hopi Iconography Project at the request of the tribe. The project

produced several publications, including the book *Painting the Cosmos: Metaphor and Worldview in Images from the Southwest Pueblos and Mexico* (Hays-Gilpin and Schaafsma 2010), which compares southwestern and Mesoamerican imagery in murals and other media through a Hopi interpretive lens and includes a chapter by Michael and Honanie Delbridge.

Michael passed in 2009, just as our collaborative journey was getting especially interesting. However, precisely when I was most despondent about the future of our efforts, Michael's son Ed appeared at the Museum of Northern Arizona. He took up an appointment as artist-in-residence and continues to include the museum and his father's and grandfather's legacies in his own artistic journey. In the next chapter, Ed Kabotie further describes how each generation of his family combines the past with new materials and images to continue this artistic legacy.

◎ ◎ ◎

## References

**Adams, E. Charles.** 2002. *Homol'ovi: An Ancient Hopi Settlement Cluster.* Tucson: University of Arizona Press.

**Brody, J. J.** 1991. *Anasazi and Pueblo Painting.* Santa Fe, NM: SAR Press.

**Covarrubias, Miguel.** 1954. *The Eagle, the Jaguar, and the Serpent: Indian Art of the Americas, North America: Alaska, Canada, the United States.* New York: Alfred A. Knopf.

**Crotty, Helen.** 1999. "Kiva Murals and Iconography at Picuris Pueblo." In *Picuris Pueblo through Time: Eight Centuries of Change in a Northern Rio Grande Pueblo,* edited by Michael A. Adler and Herbert W. Dick, 150–87. Dallas, TX: William P. Clements Center for Southwest Studies at Southern Methodist University.

**Dutton, Bertha P.** 1963. *Sun Father's Way: The Kiva Murals of Kuaua, a Pueblo Ruin, Coronado State Monument, New Mexico.* Albuquerque: University of New Mexico Press.

**Grattan, Virginia L.** 2007. *Mary Colter: Builder Upon the Red Earth.* Grand Canyon, AZ: Grand Canyon Association.

**Hays-Gilpin, Kelley A.** 2011. "Crafting Hopi Identities at the Museum of Northern Arizona." In *Unpacking the Museum Collection: Networks of Material and Social Agency in the Museum,* edited by Sarah Byrne, Anne Clarke, Rodney Harrison, and Robin Torrence, 185–208. New York: Springer.

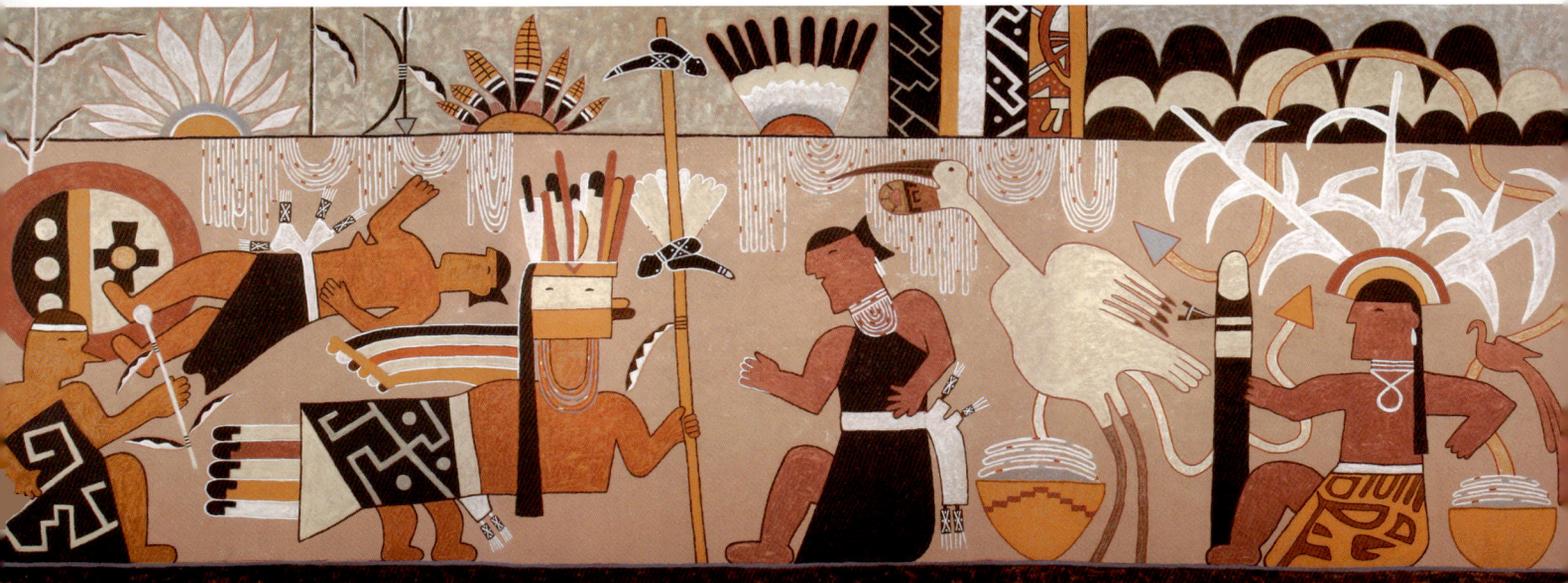

Fig. 15. Lomawywesa (Michael Kabotie; 1942–2009) and Coochsiwukioma (Delbridge Honanie; 1946–2017), *Pottery Mound: Meeting of the Hunting and Agricultural People,* 2002. Hopi, American, acrylic on canvas, 6 × 15 ft., three panels. Courtesy Museum of Northern Arizona, catalog nos. C2418A–C. Photo by Gene Balzer; composite by Robert Mark, Rupestrian CyberServices.

Hays-Gilpin, Kelley A., and Polly Schaafsma, eds. 2010. *Painting the Cosmos: Metaphor and Worldview in Images from the Southwest Pueblos and Mexico.* Bulletin 67. Flagstaff: Museum of Northern Arizona.

Hibben, Frank C. 1975. *Kiva Art of the Anasazi.* Las Vegas, NV: KC Publications.

Hough, Walter. 1903. *Archaeological Field Work in Northeastern Arizona: The Museum-Gates Expedition of 1901.* Washington, DC: US Government Printing Office.

Lomawywesa (Michael Kabotie) and Coochsiwukioma (Delbridge Honanie), with Tanya Lee and Garrett Rosenblatt. 2010. "Painting the 'Journey of the Human Spirit': A Contemporary Hopi Mural." In *Painting the Cosmos: Metaphor and Worldview in Images from the Southwest Pueblos and Mexico,* edited by Kelley Hays-Gilpin and Polly Schaafsma, 179–96. Bulletin 67. Flagstaff: Museum of Northern Arizona.

Mindeleff, Victor. 1891. "A Study of Pueblo Architecture: Tusayan and Cibola." In *8th Annual Report of the Bureau of American Ethnology 1886–'87,* 13–228. Washington, DC: US Government Printing Office.

Montgomery, Ross Gordon, Watson Smith, and John Otis Brew. 1949. *Franciscan Awatovi: The Excavation and Conjectural Reconstruction of a 17th-Century Spanish Mission Establishment at a Hopi Indian Town in Northeastern Arizona.* Reports of the Awatovi Expedition No. 3. Papers of the Peabody Museum of American Anthropology and Ethnology Vol. 36. Cambridge, MA: Harvard University.

Newsome, Elizabeth. 2005. "Weaving the Sky: The Cliff Palace Painted Tower." In "We Are Here: Pueblo Paintings and Place," edited by Kelley Hays-Gilpin. Special issue, *Plateau: The Land and People of the Colorado Plateau* 2 (2): 28–41.

Peckham, Barbara A. 1981. "Pueblo IV Murals at Mound 7." In *Contributions to Gran Quivira Archaeology, Gran Quivira National Monument, New Mexico,* edited by Alden C. Hayes, 15–38. Publications in Archaeology No. 17. Washington, DC: National Park Service.

Pond, Gordon. 1966. "A Painted Kiva near Winslow, Arizona." *American Antiquity* 31 (4): 555–58.

Schaafsma, Polly, ed. 2007. *New Perspectives on Pottery Mound.* Albuquerque: University of New Mexico Press.

Secakuku, Ferrell H. 2005. "The Snake Story." In "We Are Here: Pueblo Paintings and Place," edited by Kelley Hays-Gilpin. Special issue, *Plateau: The Land and People of the Colorado Plateau* 2 (2): 52–55.

Seymour, Tryntje Van Ness. 1988. *When the Rainbow Touches Down: The Artists and Stories Behind the Apache, Navajo, Rio Grande Pueblo, and Hopi Paintings in the William and Leslie Van Ness Denman Collection.* Phoenix, AZ: Heard Museum.

Smith, Watson. 1952. *Kiva Mural Decorations at Awatovi and Kawaika-a.* Reports of the Awatovi Expedition No. 5. Papers of the Peabody Museum of American Anthropology and Ethnology Vol. 37. Cambridge, MA: Harvard University.

Welton, Jessica. 2005. "The Watchtower Murals: 1930s Paintings by Fred Kabotie." In "We Are Here: Pueblo Paintings and Place." Special issue, *Plateau: The Land and People of the Colorado Plateau* 2 (2): 42–51.

Welton, Jessica. 2006. "Reinterpreting the Murals of Fred Kabotie: Hopi Elements for the Outside World." MA thesis, Virginia Commonwealth University, Richmond.

Welton, Jessica. 2014. "Fred Kabotie, Elizabeth Willis DeHuff, and the Genesis of the Santa Fe Style." PhD diss., Virginia Commonwealth University, Richmond.

# Mythic Archaeology

Fig. 1. Michael Kabotie and Delbridge Honanie with the last panel of *Journey of the Human Spirit* in 2001. Photo by Gene Balzer. Courtesy of the Museum of Northern Arizona.

I am a third-generation artist. I was born in 1970 and grew up dividing my time between my paternal village of Songòopavi and my maternal village of Khap'o Owinge (Santa Clara) in New Mexico. I have a deep appreciation and respect for the spiritual journey that my father, Michael, communicated through his art, silverwork, and poetry. I am also deeply appreciative of the work of my grandfather, Fred, and the blessing of his mentorship in my youth. Though both of these men have passed into the next world, they continue to have a profound influence on my life and career.

## Path to Balance

My father's art is a mirror of his spiritual journey. As a disciple of his culture, he interpreted his experiences and learning through traditional paradigms (what he referred to as "Hopi glasses") and then expressed these interpretations in his work. Ancient rock art and kiva murals were of special interest to my father, and he paid particular attention to the murals of Awat'ovi and, later, Pottery Mound. My siblings and I referred to his worn copy of Watson Smith's *Kiva Mural Decorations at Awatovi and Kawaika-a* (1952) as his Bible.

My father used to say that "mythic archaeology" is the missing discipline of anthropology. This neglected field of study combines traditional knowledge with scientific study to reveal a dynamic record of the prehistoric lives of our people. Ancient art and symbolism are key to this concept. During the Artist Hopid period of my early childhood, my father, Delbridge Honanie, Terrance Talaswaima, Milland Lomakema, and Neil David Sr. translated traditional histories and philosophies into individual paintings and collaborative murals. Embedded with a powerful sense of Hopi identity and ancient symbolism, their work inspired many young artists such as myself.

"I became an artist because I couldn't do anything else," my father often said. He loved the medium of painting. I think he was a great silversmith because he wasn't really a silversmith. Through the overlay technique, he used silver as a canvas to paint on. In his catalog of

silverwork, a perceptive eye will find a continuous thread to the Awat'ovi and Pottery Mound murals.

In his later years, my father returned to mural painting with his lifelong friend and collaborator Delbridge Honanie (fig. 1). (Delbridge and my father have a unique relational dichotomy. In the Hopi way of reckoning kinship, they are simultaneously one another's father and son.) Having valiantly and openly worked through personal struggles with alcoholism, my father became much more reflective and philosophical. With compositions that echo the "mural songs" of our ancient past, the duo's work explores cycles of meltdown and visions of renewal.

My father was at the apex of artistic expression when he passed away in 2009. I felt an intense sense of loss for myself and the world in being deprived of his voice. At home, sketches for intended murals hung on the wall (fig. 2).

When I took up residency at the Museum of Northern Arizona (MNA) in 2012, my initial focus was to create a tribute piece for my father based on one particular series of sketches. My father's Hopi name is Lomawywesa (Walking in Harmony). *Path to Balance* (fig. 3) illustrates the universal journey of life: from conception to dysfunction, from destruction to restoration, and ultimately . . . to balance. It is a tribute to his teachings and legacy.

## Qua-ah

I was vaguely aware of my grandfather's extraordinary life in my youth. From paintings, books, and pictures in the stone house that he had built for my grandmother, I knew that he was a celebrated painter, had been overseas, and that he had met the wife of one of the presidents, Eleanor Roosevelt (fig. 4). To me, however, he was Qua-ah (grandfather): teacher, storyteller, and the most diligent Hopi farmer I have ever

Fig. 2. Michael Kabotie's sketches and layout for his planned mural about the "Journey of the Sacred Clown," taken in his home on Second Mesa after his passing in 2009. Photo by Kelley Hays-Gilpin. Courtesy of Ed Kabotie.

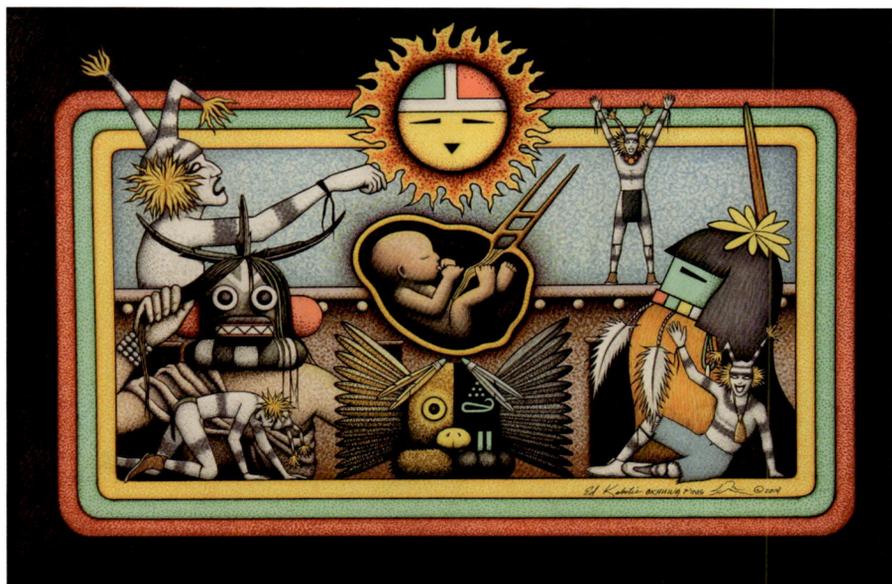

Fig. 3. *Path to Balance*, 2014, by Ed Kabotie. "*Path to Balance* is a drawing depicting the universal journey of life. Inspired by the life of my father, Michael Kabotie, and the metaphor of the Hopi clowning, the drawing illustrates nine stages of life: conception, birth, discovery, ego, ambition, dysfunction, destruction, restoration . . . and finally, balance."—Ed Kabotie, 2017. Courtesy Museum of Northern Arizona, catalog no. C2571.

Fig. 4. Painter Fred Kabotie and First Lady Eleanor Roosevelt at the exhibition *Indian Art of the United States* ( January 22–April 27, 1941). Photograph by Albert Fenn.

known. He charted the time and position of the sun's daily rising on his kitchen calendar. He planted two large fields below the mesa and nourished a home garden with household compost. "Waste not, want not" was his motto.

I have many cherished memories of my grandfather. I enjoyed listening to his stories at the dinner table and being instructed by him during drives out to the fields. I was fascinated by his geography lessons when we would hike out to harvest apricots or visit an ancestral site. He was a wealth of traditional knowledge and a patient teacher. Together, he and my grandmother exemplified *lomaqatsi* (the good life that springs from following Hopi values). He passed away when I was sixteen.

## Full Circle

A respected family friend once told me, "If you want to be a great artist, look at the work of the masters." As I prepared for *Path to Balance* at MNA, I intentionally studied the works of European "masters." It was during this time that I was interviewed by Smithsonian scholar Jessica Horton about my grandfather's representation in a 1932 exhibition at the US Pavilion in Venice, Italy. Her research and my interest in European masters gave me a new appreciation for my grandfather's work. I recognized the "Western" influences of design and perspective in many of his paintings and was

intrigued by how he applied these techniques to cultural themes.

In 2016, I was referred by the Hopi Preservation Office to work on the conservation of my grandfather's murals at the historic Desert View Watchtower on the South Rim of the Grand Canyon (fig. 5). No significant restoration work had been done on the paintings since the tower's opening in 1932. It was an unforgettable experience working under the expert direction of Angelyn Bass and Conservation Associates. Knowing that my grandfather had done the same, I hummed prayer songs as I worked, meditating on the images and stories depicted in the tower.

In the fall of 2017, five Hopi artists (including myself) were invited to participate in a Mimbres workshop led by the National

Fig. 5. Ed Kabotie taking part in conservation treatments of his grandfather's paintings in the Desert View Watchtower, Grand Canyon National Park. Photo by Erin Owensby/ WGCN. Source: https://www.grandcanyonnews.com/ news/2016/sep/27/conserving-culture-and-history-desert-view/.

Museum of Ethnology in Japan, in collaboration with the MNA, the Geronimo Springs Museum, and the New Mexico State University Museum. The group traveled to ancient sites and reviewed museum collections along the way. A key element of the workshop was considering the impact of ancient Mimbres pottery designs on early contemporary Hopi jewelry. In 1945, my grandfather was the recipient of a Guggenheim fellowship. A true mythic archaeologist, his studies were published as *Designs from the Ancient Mimbreños with a Hopi Interpretation* (Kabotie 1949). In that same year, my grandfather applied these studies to Hopi silver craft as a design instructor for the historic Hopi silver classes for veterans returning from World War II. To my knowledge, my grandfather did not physically visit the Mimbres Valley. Atsunori Ito, a scholar from the National Museum of Ethnology in Japan, said that perhaps through me, my grandfather's journey had come full circle.

## Art Is a Journey

In traditional symbolism, migration journeys are represented by a spiral. When I told my father that I wanted to pursue art as a career, he expressed his support but cautioned me to remember that "art is not a career. It's a journey." Early in my journey, I produced a painting entitled *The Parrot Trainer*. I had been interacting with images of the Pottery Mound murals and felt encouraged by the results of my study. When I displayed the piece in a show, I was offended when someone remarked that it looked very much like the work of my grandfather. Though I have deep respect for the work of my grandfather, I share with my father a keen desire to define my artwork independently from the legacy(s) of my predecessors. As I mused on my friend's well-intentioned comment, however, it occurred to me that my grandfather, my father, and I all drink from the same springs of spiritual refreshment and artistic inspiration. The voices of our ancestors speak to us in ancient murals and rock art images. It is a language that our hearts understand and our spirits respond to. Our paths are intimately integrated with the migration journey of our forefathers . . . like the ever expanding orbit of a spiral.

◎ ◎ ◎

## References

**Kabotie, Fred.** 1949. *Designs from the Ancient Mimbreños with a Hopi Interpretation.* San Francisco, CA: Grabhorn Press.

**Smith, Watson.** 1952. *Kiva Mural Decorations at Awatovi and Kawaika-a.* Reports of the Awat'ovi Expedition No. 5. Papers of the Peabody Museum of American Anthropology and Ethnology Vol. 37. Cambridge, MA: Harvard University.

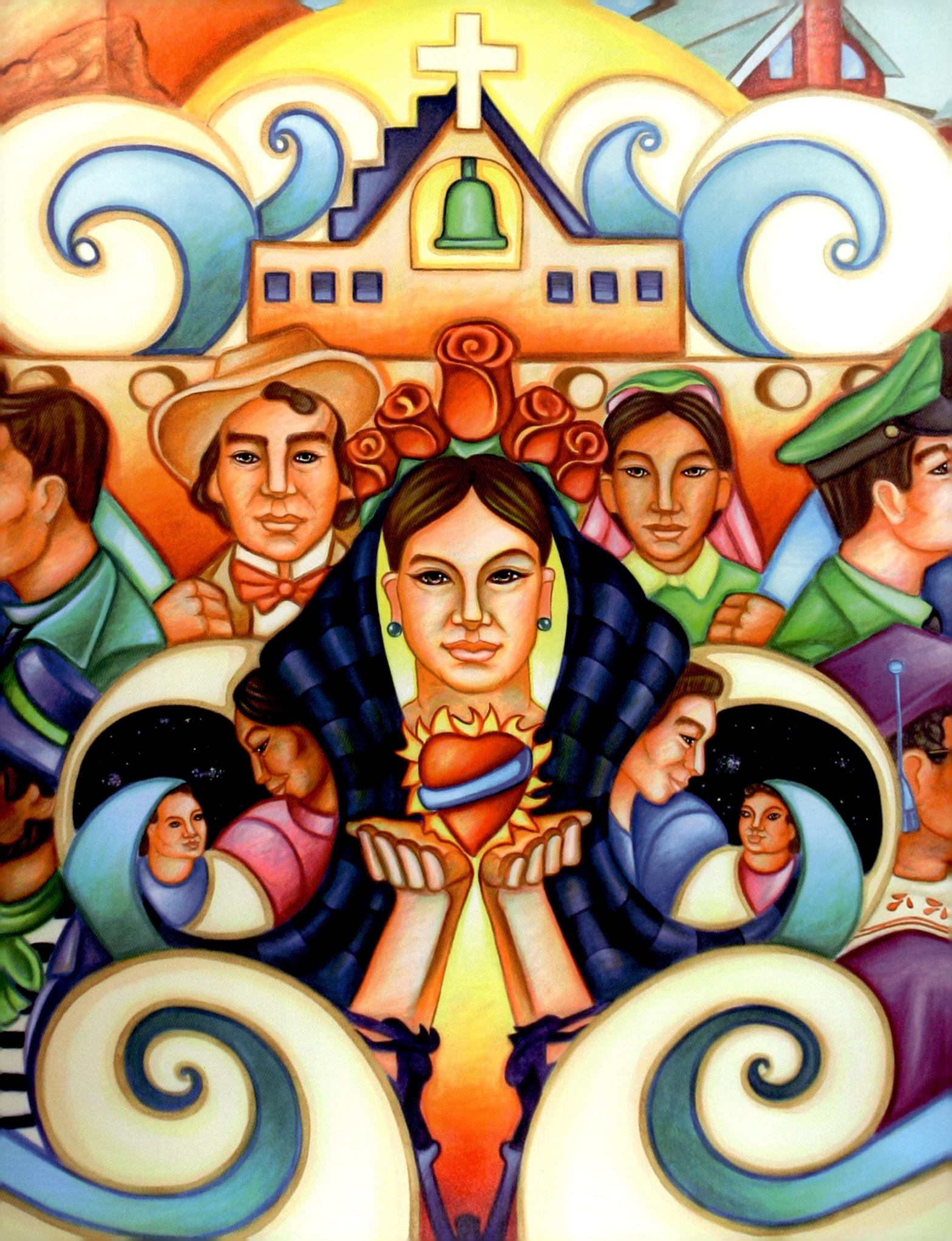

LUCHA AZTZIN MARTÍNEZ

# Heritage and Place
## Chicano Murals of Colorado

I am Chicana, and I was fortunate to grow up during the Chicano Mural Movement in Colorado. Surrounded by art and artists, I watched and often helped my father, Emanuel Martínez, paint murals throughout Colorado. My fondest memories are of when somebody from the community would walk up to a mural. I would jump off the swings in the playground or stop painting to witness the moment when the observer began to absorb the brilliant images on the wall. I'd watch as her stance became more grounded, her back straightened, and her chest struggled to hold in her pride. For those few brief moments, I experienced the power of art.

◎ ◎ ◎

The 1960s ushered in social and political upheaval throughout the United States, as the country experienced a backlash from disenfranchised, marginalized ethnic communities. Social inequality prompted a sociocultural revolution in a country that encouraged assimilation yet did not yet grant equal rights. In Colorado, Chicano youth joined the national civil rights movement to address numerous local issues—rights of farm and factory workers, resolution of land grant disputes, inclusion in the historical narrative of the nation, and equal access to quality education and employment.[1] Murals became an effective mechanism with which to fill a void after so many years of cultural abasement, functioning as a catalyst to trigger memory. This chapter explores the distinctly Colorado aesthetic that developed to describe complex narratives to legitimize Chicanos' place within the (natural and supernatural) landscape and celebrate their self-identity by venerating their ancestors.

This review of Chicano murals in Colorado focuses on murals for which we have documentary and other photographic evidence and spans the period from 1968 through 2016. The murals are not presented in the order in which they were painted; rather, I have chosen to discuss specific vignettes within the murals that describe the origins of Chicanos.

The term "Chicano" can be understood as a self-proclaimed sociopolitical term. For Chicanos living in the Southwest, many of whom are of both Native American and Spanish descent, this period marked a pivotal moment in history to publicly defend their heritage and sense of place in the national landscape. Chicanos occupied the Southwest

*Opposite:* Detail of fig. 6.

for hundreds of years before the land became part of the United States,[2] and they vehemently opposed their absence in historical accounts of Colorado, particularly in the public education curriculum. To Chicanos, these acts of erasure ignored their historical relevance and signified a concerted effort to expunge the presence and memory of an entire group of people.

Drawing inspiration from Mexican muralists such as Diego Rivera, Jose Clemente Orozco, and David Alfaro Siquieros, Chicano artists sought to educate and empower marginalized populations by publicly embracing and celebrating their cultural heritage with paintings on walls. As Chicano studies scholar and theorist Tomás Ybarra-Frausto writes, "Chicano artwork should both provide aesthetic pleasure [and] also serv[e] to educate and edify" (1991, 128). Art became an integral part of the movement.

My father, Emanuel Martínez, for example, created the image of a mestizo head to celebrate Chicanos' mixed-race heritage. He had been inspired by the tripartite face Francisco Eppens designed for a mosaic at the National Autonomous University of Mexico titled *La vida, la muerte, el mestizaje y los cuatro elementos*. Martínez adapted the head to portray a profile of a Native mother, a Spanish father, and in the center, their offspring—a Chicano with a mustache, recognizing the Mexican revolutionary hero Emiliano Zapata. He first used this image in 1967 on an altar for Cesar Chavez after he ended a hunger strike in California, where he was protesting the mistreatment of migrant laborers (fig. 1). The Chicano mestizo head became an all-encompassing icon for Hispanos, Nuevomejicanos, Mexicans, and Mexican Americans living in the Southwest, while the term "Chicano" represented an unwillingness to surrender and a call to action.

Chicano muralists functioned as visual educators, and their paintings gave neighborhoods access to a "classroom" that included and celebrated the contributions of their people in

Fig. 1. Emanuel Martínez (born 1947), *Farm Workers' Altar*, 1967. Acrylic on mahogany and plywood, 38⅛ × 54½ × 36 in. Smithsonian American Art Museum, Gift of the International Bank of Commerce in honor of Antonio R. Sanchez Sr., 1992.95. The mestizo head appears in the center of the solar motif.

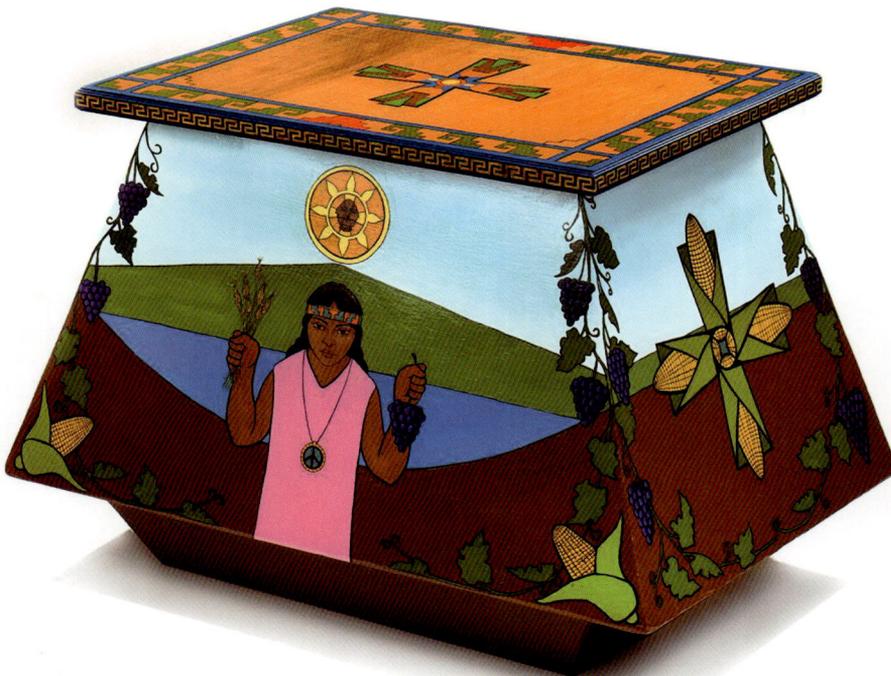

Fig. 2. Carlota D. Espinoza (born 1943), *Pasado, Presente, Futuro*, 1976. Acrylic, 5 × 20 ft. Byers Library, Denver, Colorado, located on the corner of Santa Fe Drive and W. Seventh Avenue. Courtesy of the Denver Public Library.

the historical narrative of Colorado and raised awareness of their continuing struggle. The accessibility of murals and the stories told on the walls gave people in marginalized neighborhoods a sense of pride and purpose in an otherwise hostile social environment.

The story of the Chicano people begins with the arrival of the Spanish in the Americas. In *Pasado, Presente, Futuro* (fig. 2), Denver artist Carlotta d. R. EspinoZa (who did the work under the name Carlota D. Espinoza)[3] recounts a brief history of the Mexican people from the prehispanic empires, to the arrival of the Spanish, to the Mexican Revolution, and finally the emergence of southwestern Chicano culture. Commissioned as a bicentennial project in 1976 for the Denver Public Library system, the mural celebrates the ethnic hybridity of the Southwest. Larger-than-life historical figures stand out against a vibrant Mexican landscape. In the foreground of the mural, children and elders are shown reading books, whose titles correspond to the historical period. EspinoZa's composition underscores that it is through books that children will learn about the historical figures and their actions. The pyramid visible at the far left

memorializes the ancient past. In the center of the painting, the artist makes reference to the landing of Hernán Cortés in 1519 near what is now Veracruz, Mexico, and the infamous moment when Cortés, fearing mutiny, destroyed the ships the Spaniards arrived in, forcing his reluctant men to march into Tenochtitlan, the Mexica (Aztec) capital, to search for gold and ultimately to conquer the Aztec Empire. At center right, a Mexican revolutionary astride a brown horse wears the distinctive broad-brimmed hat and sarape, a reference to the Mexican Revolution; he looks back toward the Spanish conquistador on the other side. On the far right of the mural, EspinoZa includes images related to the development of southwestern Chicano culture, including a santero crafting a sculpture of the Virgin of Guadalupe, a southwestern adobe church, and Cesar Chavez.

One of the most distinctive figures in the mural is that of the seated woman who is shown with her naked back to the viewer. The kneeling woman represents Malintzin (also known as La Malinche or Marina), the indigenous interpreter and lover of Cortés. Throughout time, Malintzin has been a controversial figure,

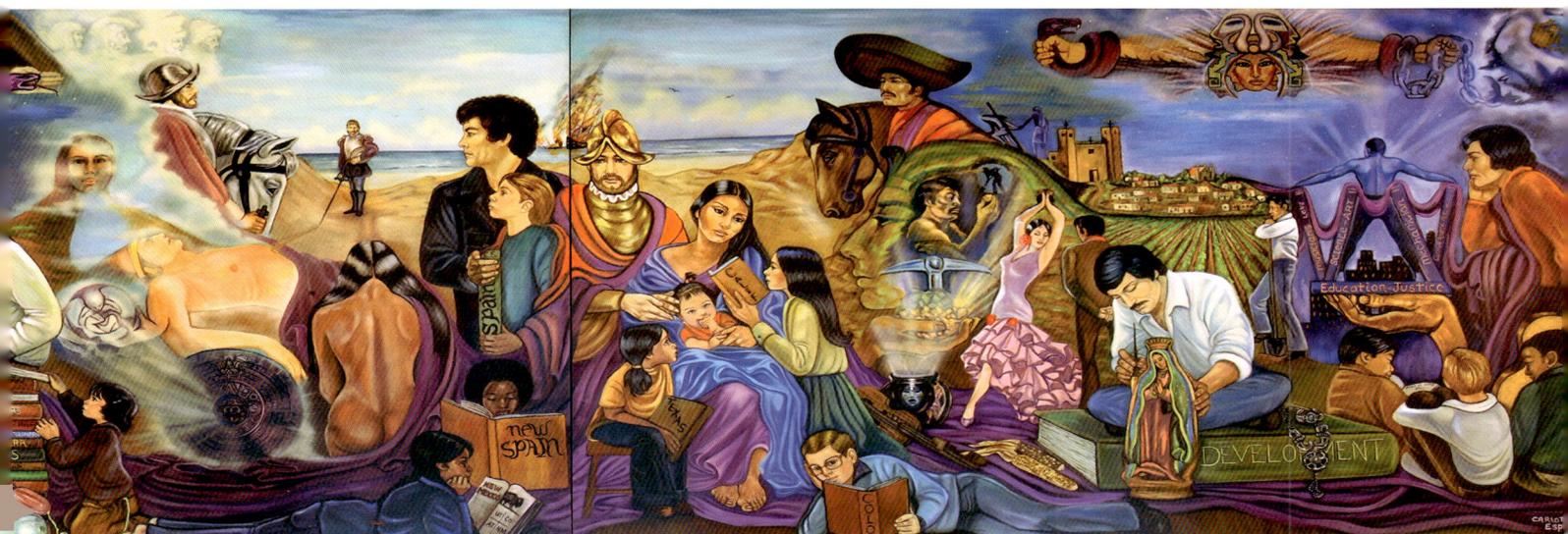

described in conflicting terms from traitor to victim. EspinoZa's decision to portray only the bare back and buttocks of Malintzin invites many interpretations of artistic intent. Certainly, the overall perception of Malintzin has evolved and will continue to evolve. The colonizing Spaniards portrayed Malintzin "as a minor character who illustrated a willing acceptance of Spanish instruction" (Jager 2016, 161); however, following the independence of Mexico from Spain, Malintzin became for some nationalists "a feminine traitor who assisted the Spanish colonizers" (161). For Chicano artists, however, the image of Malintzin conveys strength and inspires admiration, for even though her prowess and linguistic knowledge enabled Cortés to conquer the Mexica, she was a survivor and will always represent the mother of the mestizo people.

The prominent presence in the mural of children and elders reading books honors the mural's location: behind the circulation desk of the Byers Library in a predominantly Chicano neighborhood in west Denver. As mentioned earlier, one of the primary motives of Chicano murals was to serve as a visual classroom accessible to the community. But for many young Chicano artists and their peers at the beginning of the civil rights movement, learning about their past was challenging. The subject matter was not taught in public schools, and many Chicanos did not feel comfortable visiting the Denver Art Museum, which housed pre-Columbian artifacts. Instead, artists' inspiration came from books. By placing the children in the foreground and the historical figures behind them, EspinoZa's composition suggests that as they read, the children visualize the people and places of Mesoamerica. Chicano youth and artists learned about their cultural heritage from books available to them in public libraries. As EspinoZa notes in her artist's statement in a 1976 brochure for the Byers Library, the mural represents a "story of a people: Chicano! It is a story of a people's romance with history, from the Aztec Empire, through Spanish imperialism, from alienation to the struggle to re-win a people's identity, pride and future."

Fig. 3. Design by Jerry Jaramillo (born 1952), assisted by Al Sanchez, Carlos Sandoval, and Stevon Lucero, *La Familia Cósmica*, 1980. Acrylic, 17 × 75 ft. Located at La Familia Recreation Center, 65 S. Elati Street, Denver, Colorado. Photograph by Daniel Salazar.

## Mestizaje

The notion of "mestizaje" was formulated by intellectuals like José Vasconcelos, the architect of the Mexican Mural Movement, during the early twentieth century in Mexico. Chicanos later included the added dimension of mestizaje to their own US experience (Latorre 2008, 74). According to Guisela Latorre, with the term "Cosmic Race/*La Raza Cósmica*," Vasconcelos suggested that eventually "the four 'races' that exist in the world—that is, the Caucasian, the Indian, the Asian, and the African ethnicities—would converge into one superior and cosmic fifth race that would be free of the vices and weaknesses of the previous four" (2008, 74). Jerry Jaramillo, with Carlos Sandoval, Al Sanchez, and Stevon Lucero, portray this epoch merging of cultures in their mural *La Familia Cósmica* at La Familia Recreation Center in west Denver (fig. 3). Taking place in a subdued blue and gray aquatic, peaceful, supernatural setting, a family—father, mother, son, and daughter—composed of all four races gazes out into the four sacred directions.

Because of Chicanos' strong connection to the land, indigenous imagery describing their bond to the land and the supernatural deities that control this cycle of life resonated in their hearts. In his mural *The Staff of Life*, Emanuel Martínez depicts Cortés and Malintzin/La Malinche as supernatural entities, the creators of life (fig. 4). In the foreground lie skeletons of a Mexica eagle warrior and a Spanish conquistador grasping their weapons. Roots of a maize plant wrap around their arms, growing through the body of Cortés and Malintzin's offspring. From his body and the symbolic sacrifice of the people who perished during the conquest sprouts the staff of life, a maize stalk whose fruit bears the mestizo head along with profiles of other individuals, representing what is often referred as the Cosmic Race. Two platforms are

supported by a Catholic saint on the right and a Toltec warrior from Tula, Hidalgo, Mexico, on the left. Standing atop the platforms are two groups of Mexican people divided by the Treaty of Guadalupe Hidalgo—one group represents Mexico while the other represents the southwestern United States. The American bald eagle and a Mexican eagle clasp in their claws the body of the same serpent, representing a symbolic bond between the Hispanos and the Mexicans. Standing between the two platforms, a contemporary mestizo man and woman clutch the staff of life, from which the mestizo and the Cosmic Race converge.

In *Brown Flowers, the Mestizo People* (fig. 5), artist Carlotta d. R. EspinoZa similarly celebrates the mixed-race heritage of Chicanos but grounds it in the specific landscape and imagery of the Southwest. Along the horizon line, EspinoZa includes an array of recognizable architecture that references historical change. Starting at the far left, a Mesoamerican stepped pyramid gives way to a colonial church, followed by an adobe mission and

Fig. 4. Emanuel Martínez (born 1947), *The Staff of Life*, 1976. Acrylic on drywall, 15 × 20 ft. Located in the Cherry Creek building at the Community College of Denver on the Auraria Campus near the intersection of Colfax and Champa. Courtesy of Emanuel Martínez.

Fig. 5. Carlota D. Espinoza (born 1943), *Brown Flowers, the Mestizo People*, 1988. Acrylic on Masonite, approximately 7 × 20 ft. Located at the Westside Community Health Center at 1100 Federal Boulevard, Denver, Colorado. Photograph courtesy of the Chicano Murals of Colorado Project.

finally the Denver skyline. In the foreground, EspinoZa places familiar individuals, such as a Chicano couple dressed in pachuco/a clothing, embracing as they stand in a park in front of Denver's cityscape to acknowledge the active role individuals from every background and ethnicity play in an all-encompassing historical narrative.

## Regional Perspective

Unlike their Mexican counterparts who attended the best art schools and benefited from the backing of the Mexican government to paint murals in public settings, many Chicano artists were primarily self-taught and lacked the support of any cultural or government institution at the beginning of the Chicano Mural Movement. Chicano artists nevertheless persisted and began to paint their cultural heritage on the walls of buildings located in public neighborhood parks, on recreation centers, and on clinics. Similar mural movements materialized in communities across California, New Mexico, and Texas, as well as in Chicago. Artists tackled issues confronting the community, and "murals became a tool for artists to voice historical injustices and to a certain extent empower a silent audience—the poor and disenfranchised" (Martínez de Luna 2005, 158). Chicanos began to boldly declare

their significant role and importance in the identity of the nation.

One of the most well-known and well-preserved examples of Chicano mural painting in California is San Diego's Chicano Park, located directly beneath the east-west approach ramps of the Coronado Bridge where it intersects with Interstate 5. The construction of the freeway separated Barrio Logan, one of the oldest Mexican American communities in San Diego County, from the larger Logan Heights neighborhood. The park now includes forty murals on twenty-four pillars (Rosen and Fisher 2001, 94).

As mentioned above, initially some government institutions disapproved of Chicano public art throughout the region. For example, on April 22, 1970, residents of Barrio Logan occupied the land beneath the bridge to protest the city's efforts to rescind a promise made in 1967 to designate the area as a future neighborhood park and instead build a new California Highway Patrol station (Latorre 2008, 156; Rosen and Fisher 2001, 94). After blocking construction crews from the site, Salvado "Queso" Torres designed a plan for local artists to paint murals on the T-shaped highway pylons, as the activists "believed that if change were to occur for Chicanas/os at the local level, it needed to be accompanied by a discourse

that legitimized their presence in transhistorical spaces" (Latorre 2008, 159).

Artists were not discouraged, as they sought to inspire a sense of pride among members and raise awareness about community history and the ongoing struggles Chicanos faced. A shared vocabulary developed among Chicano artists throughout the region. The visual imagery of many early murals, for example, emphasized the community's indigenous heritage by employing pre-Columbian references (Goldman 1990, 167). Scenes of the war for independence or the Mexican Revolution similarly formed part of this early imagery. By the 1970s, regional groups of artists began to form that developed their own style and spoke to local issues (Ybarra-Frausto 1991, 137).

In California, however, according to Eva Sperling Cockcroft and Holly Barnet-Sánchez, by 1974, traditional Chicano symbols such as the black eagle or the nopal and pre-Columbian imagery were seen as old-fashioned and clichéd (2001, 13). By 1977, the artists of Chicano Park, for example, integrated non-Chicano artists and themes into the park's program, delving into contemporary sociopolitical issues, addressing a multiethnic population including Latinos from a variety of Latin American countries.

Colorado Latinos, on the other hand, were primarily of New Mexico/southern Colorado Hispano and Mexican ancestry; as a result, their murals frequently borrow imagery and iconography from the Native American/Hispano Southwest and Mesoamerica. This eclectic art style resonated in the hearts of many. Colorado Chicano muralists challenged communities to embrace their urban surroundings, and with this large canvas, invited people throughout the state into a narrative that acknowledged Chicanos' historical and contemporary contributions while promoting equality, celebrating

diversity, and instilling hope in beleaguered communities.

## Colorado Chicano Ties to Southwestern History

Chicano murals in Colorado reference the complex history of colonization, subjugation, and racial intermixing of the Southwest. Southern Colorado, specifically the San Luis Valley, constituted the northernmost frontier of the Spanish Empire and later Mexico. From the initial explorations of Coronado in 1540 to the Pueblo Revolt of 1680, from the fight for Mexican independence in 1810 to the annexation by the United States in 1848, southwestern communities witnessed intense cultural clashes and changes to their daily existence. Isolated from the rest of New Spain, the people living in this region formed a compact group. The blending of cultures—Spanish and Native American—resulted in a unique Hispano identity that many Colorado Chicano artists continue to reference in their work.[4]

In 1540, Francisco Vázquez de Coronado led an expedition through the present-day states of Arizona, Kansas, New Mexico, Oklahoma, and Texas. This early expedition paved the way for later explorer Juan de Oñate, who by directive of the king of Spain ultimately colonized the northern territories, including present-day New Mexico, nearly fifty years later. Home to the Ancestral Puebloan people, who had learned to farm the land, the territory later attracted additional indigenous groups, most notably Navajos and Jicarilla Apaches.

Early Spanish settlers of New Mexico lived hundreds of miles from cosmopolitan centers such as Guanajuato and had limited access to the lucrative exchange network of goods from the capital, Mexico City. Settlers in New Mexico became increasingly more reliant on

trade with Puebloan groups and other tribes who practiced a nomadic lifestyle, particularly in the seasonal trade fairs in Taos, Pecos Pueblo, and Abiquiu (Chávez 2006, 64).

Although the Spanish Crown officially outlawed the enslavement of indigenous people throughout the Spanish Empire in 1542, cheap labor formed a cornerstone of the empire's economic success; therefore, opportunities were found to circumvent the antislavery laws, particularly in remote settlements such as New Mexico. The rampant enslavement and forced labor practices were key factors in bringing the tensions between the Spanish colonizers and the indigenous community to a head in 1680. As historian Andrés Reséndez writes, "A long list of New Mexican governors right up to the Pueblo Revolt of 1680 were not only tolerant or complicit in trafficking [of indigenous slaves], but were directly and actively involved" (2016, 119). Indigenous slaves were often sold to work the silver mines of northern Mexico (169). The Pueblo people, under the leadership of Po'pay of Ohkay Owingeh (renamed San Juan Pueblo by the Spanish during the colonial period), organized a revolt against their Spanish overlords, systematically destroying missions, churches, and other Christian material and ultimately decimating the Spanish population in the region (156–57).

The revolt prompted many settlers to flee toward present-day Texas. However, the Spanish Crown was determined to resettle the area and appointed Don Diego de Vargas the new governor of New Mexico in 1691. De Vargas negotiated the return of the Spanish colonists, many of whom had grown attached to the land, which marked the birthplace of many of their children and the resting place of relatives (Chávez 2006, 77). The negotiations between de Vargas and Pueblo leaders marked a significant settlement strategy shift by the

Spanish government, including the abolishment of the encomienda social system, which had granted landowners parcels of land as well as control of indigenous laborers in exchange for arranging for their religious instruction (Chávez 2006, 63; Reséndez 2016, 35–37). Furthermore, the negotiations encouraged the formation of an agrarian society by giving out land grants to both Pueblos and the colonists who resettled in the area (Esquibel 2003); however, both the settlers and Pueblos faced new threats as the Plains Apaches, Comanches, and Pawnees began to conduct continuous raids. Between 1693 and 1719, Pueblo auxiliaries joined forces with the Spaniards to defend themselves against these new threats.

In subsequent years, the territories witnessed greater social and political upheaval as their national affiliation became unstable. On September 16, 1810, Miguel Hidalgo y Costilla initiated Mexico's War of Independence with a battle cry now known as the "Grito de Dolores" in Guanajuato, Mexico. During the next eleven long years, the independence movement ensued, ultimately resulting in the creation of the new country of Mexico in 1821.

On the front line of two young countries—the United States of America and Mexico—Hispanos in New Mexico experienced significant changes in the cultural, social, and economic dynamics of their society. After the war of Mexican independence, a flow of commercial goods and people traveled between the Mexican heartland and its northern territory. Mexico encouraged settlement in its northern territory with numerous land grants, particularly north of New Mexico, attempting to ward off growing American interests in their territory. In 1842, the newly established settlement of El Pueblo (today Pueblo, Colorado), located along the Arkansas River and the great headquarters and wintering place of the fur trade, stood at

the edge of the two countries, United States to the north and Mexico to the south.

David Ocelotl Garcia's mural, *Corazón del Pueblo* (fig. 6), for the Rawlings Library in Pueblo, Colorado, synthesizes the history of the Southwest. Structured in three parts, the mural was designed by Garcia to create a symmetrical balance—a technique often applied in Chicano narrative murals in Colorado, such as Emanuel Martinez's *Staff of Life* (see fig. 4) and Carlotta d. R. EspinoZa's *Pasado, Presente, Futuro* (see fig. 2). The left-hand side of the work references the colonization of the Southwest, the displacement of Native peoples, and independence from Spain, while the right-hand side documents struggles of the modern era including the building of the railroads, the annexation by the United States, and the plight of farmworkers.

Notice at the bottom left the sharp contrasts of reds and purples that capture the mantas of the Pueblo women, bending over their harvest of corn, beans, and squash along a river drainage, their velvety black braids dangling over their shoulders. Garcia references the struggles between the Spanish settlers and the indigenous community as well as the unusual alliances that formed between them. At the far-left edge, an indigenous mother holds her son back with one hand while the boy reaches out to grasp the bow of a Native American warrior wearing a war bonnet, a group of tipis between them. With her other hand, the mother tears at a Spanish Empire flag waving above an ominous, dark gray scene of a large cross held by indigenous slaves as they follow a Spanish governor leading a group of Franciscan monks carrying spears. In the center of the left side appears the battle for Mexican independence: Spanish and Mexican soldiers raise their weapons against each other. At the far-left edge, above the battle scene, a

solemn mestiza/Hispana emerges from the same Spanish Empire flag, symbolizing the birth of the mestizo people in Spain's northern territory. Unlike the romanticized pictorial account of the birth of a mestizo child in *Pasado, Presente, Futuro*, in *Corazón del Pueblo* (see figs. 2 and 6) Garcia portrays the birth of mestizos in the Southwest as rooted in conflict.

In the center of *Corazón del Pueblo*, people ascend from the cavity of the earth, referencing the origin story of the Tewa Pueblo people, while the powerful image of Mother Earth is portrayed as a Hispana with strong Spanish features holding the heart of the city of Pueblo. In addition to these two images, Garcia celebrates the diversity of southern Colorado by adding numerous portraits of prominent individuals from the area, such as pioneers Mariano Autobee and Teresita Sandoval.

The right-hand side of *Corazón del Pueblo* references the anguish of many Hispanos as they made the heartbreaking decision to move away from their homeland with the hopes of securing job opportunities as laborers in the coal mines, on the railroads, or for seasonal agricultural work in the late 1880s and early 1900s. Many migrated from San Luis de la Culebra (San Luis), the oldest town in Colorado, which was founded by Hispanos in 1851 when the area was still part of the Territory of New Mexico until Colorado became a territory in 1861 and later a state in 1876. Located in the southern end of the state, the fertile San Luis Valley had been inhabited for thousands of years by indigenous people such as Pueblos, Utes, Navajos, Apaches, and Comanches when Hispanos arrived. For example, according to Shannon A. Mahan, Rebecca A. Donlan, and Barbara Kardos, "the Tewa Pueblo, established circa AD 1300, and the Taos Pueblo people both have origin stories that indicate the emergence of these Pueblo peoples were from

a place near Blanca Peak on the eastern edge of the San Luis Valley" (2014, 1).

In *Sierras y Colores*, artist Carlos Sandoval represents the brilliant, sharp, cool hues of the San Juan Mountains, La Garita Mountains, Sawatch Range, and the Sangre de Cristo Mountains of southern Colorado (fig. 7). Three men stand proudly admiring their work, gazing across the acequias, a network of irrigation ditches and canals designed by the early settlers to share and distribute water equally. In the center, the eye is drawn to the hypnotic gaze of a Hispana displaying the abundant array of fruits and vegetables harvested in the valley. Sandoval captures the spirit of both the Native Americans and Hispano settlers converging in the center, symbolizing the sacrificial toll and spread of Christianity during the period of colonization.

The San Luis Valley area became a symbol of dispossession and discrimination for the

Colorado Chicano community during the civil rights era. In the 1840s, Canadian-born Charles Beaubien became the owner of a one-million-acre tract in the San Luis Valley known as the Sangre de Cristo land grant. Because the Mexican government required Beaubien to settle the land as a condition of ownership, he recruited Hispano settlers from northern New Mexico. Before his death in 1864, Beaubien described in detail how he intended for the Hispano community to maintain rights and access to the land. In 1960, however, Jack Taylor purchased the northern half of the property and began to deny access and build fences to keep people out. Decades of litigation ensued until the Colorado Supreme Court affirmed the historic grazing rights on June 24, 2002.[5]

The mural *Primavera* by Jerry Jaramillo was painted with students from Servicios de La Raza (a Colorado nonprofit human services

Fig. 6. David Ocelotl Garcia (born 1977), *Corazón del Pueblo*, 2011. Acrylic on canvas, 10 × 30 ft. Robert Hoag Rawlings Public Library, Pueblo, Colorado. Courtesy of David Ocelotl Garcia.

organization) and hearkens back to memories of the Spanish settlers singing a type of corrido (Mexican folk ballad) called *alabados*, religious hymns not only sung in church but also while tending fields to request aid from saints during the precarious period when plants are getting established (fig. 8). Chicano ancestral familial traditions revolved around an agrarian-based lifestyle, just as in the ancient agricultural societies of the Southwest and Mesoamerica. As a result, Chicanos' connection to the natural world is a theme revisited in numerous murals recalling memories of a time when they owned and cultivated land. In *Primavera*, a farmer beckons the aid of a spring goddess materializing from a silver-blue early morning mist floating above the crops. To both celebrate and honor the fertility of the earth, the musician serenades the deity with an alabado to request her aid during the growing season.

As seen in *Pasado, Presente, Futuro*; *Corazón del Pueblo*; and *Sierras y Colores* (see figs. 2, 6, and 7), Colorado Chicano artists repeatedly reference the connection to their New Mexican ancestry, thereby publicly linking the self, family, and community to a broader historical narrative. The history of the Southwest is a complicated narrative: while many arbitrary borders were drawn and redrawn, and claims and territories were taken and retaken, the spirit of the mestizo people remained constant, and Chicanos insisted that no arbitrary line would erase their identity.

By the late 1880s and early 1900s, many Hispanos continuously migrated in search of seasonal labor, becoming more disconnected from their homeland in southern Colorado and New Mexico. In many families, siblings were born in numerous towns throughout Colorado where their parents could find seasonal work.

Fig. 7. Carlos Sandoval (born 1944), *Sierras y Colores*, 1986. Acrylic on cement, 24 × 43 ft. Located in San Luis, Colorado. Courtesy of Joe Beine.

Fig. 8. Jerry Jaramillo (born 1952), *Primavera*, 1981. Acrylic glazes and exterior latex on brick, 14 × 14 ft. Located at W. Forty-First and Tejon, Denver, Colorado; destroyed. Courtesy of Jerry Jaramillo.

The completion of railroad lines in the plains of Colorado sparked an ambitious effort by the Great Western Sugar Company to encourage farmworkers to settle in areas once considered uninhabitable (Aguayo 1998, 107). Initially, German and Russian families from Nebraska and Japanese single males were recruited, and these initial immigrants eventually settled and some bought farms of their own (107). Great Western, in need of more farmworkers, sent agents to southern Colorado, New Mexico, and Texas to entice impoverished Hispanos to join their labor force (107). The company also employed Mexican immigrants fleeing from the violence of the Mexican Revolution that was ravaging the country between 1910 and 1920.

In many of the rural towns in northern Colorado where Great Western, coal mines, and meatpacking companies hired Mexican and Hispano migrant laborers, housing was only made available near the factories, on the fringes of society (Aguayo 1998, 114). Despite the fact many of these laborers were American citizens, it was not uncommon to see store or restaurant signs in windows stating "we cater to the white trade only" (Aguayo 1998, 118) or "No Spanish No Mexicans No Dogs Allowed." The creators of these signs were careful to clarify the distinction between Hispanos and more recent Mexican arrivals on their offensive signs, evidently aware that Hispanos were "different," but both ethnic groups were considered unwelcome at these local establishments. The Hispano and Mexican children who were fortunate enough to attend rural schools in northern Colorado (as opposed to having to work in the fields alongside their family members) were often hit over the hands with rulers if caught speaking Spanish on school grounds and often ridiculed by classmates and teachers. Many Spanish-speaking children of this generation sacrificed their identities by ceasing to speak their native language to avoid calling attention to themselves.

## Denver Chicano History

Prospects of better employment and education opportunities lured many Hispano and Mexican families that worked as seasonal

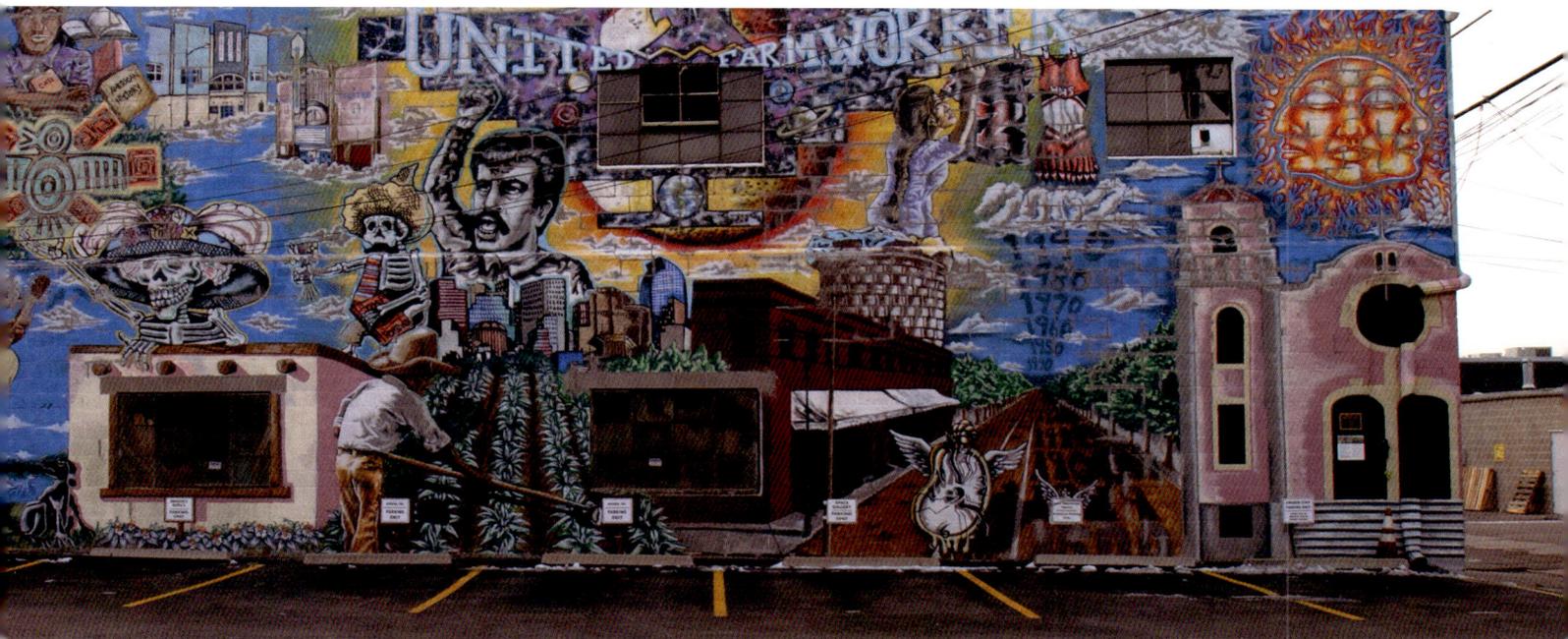

migrant laborers away from northern and southern Colorado to Denver, while other Hispanos migrated from northern New Mexico to settle in the growing city. Auraria, Denver's oldest neighborhood, was once home to seasonal Arapaho and Cheyenne encampments, but with the discovery of gold in the Platte River in 1858, prospectors transformed the riverbanks into a thriving city. Staking claims to the land, immigrants of Central and Eastern European origins began to populate the area ("Auraria Neighborhood History," n.d.). As the source of gold waned, however, Auraria became home to a poor, working-class population and small business and industry ("Auraria Neighborhood History," n.d.). The ethnic makeup of Auraria continued to shift as Hispano and recent arrivals from Mexico began to work in the industrial sector of the city. By 1941, a large concentration of Hispanos and Mexicans lived in Auraria. In 1956, under the pretext of overcrowding, the city changed zoning rules, prohibiting the construction of new residential housing.

In the spray-painted mural *History of the West Side Community*, artist Marc Anthony Martínez describes in detail the role of Chicanos in Auraria (fig. 9). Shortly after the city enacted zoning changes, city officials began the construction of the Lincoln Park housing project south of Colfax Avenue to absorb the growth in Auraria. After a devastating flood severely damaged the Auraria neighborhood in June 1965, city officials seized the opportunity to declare the area irreparable. Local newspapers "described the neighborhood as dilapidated and the residents as uneducated and poor" (Su Teatro Cultural and Performing Arts Center, n.d.). The city chose Auraria as the site of a new urban redevelopment project: the building of new college campuses for the Metropolitan State College of Denver (Metropolitan State University [MSU]), Community College of Denver, and, eventually, University of Colorado at Denver. The project displaced Auraria's primarily Hispano and Mexican residents.

The Hispano and Mexican American population living in Auraria resisted this

Fig. 9. Marc Anthony Martínez, *History of the West Side Community*, 2002. Spray paint on cement. 25 × 125 ft. Located on the back side of 771 Santa Fe Drive at Eighth and Santa Fe Drive, Denver, Colorado. Courtesy of Tony Ortega.

displacement by organizing the Auraria Residents Organization, led by Father Pete Garcia of St. Cajetan Catholic Church, to protest the city's bond issue that would destroy their neighborhood. However, attempts to stop the project were ignored, and demolition of their neighborhood promptly began. As Julie Torres-Lopez recalls, "It was a very, very sad time. People wanted to hold on to each other. . . . When you're united like that and then not knowing where you're going to end up—or where you're going to go—or will we see you again—or when will we see you again. It just divided everybody" (Gallegos 1991, 59). By 1972, the entire community was forced out, with many people moving into the adjacent Lincoln Park housing project built by the city years earlier, while others fled to other parts of the city.

In *History of the West Side Community*, Martínez memorializes the cultural influence of St. Cajetan's church by detailing the Spanish Colonial Revival–style architecture at the far right. After the displacement of the people, the once sacred space of many families was converted into offices and an auditorium for the newly built colleges, and the congregation was relocated to St. Cajetan Catholic Church at 299 South Raleigh Street in southwest Denver. Martínez, acknowledging the ancestry of Chicanos, paints the bright sun in the image of a mestizo head shining above the Denver landscape. To the right, a mother hangs sports clothes from the neighborhood's West High School out to dry on a clothesline, referencing the important role the students played during the civil rights movement.

In March 1969, students from West High walked out of school to protest discriminating remarks from and actions of teachers. The West High School "blowout" marked a pivotal moment for the Chicano Movement,

as it became a call to action, even though the threat of police brutality and harassment increased. Nevertheless, the young activists persisted in proclaiming West Denver their rightful home, as Martínez shows in the mural with historical landmarks such as the Byers Library, the Buckhorn Exchange Steakhouse (Denver's oldest restaurant), and the Santa Fe Theatre. Referencing these older buildings with Chicanos performing chores within the painting portrays how the structures relate to daily life in the community. For a community that has repeatedly felt threatened and displaced, the mural provides a sense of place within the greater landscape, hence legitimizing the role Chicanos play in the city.

Coinciding with a grassroots neighborhood movement in Lincoln Park (West Side neighborhood), Chicano youth from all corners of the state were periodically joining together with African American and American Indian communities in downtown Denver to rally against an oppressive sociopolitical system and demand equal civil rights. As the civil rights movement enfolded Colorado, protesters gathered in front of the state capitol armed with posters and a banner with the famous quote by Mexican revolutionary Emiliano Zapata—"It is better to die on your feet than to live on your knees"—as well as the image of a mestizo head.

In 1969, Chicano activists drafted "El Plan Spiritual de Aztlan" at the Chicano Liberation Youth Conference in Denver. Inspired by the Aztec creation story and their ancestral homeland, Aztlan, Chicanos proclaimed the American Southwest as their Aztlan. At the conference, Chicano youth drafted a resolution to proudly embrace and celebrate their origin story through music, dance, theater, and art. With the powerful application of public art, artists and people from the community challenged the status quo by questioning the prevailing

ideology and joining together to create monumental art that described their cultural identity and legitimate right to live in the landscape. The location for the first open space public murals was in the Lincoln Park housing project, in an area Chicanos referred to as the West Side.

The Lincoln Park housing project symbolized a vicious cyclical pattern of resettlement in the history of the Chicano/mestizo people in the Southwest. In 1970, as an artist and resident of Lincoln Park housing project, my father, Emanuel Martínez, began to assemble youth volunteers living in the projects. With recycled paint, Martínez and the youth began to paint narratives of their heritage in the Lincoln Park/La Alma Park neighborhood. Martínez began by painting the façade of his and other residents' homes with bold red and white Zapotec geometric designs (fig. 10). The Denver Housing Authority did not appreciate these beautification efforts and threatened to evict us. Disheartened, neighbors joined together and signed a petition to prevent our eviction and the destruction of the paintings.

Motivated by the positive response in the community, Martínez decided to paint the side of a storage building in the pool area of the Lincoln Park housing project's neighborhood park. The City and County of Denver tried to stop the mural painting by mandating that the walls of city buildings could only be painted by a city employee. Martínez solved this problem by training to be a lifeguard and officially becoming a city employee. So, in 1970, Martínez, with the assistance of youth from the neighborhood, painted the entire swimming pool building at Lincoln Park (fig. 11).

On the center of the wall, Martínez suggested the Mexica Sunstone, often referred to as the Aztec Calendar Stone, in the background. Martínez replaced Tonatiuh, the fifth sun, with an image of the mestizo head—symbolizing

Top: Fig. 10. Zapotec geometric designs painted by Emanuel Martínez, 1969, Lincoln Housing Projects. The author is at right, with her sister. Photograph courtesy of Emanuel Martínez.

Bottom: Fig. 11. Emanuel Martínez (born 1947), *Untitled*, 1971. Enamel on brick, 10 × 60 ft. Lincoln Park pool building, Denver, Colorado; destroyed. Courtesy of Emanuel Martínez.

the creation of Chicanos. According to Guisela Latorre, "The ubiquity of the Aztec Calendar Stone was only rivaled by the recurrent use among Chicana/o muralists of the mestizo or tripartite face . . . [which] came to define, in its most basic and direct form, the essence of Chicana/o cultural and ethnic identity" (2008, 74). Encircling the mestizo head were two images of Quetzalcoatl,[6] and written on the body of one of the serpents was "La Raza."[7] Below the sun, Emiliano Zapata, the revolutionary hero for both Chicanos and Mexicans, stood on the first steps of a pyramid. Zapata symbolized the struggle of the poor, marginalized populations, and most importantly, the indigenous peoples in Mexico. On the right side of the sun, four hands—brown, black, white, and yellow—were clasped, signifying the unity of races. From the beginning of the movement, Chicanos emphasized the equality of all ethnicities.

At the base of the building, a band of white, stepped diamonds ran through the center of elongated red diamonds outlined by thick, blue lines, and above, there was a band of green, stepped diamonds with a yellow, elongated rectangle in the center, and elongated yellow diamonds outlined thick red lines. Similar geometric designs are found on Navajo textiles. Perched above the designs, a band of stylistic eagles with a sun behind each defined the horizon: "The eagle image—the logo for the United Farm Workers movement in California led by Cesar Chavez—symbolized solidarity with Chicanos throughout the nation. At the south side of the building, a profile of four indigenous people, two on each side, gazed toward the horizon" (Martínez de Luna 2015, 27).

After the pool closed for the season, Martínez sought to keep the mural momentum alive in his community. He applied for a six-month grant to create a Denver Opportunity Arts and Crafts community program through Denver Opportunity (Barnett 1984, 69). Martínez approached the parks and recreation department to seek permission to create an ongoing community program. With permission from the city, he became the founder and director of La Alma Recreation Center, converting the storage facility into a local recreation and community center. The artist and youth went on to paint the exterior walls and the interior ceilings and walls of the storage facility/recreation center with inspirational pre-Columbian images, a Mexica warrior, and Puebloan warriors.

Soon, officials from neighborhood parks in other impoverished ethnic communities began requesting that Martínez paint murals, such as on walls in Curtis Park, Argo Park, and the Robert F. Kennedy Recreation Center. For example, in Curtis Park, a dilapidated pool building covered with graffiti was more reminiscent of a wall along a highway than a place where a community gathered to socialize. Here, Martínez created large portraits of both a Chicano female and male and an African American female and male because he designed murals considering the ethnicity of the people living in the neighborhoods (fig. 12). At the other end of the pool wall, children of diverse ethnic backgrounds hold hands. With these public art projects, the painted images jumped off the walls into the heart of the community: "Within this art, children could see their faces in the images: They looked like the figures in the paintings and felt proud of their heritage" (Martínez de Luna 2015, 31).

At the Robert F. Kennedy Recreation Center, named in honor of the senator's support for Chicano and Mexican causes, Martínez painted on the interior and exterior of the building. On the 50 × 40-ft. exterior wall, highly stylized designs wrapped around

large windows as three large corn stalks ascend from the base of the building (fig. 13). In the center, a large stained-glass window was framed on one side by a large mestizo and on the other side a mestiza looking out into the community. Both wear traditional white ponchos designed with a red step fret motif, and the figures represent Father Sky and Mother Earth. With these murals, Martínez aspired to "use mural painting in Denver, in the way it is used in Mexico, telling the story of a people's history and their present aspirations." He added that "in Mexico, murals are not art for art's sake. . . . They are a medium of visual education, monumental in size, and become public property" (Scott 1972, 24).

Gradually, Chicanos began to take ownership of these neglected parks and began to feel a connection with their surroundings as they strived to improve them. Familiar images on the walls of neighborhood parks created a sense of belonging in a space considered the heart of the community, to the extent that Chicanos began to conduct ceremonies there, such as baptisms and other cultural events. Children swam in the pools while families had picnics, listened to music, and socialized. But the city continued to closely monitor all activity in neighborhood parks; if too many Chicanos were gathered in the parks, the police would disperse them. On at least three occasions, the police arrived in riot gear to disperse crowds with tear gas at

*Above:* Fig. 12. Emanuel Martínez (born 1947), *Untitled*, 1971. Enamel on brick, 10 × 60 ft. Mestizo-Curtis Park, located at Thirty-First Avenue and Curtis Street, Denver, Colorado; destroyed. Courtesy of Emanuel Martínez.

*Below:* Fig.13. Emanuel Martínez (born 1947), *Untitled*, 1971. Enamel on brick, 50 × 40 ft. Robert F. Kennedy Recreation Center, Denver, Colorado; destroyed. Courtesy of Emanuel Martínez.

both Columbus Park/La Raza Park and Lincoln Park/La Alma Park during community events.

The artists did not back down and continued to paint images that represented their cultural heritage on the walls of their barrios. Then, in 1971, artist Roberto Lucero painted a controversial mural in Columbus Park/La Raza Park. The director of Denver's Department of Parks and Recreation demanded that a city employee (who happened to be my father) paint over the mural because it angered a councilman (Barnett 1984, 69). The mural had depicted colorful pre-Columbian images, such as the

Aztec Sun Stone. As reported in the *Straight Creek Journal*, "Lucero said that he chose the Aztec symbols because . . . for a lot of Chicano people there is too much emphasis on Hispano background and not enough on the Indian background" (Scott 1972, qtd. in Martínez de Luna 2015, 31). Emanuel Martínez refused and resigned from his position as a City of Denver employee in protest. Shortly after, Parks and Recreation created a new ordinance putting a halt to any new murals. Unfortunately, Lucero's mural was swiftly painted over by the city and erased from memory, with no known photographs documenting the painting.

The attempt to suppress mural painting lasted for approximately three years, but with increased support from federally funded and privately funded programs, Chicano artists mobilized, forming their own collective, creative force. Meanwhile, Martínez returned to the Lincoln/La Alma Park neighborhood in 1978 to paint *La Alma*, a gift from the artist to the community. The mural, painted with the aid of Michael Maestas and the people of Lincoln Park, honors the link between past and present. Martínez's symmetrical composition juxtaposes a Chicano with an indigenous man to recall the accomplishments of the past and the responsibility of the youth to continue their legacy (fig. 14). In the center, a bald eagle's outstretched royal-blue and rust-brown wings embrace the two men while clutching in one claw a skull and in the other a human embryo, the cycle of life. On the eagle's chest, a brilliant blue butterfly represents the transformative stage in a young man's life, analogous to Mesoamerica's perception of the butterfly as a symbol of renewal and transformation. Forming the body of the eagle are the profiles of two women. On the right, a light brown profile of Mother Earth gazes out into a Puebloan landscape recalling the great Native American cultures of North America. On the left, a celestial blue profile of the Moon Goddess gazes over Denver's cityscape into the future of every community, the youth.

Fig. 14. Emanuel Martínez (born 1947), *La Alma*, 1978. Acrylic on stucco, 20 × 60 ft. La Alma Recreation Center, located at 1325 W. Eleventh Avenue, Denver, Colorado, at Eleventh and Mariposa. Courtesy of Emanuel Martínez.

## Chicano Art Themes: Pre-Columbian Mythology and Iconography

Just as Western cultures were captivated by Greek mythology, Chicanos from the 1960s embraced Mesoamerican mythology, featuring it in many of their murals. Pre-Columbian imagery had been a touchstone for artists since the beginning of the Chicano Movement, and it continues to play an important role in Denver murals as a means to inspire local youth. For example, Chicano youth embraced the image of the deity Quetzalcoatl. The image of Quetzalcoatl is often portrayed on lowrider cars and in the form of tattoos. Painted on the façade of Su Teatro, a Chicano theater company located on Santa Fe Drive, a colorful, undulating feathered serpent measuring 20 × 64 ft. greets visitors (fig. 15). The plumed serpent's back shimmers with blue-green plumage and a crimson, orange, and yellow belly. Quetzalcoatl continues to represent a fierce force of power and reverence that emboldens youth.

The mural *Urban Dope, Rural Hope* likewise invokes Quetzalcoatl.[8] Designed by Emanuel Martínez in collaboration with Elfego Baca, Ernie Gallegos, Roberto Roybal, and Carlos Sandoval, as well as numerous neighborhood children, the painting measured 16 × 350 ft. along the side of a building at Ninth and Bryant. In the center of the mural, a stylized eagle clutched in its beak the plumed serpent Quetzalcoatl. Behind the eagle, a large maize cob transformed into the cloak of Mother Earth, who embraced her child, while Father Sky played his guitar and sang a corrido. In contrast, on the other side of the wall, an image portrayed the danger of drugs. Attempts to steer youth away from such dangerous lifestyles were one of the motivations behind painting murals at recreation centers, where the youth would tend to socialize.

Like Martínez, artist Jerry Jaramillo sought to inspire youth by invoking indigenous mythology. In his mural for the Aztlan Recreation Center, *Flight of the Eagle Dancer*, Jaramillo depicts a young eagle dancer floating above the steps of the Templo Mayor, located in the Mexica capital, Tenochtitlan, now Mexico City (fig. 16). An aura surrounds him as he transforms into an eagle soaring above Lake Texcoco into a cool, somber midnight-blue evening sky. This moment of transformation greets youth as they enter the recreation center. Jaramillo chose the subject to inspire adolescents as they undergo a period of transformation and uncertainty in their own lives.

Fig. 15. Carlos Fresquez (born 1947), and MSU Denver students, *Quetzalcoatl*, 2012. Acrylic, (approximation) 20 × 64 ft. Su Teatro, located at 721 Santa Fe Drive, Denver, Colorado, on Santa Fe between Eighth and Seventh. Courtesy of Carlos Fresquez and MSU Denver Students.

Fig. 16. Jerry Jaramillo (born 1952), *Flight of the Eagle Dancer*, 1984. Acrylic on concrete block, 20 × 45 ft. Aztlan Recreation Center, located at 4435 Navajo Street, Denver, Colorado. Courtesy of Tony Ortega.

In his mural *Huitzilopochtli* (fig. 17), David Ocelotl Garcia explores the mythology surrounding another Mesoamerican deity, the patron of the Mexica, Huitzilopochtli, a warrior whose name translates to "Hummingbird of the South [or Left]." The wall faces south, the direction of Huitzilopochtli. Garcia transports the viewer to a vivid supernatural realm bursting with energy from the four natural elements—earth, water, fire, and air—merging in the center to celebrate Huitzilopochtli's divine birth, a momentous occasion that defined the Mexica as a people and inspired them to conquer a large portion of present-day Mexico during the Postclassic period (AD 900–1521). Mexica mythology recounts that while in the womb, Huitzilopochtli learned that his brothers, known as the Centzon Huitznaua, the stars in the southern sky, and his sister, Coyolxauhqui, the Moon Goddess, plotted to kill him but instead murdered his mother, Coatlicue. He emerged from his mother's womb fully armed and, in revenge, murdered his sister. While Garcia references Huitzilopochtli through the title and the central figures of mother and child, he does

not focus on the violence associated with the myth. Instead, as the artist describes it, "the characters, objects, elements, and symbols represent a [variety] of spiritual ideas and philosophies specific to the healing of the mind, body and soul."[9] The iconography of the mother and child—the skull belt ornament at her waist and the hummingbird staff, respectively—identify them as Coatlicue and her son Huitzilopochtli, but Garcia reimagines them as mestizos. Perhaps a nod to the connection between a healthy body and mind and the earth, corn stalks grow from the mind of a child pictured at the lower right- and left-hand corners. The stalks emanate from what would be the location of one's third eye, which Garcia marks with a spiral. Interestingly, the imagery associated with corn sprouting from one's forehead dates back to Formative period (2000 BC–AD 250) cultures, when communities transitioned to an agrarian society. Olmec artists, for example, sculpted a maize cob or a maize plant emerging from a V-shaped cleft at the top of anthropomorphic figures' skulls.

Huitzilopochtli and his sister Coyolxauhqui appear on another mural located along the

Fig. 17. David Ocelotl Garcia (born 1977), *Huitzilopochtli,* 2008. Acrylic on concrete, 15 × 40 ft. Sisters of Color United for Education building, located at W. Eighth Avenue between Federal and Decatur, Denver, Colorado. Courtesy of David Ocelotl Garcia.

southern wall of Su Teatro (fig. 18). The siblings flank a central, multicolored disk that at once resembles the central image of the Aztec Calendar Stone and a Native American medicine wheel. Coyolxauhqui, whose name translates to "She with the Bells on Her Cheeks," appears to the left of the wheel painted in gray; her severed arm floats in front of her. The color references the stone sculpture of this same image recovered during excavations in the Templo Mayor pyramid. Her brother appears to the right of the disk, grasping his staff and the bodies of serpents that connect the two siblings. Fresquez and his students bring the sibling drama to life, but as mentioned previously, they combine imagery from several indigenous cultures in the mural, common practice in Chicano iconography.

## Chicano Art Themes: Historical Figures/Ancestral Veneration

Many Chicano artists incorporate a veneration of historical figures and ancestors into their work as a way to pay respect to the past as well as instill a sense of pride in Hispano and Mexican communities. In some instances,

Fig. 18. Carlos Fresquez (born 1957) and MSU Denver students, *Coyolxauhqui and Huitzilopochtli,* 2017. Acrylic, (approximation) 12 × 36 ft. Su Teatro, 721 Santa Fe Drive, Denver, Colorado, located at Seventh Avenue and Santa Fe Drive. Courtesy of Carlos Fresquez and MSU Denver Students.

ancestors take the form of pre-Columbian figures such as the renowned Late Classic Maya king, K'inich Janaab' Pakal (or Pakal), lord of Palenque, a site located in Chiapas, Mexico.

Josiah Lopez emblazoned the head of Pakal on the outside of an auto body shop in Westwood, a Latino neighborhood in southwest Denver. Rendered in a pixelated aesthetic, Lopez's portrait of Pakal, *The House of the Nine Sharpened Spears: Pakal, the Maya King and the*

*Astronaut* (fig. 19), is recognizably modeled after the stone portrait head recovered from Pakal's tomb found below the Temple of the Inscriptions in the summer of 1952. The black background with white dots and diamonds suggests a balanced universe, yet the black serves as a foreground with sharp angular lines to create a symmetrical structural composition. The iconic figure painted in shades of turquoise blue with stark white highlights contrasts with the dark shadows to create a three-dimensional effect. The figure's bright white eyes suggest it may be a mask rather than a solid form. In this mural, Lopez pokes fun at fallacious documentaries and books that suggest extraterrestrials were responsible for the impressive accomplishments of indigenous people. Perhaps for many it may seem strange to find a portrait of Pakal in Denver, but Chicanos and Mexicans identify with historical figures such as Pakal, just as they do with Po'pay and Emiliano Zapata in artworks discussed earlier.

Other Chicano artists such as Tony Ortega, Carlos Sandoval, and Carlotta d. R. EspinoZa connect ancestor veneration to family and frequently feature images of the Virgen de Guadalupe in their works. Artist Tony Ortega emphasizes the importance of community by depicting recognizable landmarks and common scenes in Denver neighborhoods. He paints with bold colors, reminiscent of New Mexican landscapes and indigenous textiles with often faceless individuals telling stories of everyday community life. In the mural at the Escuela de Guadalupe, an elder sits with a group of students as he tells stories of past and present, with iconic images of Mexican culture appearing around them (fig. 20). The El Castillo pyramid from Chichen Itza, Yucatán, Mexico, serves as a backdrop for the iconic image of Our Lady of Guadalupe emanating from it, Mexican dancers from the state of Veracruz, and a Chicano couple dressed in pachuco/a clothing. Ortega also reinforces the importance of farming

Fig. 19. Josiah Lopez (born 1974), *The House of the Nine Sharpened Spears: Pakal, the Maya Astronaut King*, 2017. Spray paint on concrete, 12 × 22 ft. 3650 Morrison Road, Denver. Courtesy of Josiah Lopez.

as black lines cut into the field, a meadow landscape of brilliant color combinations of yellows and greens defining rows of crops harvested by farmworkers wearing splashes of hot and cool colors.

In his mural *La Sagrada Familia* (fig. 21), Carlos Sandoval makes reference to the sanctity of family and the wisdom of elders. Set in the San Luis Valley, the airy composition consists of a central group of five figures set against the rich blues and greens of the fertile fields. At the center of the group stands an elderly man, a halo encircling his head and a hoe in his left hand. The bottom of this figure appears to be transparent, suggesting that he has passed on, while the halo and the hoe imply both his saintliness and the sanctity of agriculture. Behind him, an elderly female gazes at a descending dove. A mother and child occupy the lower portion of the group, their bodies

transforming into slices of cantaloupe and watermelon, a celebration of the fruits of labor. The five figures are joined together with vines interlaced between them; the emerald green leaves blow in a slight breeze, referencing the fertility of the earth and the role Chicanos play in the cycle of life. This homage to ancestors and the continuation of their legacy resonates in Chicano communities that have historically been devalued in mainstream society. Practicing ancestral reverence encourages the strength of familial bonds, thus validating the relevance of their strong cultural heritage. Such customs commonly overlap with Mexican traditions, as Chicanos share a historical bond with Mexico.

During the last several decades, the city of Denver has undergone radical growth, which has resulted in further change and displacement of many longtime Chicano communities. North

Fig. 20. Tony Ortega (born 1958), *Untitled* ("La Escuela Guadalupe Community Mural"), 2015. Acrylic, 6 × 10 ft. La Escuela de Guadalupe, located at 660 Julian Street, Denver, Colorado. Courtesy of Tony Ortega.

Denver, a historically Latino neighborhood, for example, has seen a change in demographics. In 1976, Carlotta d. R. EspinoZa painted a mural commemorating the apparition of the Virgen de Guadalupe, a powerful cultural symbol for both Mexicans and Chicanos, at Our Lady of Guadalupe Church in north Denver.[11] Because the Virgen appeared to Juan Diego, an indigenous peasant in Mexico, she became a New World Virgin. EspinoZa chose to depict her "more like a Chicana, more like a modern woman" (Paul [1979] 1992). The church functioned as a community center for the neighborhood, and the mural "stood as a backdrop to three decades of Masses, baptisms, First Communions, and funerals. It was witness to United Farm Workers meetings, to the fevered days of the Chicano movement, to visits by civil rights leaders. The church was a symbol of a fight for equality, and the mural was its emblem" (Griego 2010).

With changes to the neighborhood, the congregation of Our Lady of Guadalupe has also shifted. A more socially conservative priest and congregation painted over the church's exterior murals during the early 2000s, covered two of the interior murals, and built a wall to cover the Virgen de Guadalupe mural. For Chicano community members who had

attended this church for generations, this act of erasure by the current congregation symbolized an unimaginable reality that fifty years ago would have been incomprehensible, when Chicanos and Mexicans fought together to defeat discrimination. The wall covering the mural continues to spark a heated debate between current and former parishioners who maintain spiritual and historical ties to the church.

## A New Generation of Colorado Muralists

Despite these setbacks, the Colorado Chicano mural tradition continues. Artists such as David Ocelotl Garcia, Jaime Molina, and Pedro Barrios are three among many who represent the next generation of muralists who continue to beautify public spaces with paintings that honor Chicano history and raise public awareness of the struggles we have overcome. For example, Jaime Molina and Pedro Barrio's mural *Song for Sloan's Lake* (fig. 22) depicts a balladeer strumming his guitar and singing corridos against the backdrop of the Coloradan sierra. The musician, pictured with his eyes closed and reclining backward, serenades the mountains behind him.

In 2016, David Ocelotl Garcia was commissioned to paint a mural for Columbus Park/ La Raza Park in north Denver. Titled *El Viaje/ The Journey* (fig. 23), the work celebrates "the Mexican peoples' journey from creation, to the present and into the future."[10] Designed to adorn the inside of a four-sided structure, the mural wraps around the interior, moving from the prehispanic past—symbolized by the appearance of Mesoamerican deities such as Mayahuel—to contemporary references to struggle and perseverance. On one side of the structure, Garcia stacks references to both the fight for land equality waged during the Mexican Revolution and the protests of the

Fig. 21. Carlos Sandoval (born 1944), *La Sagrada Familia*, 1982. Acrylic on stucco, 16 × 22 ft. Located at Our Lady of Guadalupe Church, 1209 W. Thirty-Sixth Avenue, Denver, Colorado; destroyed. Courtesy of Tony Ortega.

Fig. 22. Jaime Molina (born 1981) and Pedro Barrios (born 1981), *Song for Sloan's Lake*, 2016. Acrylic, latex, and spray paint, 10 × 25 ft. Located at Colfax and Raleigh, Denver, Colorado. Courtesy of Jaime Molina.

Chicano civil rights movement on top of each other. On the upper panel, Garcia projects swelling clouds in hues of blue and magenta as young Hispano and Mexican American activists anxiously march forward with their fists raised. Below, field hands emerge from a tangle of agave and maguey plants, armed with guns, as a bandolier undulates behind them. During the Mexican Revolution (1910–20), hundreds of thousands of people died fighting against the unequal distribution of wealth and landownership of early twentieth-century Mexico. Other scenes depict farmworkers in the fields carrying bushels of tomatoes and surrounded by lush green plants, while additional vignettes record the harsh conditions of factory work as workers are ground beneath the machinery they operate. The mural also references the contemporary plight of recent immigrants torn between their homeland and a chance to live a better life. The Mexican and American flags billow in the background as a family moves forward, as a child reaches for a star. The symbolism of the star demonstrates how Chicano murals recount the journey of a nation, contextualizing within a historical and social framework the spirit of mestizaje, profoundly American, yet uniquely Coloradoan.

For more than fifty years, Chicano muralists have transformed their communities in Colorado, creating images that legitimize their place, describing the role of the group within the supernatural and natural landscape, and celebrating their cultural heritage. This journey began with a small group of young Chicana/o artists who challenged the status quo as they discovered within themselves the skill to empower communities through monumental art. The mission of muralists to share their heritage grows in Colorado as younger generations of muralists develop distinct, holistic approaches to describe the human cultural experience yet continue to embrace the struggle and perseverance of Chicanismo!

◉ ◉ ◉

Fig. 23. David Ocelotl Garcia (born 1977), *El Viaje/The Journey*, 2016. Acrylic, 6 × 200 ft. Located at Columbus Park/La Raza Park, 1501 W. Thirty-Eighth Avenue, Denver, Colorado. Courtesy of David Ocelotl Garcia.

## Notes

Readers wanting to know more about Chicano/a murals in Colorado are directed to the Chicano/a Murals of Colorado Project (CMCP), https://chicanomuralsofcolorado.com.

**1** For clarity, additional terms used to describe Chicanos in this chapter include Latino/a, referring to a person of Latin American origin living in the United States; mestizo/a, referring to people with Native American and mixed European ancestry; Hispano/a, referring to North American Indian and a dominant Spanish ancestry/heritage; and Nuevomejicano/a, referring to Hispanos/as from the New Mexican cultural geographic area that includes southern Colorado.

**2** In 1848, the United States annexed a large portion of the Southwest, including what would become the states of Texas, New Mexico, Arizona, Nevada, and California, plus southwestern Colorado. These lands had belonged to the Republic of Mexico since 1821. Prior to 1821, the land formed part of the Spanish Empire and was known as New Spain.

**3** In this essay I use the artist's preferred spelling.

**4** Historical accounts describe a large number of single Spanish male settlers arriving in this area, meaning that most of the unions that took place in northern New Mexico and southern Colorado were between European males and Native American females. Recent DNA studies in both southern Colorado and northern New Mexico support historic colonization accounts describing a gene pool derived primarily from Europeans (63 percent) and Native Americans (34 percent), with a minor but definite African contribution of approximately 3 percent (Bonilla et al. 2004, 139). Testing mitochondrial DNA (mtDNA), the maternal lineage traces back thousands of years, to a family's Eve. Results demonstrate that the mtDNA is Native American in origin 85 percent of the time and European in origin 15 percent of the time (New Mexico Genealogical Society 2019).

**5** Litigation continues to this day. See the opinion of the Colorado Court of Appeals in Alire v. Cielo Vista Ranch; https://www.courts.state.co.us/Courts/Court_of_Appeals/Opinion/2018/16CA2083-PD.pdf.

**6** Quetzalcoatl, or the plumed serpent, was one of the creator deities in Mesoamerican mythology who could travel between the earthly and celestial realms.

**7** "La Raza" is defined by Matt S. Meier and Feliciano Ribera as an "ethnic term for Spanish-speaking people, connoting a spirit of belonging and sense of common destiny" (1993, 284).

**8** An image of *Urban Dope, Rural Hope* can be seen at https://denverartmuseum.org/murals-america.

**9** https://www.ocelotlart.com/murals.html.

**10** https://www.ocelotlart.com/murals.html.

**11** An image of *Our Lady of Guadalupe* can be seen at https://denverartmuseum.org/murals-america.

## References

**Aguayo, José.** 1998. "Los Betalberos (The Beetworkers)." In *La Gente: Hispano History and Life in Colorado*, edited by Vincent C. de Baca, 105–19. Denver: Colorado Historical Society.

**"Auraria Neighborhood History."** n.d. Denver Public Library (website). Accessed February 26, 2019. https://history.denverlibrary.org/auraria-neighborhood.

**Barnett, Alan W.** 1984. *Community Murals: The People's Art*. Philadelphia, Pennsylvania: Art Alliance Press.

**Bonilla, C., E. J. Parra, C. L. Pfaff, S. Dios, J. A. Marshall, R. F. Hamman, R. E. Ferrell, C. L. Hoggart, P. M. McKeigue, and M. D. Shriver.** 2004. "Admixture in the Hispanics of the San Luis Valley, Colorado, and Its Implications for Complex Trait Gene Mapping." *Annals of Human Genetics* 68:139–53. DOI:10.1046/j.1529-8817.2003.00084.x.

**Chávez, Thomas E.** 2006. *New Mexico Past and Future*. Albuquerque: University of New Mexico Press.

**Cockcroft, Eva Sperling, and Holly Barnet-Sánchez.** 2001. "Introduction." In *Signs from the Heart: California Chicano Murals*, edited by Eva Sperling Cockcroft and Holly Barnet-Sánchez, 5–21. Venice, Calif: Social and Public Art Resource Center; Albuquerque: University of New Mexico Press.

**Esquibel, José Antonio.** 2003. "The Artisan Families of Mexico City That Settled New Mexico in 1694." *Tradición Revista* 8 (1). nmsantos.com/ResourceFiles/Feature-Articles/Artisan-Families/Artisan-Families.html.

**Gallegos, Magdalena, ed.** 1991. *Auraria Remembered*. Denver, CO: Community College of Denver.

**Goldman, Shifra.** 1990. "The Iconography of Chicano Self-Determination: Race, Ethnicity, and Class." *Art Journal* 49 (2): 167–73.

**Griego, Tina.** 2010. "Church Wall Hiding Our Lady of Guadalupe Mural Brings Protests."

*Denver Post,* July 3. www.denverpost.com/news/ci_15432318?source=infinite.

**Jager, Rebecca Kay.** 2016. *Malinche, Pocahontas, and Sacagawea: Indian Women as Cultural Intermediaries and National Symbols.* Norman: University of Oklahoma Press.

**Latorre, Guisela.** 2008. *Walls of Empowerment: Chicana/o Indigenist Murals of California.* Austin: University of Texas Press.

**Mahan, Shannon A., Rebecca A. Donlan, and Barbara Kardos.** 2014. "Luminescence Dating of Anthropogenic Features of the San Luis Valley, Colorado: From Stone Huts to Stone Walls." *Quaternary International* 362 (March): 50–62.

**Martínez de Luna, Lucha.** 2005. "Murals and the Development of Merchant Activity at Chichen Itza." Master's thesis, Brigham Young University, Provo, Utah.

**Martínez de Luna, Lucha.** 2015. "Chicano Murals in Colorado: The First Decade." *Colorado Heritage, The Magazine of History Colorado,* September/October, 24–31.

**Meier, Matt S., and Feliciano Ribera.** 1993. *Mexican Americans/American Mexicans: From Conquistadores to Chicanos.* New York: Hill and Wang.

**New Mexico Genealogical Society.** 2019. "NMGS DNA Project." https://www.nmgs.org/nmgs-dna-project. Accessed August 17, 2019.

**Paul, Millie.** (1979) 1992. *Espejos = Mirrors: Reflections of a Culture.* Churchill Films. New York: Modern Educational Video Network.

**Reséndez, Andrés.** 2016. *The Other Slavery: The Uncovered Story of Indian Enslavement in America.* Boston: Houghton Mifflin Harcourt.

**Rosen, Martin D., and James Fisher.** 2001. "Chicano Park and the Chicano Park Murals: Barrio Logan, City of San Diego, California." *Public Historian* 23 (4): 91–111.

**Scott, Lynn.** 1972. "Artist Sees Mural Project as Vital Education Medium." *Denver Post,* June 21.

**Su Teatro Cultural and Performing Arts Center.** n.d. "About the St. Cajetan's Reunification Project." Suteatro.org/the-st-cajetans-reunification-project. Accessed February 26, 2019.

**Ybarra–Frausto, Tomas.** 1991. "The Chicano Movement/The Movement of Chicano Art." In *Exhibiting Cultures: The Poetics and Politics of Museum Display,* edited by Ivan Karp and Steven D. Lavine, 128–50. Washington, DC: Smithsonian Institution.

# Acknowledgments

I would like to express my sincere gratitude to the many colleagues and friends who contributed to the success of the 2017 symposium: Judy Baca, Claudia Brittenham, Severin Fowles, Kelley Hays-Gilpin, Heather Hurst, Diana Magaloni, Lucha Aztzin Martínez, Franco Rossi, Alexandre Tokovinine, Lisa Trever, and María Teresa Uriarte.

I thank in particular the Mayer Center staff who organized the event and ensured that it ran smoothly: Julie Wilson Frick, former Mayer Center Program Coordinator; Jesse Laird Ortega, Senior Curatorial Assistant; Sabena Kull, former Mayer Center Spanish Colonial Fellow; and Sarah Krantz, former intern. In addition, I am grateful for the support of the Alianza de las Artes Americanas, for its enduring enthusiasm and many years of support for the symposium. Special recognition goes to my colleague, Jorge Rivas Pérez.

Volumes such as this come to fruition through the efforts of many, and I am grateful for the extraordinary editing and insight provided by both Laura Caruso, Director of Publications at the Denver Art Museum, and Maya Allen-Gallegos, whose keen eyes ensured consistency and clarity; to our magnificent designer Nancy Bratton, who gave the book shape and brought the essays to life; to Renée B. Miller, for her assistance in obtaining images and permissions; and to Steve Grinstead at Colorado History for help in locating photographs.

Special thanks go to Jesse Laird Ortega, for her invaluable assistance thought both the symposium and the production of this volume. In addition to myriad administrative tasks, Jesse contributed an interview with Judy Baca that, along with the recollections of Ed Kabotie also printed here, brings in a contemporary perspective. I thank all the authors for the hard work they put in to prepare the symposium papers for publication.

The ability to gather scholars and artists from across the Americas annually and publish innovative, thought-provoking research is a rare gift. I would like to thank the late Frederick Mayer and his wife, Jan, for their remarkable foresight and generosity. The annual Mayer Center symposium is an extraordinary contribution to the field of art of the Americas.

Victoria I. Lyall
*Frederick and Jan Mayer Curator of the Art*
*of the Ancient Americas*
Denver Art Museum

Published by the Mayer Center for
Ancient and Latin America Art at
the Denver Art Museum
100 W. 14th Ave. Pkwy
Denver, CO 80204

mayercenter.denverartmuseum.org

denverartmuseum.org

ISBN 978-0914738-85-5

Library of Congress Cataloging-in-Publication Data

Names: Mayer Center Symposium (17th : 2017 : Denver Art Museum), author. |
    Lyall, Victoria I., editor. | Frederick and Jan Mayer Center for
    Ancient and Latin American Art, issuing body.
Title: Murals of the Americas / edited by Victoria I. Lyall.
Description: Denver, CO : Denver Art Museum, [2019] | Series: Readings in
    Latin American studies | Includes bibliographical references. | Summary:
    "This volume presents the work of scholars who shared their research at
    the Denver Art Museum's 2017 symposium hosted by the Frederick and Jan
    Mayer Center for Ancient and Latin American Art. Centered on the theme
    of murals, each chapter discusses how this art form functions as a
    powerful tool for the expression of political, social, or religious
    ideas across diverse time periods and cultures in the Americas, from the
    ancient rock cave paintings of Guerrero, Mexico, to the murals of the
    1960s Chicano movement"—Provided by publisher.
Identifiers: LCCN 2019038782 | ISBN 9780914738855 (paperback)
Subjects: LCSH: Mural painting and decoration—Latin America—Congresses. |
    Art and society—Latin America—Congresses.
Classification: LCC ND2602 .M39 2019 | DDC 751.7/3098—dc23
LC record available at https://lccn.loc.gov/2019038782

Copyeditor: Maya Allen-Gallegos

Design: Nancy Bratton Design

Project management: Laura Caruso and Jesse Laird Ortega

Proofreaders: Laura Caruso and
Maya Allen-Gallegos

Printed by D&K Printing, Boulder, CO

Distributed by University of Oklahoma Press, Norman, OK

Front cover and page vi (detail):
Judith F. Baca, *La Memoria de Nuestra Tierra: Colorado (The Memory of Our Land)*, 2000.
Hand painted and digitally generated mural on aluminum substrate, 10 x 55 ft. Located at the
Denver International Airport. Image courtesy of the SPARC Archive. (sparcinla.org).